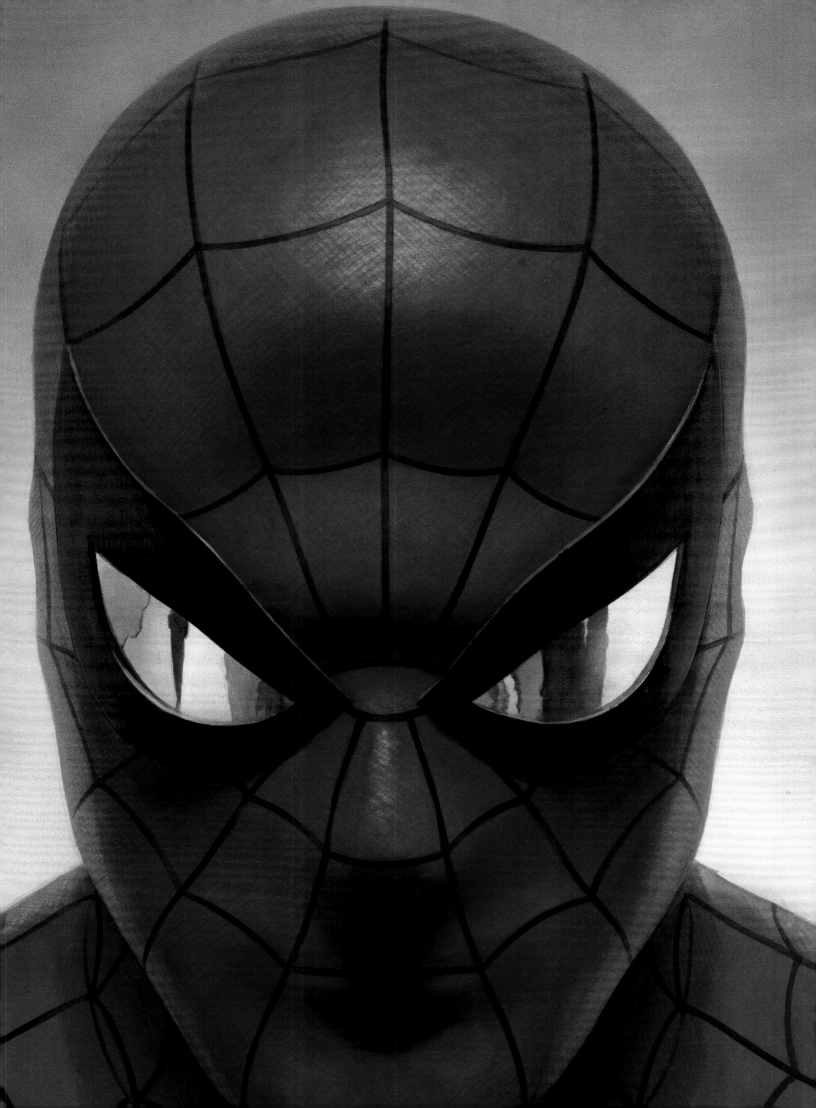

Once upon a time, there was
a little boy in Lubbock, Texas,
who decided that drawing
uperheroes was his only realistic
option, if he couldn't
actually become one.

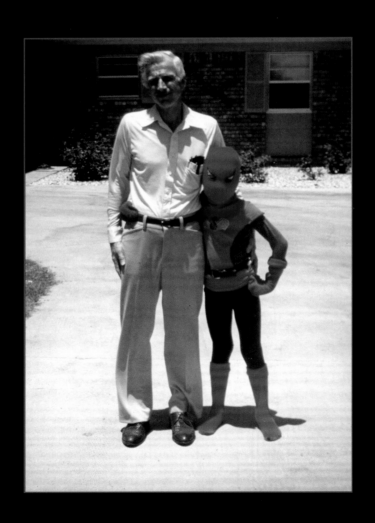

ABOVE: Clark Ross (left) with his son, Nelson Alexander, 1976.

OPPOSITE: Spider-Man by Nelson Alexander Ross, age 5,

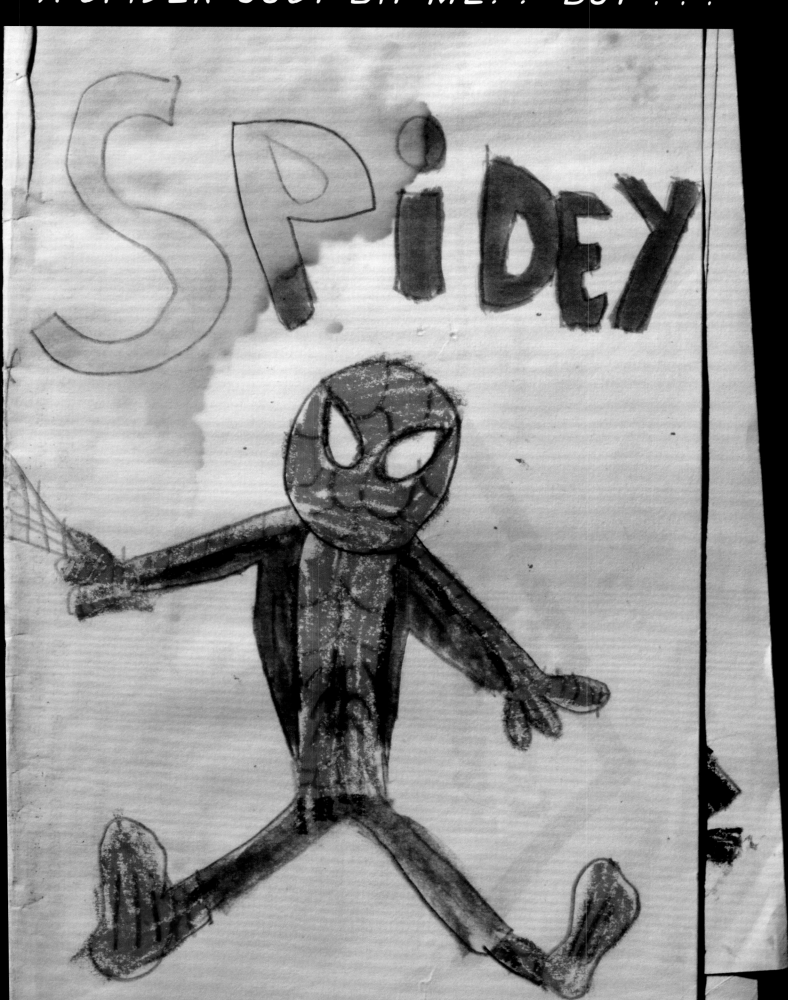

And so he set to training his hand . . .

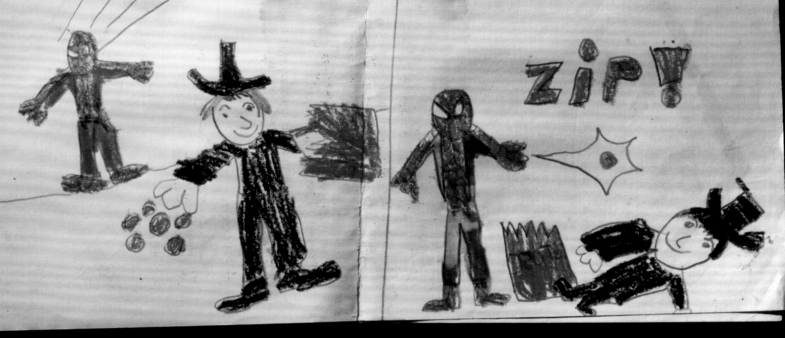

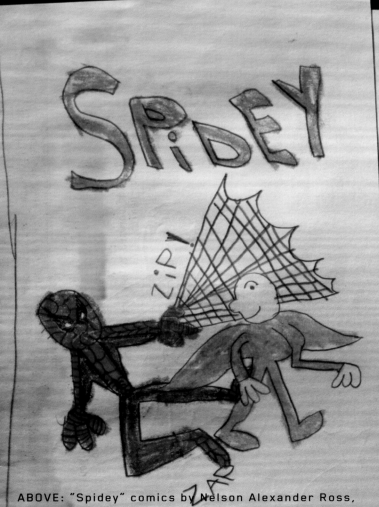

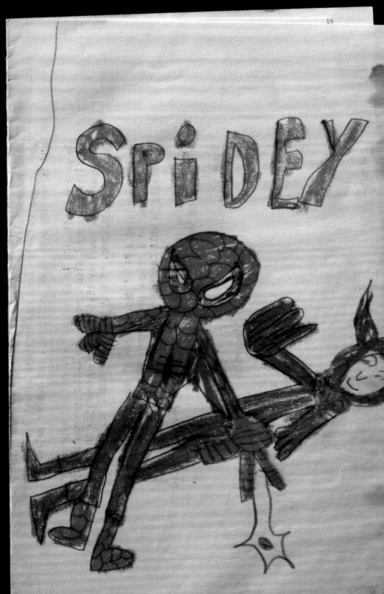

ABOVE: "Spidey" comics by Nelson Alexander Ross, age 5.

OPPOSITE: Spider-Man print by Alex Ross, age 40, 2010.

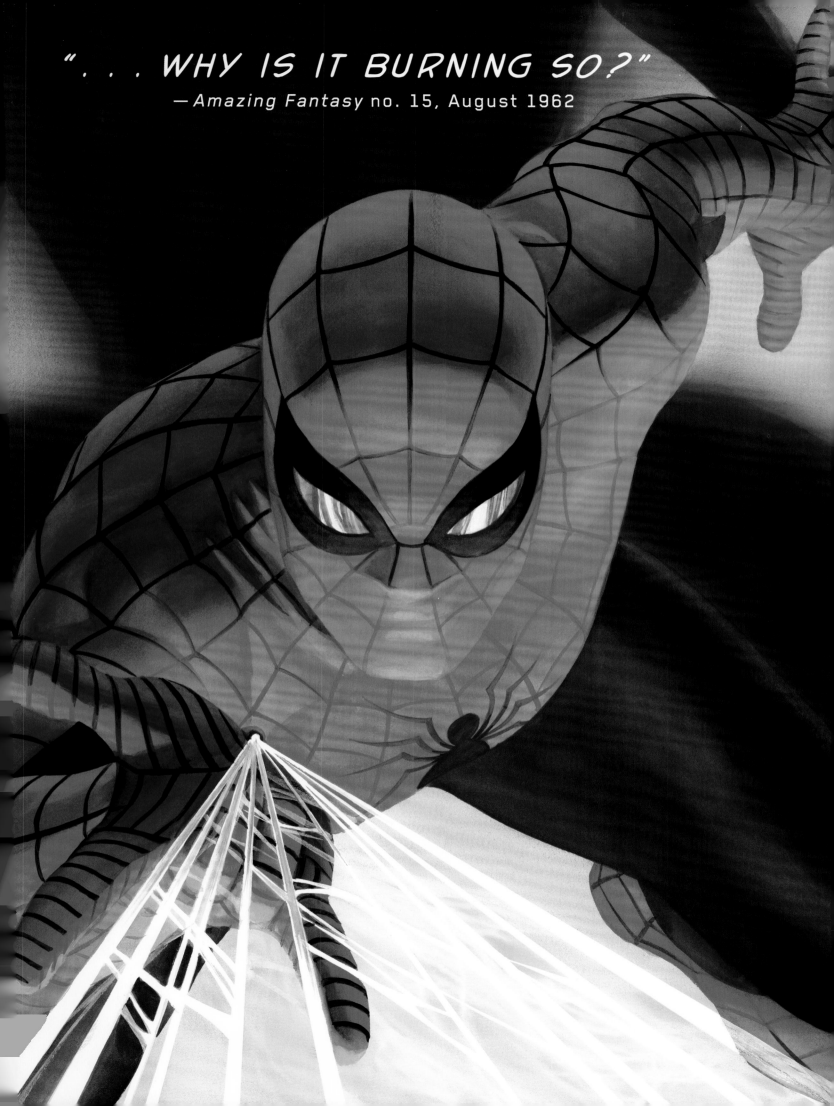

"... WHY IS IT BURNING SO?"
—Amazing Fantasy no. 15, August 1962

OPPOSITE: Hulk mask made out of a paper bag by Alex, age 8.

ABOVE: Life-size Hulk bust designed by Alex and sculpted by Mike Hill, 2003.

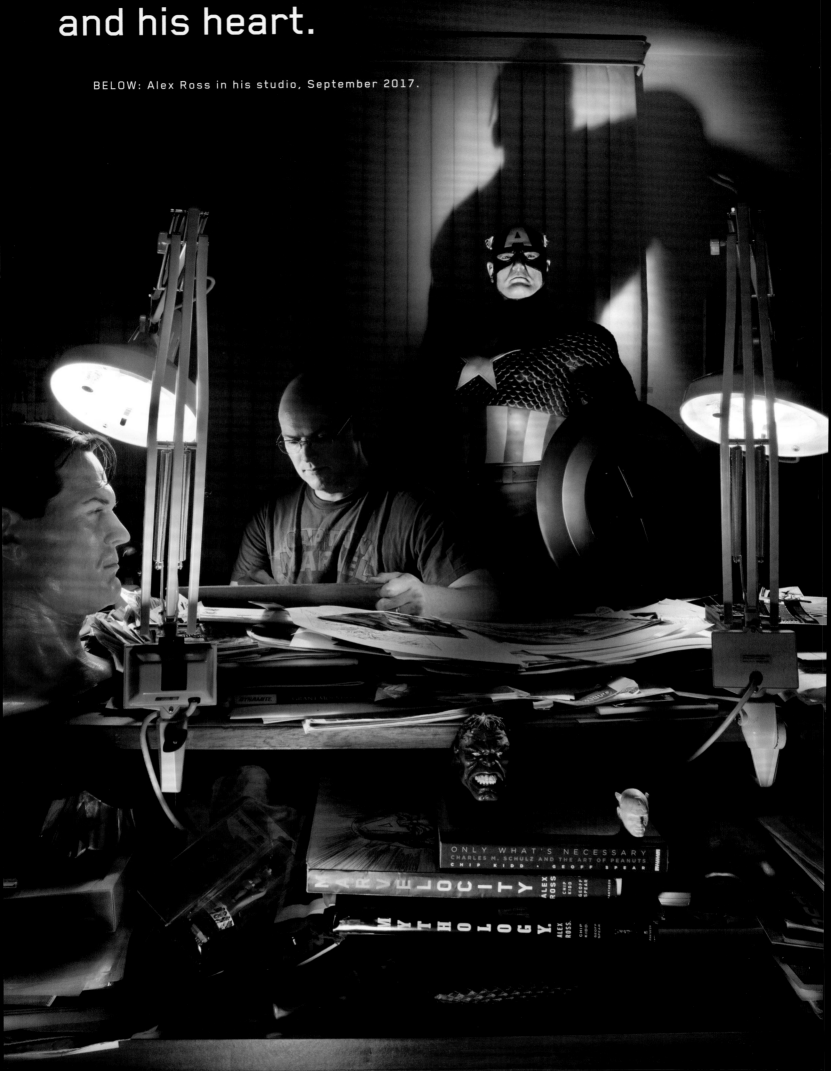

and his heart.

BELOW: Alex Ross in his studio, September 2017.

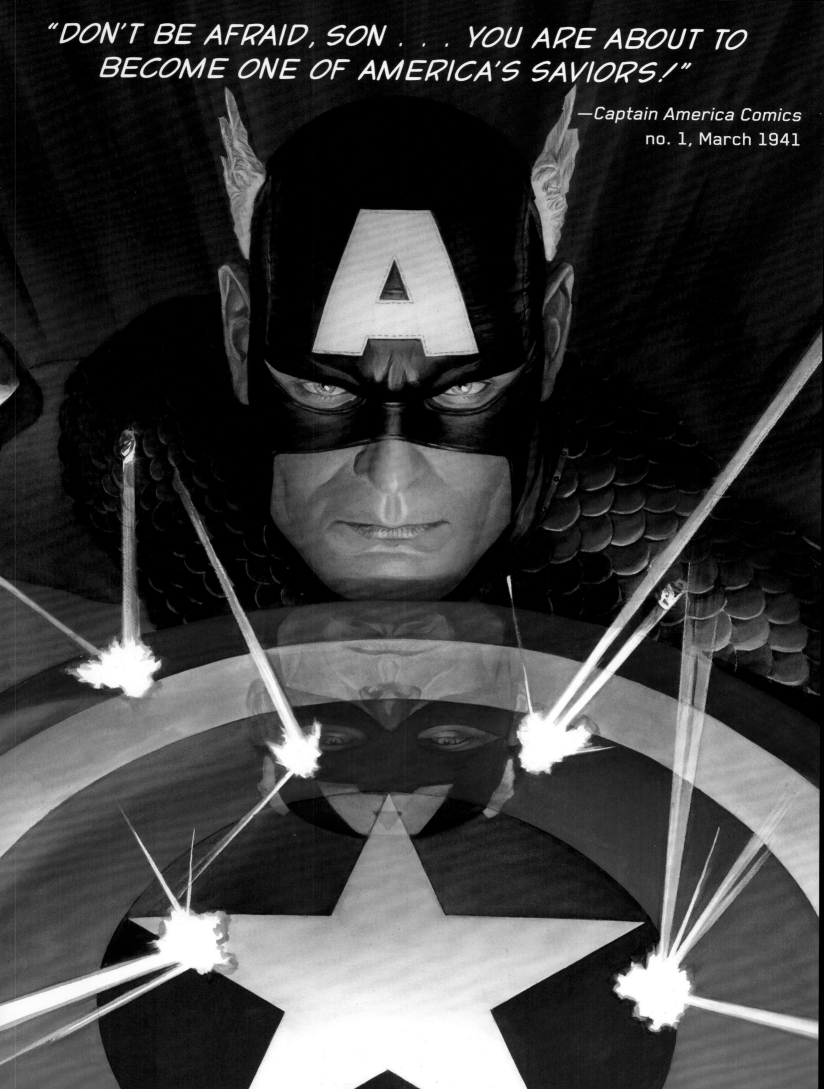

"DON'T BE AFRAID, SON . . . YOU ARE ABOUT TO BECOME ONE OF AMERICA'S SAVIORS!"

—Captain America Comics
no. 1, March 1941

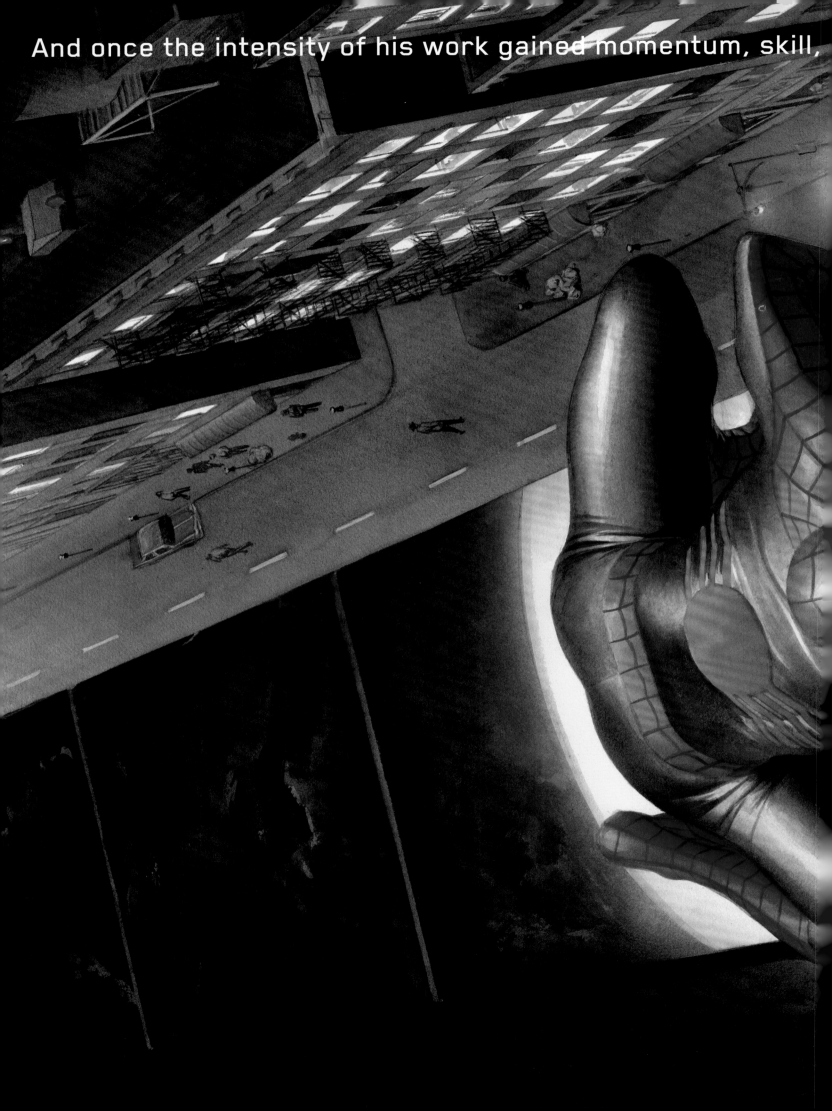

And once the intensity of his work gained momentum, skill,

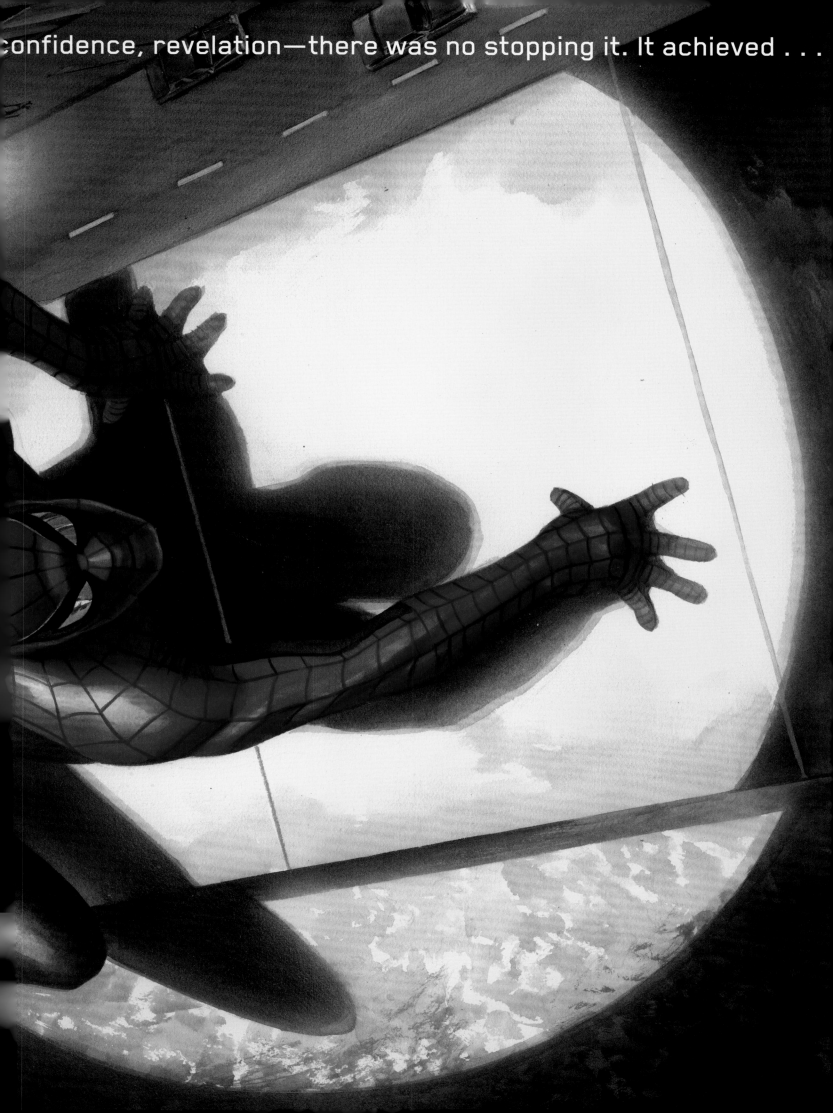

MARVELOCITY

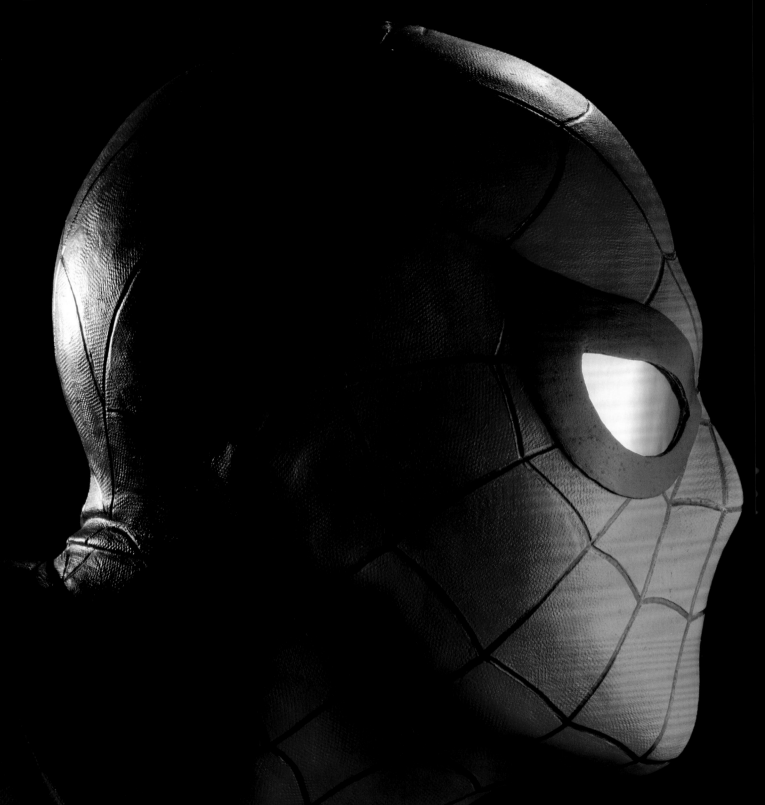

THE MARVEL COMICS ART OF **ALEX ROSS**

CHIP KIDD · GEOFF SPEAR

INTRODUCTION BY J. J. ABRAMS

PANTHEON BOOKS · NEW YORK 2018

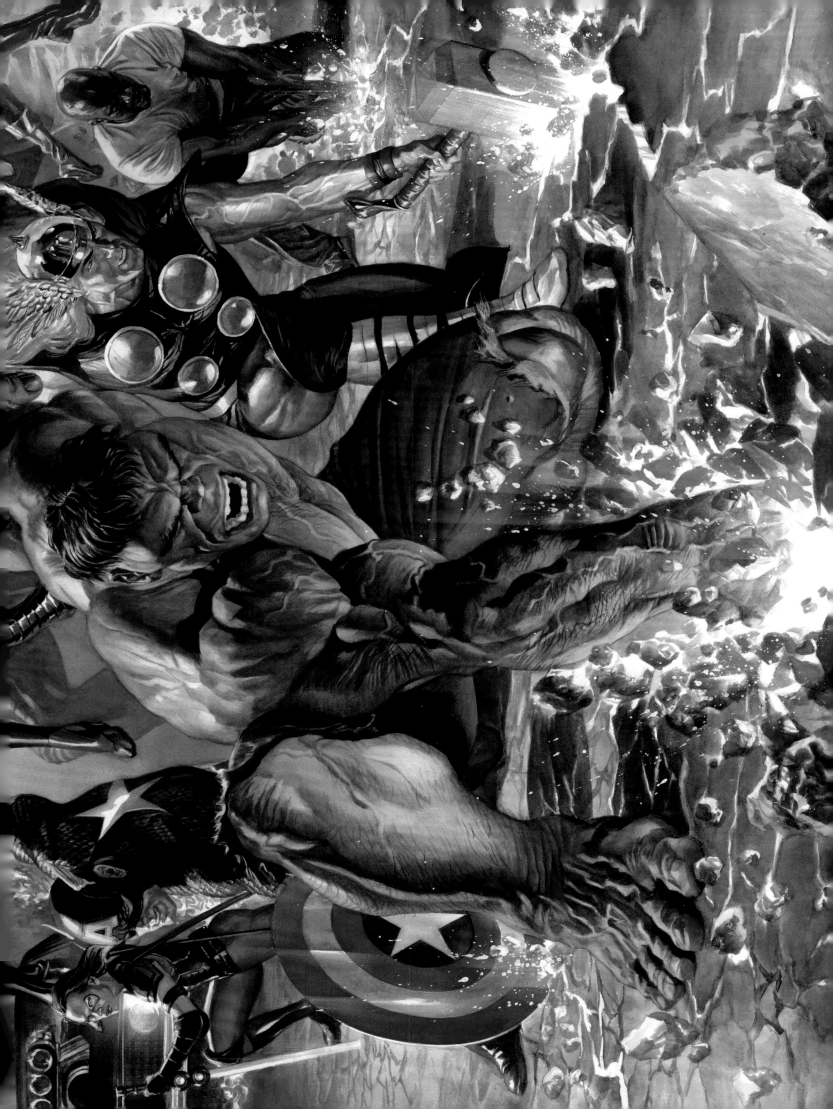

PRECEDING PAGES, IN ORDER:

ENDPAPERS: Detail, Giant-Man from *Marvels* no. 2, 1993.

Cover sketch re-creating John Romita Sr.'s cover of
Amazing Spider-Man A Rockomic! (Buddah Records, 1972), 2017.

Cover of *Amazing Spider-Man* no. 796, 2018.

Captain America portrait, 2011.

Cover of *Spectacular Spider-Man* no. 500, re-creating a
John Romita Sr. painting (2018).

TITLE PAGE: Life-size Spider-Man bust designed by Alex and
sculpted by Mike Hill, 2002.

Cover of and poster for *Marvel Legacy* no. 1, 2017.

THIS SPREAD: Cover of *Universe X Special: Cap* no. 1, 2001.

Library of Congress Cataloging-in-Publication Data
Names: Ross, Alex, [date] artist. Kidd, Chip. Spear, Geoff. Abrams, J. J. (Jeffrey Jacob),
[date] writer of introduction.
Title: Marvelocity : Marvel Comics art of Alex Ross / Alex Ross, Chip Kidd, Geoff Spear ;
with an introduction by J. J. Abrams.
Description: New York : Pantheon Books, 2018.
Identifiers: LCCN 2018013823. ISBN 9781101871973 (hardback).
Subjects: LCSH: Ross, Alex, [date]—Themes, motives. Superheroes in art. Comic books,
strips, etc.—United States. Marvel Comics Group. BISAC: ART/Techniques/Cartooning.
COMICS & GRAPHIC NOVELS/Superheroes. COMICS & GRAPHIC NOVELS/Anthologies.
Classification: LCC NC1429.R7628 A4 2018 | DDC 741.5/9092—dc23 | LC record available
at lccn.loc.gov/2018013823

pantheonbooks.com
alexrossart.com
marvel.com

Jacket illustrations by Alex Ross
Jacket and book design by Chip Kidd
Prepress by John Kuramoto

Printed in China
First Edition
9 8 7 6 5 4 3 2 1

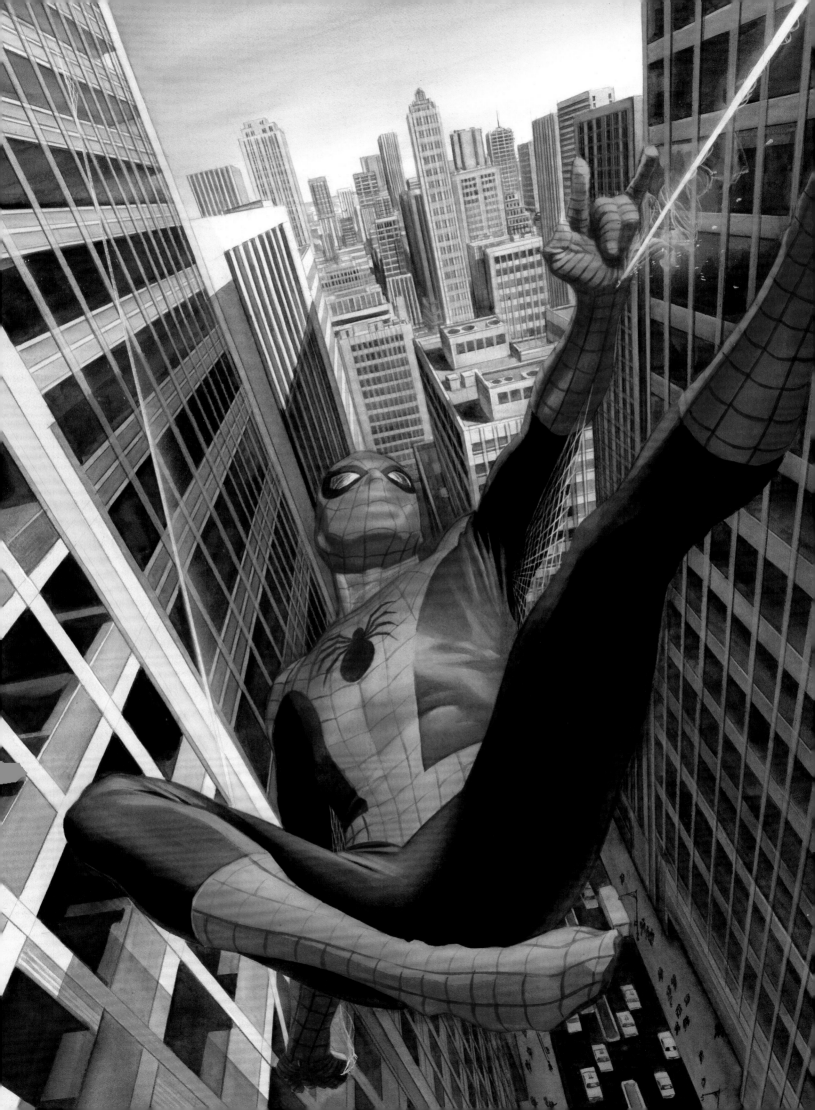

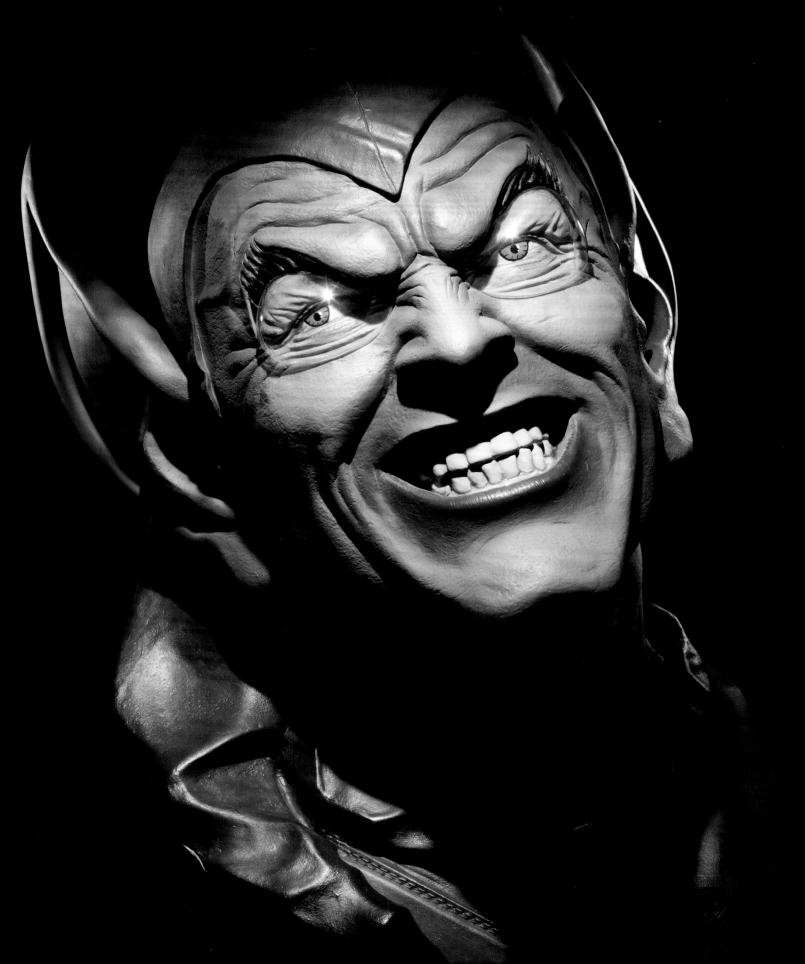

ART DIRECTION, DESIGN, TEXT BY CHIP KIDD

PHOTOGRAPHY BY GEOFF SPEAR

COMMENTARY THROUGHOUT BY ALEX ROSS

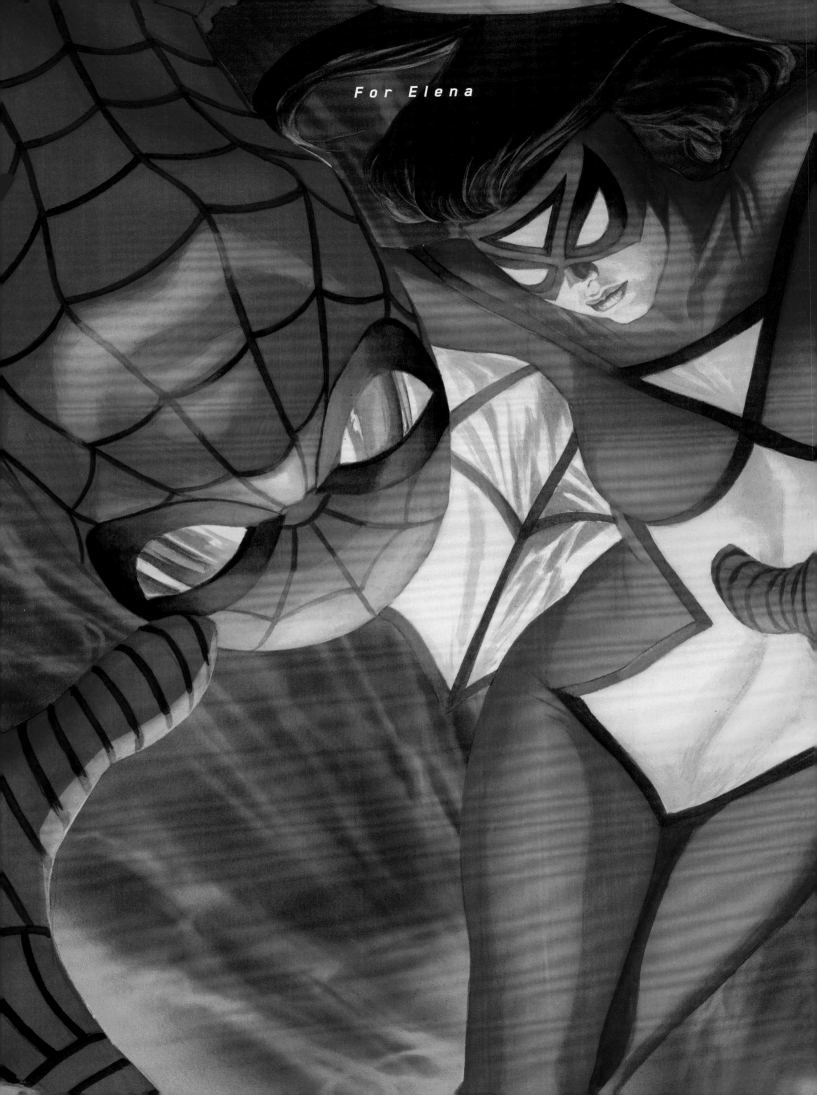

For Elena

PREVIOUS SPREAD, LEFT: Cover to
Amazing Spider-Man: Learning to Crawl no. 1.1, 2014.
PREVIOUS SPREAD, RIGHT: Life-size Green Goblin bust
designed by Alex and sculpted by Mike Hill, 2003.
OPPOSITE: Cover to *Alex Ross Millennium Edition,*
Spider-Man and Spider-Woman cover, 2009.
ABOVE: Ink drawing of the original Human Torch from the book-casing
stamp for the *Marvels* Graphitti Designs hardcover, 1994.

INTRODUCTION BY J. J. ABRAMS

Why do we care about characters in capes? Why do these masked, winged, webbed, green, shielded, flying, leaping powerhouses mean anything to us? I think, in part, it is because, when the stories are well-told and rendered, we all marvel at the idea of these beings actually living among us. It's the great "what if": imagine if these pop cultural gods existed in this world!

Comic art, an obsession of so many including yours truly since childhood, has always been a wonderful step removed from what's real. This allows for a hyper-reality that permits all sorts of wild and wonderful acrobatic feats—physical and narrative—to be performed, and then interpreted by the eager reader. We believe the impossible, in part, because it's a comic book.

What Alex Ross does is different.

He combines a remarkable, incomparable, classical artistry with the sheer fantasy of superheroes. In a style that owes as much to Norman Rockwell as it does to Jack Kirby, Ross makes the nearly impossible look easy: he brings our favorite characters to actual, familiar, relatable life. Even as I describe it here it seems like something that couldn't possibly be achieved—and yet in mindblowing image after image, his compositions and lighting and passion and power and pathos make the larger-than-life feel that much closer to us all. As if these characters were flesh and blood, posing before the artist, whose preternatural gift with the brush allows him to depict what he's seen.

There's nothing more fun or enriching than having your breath taken away by a story, or song, or image, or magic trick—or anything that helps you see the world differently. I dare you not to be breathless at this collection of Ross' extraordinary work.

—J. J. A., 2017

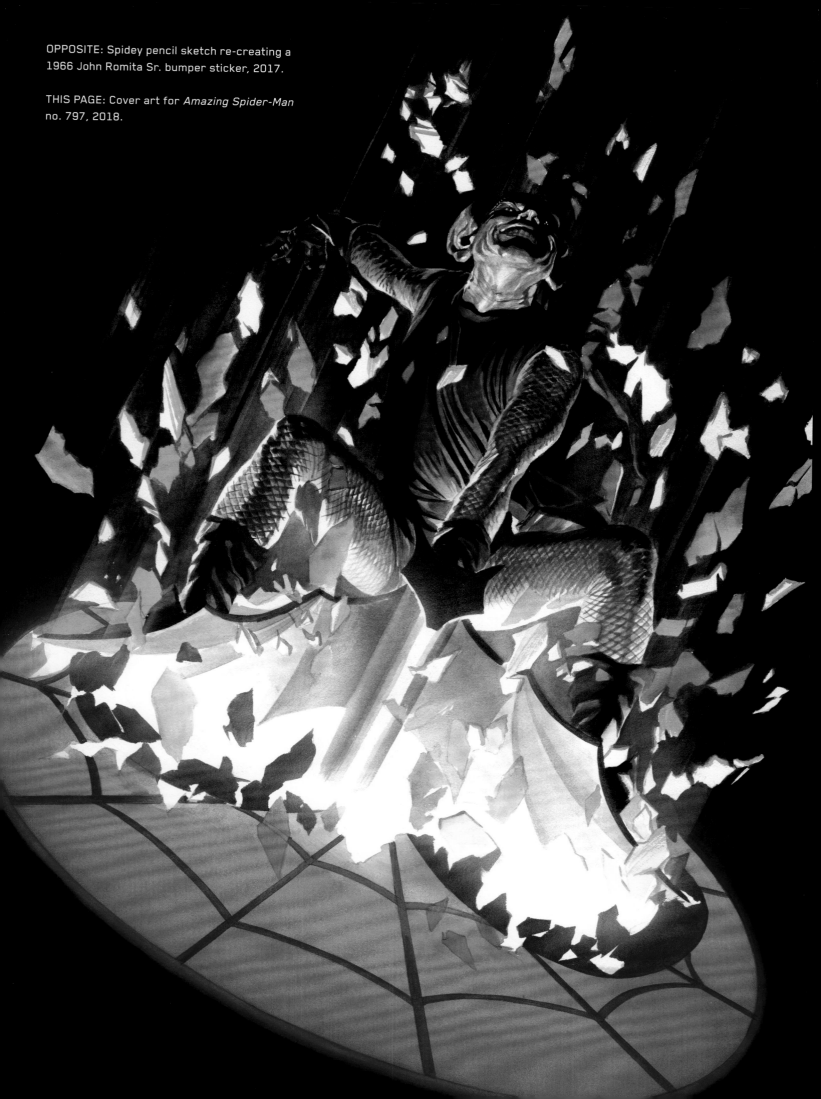

OPPOSITE: Spidey pencil sketch re-creating a
1966 John Romita Sr. bumper sticker, 2017.

THIS PAGE: Cover art for *Amazing Spider-Man*
no. 797, 2018.

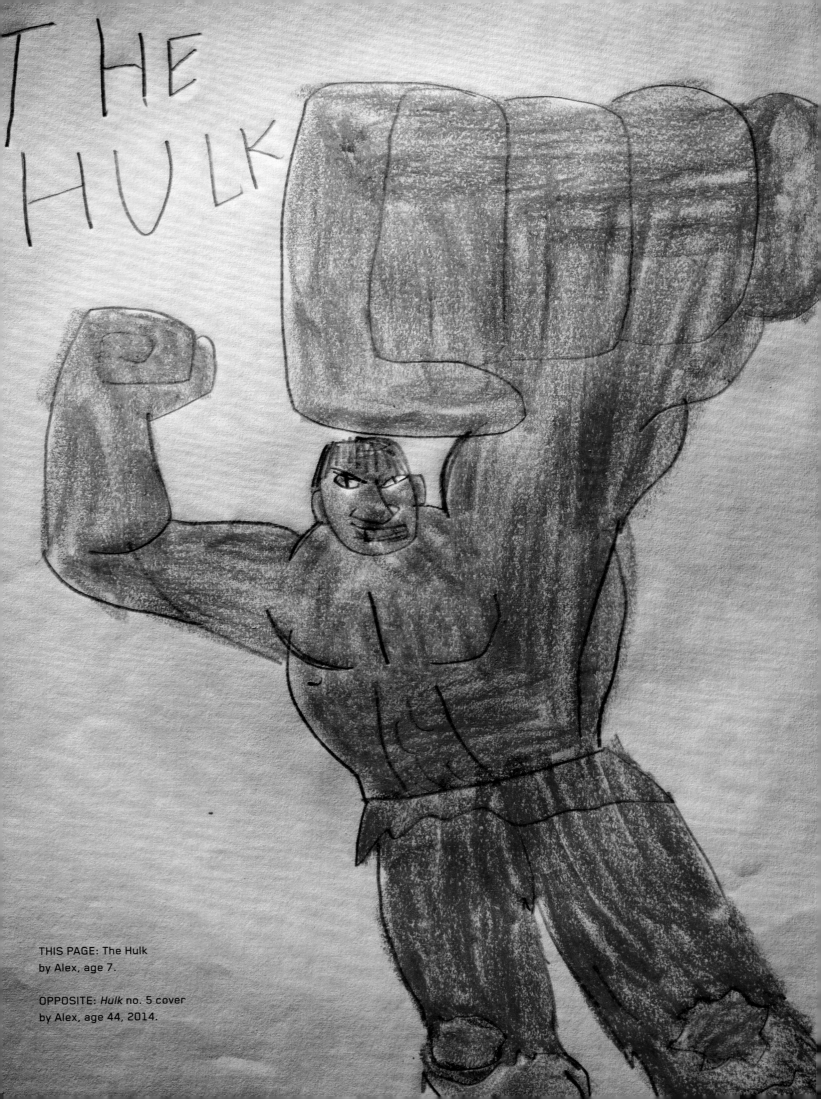

THE HULK

THIS PAGE: The Hulk
by Alex, age 7.

OPPOSITE: *Hulk* no. 5 cover
by Alex, age 44, 2014.

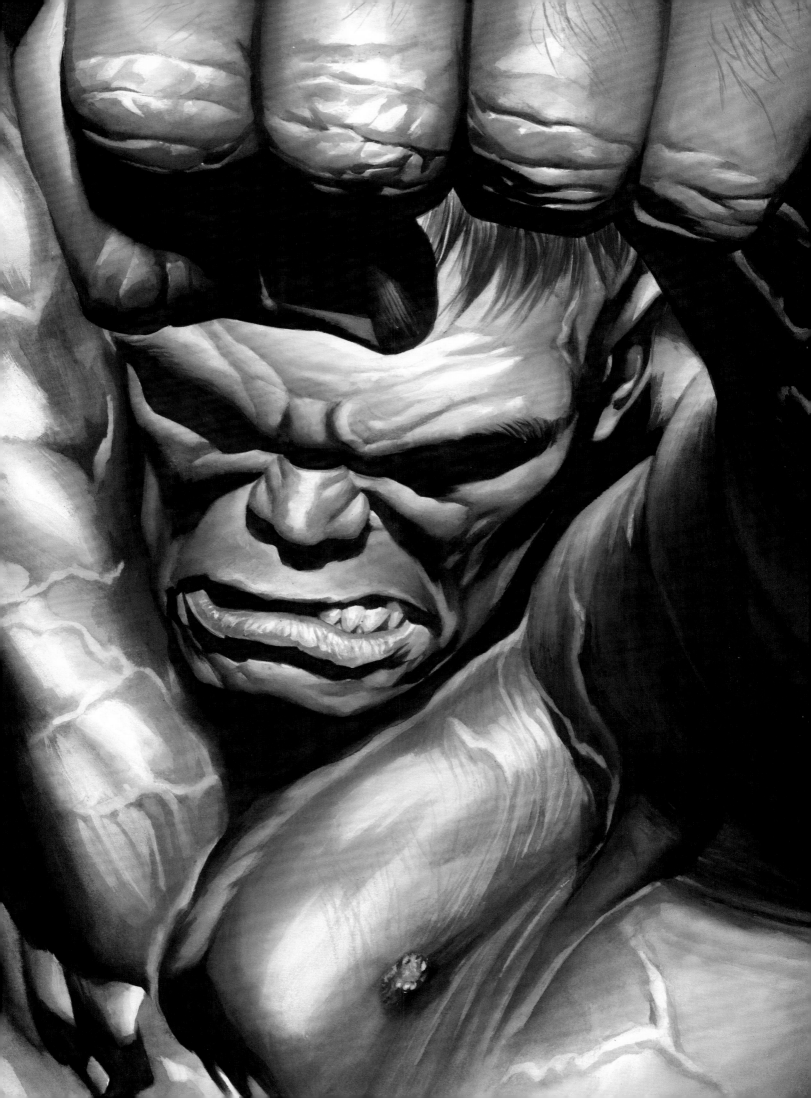

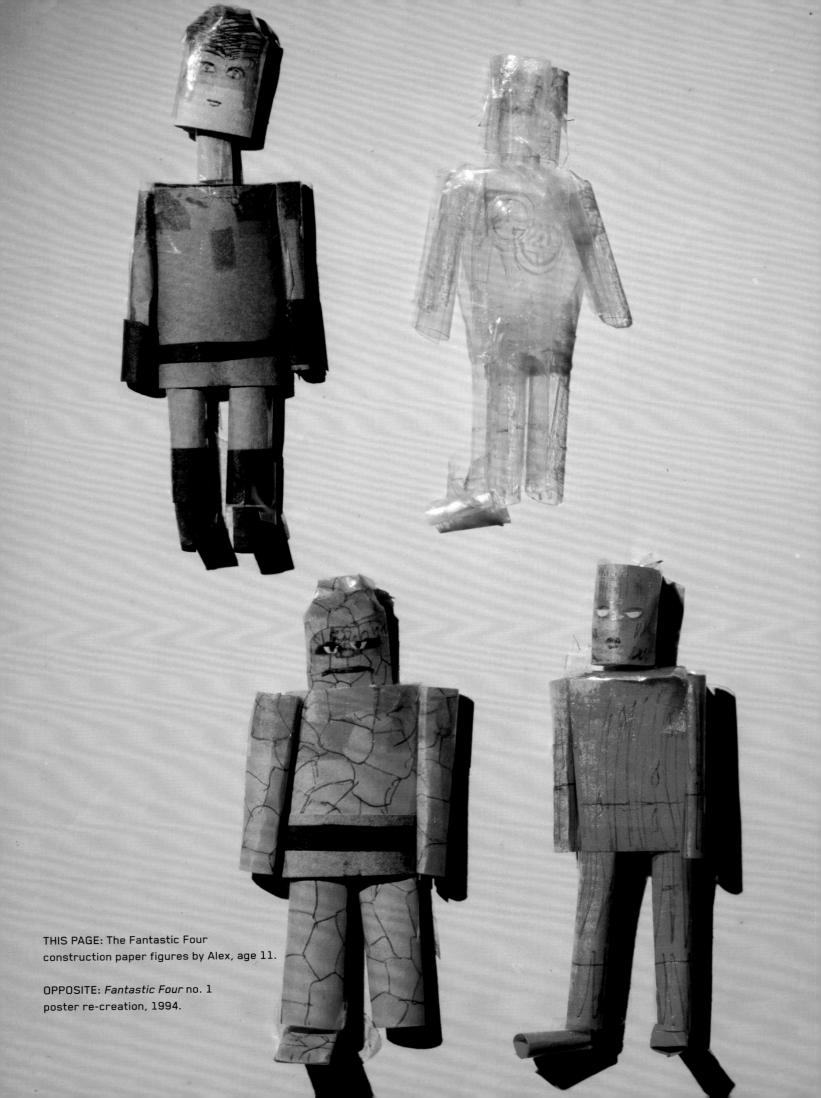

THIS PAGE: The Fantastic Four
construction paper figures by Alex, age 11.

OPPOSITE: *Fantastic Four* no. 1
poster re-creation, 1994.

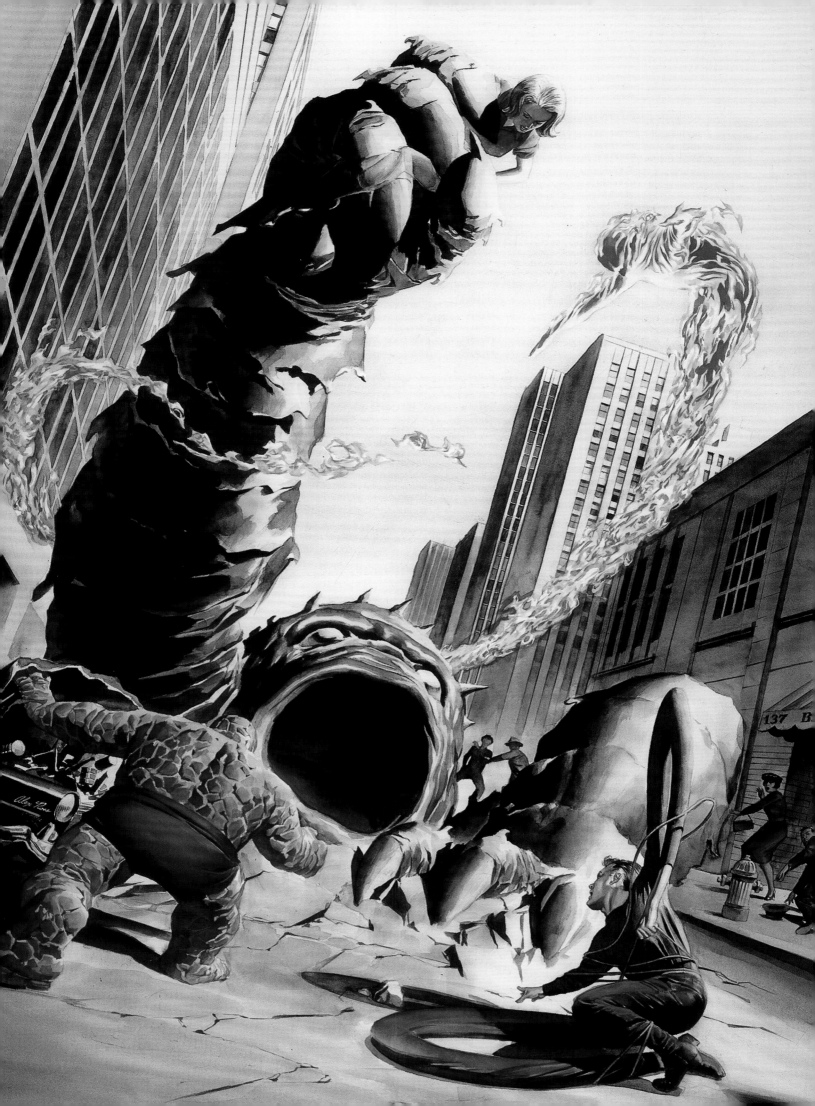

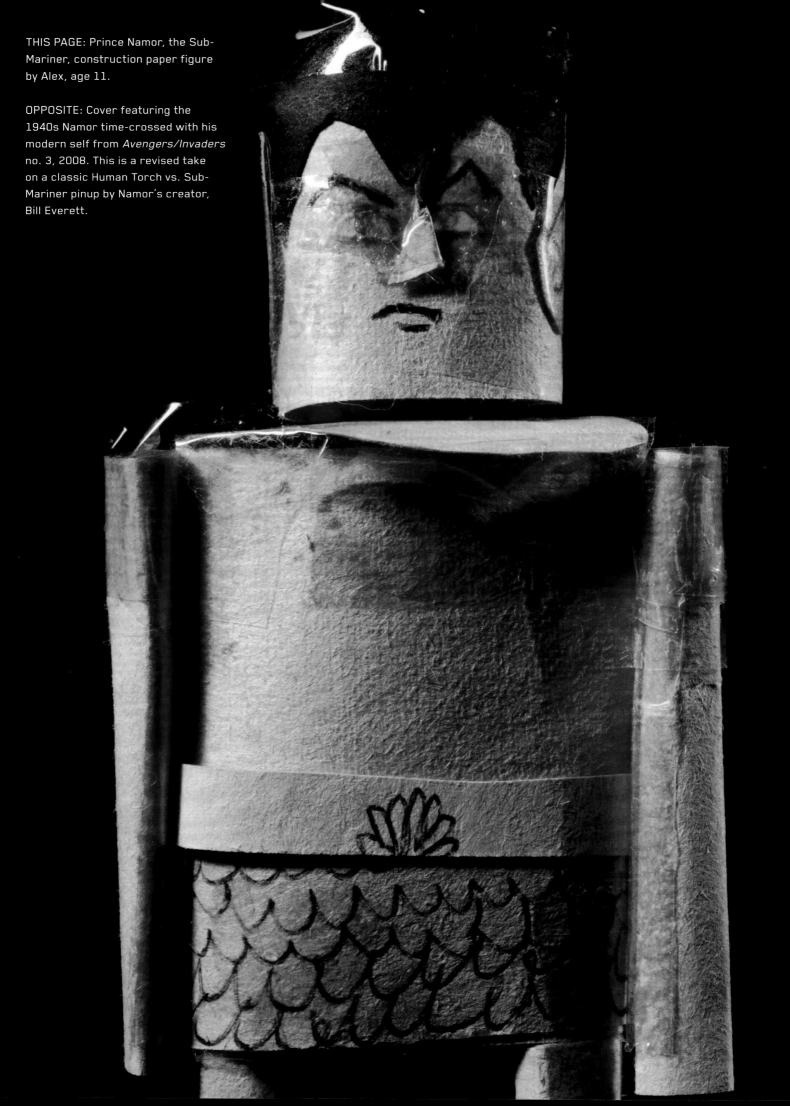

THIS PAGE: Prince Namor, the Sub-Mariner, construction paper figure by Alex, age 11.

OPPOSITE: Cover featuring the 1940s Namor time-crossed with his modern self from *Avengers/Invaders* no. 3, 2008. This is a revised take on a classic Human Torch vs. Sub-Mariner pinup by Namor's creator, Bill Everett.

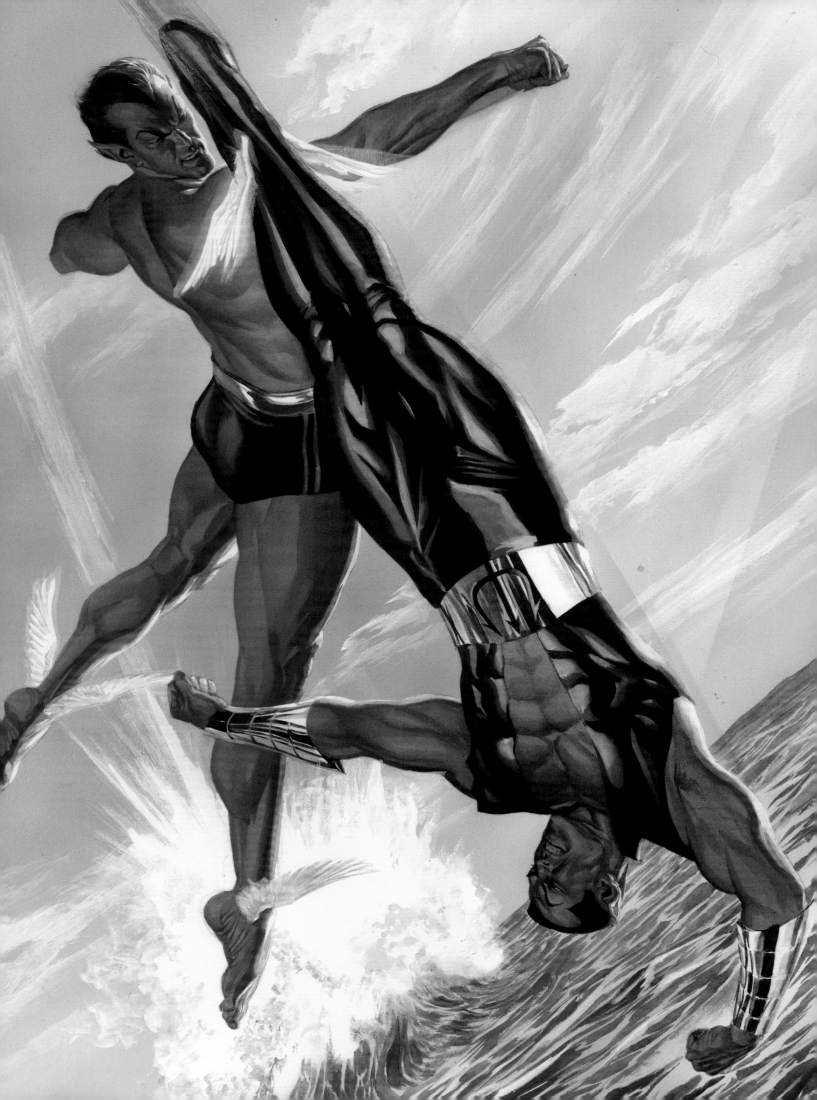

With comic book creations like the Fantastic Four, the Hulk, Iron Man, the Avengers, and especially Spider-Man, Marvel Comics completely re-imagined the idea of the superhero and what that concept could mean. Starting in 1961, creators Stan Lee and Jack Kirby, Steve Ditko, Don Heck, and many others introduced powerful costumed characters that were otherwise very much . . . like us, the readership. They had distinct personalities that were not what we were used to from stories we had been reading (and growing a little tired of) from other publishers. But we could totally relate to them: they had doubts (about themselves and their colleagues), they had worries, they bickered, they struggled with real problems, they fought with each other (!!) until an actual villain showed up (which of course was inevitable), and then re-focused everything. They were neurotic before it was a thing.

And, it must be said, they were beautifully designed. When you analyze it, Spider-Man's costume is utterly iconic without looking *anything* like a spider: it's bright red and blue, four limbs hugged skin-tight, full head-mask with crescent white eyes rimmed in thick black, the suggestion of gloves and boots. No spider looks like that, but Spider-Man looks like that, and it's the web motif that literally weaves it all together—by now you can't imagine him looking any other way. But the appeal is also due to the innovative storytelling.

If Peter Parker weren't so empathetic and relatable, archenemies so distinctive, we wouldn't care.

Nelson Alexander Ross, born in 1970 in Portland, Oreg[on] cared.

Boy, did he.

His first exposure to Spider-Man was not from the com[ics] but from a feature of *The Electric Company* TV show, which [was] a sort of next-level graduation from *Sesame Street* on P[BS]. Whereas *Sesame Street* was introducing toddlers to the alp[ha]bet, *The Electric Company* was taking the next step, talking [to] grade-schoolers about sentences and narrative concepts. [The] show's "Spidey Super Stories" segments were a big part of th[at].

"Spider-Man was the opening door," says Alex. "That w[as] the first time I had seen him—or anyone had—in three dim[en]sions, and in action. It was weird and stilted, but it was th[e thing]: there he was, the costume was vibrant, he was aliv[e.] hadn't seen the comics yet, but soon did, and then that le[d to] all the other characters: Cap and the rest of the Avenge[rs,] the Green Goblin, the Invaders. It was amazing to me."

When he was 8, Alex's family moved to Lubbock, Texas. T[his] had a profound effect on him: meeting new friends wa[s a] challenge, and his siblings, a good deal older than him, [had] moved on to the next stage of their lives. He was isolated, [and] took refuge in the comics.

And learning to draw them was his greatest joy . . .

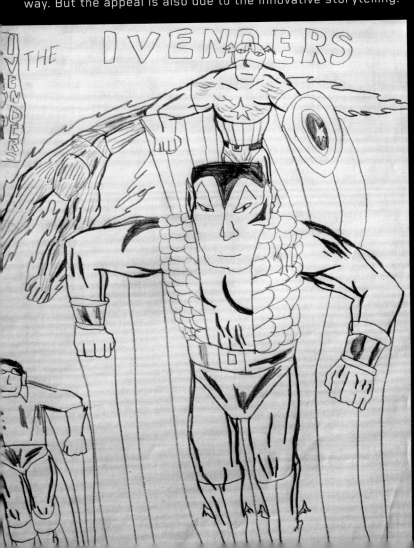

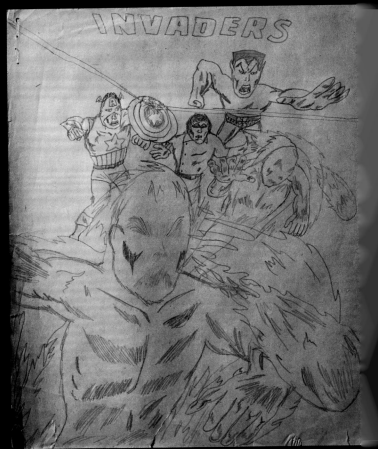

THIS PAGE: The *Invaders* by Alex, age 7. This was Marvel's first su[per] group, with origins in the 1940s. Roster: Captain America and Bu[cky,] the Sub-Mariner, the Human Torch and sidekick Toro.

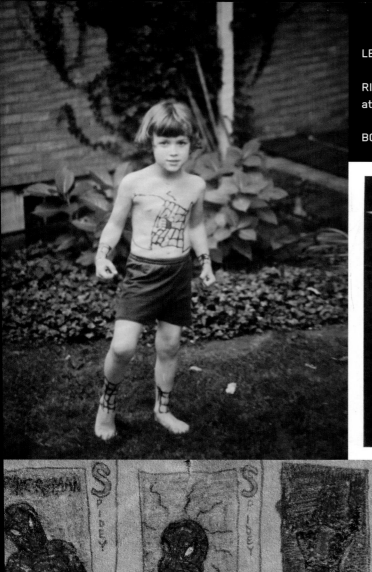

LEFT: Alex Ross, age 6, with Spidey marker augmentation.

RIGHT: A costume made by Alex's mother, Lynette, for him (center), age 7, at a mall event.

BOTTOM: Marvel character stamps by Alex, age 8.

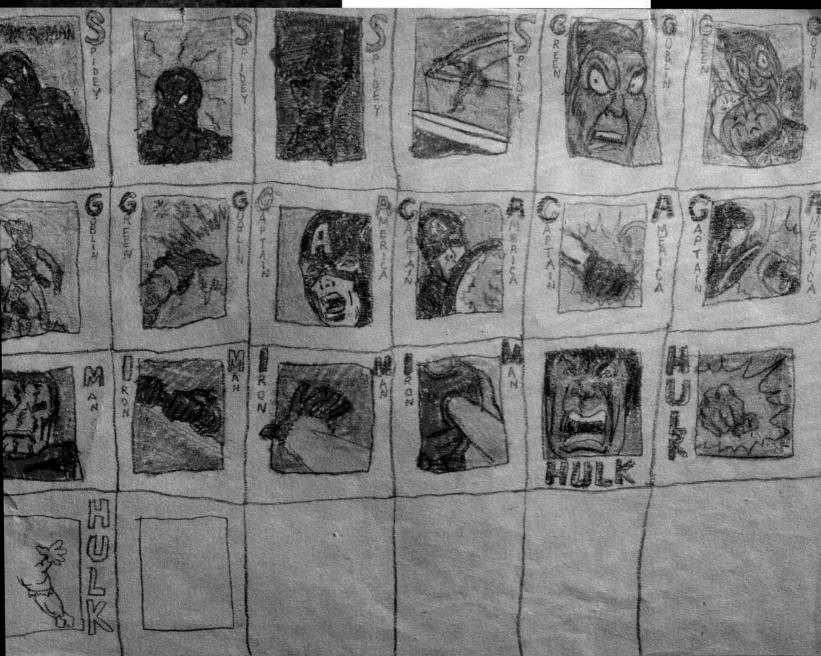

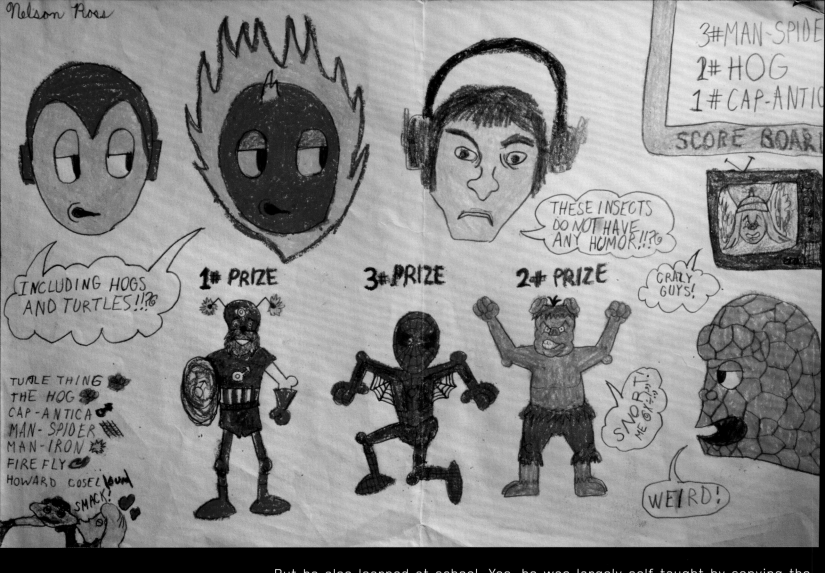

ABOVE: Marvel parody art style inspired by a Scott Shaw story, "What if the spider had been bitten by a radioactive human?"—featuring the 'Mazing Man-Spider, from *What If?* no. 8, 1978. Art by Alex, age 9.

RIGHT: Alex, age 8, seen here with his identity compromised in his homemade Spidey suit.

OPPOSITE, ABOVE: Cardboard, Silly Putty, clay, colored tape, and cloth figures of X-Men members Colossus, Cyclops, and Wolverine, constructed by Alex, age 14.

OPPOSITE, BELOW: *Uncanny X-Men* artwork in markers and colored pencils by Alex, age 14.

But he also learned at school. Yes, he was largely self-taught by copying the comics and with encouragement from his parents, but, he says, "I always had art classes, from grade one to twelve, and that gave me an outlet to get feedback on my work. Was I trying to show off? Absolutely, but I needed that. That's what school is supposed to do, test your abilities. It would have been much harder to develop without that outlet. Art classes confirmed to me, again and again, what I wanted to do with my life."

As Alex's aesthetic sensibilities developed, slowly so did his artistic skills. The key was repetition and learning from his mistakes and weaknesses, and how to improve upon them. It wasn't just a matter of practice, practice, practice; it depended on recognizing why the professionals' drawings worked and his did not. "If I would have been introduced to life-drawing at an earlier age before the Academy, I would have progressed much more quickly."

Every aspiring artist goes through this process, with varying degrees of success. Even if you are "naturally gifted," progress depends upon whether or not you are willing to develop that gift and hone it, to work very hard to take it to the next level, and the level after that, and frankly never stop learning. It can be extremely difficult. Many aspiring creative people give up and try something else.

Alex never did.

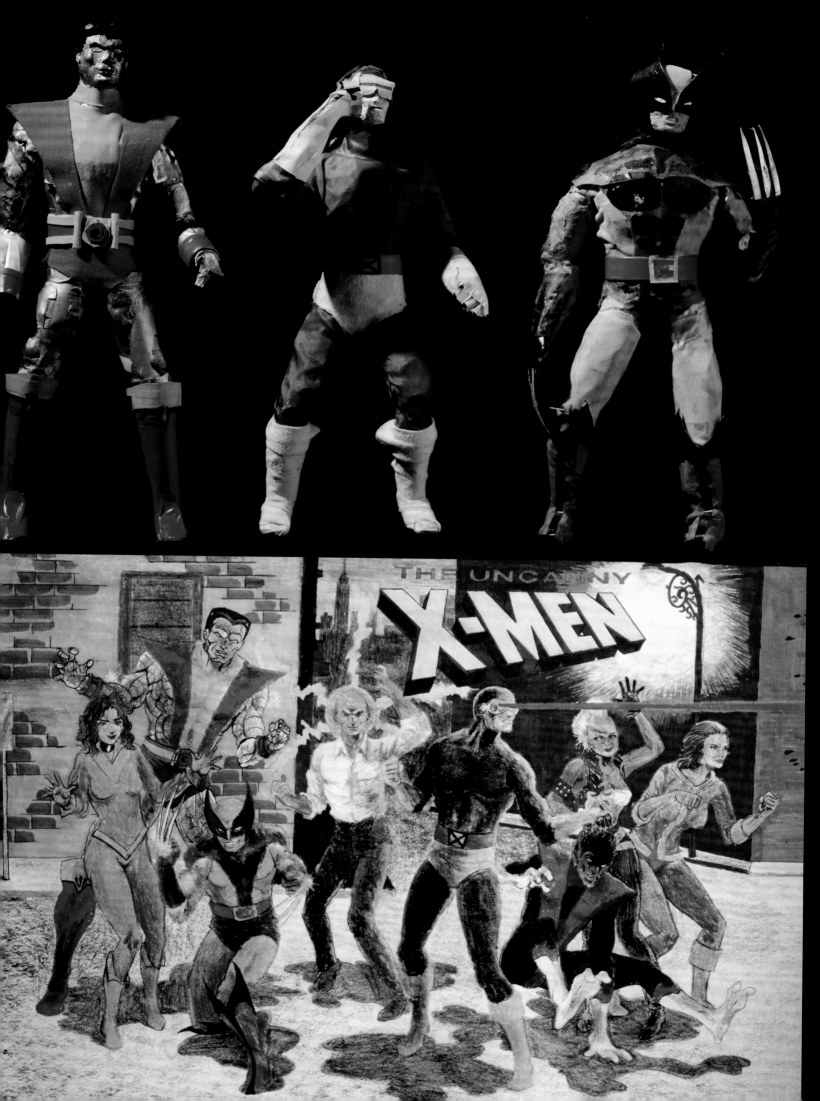

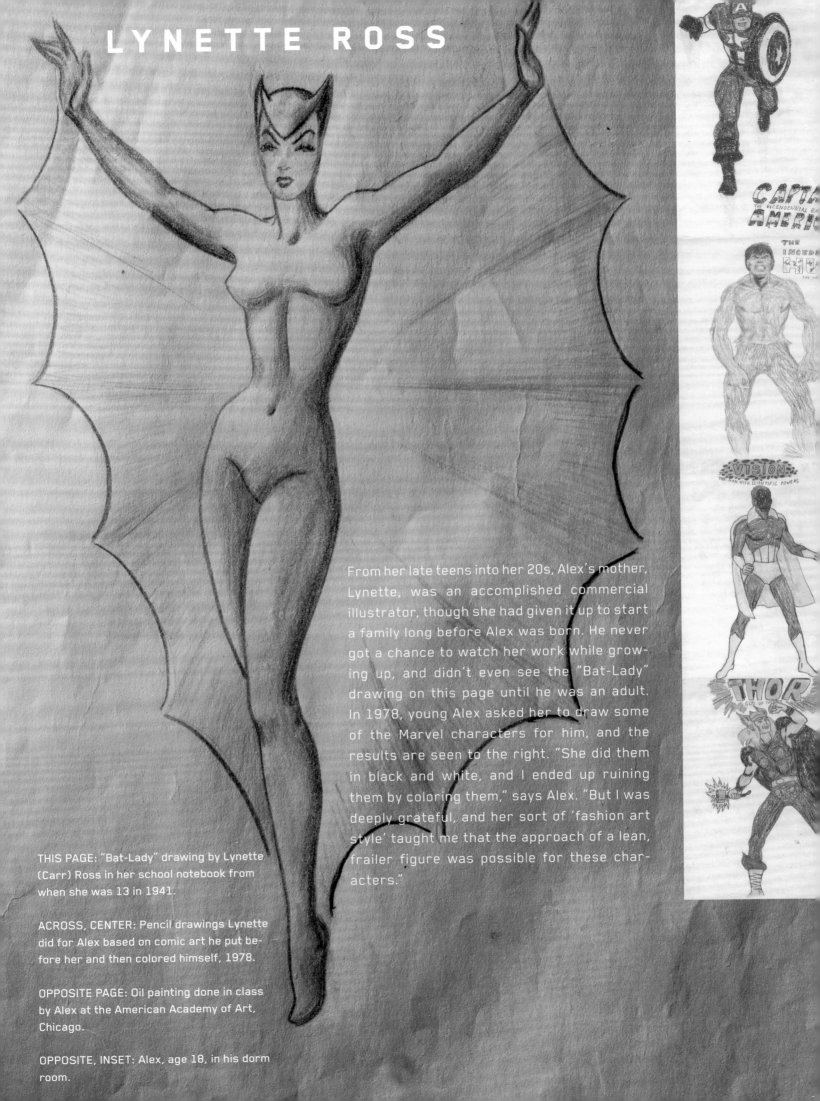

LYNETTE ROSS

From her late teens into her 20s, Alex's mother, Lynette, was an accomplished commercial illustrator, though she had given it up to start a family long before Alex was born. He never got a chance to watch her work while growing up, and didn't even see the "Bat-Lady" drawing on this page until he was an adult. In 1978, young Alex asked her to draw some of the Marvel characters for him, and the results are seen to the right. "She did them in black and white, and I ended up ruining them by coloring them," says Alex. "But I was deeply grateful, and her sort of 'fashion art style' taught me that the approach of a lean, frailer figure was possible for these characters."

THIS PAGE: "Bat-Lady" drawing by Lynette (Carr) Ross in her school notebook from when she was 13 in 1941.

ACROSS, CENTER: Pencil drawings Lynette did for Alex based on comic art he put before her and then colored himself, 1978.

OPPOSITE PAGE: Oil painting done in class by Alex at the American Academy of Art, Chicago.

OPPOSITE, INSET: Alex, age 18, in his dorm room.

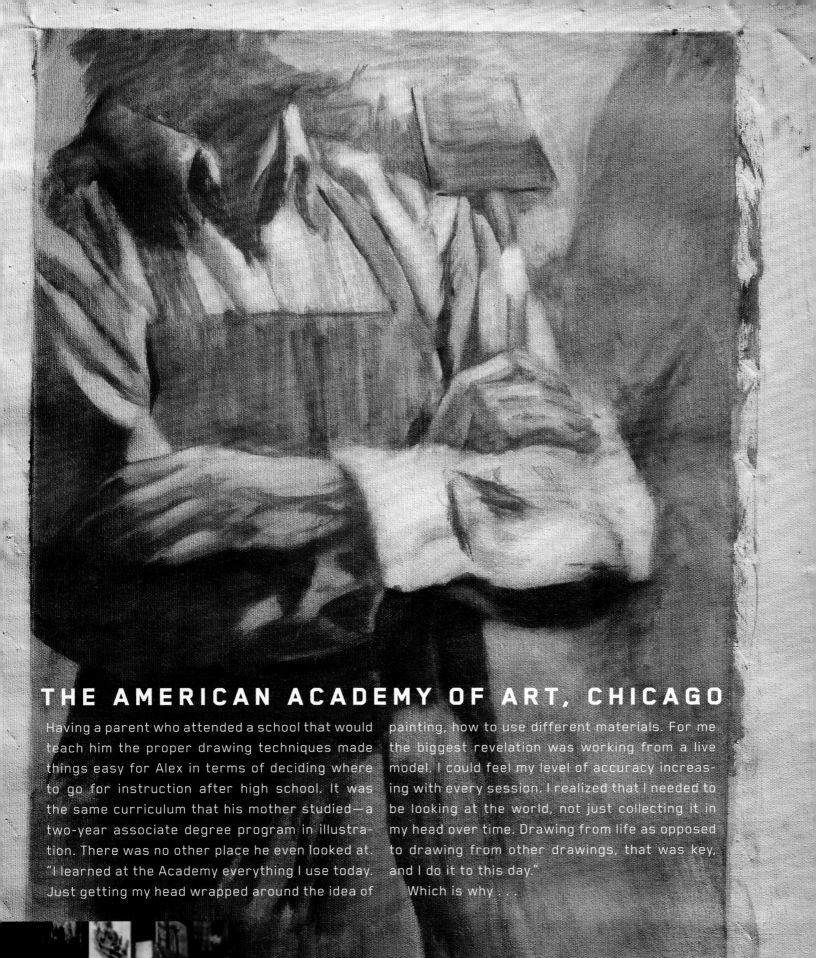

THE AMERICAN ACADEMY OF ART, CHICAGO

Having a parent who attended a school that would teach him the proper drawing techniques made things easy for Alex in terms of deciding where to go for instruction after high school. It was the same curriculum that his mother studied—a two-year associate degree program in illustration. There was no other place he even looked at. "I learned at the Academy everything I use today. Just getting my head wrapped around the idea of painting, how to use different materials. For me the biggest revelation was working from a live model. I could feel my level of accuracy increasing with every session. I realized that I needed to be looking at the world, not just collecting it in my head over time. Drawing from life as opposed to drawing from other drawings, that was key, and I do it to this day."

Which is why . . .

x actually hates these. I had no idea why; I thought they
retty cool, and I love the idea of combining Marvel's Dare-
ith the relatively obscure Golden Age version (opposite
Silly me. "All I can think of is I was trying to see if I could
e good layouts without any reference," he explains. "The
r is I couldn't. This is all so flat and bland and stiff. As
as I thought I was getting a handle on realism from art

school, it didn't flow out of me naturally without drawing fro
live subject. I needed to take that step. These two pages p
to me that I couldn't just draw out of my head and achieve u
I wanted to. I needed to look at life, and I needed to learn n
about composition in order to present a dramatic impac
also couldn't help noticing that the guy that Daredevil's bea
looks a lot like Harvey Pekar. "Yeah, I know. Go figure."

IRON MAN PROPOSAL WITH KURT BUSIEK, 1991.

"It's improving here, though a lot of the same problems remain. That said, the dramatic impact is better. My use of ink is not good, and the use of light and shadow isn't there yet. It's pure lights and darks, no subtlety in between. The drawing of the two girl characters (above) is closer to what I do now, but the transfer from pencil to ink is a failure." What was Marvel's response? "I honestly don't think this proposal was ever seen by the people we wanted to see it. In the meantime the 'Marvels' pitch was there, too, and was languishing."

THIS SPREAD: This story proposal featured a time-crossing of the 1990s Iron Man with his future inheritor, Arno Stark, the Iron Man of 2020. The 1990s Tony's mind inhabits his future aging brain and body and reunites with an older Hawkeye and his twin daughters. Alex redesigned the armor and supporting players of Iron Man's book as well.

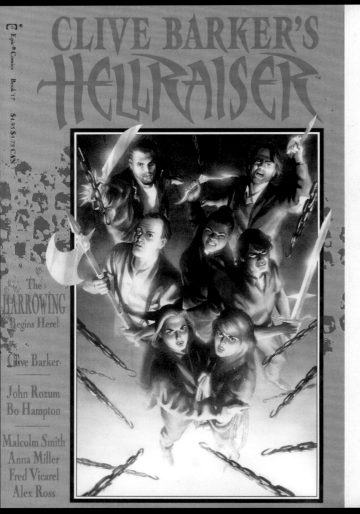

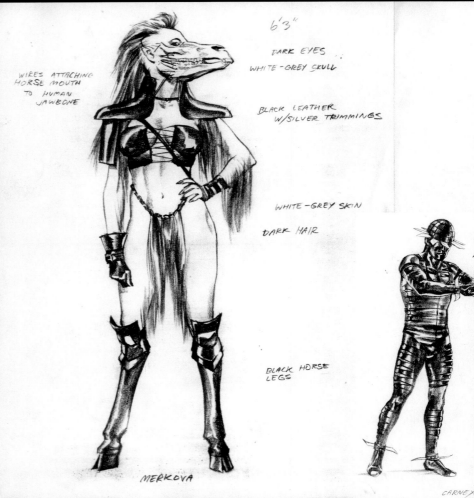

In 1989, Alex got his first professional work doing storyboards for the Leo Burnett ad agency in Chicago, and that led to his working on a comic book gig for *Terminator: The Burning Earth* for Now Comics. He was 19 and had just graduated from the Academy. Even though he wasn't crazy about *The Terminator* (other than having a crush on Linda Hamilton), he very much wanted to start working in comics before he was 20. That was of symbolic importance to him.

The publication of his five issues of *The Burning Earth* led to a call from Kurt Busiek, the editor of a sci-fi anthology series from Marvel called *Open Space*. The format of a short story enabled Alex to fully explore the process that interested him: photo reference, pencils, full paint. The *Terminator* series left no time to do that, but here it was possible (see opposite).

Alas, the series got canceled before Alex's story ran (though it eventually appeared in *Wizard* magazine). And then Busiek left the company. But Alex felt he had made a breakthrough. "I confirmed to myself that I wanted to make comics with paint as opposed to, say, colored pencils (because that's murder on your hands)."

Next came an assignment from Eclipse Comics for a story in an anthology of Miracleman tales called *Apocrypha,* and then another for Marvel Comics, which published a *Hellraiser* series by Clive Barker. That book's editor at Marvel, Marcus McLaurin, caught sight of Alex's and Kurt's "Marvels" pitch and said, "Hey, did we publish this? If we didn't, we should!" And so . . .

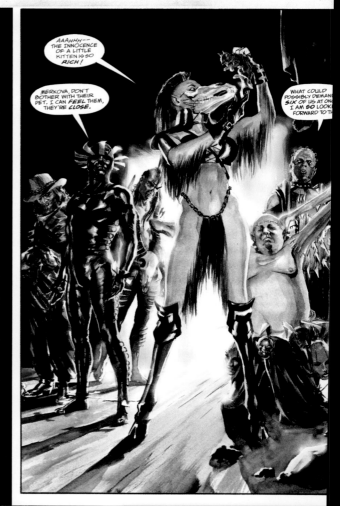

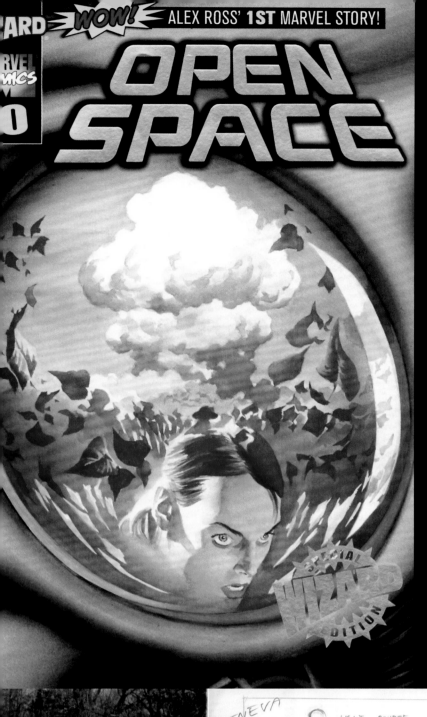

OPPOSITE, CLOCKWISE FROM TOP LEFT: Cover to *Hellraiser* no. 17; drawings of "Merkova" and "Carnex," two of the many characters that Alex had to design for his story, including two new groups of heroes and villains; and a splash page focusing on the hellish bad guys, 1992.

THIS PAGE, LEFT: The 1999 printing of Alex's *Open Space* story from 1990, after the original art was lost by Marvel for several years. It only surfaced in time for this *Wizard* magazine special focusing on Alex.

THIS PAGE, BOTTOM TIER: Photo reference of Alex's sister Geneva for the main character Sancha from the *Open Space* story; a page layout guide for Alex's brother-in-law to take pictures by, as they were in another state; and the finished title page for "Deadline," 1990.

BELOW: Page detail from *Miracleman: Apocrypha* no. 3 for the short story "Wishing on a Star," 1991.

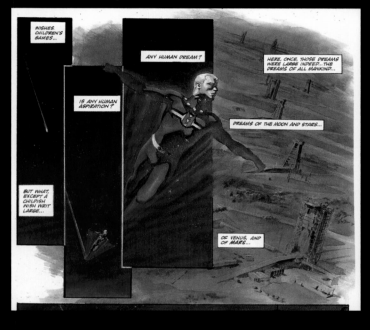

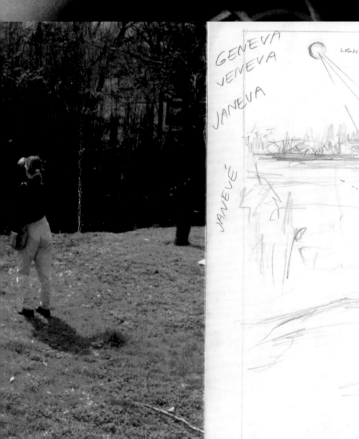

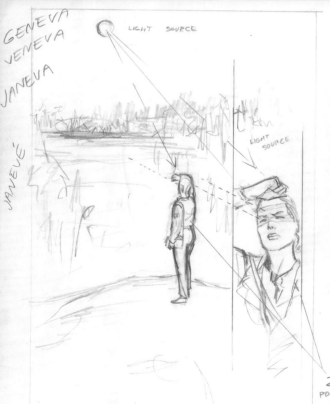

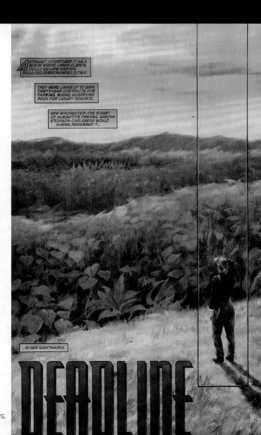

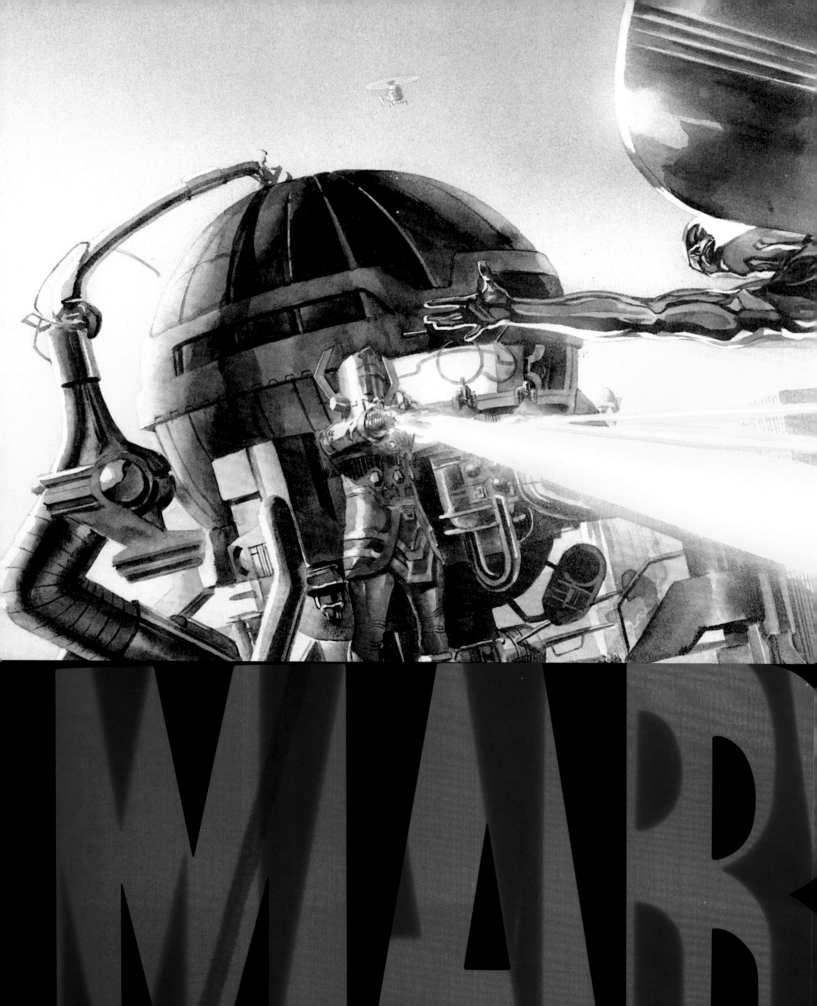

ALEX CHANGED THINGS

Marvels is a four-issue comics series by Alex and writer Kurt Busiek that appeared in 1993, and chronicled the history of the Marvel characters from their beginnings in 1939 up to the early 1970s.

But it is SO much more than that. Alex's idea was to depict scenes of Marvel lore in what appeared to be three-dimensional photographic stills. Ultimately, he totally pulled it off, but it was a long, hard road to get there.

One could effectively argue that this epic laid out the potential for the Marvel movies of many years later, showing how these characters could look in our "real" world. The ingenious construct that Ross and Busiek created was literally a lens through which we would perceive this universe, shot and transmitted by a humble freelance newspaper photographer named Phil Sheldon. It is through *his* eyes and voice that we witness what is going on, but that was a brilliant illusion: it was of course Alex's and Kurt's eyes and voice the whole time, and what an astonishing experience for the reader it proved to be.

6171 N. Sheridan Road, #1808
Chicago, IL 60660

March 27, 1991

Dear Kurt,

Yes, it is a couple of months later than I originally spoke of, but hopefully, after looking it over, you will understand and appreciate the labor involved.

Those things which have held me up are aspects of production that I normally wouldn't be involved in: getting lettering for the artwork typed and placed, photostats made, etc. - most of which I have had to trust to others.

Also, although I actually finished the art months ago, my writer-associate spent much time plotting out various stories, most of which were very good, but in the end produced nothing I can actually use.

I have assumed that plot summaries and sample pages of script would be essential in selling any proposal, that the artwork might not be able to do the job on its own. Therein lies one reason why I seek your counsel. Also, my friend, Matt Paoletti, whom I recommended as an illustrator for your BLADE RUNNER concept, has produced some samples on that subject. These are included on his behalf but are not part of my proposal.

Copies of this proposal would normally go out with a formal cover letter, introducing myself and explaining the concept. Included would be 13 illustrations of the cover and prologue story for the first issue, followed by 9 pages displaying the various characters featured in following issues of the series.

The basic concept of my proposal is this: to offer a book that harks back to the very first comic title published by this company and spotlighting the most original creations from their 50-odd year history. This would be done in short stories with an illustrative style. MARVEL COMICS #1, as everyone knows, was the first appearance of both the human torch and sub-mariner; and they remain two of the most original characters produced for the company. They are spotlighted in my revitalization (simply called MARVEL) before featuring a more currently popular creation.

The cover of this proposed first issue is once again the human torch in menacing form, the artwork recalling the late 30"s style. At the beginning of the book is a 12-page prologue story recounting his origin.

I wrote this in a rough draft and then ran it through a couple of writers to get the final product presented here. Another idea I had is that every short story in this series be written with consideration for readers who have no previous knowledge of the characters or are unaccustomed to comic book fantasy

in general. This would not necessarily be done by recapitulation but by making each story a complete whole and not fitting it in with any specific continuity. There is no set story line encompassing all the issues. Basically, I'm thinking of something along the lines of the old BIZARRE ADVENTURES magazine and MARVEL FANFARE.

Putting this all together, then, the first issue would consist of two 24-page stories following the prologue. These would be unrelated in plot, featuring first the Torch then Namor. This puts the book at about 60-64 pages, most likely fit for the Deluxe format. The second issue and following could move to a much smaller monthly format - possibly 24 pages monthly, or more on a bi-monthly basis.

Each issue, then, would focus on a different character with a story that best conveys their special aspects and world. With the standard of inclusion in this series being depth of originality, I've explored those depths to find the characters I feel most closely fit the bill. They are illustrated on the following pages in the style in which I might present them. They are:

THE HUMAN TORCH	TONY STARK, IRON MAN
NAMOR, THE SUB-MARINER	THE BLACK WIDOW
BEN GRIMM, THE THING	GWEN STACY AND SPIDER-MAN
DOCTOR DOOM	THE BLACK PANTHER

and lastly a MELANGE of various characters and elements I feel deserve inclusion for certain aspects.

As you can see, the series could run a number of different lengths
The first issue could be a one-shot to sample response;
A 5 to 6 issue series with two characters a book on a bi-monthly basis;
An 8 to 12 issue series by expanding the remaining ideas to fill in the gaps.

My main intention before attempting to get back into the comic book field is to negotiate for myself a level of creative input at the beginning stages of a story. This is something I never had to any degree while working on the TERMINATOR.

If my ideas grab you at all, and you would be interested in the writing chores, I would very much like to discuss it with you further. Otherwise, I would just appreciate hearing your opinion and whatever advice you can offer me.

Please reply soon, as I've got 9 more of these waiting to litter the desks of editors everywhere.

Best wishes,

Alex Ross

P I T C H I N G *M A R V E L S* I N 1 9 9 1

What was first pitched as "Marvel" was proposed by Alex as an anthology of stories featuring various Marvel characters, to be drawn by several different artists. It was not originally conceived as a continuous narrative with him as the sole illustrator (see above). Writer Kurt Busiek didn't like that idea. "Anthologies don't sell," he said. "It's not going to keep an audience. But your art looks great; the whole thing should be painted by you." Busiek especially liked the Iron Man image, and that led to creating the Iron Man pitch, which didn't fly, so to speak.

Kurt passed along the *Marvel* pitch art to Eclipse Comics to help Alex get more work. Clive Barker saw it and passed it along to his editor at Marvel. Marvel editor Marcus McLaurin's interest in what was eventually published as *Marvels* helped the project to take shape and become a reality, as did Marvel editor in chief Tom DeFalco's input to make it about key moments in the history of the company's characters. It would start in 1939, with the introduction of the Hu-

man Torch and the Sub-Mariner (Alex's original idea) and go on up through the years to circa 1973 (arguably the end of the Silver Age of Comics)—all via the viewpoint of Phil Sheldon, who at the outset is a young freelance stringer for New York newspapers, and we watch him age in "real time" throughout the series.

At first, Sheldon was going to be a reporter, but Busiek suggested he be a photographer. "And that made it seem a good metaphor for why the art was painted in the first place," says Alex. "That's why the artwork is going this extra graphic mile."

The result was a popular and critical sensation, a spectacular feat of comics history in and of itself. Every event depicted in it seems to be actually *happening,* from the epic and awe-inspiring siege of New York City by Galactus (yet to be seen in any movie, as of this writing) to the tragic death of Gwen Stacy at the hands of the Green Goblin. We were seeing it all again for the first time—somehow Ross and Busiek made it all *real.*

And Alex peppered its pages with dozens and

dozens of what are now known as "Easter eggs," many years before that became a thing. Myriad cameos and pop-culture references are worked into the scenes, and if you look hard enough you can find the Beatles, the Monkees, the Watchmen, Billy Batson, Superman (!!), dozens of comics creators and Marvel staff members, and a Mr. Fantastic who closely resembles a certain Professor from *Gilligan's Island*.

As the 25th anniversary of the publication of *Marvels* draws nigh, it has more than held up as a classic feat of pop mythmaking.

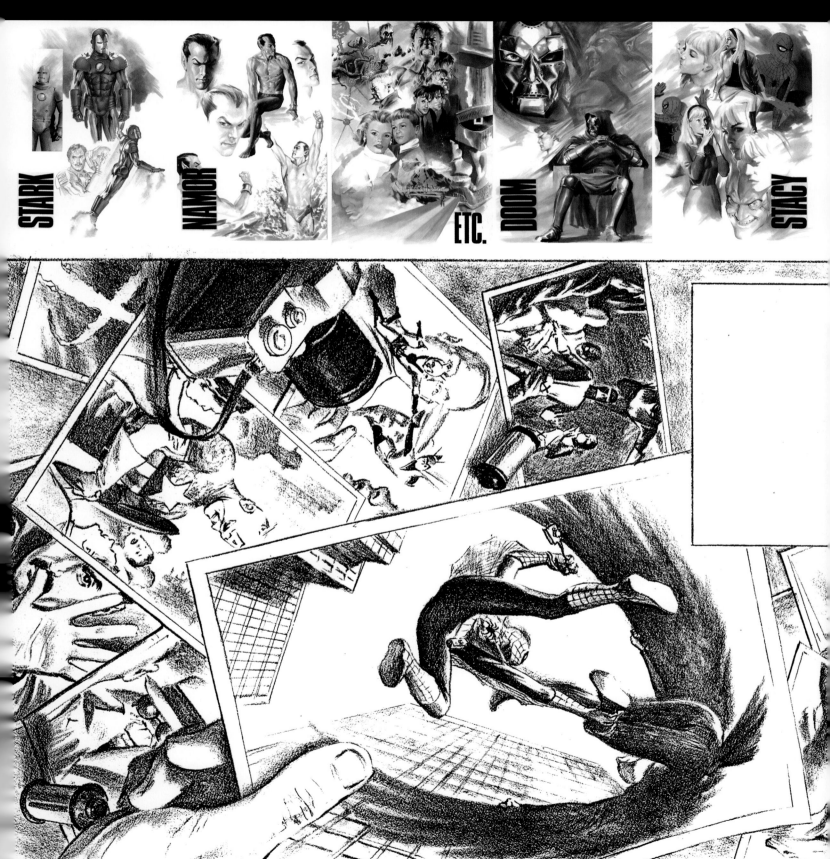

STARK NAMOR ETC. DOOM STACY

THE TORCH

"I have always loved the original Human Torch from 1939; he was the character who started it all off for Marvel, this faceless flaming entity. He was their Superman. And my thought was: if I can make this being look realistic, if I can solve this, I've got something that will open up people's minds regarding painted versions of the Marvel characters. How do I make a man really look like he's burning? If I could convince people to see that with fresh eyes, then I could reignite, if you will, an interest among a new generation of fans. It was a passionate challenge."

The *Terminator: The Burning Earth* project culminated with a trade paperback cover that provided a gateway for how to proceed: Alex created an image of one of the robot skeletons walking through a wall of flame (see overleaf). "And I thought: imagine if it was the same pose, but what if it was the Human Torch instead? I felt that no one had done this before, at least *I* hadn't seen it. The primal aspect of a naked flaming form elevates the concept beyond the simplicity of a superhero, into something much more graphically impactful." Ross was still just 20 when he tried this. The key was, as always, photographic reference. "I figured out that a photo-negative of a person generates the illusion of a flame burning from within them, yet they *themselves* are not on fire. But I also realized I had to show his human features for this effect to work. The photo-negative has to show the effect of *something,* not nothing.

"I thought the best way to do this as a narrative for *Marvels* was with an introductory short story, in his voice, about how it felt to be an artificial being and his relationship to his creator. I enlisted my friend Frank Kasy to be my first model, to be my superhero muse.

"And I decided to try illustrating flame by studying what something on fire—a figure, specifically—actually looks like."

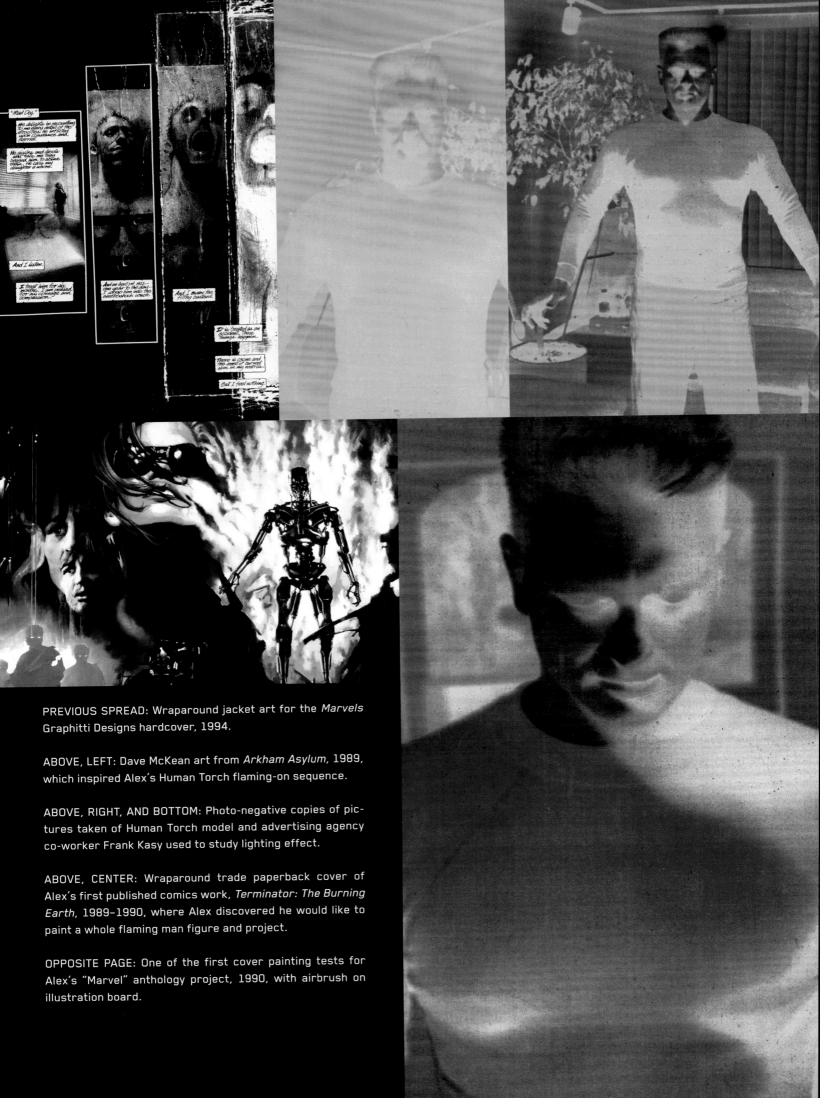

PREVIOUS SPREAD: Wraparound jacket art for the *Marvels* Graphitti Designs hardcover, 1994.

ABOVE, LEFT: Dave McKean art from *Arkham Asylum*, 1989, which inspired Alex's Human Torch flaming-on sequence.

ABOVE, RIGHT, AND BOTTOM: Photo-negative copies of pictures taken of Human Torch model and advertising agency co-worker Frank Kasy used to study lighting effect.

ABOVE, CENTER: Wraparound trade paperback cover of Alex's first published comics work, *Terminator: The Burning Earth*, 1989–1990, where Alex discovered he would like to paint a whole flaming man figure and project.

OPPOSITE PAGE: One of the first cover painting tests for Alex's "Marvel" anthology project, 1990, with airbrush on illustration board.

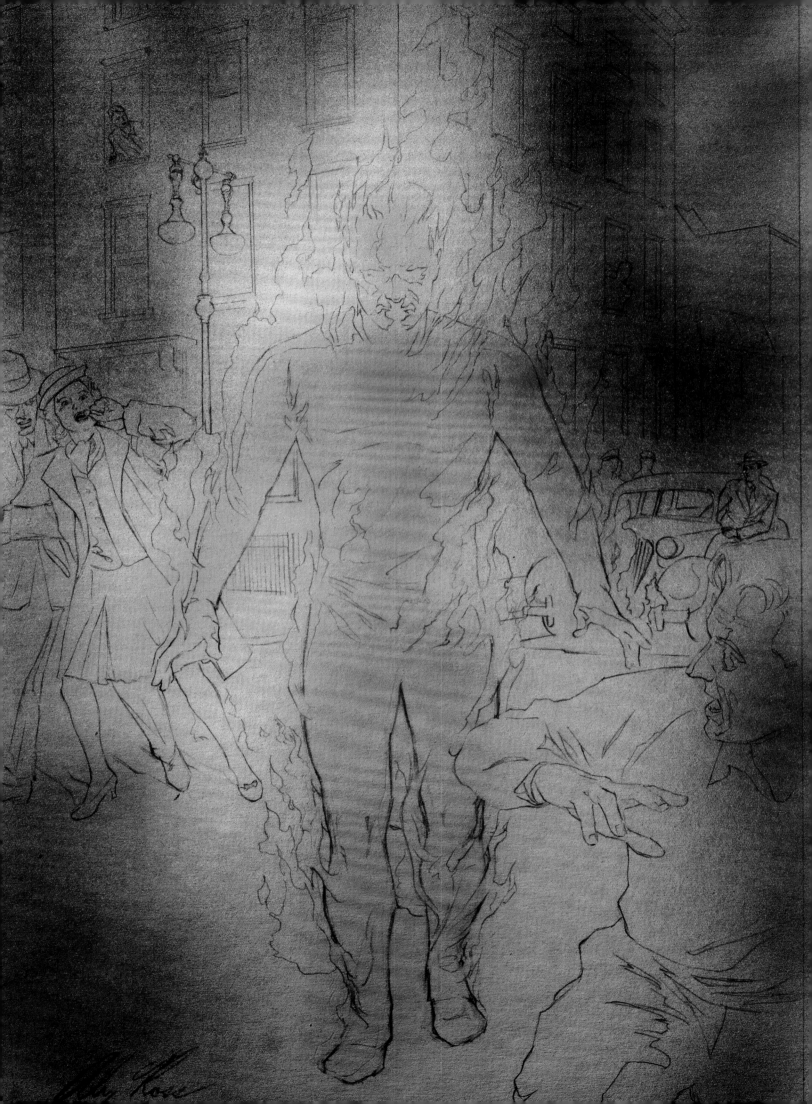

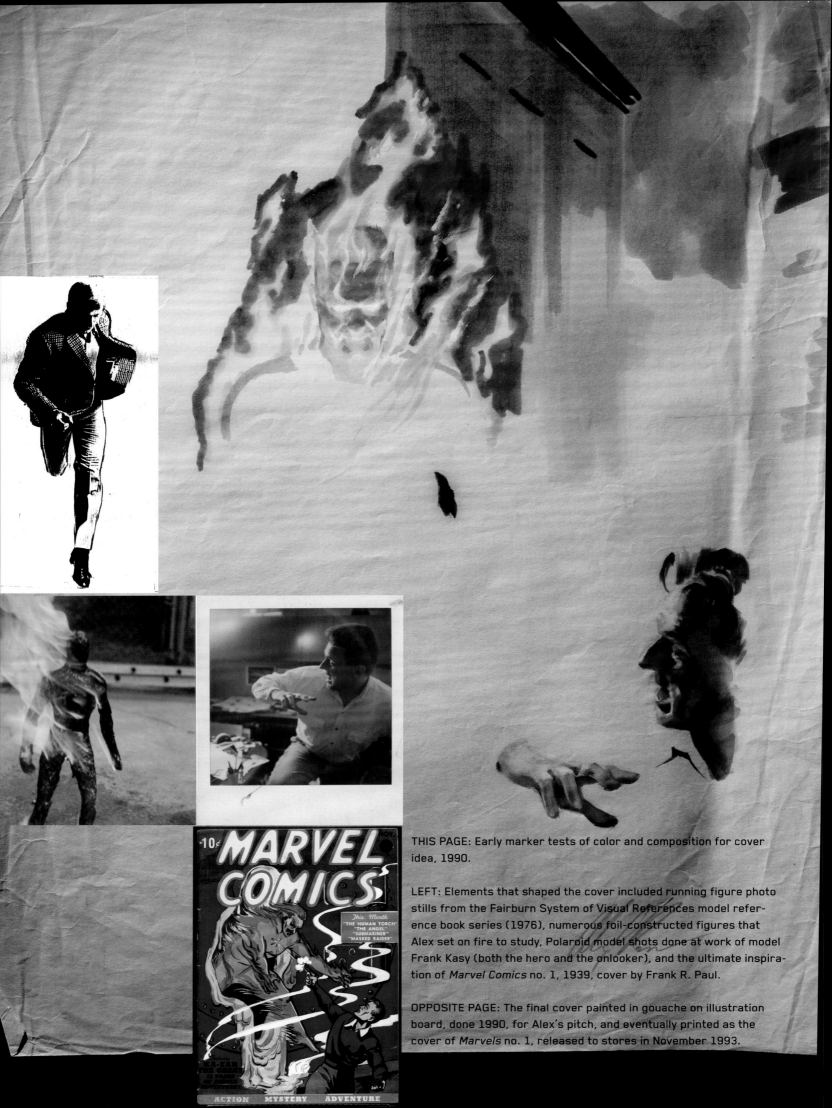

THIS PAGE: Early marker tests of color and composition for cover idea, 1990.

LEFT: Elements that shaped the cover included running figure photo stills from the Fairburn System of Visual References model reference book series (1976), numerous foil-constructed figures that Alex set on fire to study, Polaroid model shots done at work of model Frank Kasy (both the hero and the onlooker), and the ultimate inspiration of *Marvel Comics* no. 1, 1939, cover by Frank R. Paul.

OPPOSITE PAGE: The final cover painted in gouache on illustration board, done 1990, for Alex's pitch, and eventually printed as the cover of *Marvels* no. 1, released to stores in November 1993.

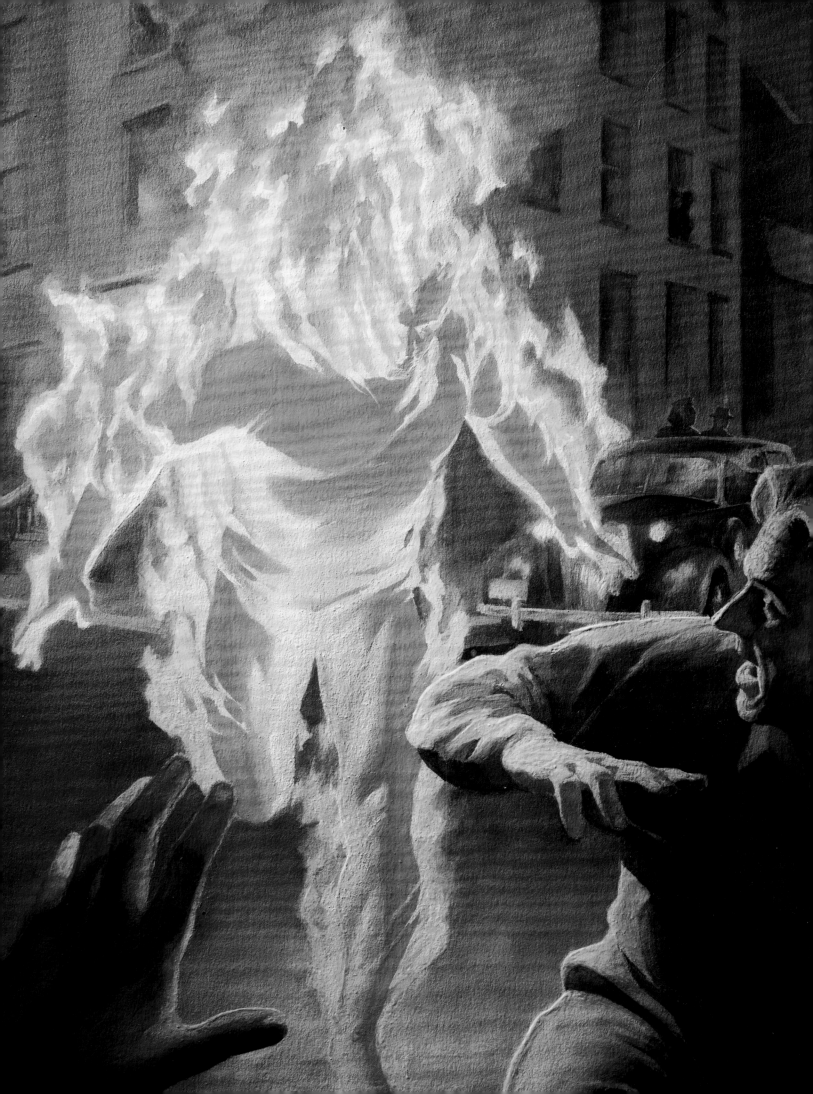

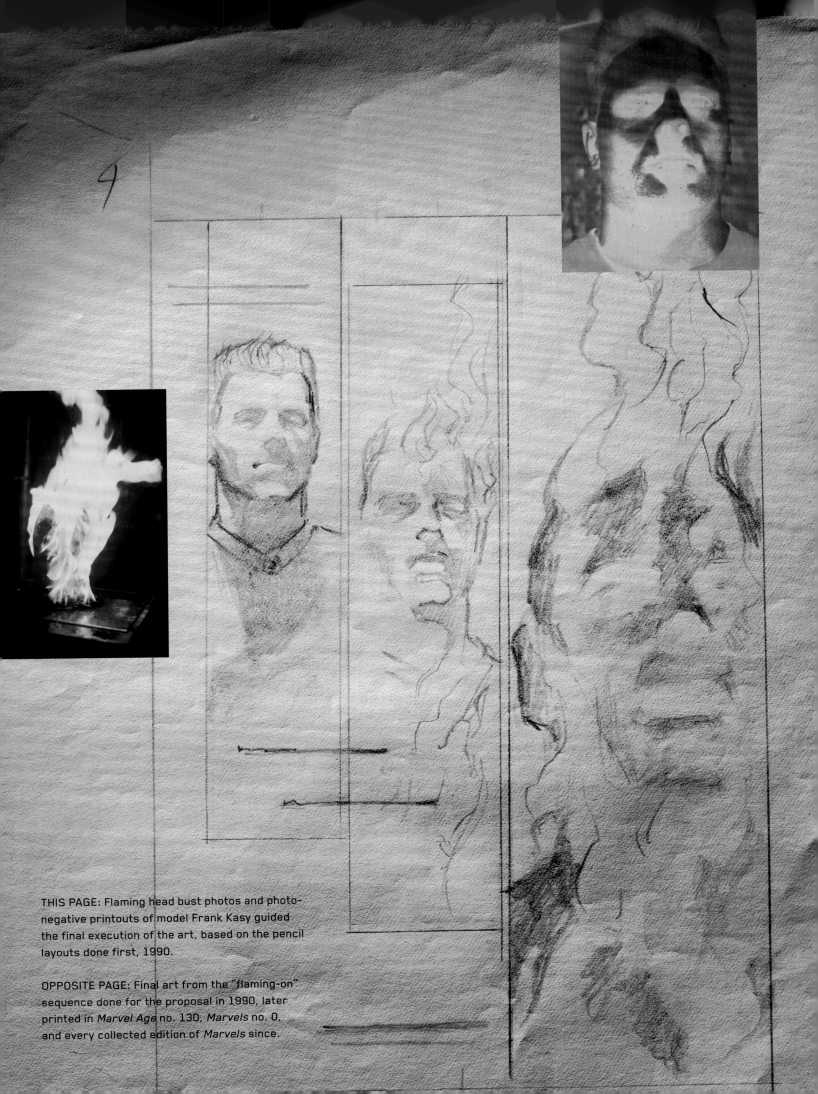

4

THIS PAGE: Flaming head bust photos and photo-negative printouts of model Frank Kasy guided the final execution of the art, based on the pencil layouts done first, 1990.

OPPOSITE PAGE: Final art from the "flaming-on" sequence done for the proposal in 1990, later printed in *Marvel Age* no. 130, *Marvels* no. 0, and every collected edition of *Marvels* since.

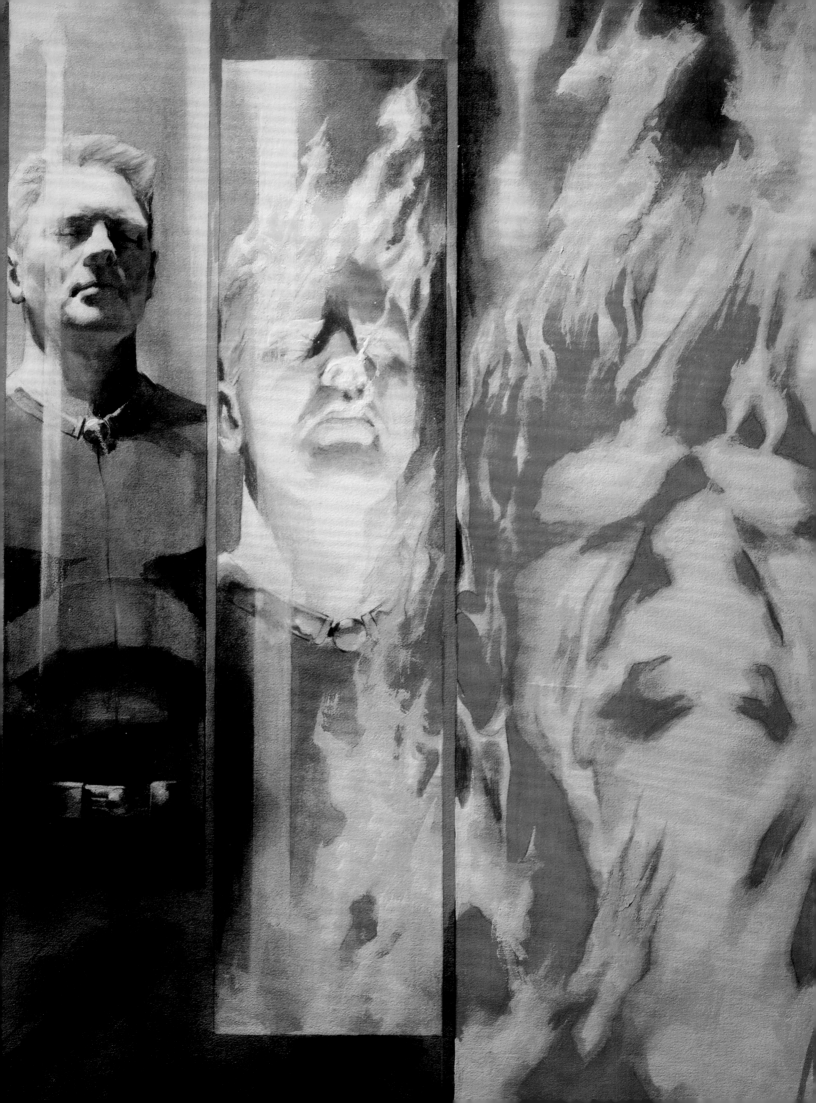

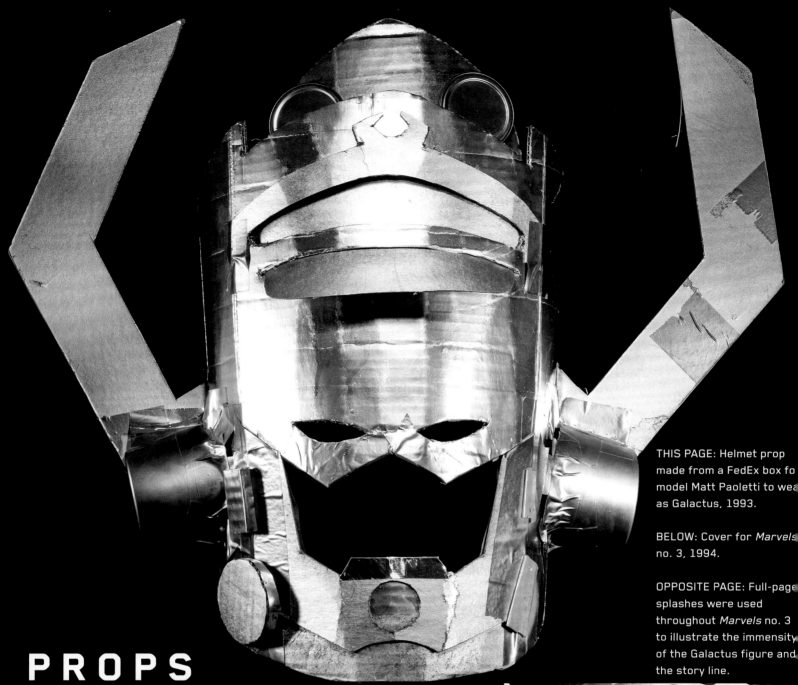

PROPS

For Alex, drawing from life means also drawing from the attending props associated with whatever character he is working on. There is a dedicated area in his basement that, over the last three decades, has accrued enough material to become a veritable superhero wardrobe department. Capes, gloves, masks, bodysuits, belts, boots, shields, weapons, wigs: you name it, it's there. And if it isn't, he either makes it himself (a la the Galactus helmet seen above, constructed out of duct tape and cardboard, circa 1993) or has it fabricated by trusted craftspeople.

"Key to making the most effective images is creating components of the costumes for me or the models to actually wear. I also use toys, dolls, action figures; all of these are instrumental to manifesting the images on the page."

You can see part of this arsenal in the background of pictures in "The Process" section toward the end of this book. The purpose of that particular photo shoot was to get the details correct on Captain America's gloves for the front cover.

And the right models are the ultimate props. "After I graduated from the Academy and started working at the Leo Burnett ad agency, I got to know some of the local artists in Chicago. Mark Braun was one of them, and he became the model for Phil Sheldon in *Marvels*. He seemed like the same guy in real life who we were writing about. In the story line, Phil has two young daughters, and Mark had two daughters, who we also used as models. My social circle became my 'acting troupe' for this project. It was very personal and inspirational."

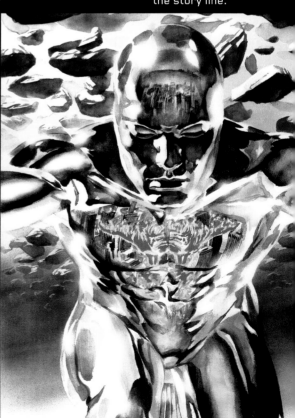

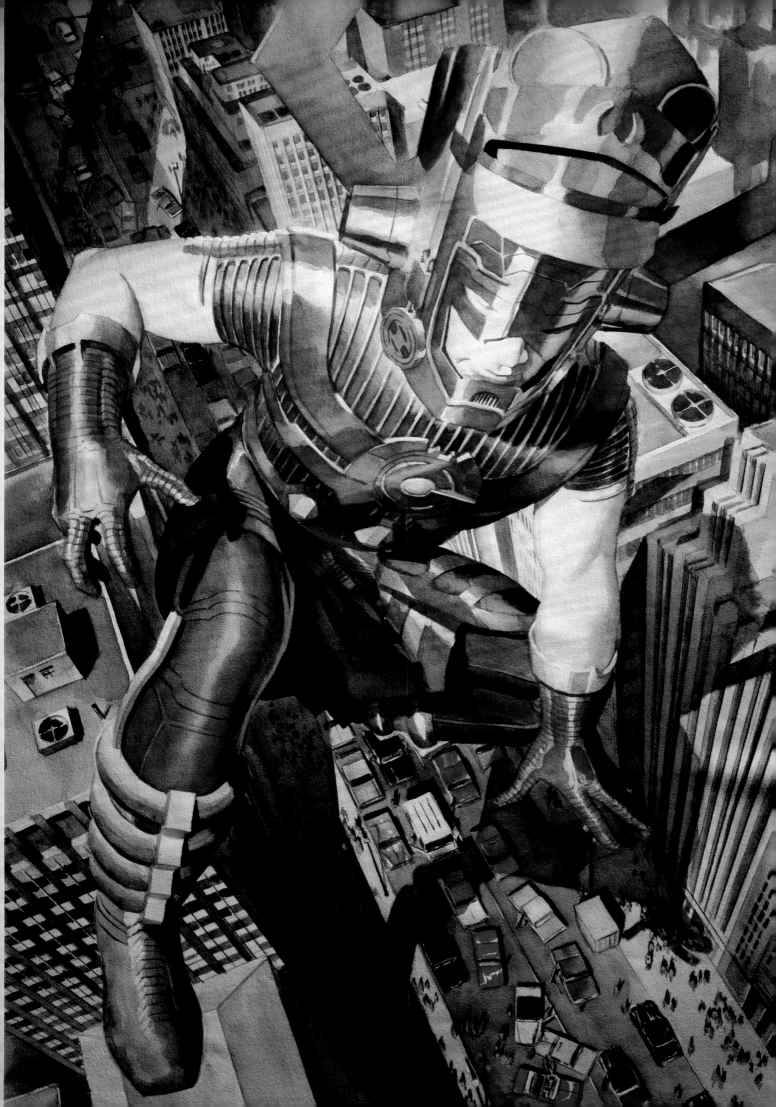

PAGE ONE - 5 PANELS

[1.1] SMALL PANEL -- VERY CLOSE ON A LIGHTER, AS PHIL FLICKS IT TO LIFE
 TO LIGHT A CIGARETTE. PHIL LEANS FORWARD, HIS FACE TILTED
 DOWN, SO BETWEEN HIS HANDS, THE FLAME AND HIS HAT-BRIM,
 WE DON'T SEE MUCH OF HIS FACE -- MOSTLY JUST FLAME.

 1 Caption: There was <u>fire</u>, then, at the beginning.
 2 FX: SKATCH
 3 Caption: The fire of <u>war</u> -- and of <u>youth</u>!

[1.2] PULL BACK TO REVEAL -- IN A GRAVELLY PARKING LOT IN BROOK-
 LYN, A BUNCH OF REPORTERS STAND AROUND A FEW CARS, CHAT-
 TING SARDONICALLY AND SMOKING. CLOSER TO US THAT THE
 MAIN KNOT OF REPORTERS, PHIL SHELDON AND A YOUNG J. JONAH
 JAMESON SIT ON THE RUNNING BOARD OF ONE OF THE CARS,
 TALKING AND SMOKING AS WELL. THIS NEEDS TO BE A PRETTY
 LARGE PANEL -- OR AT LEAST NEEDS ENOUGH DEAD SPACE (ESPECI-
 ALLY AT THE TOP -- IT'S THAT FIRST CAPTION AND THE REPORTERS'
 HUBBUB THAT'LL TAKE UP THE ROOM) FOR ALL THE COPY.

 4 Caption: Europe burned in '39 -- but we'd beaten the <u>Great</u>
 <u>Depression</u>, and we weren't <u>scared</u>! We knew what we
 were <u>about</u>, back then --
 5 Reporter: You <u>believe</u> that Hitler and his "readiness for peace" bunk?
 6 Reporter2: Yeah -- while he's pourin' <u>crack troops</u> into the Rhine.
 7 Reporter3: How soon you figure before <u>we're</u> in it?
 8 Reporter4: Ask <u>Senator Tobey</u> -- once <u>FDR</u> finishes chewin' him up!
 9 Caption: -- and I was a <u>part</u> of it!
 10 Phil: I'm going to <u>get there</u>, Jonah --

[1.3] ON PHIL AS WE SEE HIM CLEARLY FOR THE FIRST TIME, CONFIDENT
 AND DETERMINED IN HIS YOUTHFUL SELF-ASSURANCE.

 11 Phil: -- they're going to <u>need</u> good photographers. It's just a
 matter of <u>time</u> for me.
 12 Phil: Europe's where things are <u>jumping</u>! Where <u>careers</u> are
 being made!

[1.4] ON JONAH, AS YOUNG AS PHIL, SMILING IRONICALLY, HIS CIGARETTE
 AT THE ANGLE HIS CIGARS ARE TODAY, HIS HAT IN HIS HANDS.

 13 Jonah: Yeah, Phil -- and where people are dying by the <u>carload</u>.
 Me, I'm not tired of sordid, entertaining old <u>New York</u> yet.
 14 Jonah: I don't think I ever <u>will</u> be!

[1.5] ON THE TWO OF THEM BANTERING AS JONAH GETS TO HIS FEET.

 15 Jonah: But to each his own. When I run the Bugle --
 16 Phil: Here we <u>go</u> again.
 17 Jonah: As I was <u>saying</u>, when I run the Bugle, you can head the
 Foreign Bureau. <u>Maybe</u>. If I still <u>feel</u> like it.
 18 Jonah: For now, though --

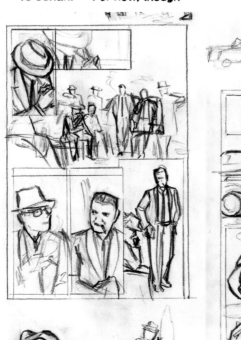

THIS PAGE: Original script page by Kurt Busiek with varying thumbnail layouts seen below, 1992.

BELOW: Photo reference of Mark Braun as young Phil Sheldon for his 1939 introduction in *Marvels* no. 1, page 1.

OPPOSITE: Page 1, *Marvels* no. 1 final art, 1992, featuring Phil Sheldon, the protagonist, and young J. Jonah Jameson, the future *Daily Bugle* publisher and Spider-Man antagonist.

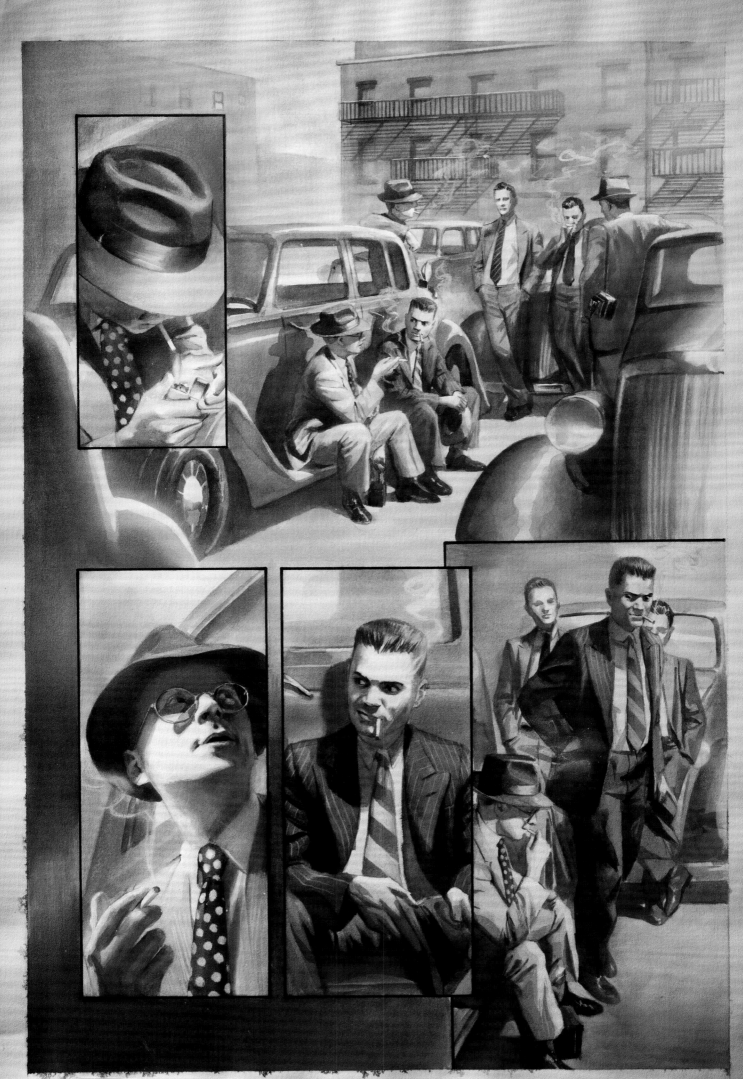

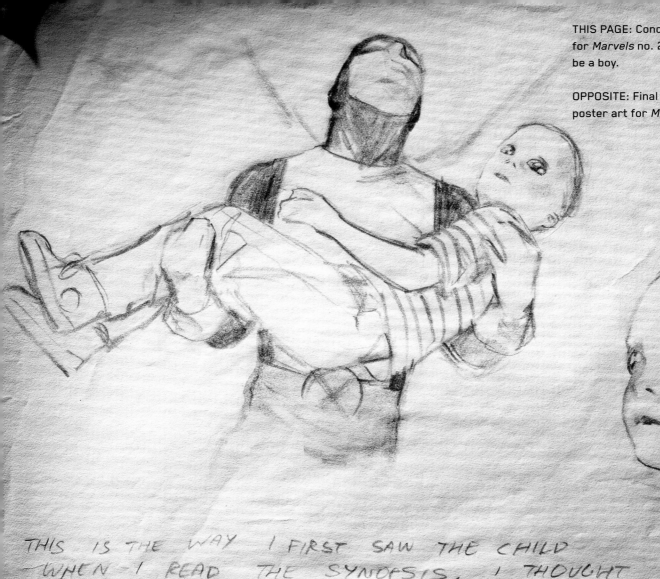

THIS PAGE: Conceptual study of mutant child for *Marvels* no. 2, when she was still going to be a boy.

OPPOSITE: Final cover and promotional poster art for *Marvels* no. 2, 1993.

ALMOST HAIRLESS

OVERSIZED GLASS LIKE EYES

THIS IS THE WAY I FIRST SAW THE CHILD WHEN I READ THE SYNOPSIS. I THOUGHT BACK UNCONSCIOUSLY TO THE WALLY WOOD STORY (INCLUDED HERE) WITH THE LITTLE MUTANT GIRL AND MY MIND SOFTENED HER MUTATED FEATURES TO THE MINIMUM QUALITIES THAT ALLOWED FOR THE SYMPATHETIC CHILDLIKE QUALITIES TO BALANCE OUT.

I THINK THAT INSTEAD OF A CHILD WITH JUST A DIFFERENT SKIN COLOR (WHICH FOR SOME REASON MAKES ME THINK OF FRED MACMURRAY IN THAT SHAGGY DOG MOVIE AND ALL THAT OTHER STUFF HE MADE WITH DISNEY) OR SLIGHT SUPERHERO-LIKE MUTATION YOU NEED SOMETHING THAT'S A BIT MORE VISUALLY UPSETTING. THE X-MEN HAVE ALWAYS BEEN THE MOST ATTRACTIVE OF FREAKS (ESPECIALLY THE FIRST GROUP) AND YOU COULD CONTRAST THEIR ALMOST <u>ANGELIC</u> AND POWERFUL INHUMAN QUALITIES AS THEY COME TO THE AID OF A MUTANT CHILD WITH A MUCH MORE SUBDUED AND SIMPLY <u>INHUMAN</u> QUALITY.

NONE OF MY IDEAS OF HOW TO HANDLE THIS KID COME FROM THE RECENT PENGUIN INTERPRETATION BY TIM BURTON.

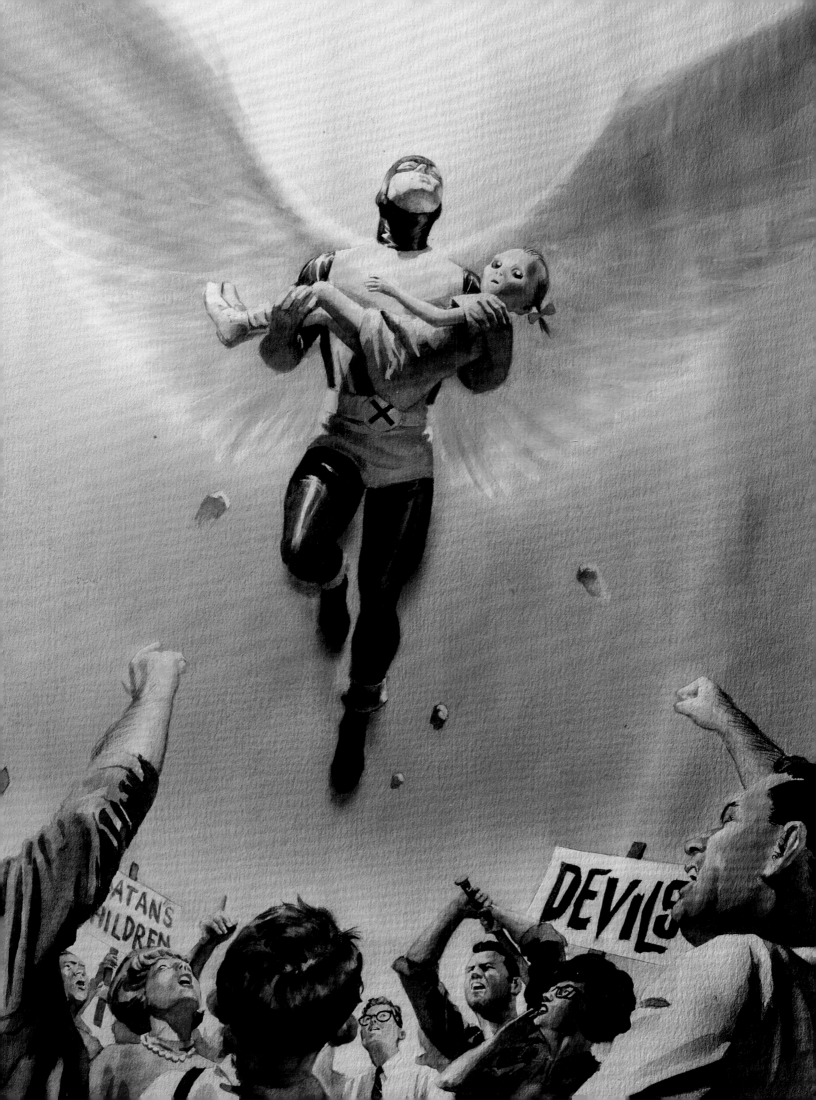

13

PAGE TWELVE - 6 PANELS

[12.1] ON **PHIL** AT PENN STATION, BOARDING THE LIRR TRAIN HOME AMID
 CROWDS.
 1 Caption: On the way home, I wondered why I did what I did.
 2 Caption: I was a <u>newsman</u>. I didn't make the news -- I <u>observed</u> it.
 3 Caption: At least, I usually did.

[12.2] CLOSER ON **PHIL** ON THE TRAIN, THINKING.
 4 Caption: But there was something <u>about</u> the mutants.

[12.3] AND EVEN CLOSER ON **PHIL**.
 5 Caption: They were the <u>dark side</u> of the marvels. Where Captain
 America and Mister Fantastic spoke to us about the
 greatness within us all --
 6 Caption: -- the mutants were <u>death</u>.

[12.4] EXTERIOR SHOT -- **PHIL** GETTING OFF THE TRAIN AT A SUBURBAN
 STATION, ALONG WITH A FEW OTHER LOCALS.
 7 Caption: They didn't even have to <u>do</u> anything. They were our
 <u>replacements</u>, the scientists said.
 8 Caption: The next <u>evolutionary step</u>.
 9 Caption: We -- homo sapiens -- were obsolete, and <u>they</u> were the
 future.

[12.5] SAME AS PANEL 11.5, BUT EVEN CLOSER.
 10 Caption: They were going to kick the dirt onto our <u>graves</u>.
 11 Cyclops: They're not <u>worth</u> it!

[12.6] ON **PHIL**, HEADING UP A HILL IN A RESIDENTIAL NEIGHBORHOOD.
 12 Caption: It was a <u>terrifying thought</u>.

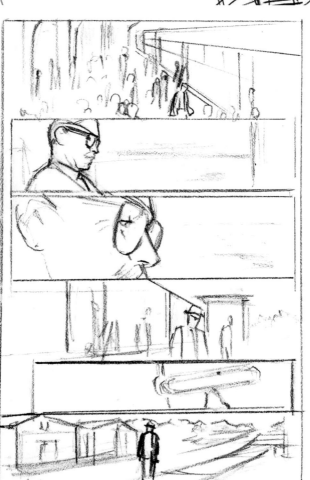

THIS PAGE: Original script page 12
for *Marvels* no. 2 by Kurt Busiek with
developing thumbnail layouts seen
below, 1993.
RIGHT: Photo reference for 1964
version of Phil Sheldon with model
Mark Braun.
OPPOSITE: Page 12, *Marvels* no. 2
final art, 1993, with Phil haunted by
the mutant Cyclops' words, "They're
not worth it!"

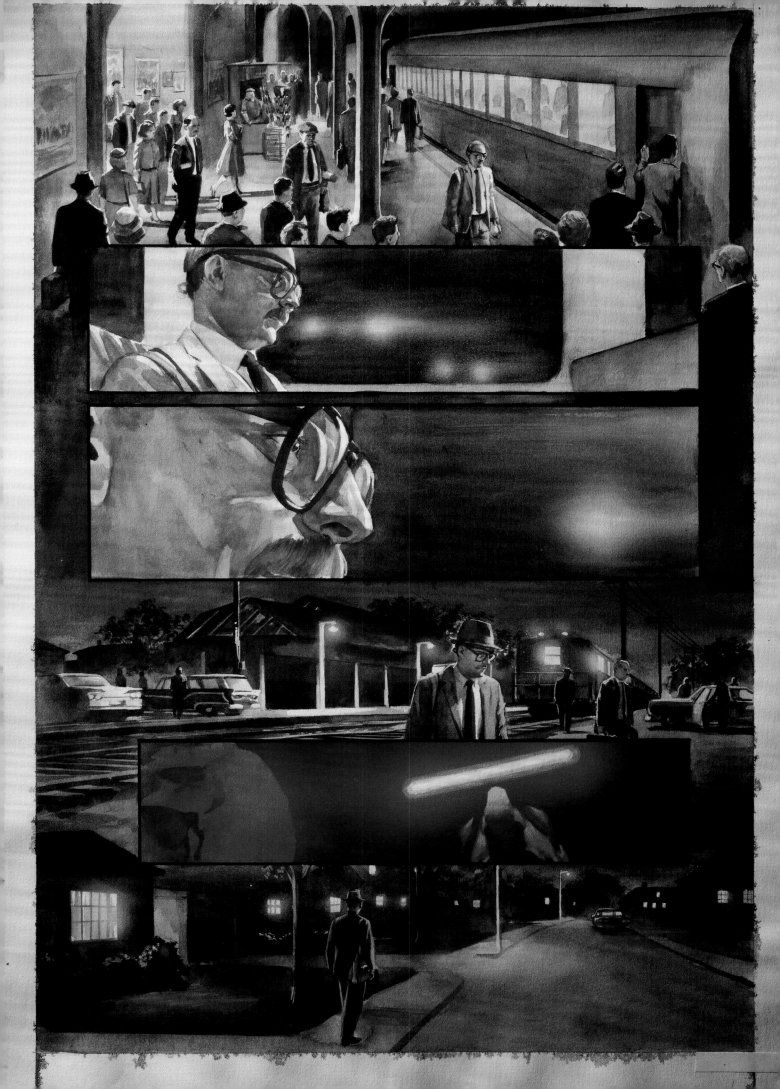

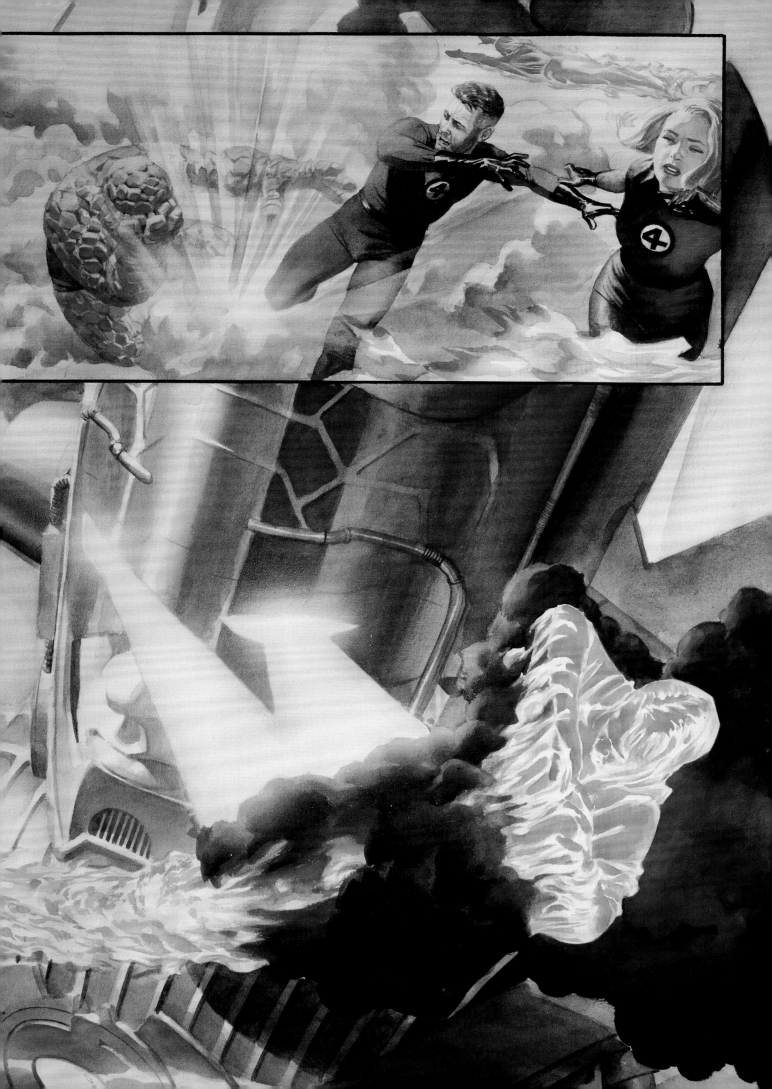

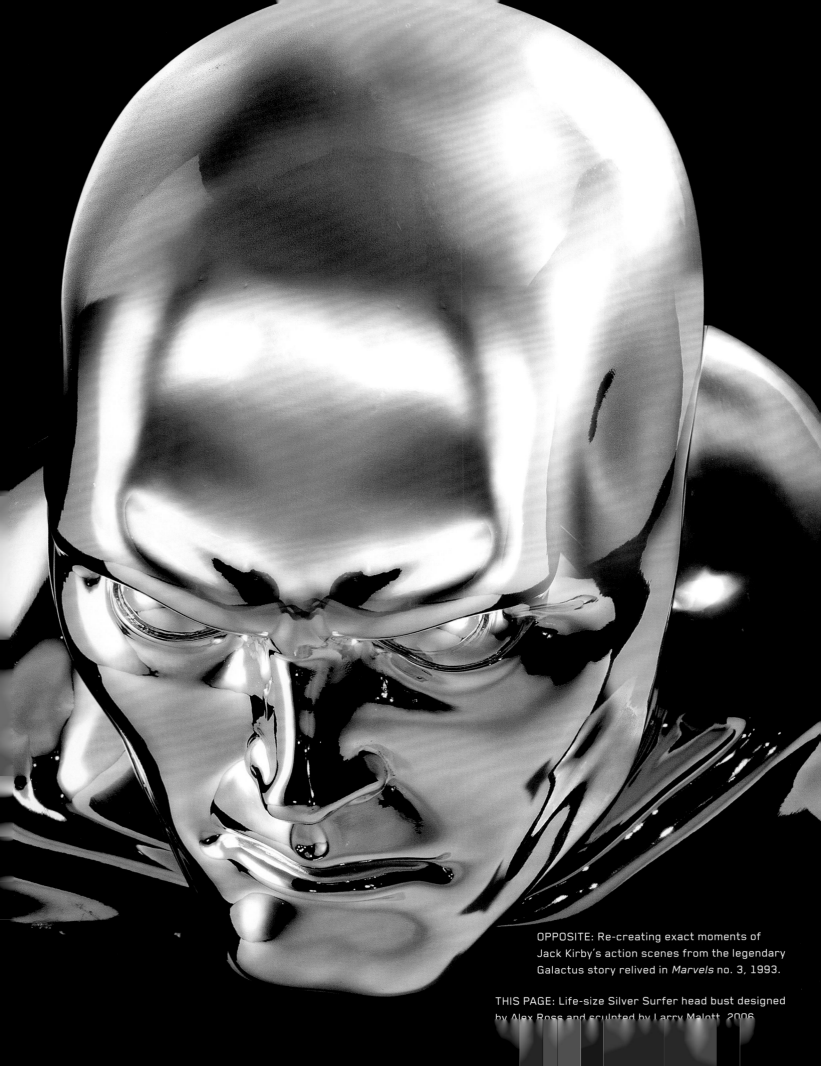

OPPOSITE: Re-creating exact moments of
Jack Kirby's action scenes from the legendary
Galactus story relived in *Marvels* no. 3, 1993.

THIS PAGE: Life-size Silver Surfer head bust designed
by Alex Ross and sculpted by Larry Malott, 2006.

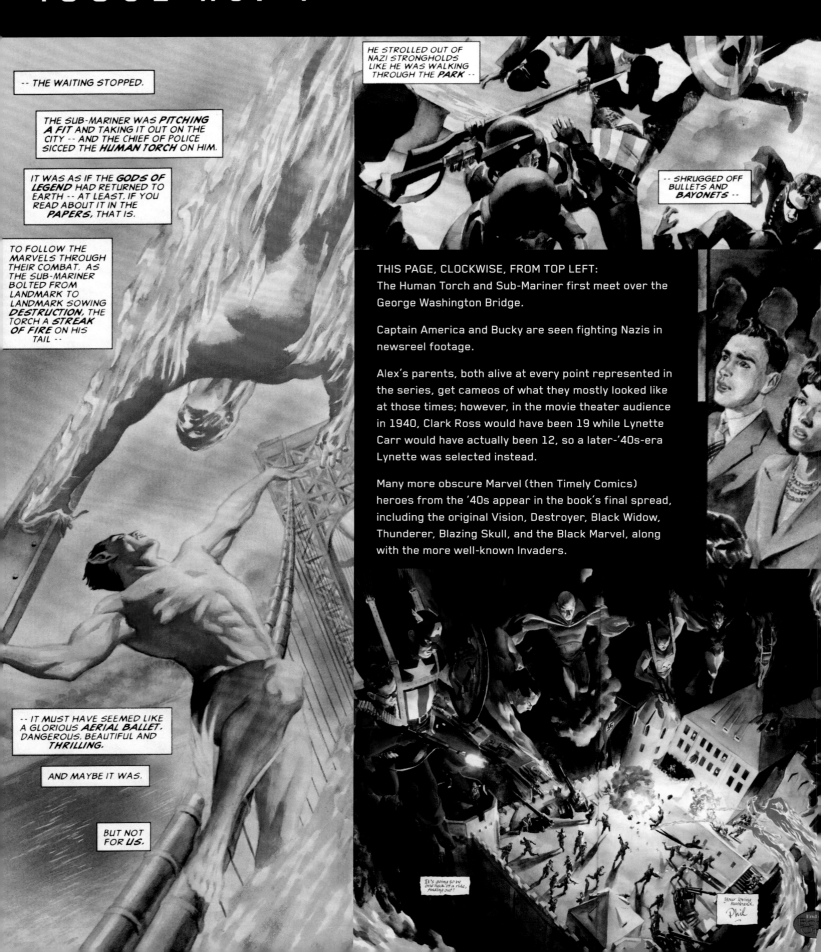

-- THE WAITING STOPPED.

THE SUB-MARINER WAS *PITCHING A FIT* AND TAKING IT OUT ON THE CITY -- AND THE CHIEF OF POLICE SICCED THE *HUMAN TORCH* ON HIM.

IT WAS AS IF THE *GODS OF LEGEND* HAD RETURNED TO EARTH -- AT LEAST, IF YOU READ ABOUT IT IN THE *PAPERS*, THAT IS.

TO FOLLOW THE MARVELS THROUGH THEIR COMBAT, AS THE SUB-MARINER BOLTED FROM LANDMARK TO LANDMARK SOWING *DESTRUCTION*, THE TORCH A *STREAK OF FIRE* ON HIS TAIL --

-- IT MUST HAVE SEEMED LIKE A GLORIOUS *AERIAL BALLET*. DANGEROUS, BEAUTIFUL AND *THRILLING*.

AND MAYBE IT WAS.

BUT NOT FOR *US*.

HE STROLLED OUT OF NAZI STRONGHOLDS LIKE HE WAS WALKING THROUGH THE *PARK* --

-- SHRUGGED OFF BULLETS AND BAYONETS --

THIS PAGE, CLOCKWISE, FROM TOP LEFT:
The Human Torch and Sub-Mariner first meet over the George Washington Bridge.

Captain America and Bucky are seen fighting Nazis in newsreel footage.

Alex's parents, both alive at every point represented in the series, get cameos of what they mostly looked like at those times; however, in the movie theater audience in 1940, Clark Ross would have been 19 while Lynette Carr would have actually been 12, so a later-'40s-era Lynette was selected instead.

Many more obscure Marvel (then Timely Comics) heroes from the '40s appear in the book's final spread, including the original Vision, Destroyer, Black Widow, Thunderer, Blazing Skull, and the Black Marvel, along with the more well-known Invaders.

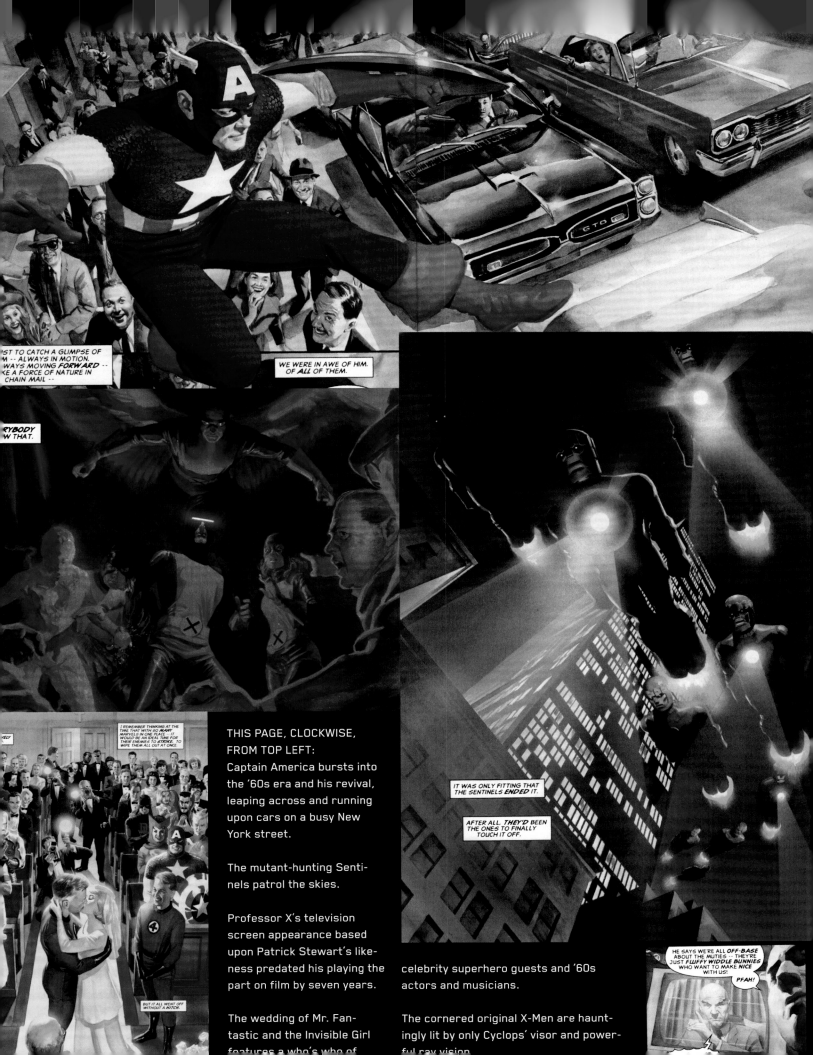

...ST TO CATCH A GLIMPSE OF
...M -- ALWAYS IN MOTION.
...WAYS MOVING *FORWARD* --
...KE A FORCE OF NATURE IN
...CHAIN MAIL --

WE WERE IN AWE OF HIM.
OF *ALL* OF THEM.

...RYBODY
...W THAT.

I REMEMBER THINKING AT THE
TIME THAT WITH SO *MANY*
MARVELS IN ONE PLACE -- IT
WOULD BE AN IDEAL TIME FOR
THEIR ENEMIES TO *STRIKE*. TO
WIPE THEM ALL OUT AT ONCE.

BUT IT ALL WENT OFF
WITHOUT A *HITCH*.

IT WAS ONLY FITTING THAT
THE SENTINELS *ENDED* IT.

AFTER ALL, *THEY'D* BEEN
THE ONES TO FINALLY
TOUCH IT OFF.

HE SAYS WE'RE ALL *OFF-BASE*
ABOUT THE MUTIES -- THEY'RE
JUST *FLUFFY WIDDLE BUNNIES*
WHO WANT TO MAKE *NICE*
WITH US!

PFAH!

THIS PAGE, CLOCKWISE,
FROM TOP LEFT:
Captain America bursts into
the '60s era and his revival,
leaping across and running
upon cars on a busy New
York street.

The mutant-hunting Senti-
nels patrol the skies.

Professor X's television
screen appearance based
upon Patrick Stewart's like-
ness predated his playing the
part on film by seven years.

The wedding of Mr. Fan-
tastic and the Invisible Girl
features a who's who of

celebrity superhero guests and '60s
actors and musicians.

The cornered original X-Men are haunt-
ingly lit by only Cyclops' visor and power-
ful ray vision.

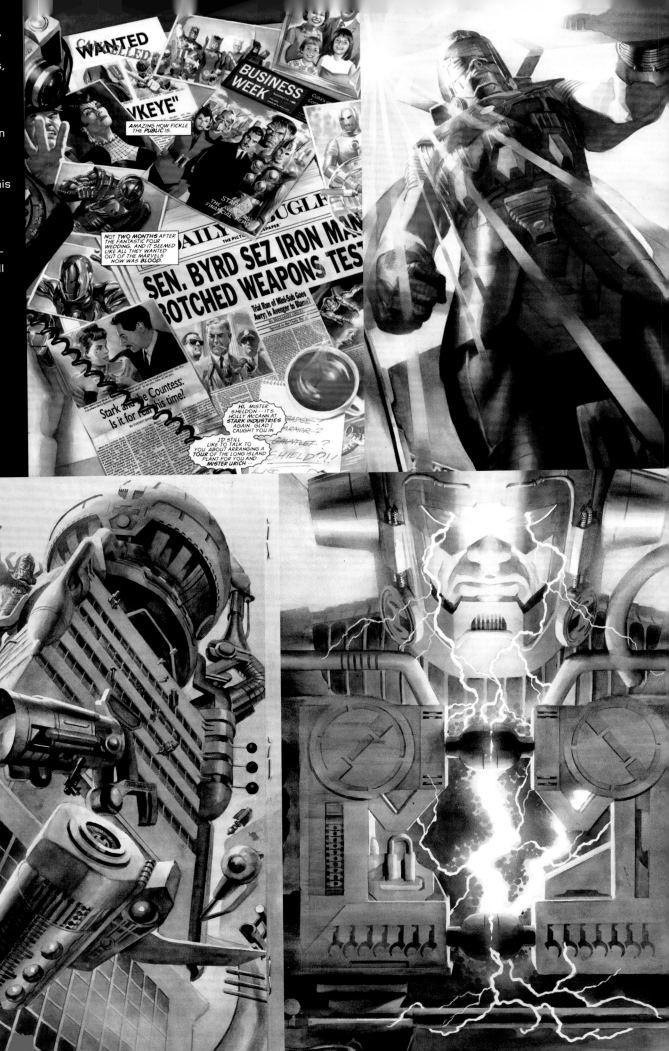

THIS PAGE, CLOCKWISE, FROM TOP: Specific images from Neal Adams' work on the Avengers Kree-Skrull War story line are re-created in this spread.

Spider-Man and the Green Goblin's battle over the Brooklyn Bridge builds tension up to our witnessing the death of Gwen Stacy.
Red tones illustrate the dark perception of a bystander's point of view that Spider-Man caused the death of police captain George Stacy.

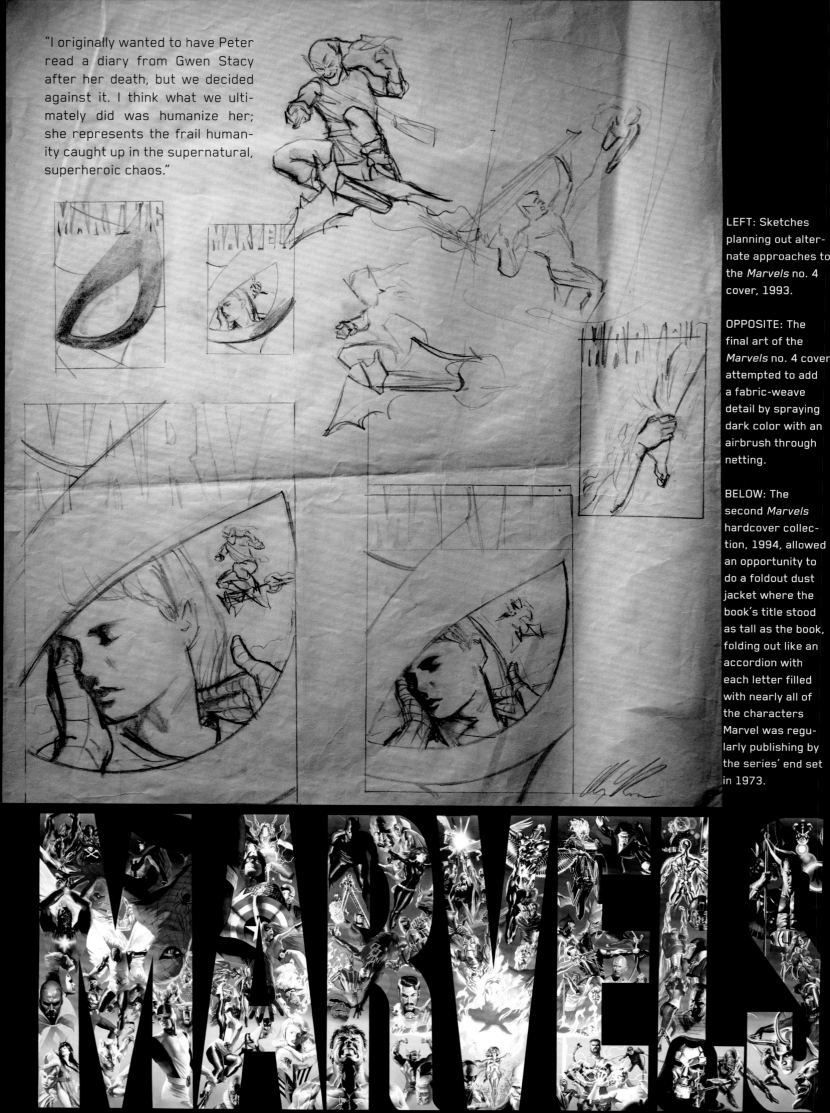

"I originally wanted to have Peter read a diary from Gwen Stacy after her death, but we decided against it. I think what we ultimately did was humanize her; she represents the frail humanity caught up in the supernatural, superheroic chaos."

LEFT: Sketches planning out alternate approaches to the *Marvels* no. 4 cover, 1993.

OPPOSITE: The final art of the *Marvels* no. 4 cover attempted to add a fabric-weave detail by spraying dark color with an airbrush through netting.

BELOW: The second *Marvels* hardcover collection, 1994, allowed an opportunity to do a foldout dust jacket where the book's title stood as tall as the book, folding out like an accordion with each letter filled with nearly all of the characters Marvel was regularly publishing by the series' end set in 1973.

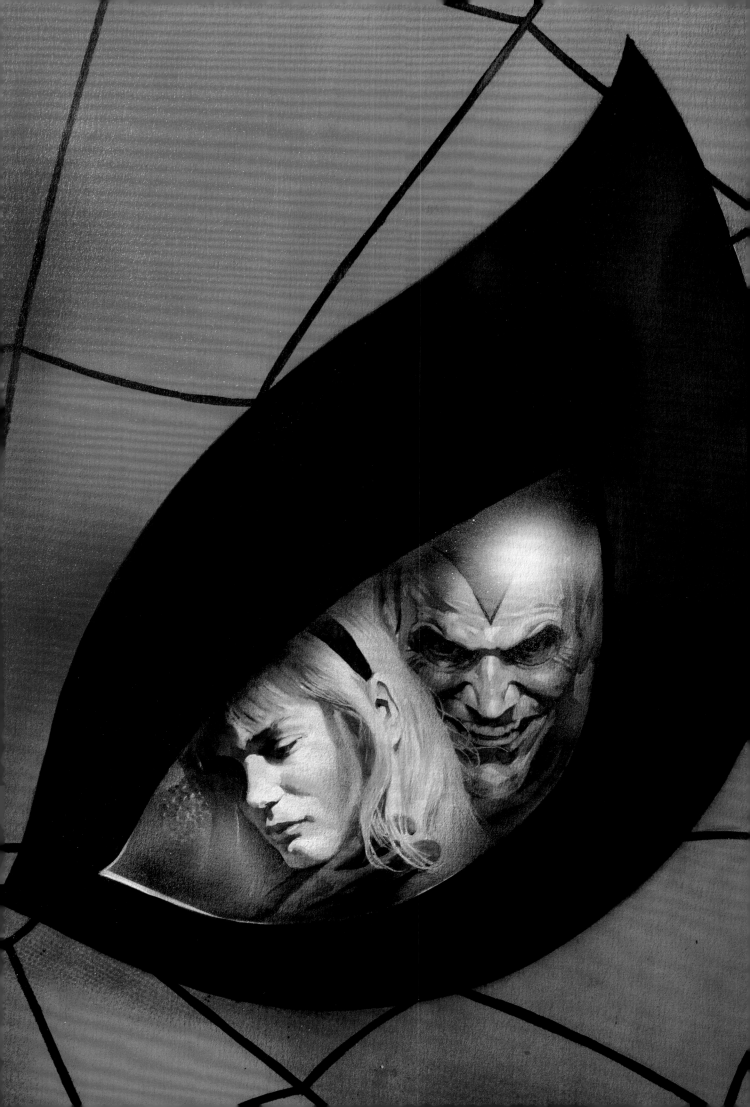

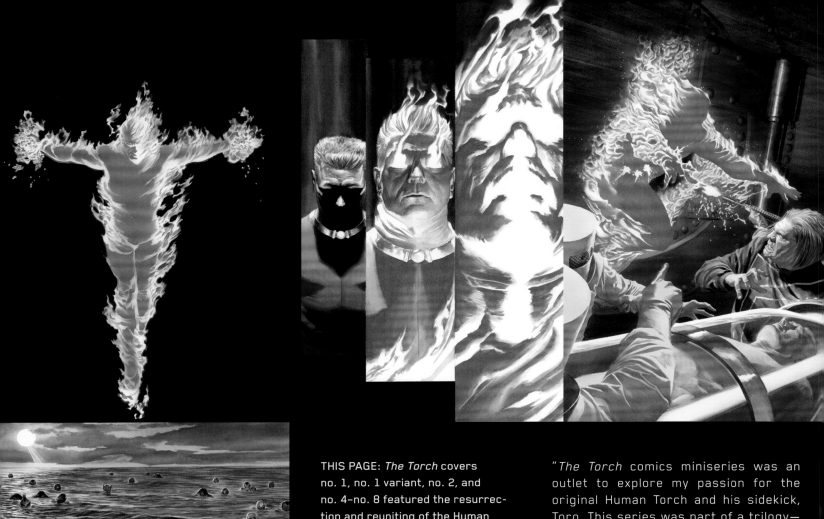

THIS PAGE: *The Torch* covers no. 1, no. 1 variant, no. 2, and no. 4–no. 8 featured the resurrection and reuniting of the Human Torch and Toro team for the first time in many decades and included the Sub-Mariner as a vampiric foe; the Fantastic Four's Human Torch joining made a trinity of Torches; and introduced a new Bizarro-like enemy, the "Inhuman Torch," 2009–2010.

OPPOSITE: *The Torch* no. 3 cover has a background blown up from the original *Marvel Mystery Comics* no. 43 cover, 1943, by Alex Schomburg; Alex Ross redrew and painted it, 2010.

"*The Torch* comics miniseries was an outlet to explore my passion for the original Human Torch and his sidekick, Toro. This series was part of a trilogy— a linked set of three serials that begin with the Avengers meeting the time-displaced, WWII-era Invaders in the modern day, and further resurrecting and reuniting the full Invaders team in present-day Marvel continuity in *Invaders Now!* The whole project allowed me to depict all of the original Marvel characters here and now, something I had yearned to do as an artist and fan for a long time. I wanted to preserve each one, especially Toro. From now on the Invaders were all back, alive, and able to appear in new stories."

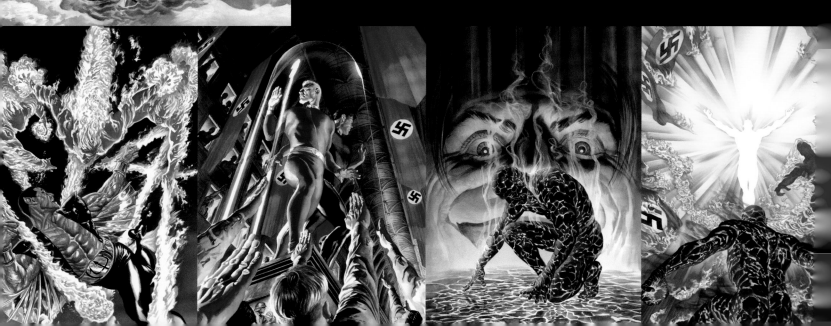

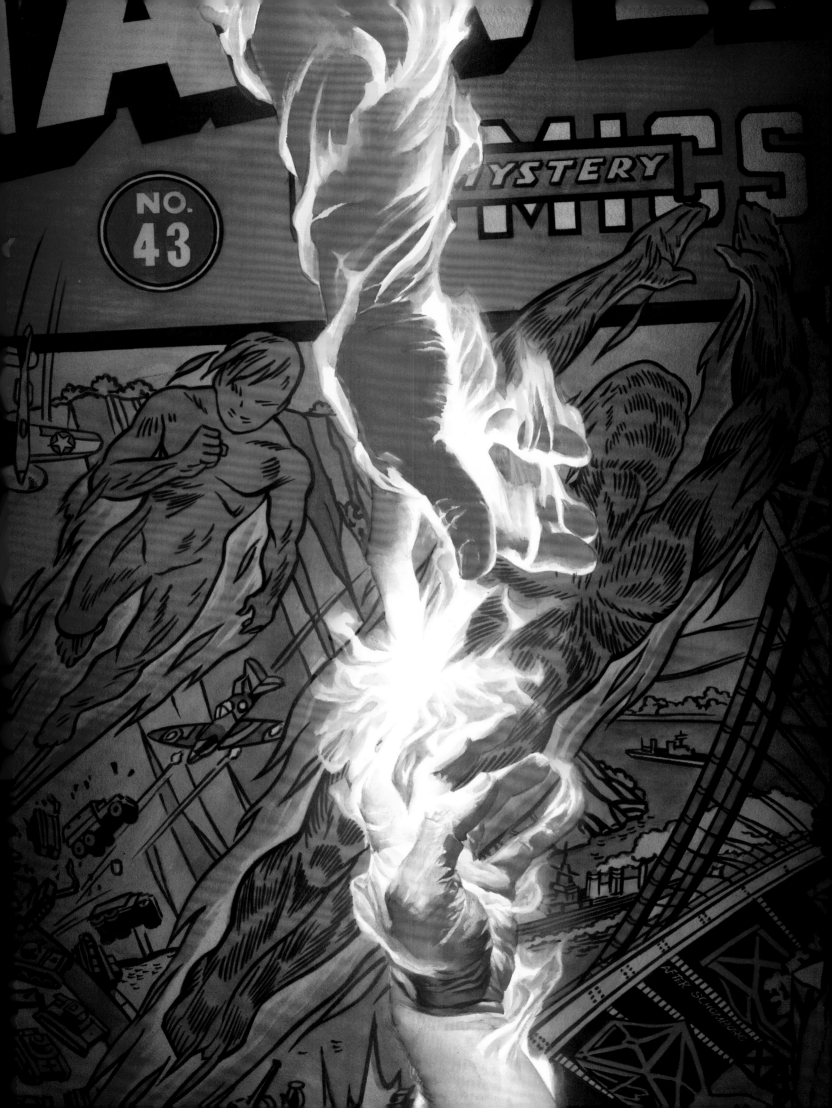

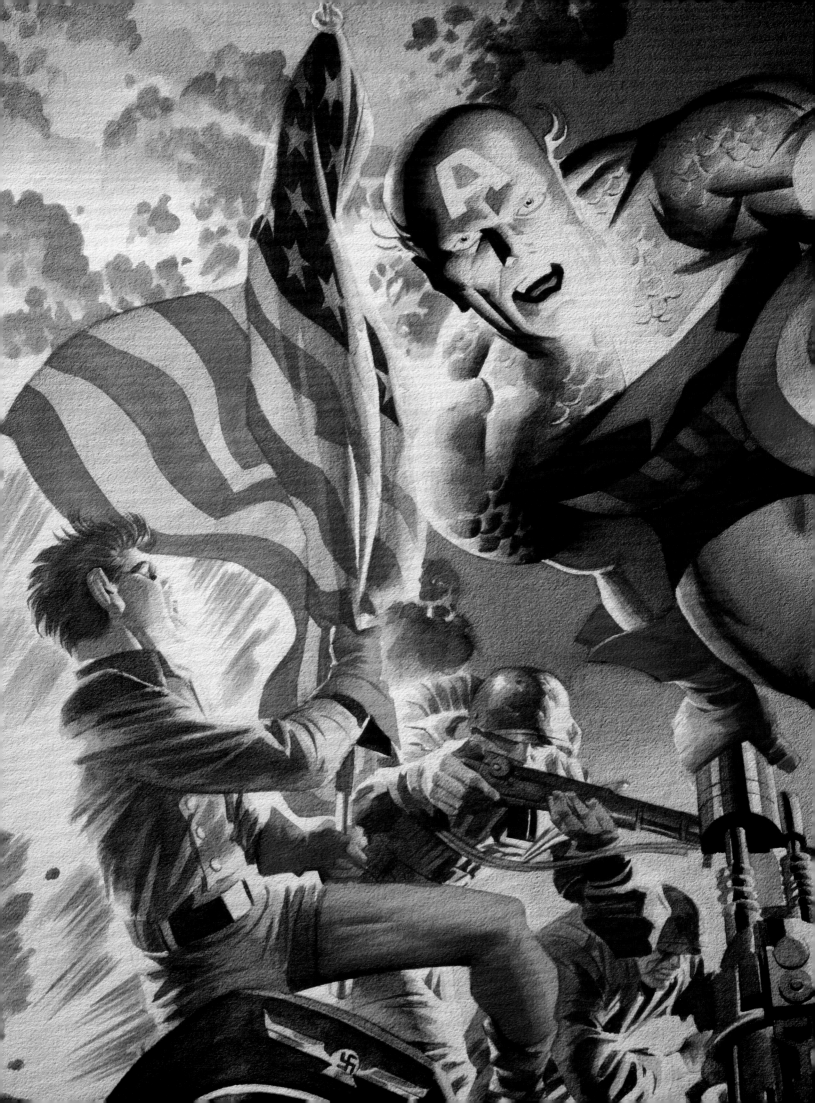

INFLUENCES
JACK KIRBY

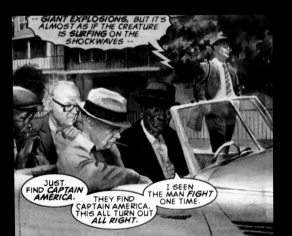

OPPOSITE: Detail of the back cover to the *Jack Kirby Collector* no. 19, painted over a copy of Jack Kirby's pencils, 1998.

ABOVE: Jack Kirby's original pinup from the *Steranko History of Comic Books* Vol. 1, 1970.

BELOW: Joe Sinnott and Jack Kirby's cameo in *Marvels* no. 3 listening to the radio cover the Galactus and Silver Surfer battle they illustrated, 1994.

So, who was Jack Kirby? As his former assistant and official biographer, Mark Evanier, writes in the book *Kirby: King of Comics*, "Jack Kirby didn't invent the comic book. It just seems that way." For almost six decades, Kirby created or cocreated some of the world's most popular and enduring superheroes—including Captain America, the X-Men, the Incredible Hulk, the Fantastic Four, the Mighty Thor, Iron Man, Ant-Man, the Avengers, Darkseid, the New Gods, and Black Panther. "More significantly," Evanier explains, "Kirby created much of the visual language for fantasy and adventure comics. Along with his partner, Joe Simon, Kirby also invented romance comics, and raised the standard for the genres of western, crime, and horror. There were comics before Kirby, but for the most part their page layout, graphics, and visual dynamic aped what was being done in syndicated newspaper strips. Almost everything that was different about comic books began in the '40s on the drawing table of Jack Kirby." His influence can be felt to this day, from the blockbuster movies that feature his superhero creations, to the artists like Alex whose careers owe more than a passing debt of gratitude to the man known by all as the undisputed King of Comics.

"Jack is my ultimate artistic hero. There is no single influence that is more important to me than him," says Ross, "as he is to so many other artists as well. He is the ultimate father of comics.

"I've tried to incorporate Jack's work into mine, to capture his energy into my compositions. By re-creating his covers, my ambition is to try to show that a realistic depiction of what he did is an advancement . . . and ultimately a failure." A failure? Why? "Because Jack's work in and of itself is beautiful; what I do isn't going to accomplish depicting anything in any better way." So why do it? "Because it's fun! It doesn't mean I won't continue to try. It's me attempting to live in his skin, and there's something truly engaging about that, wonderfully challenging.

"The honorable manner in which Jack lived his life, his professionalism, his creative excellence, and the gracious way he treated people, I ask myself: how could anybody ever live up to that? But I want to, and I try to."

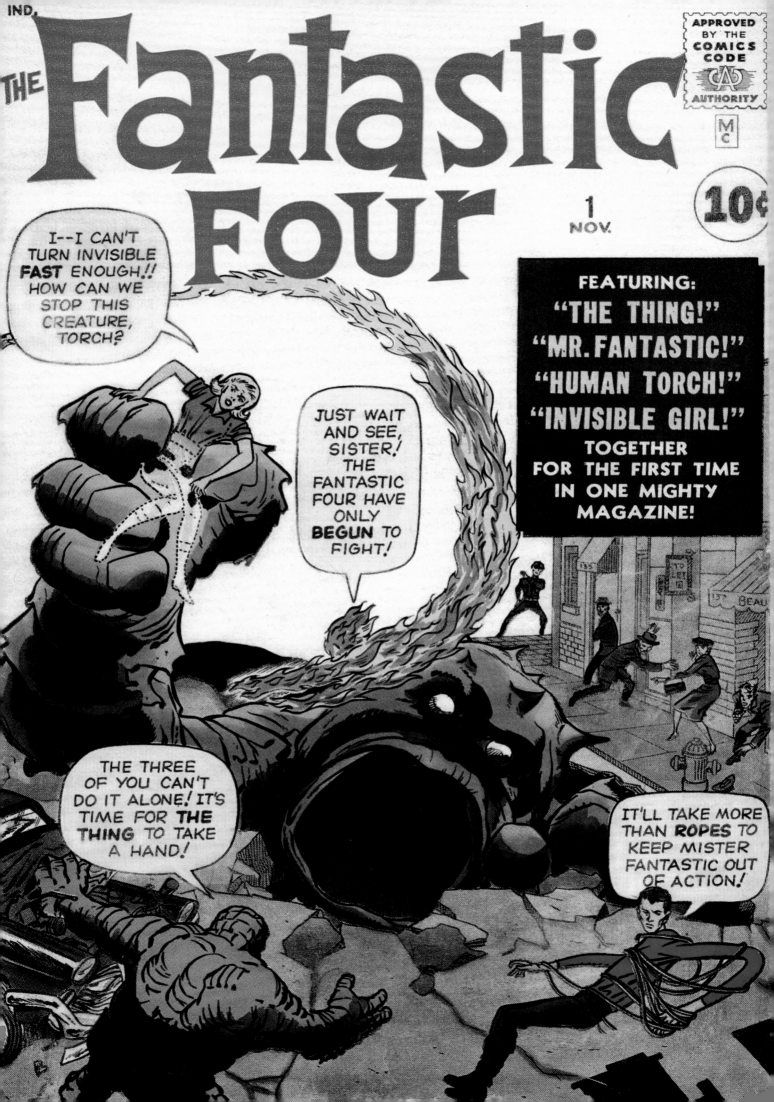

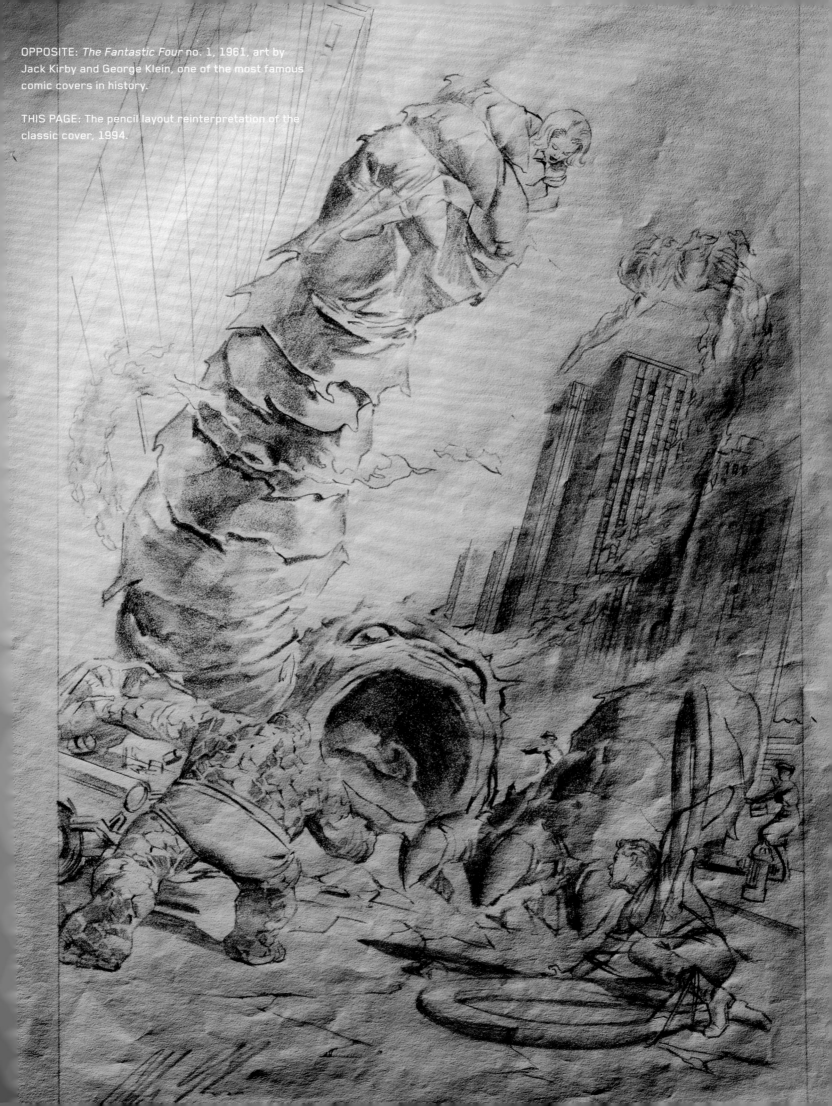

OPPOSITE: *The Fantastic Four* no. 1, 1961, art by Jack Kirby and George Klein, one of the most famous comic covers in history.

THIS PAGE: The pencil layout reinterpretation of the classic cover, 1994.

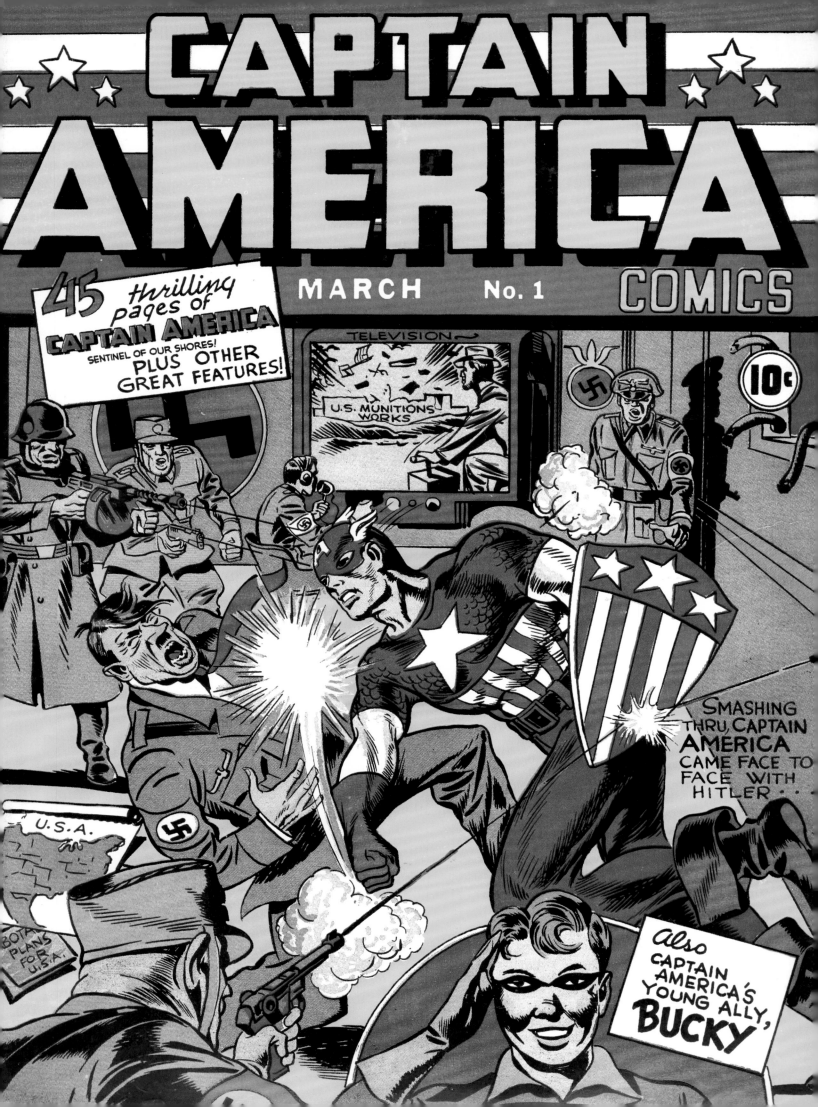

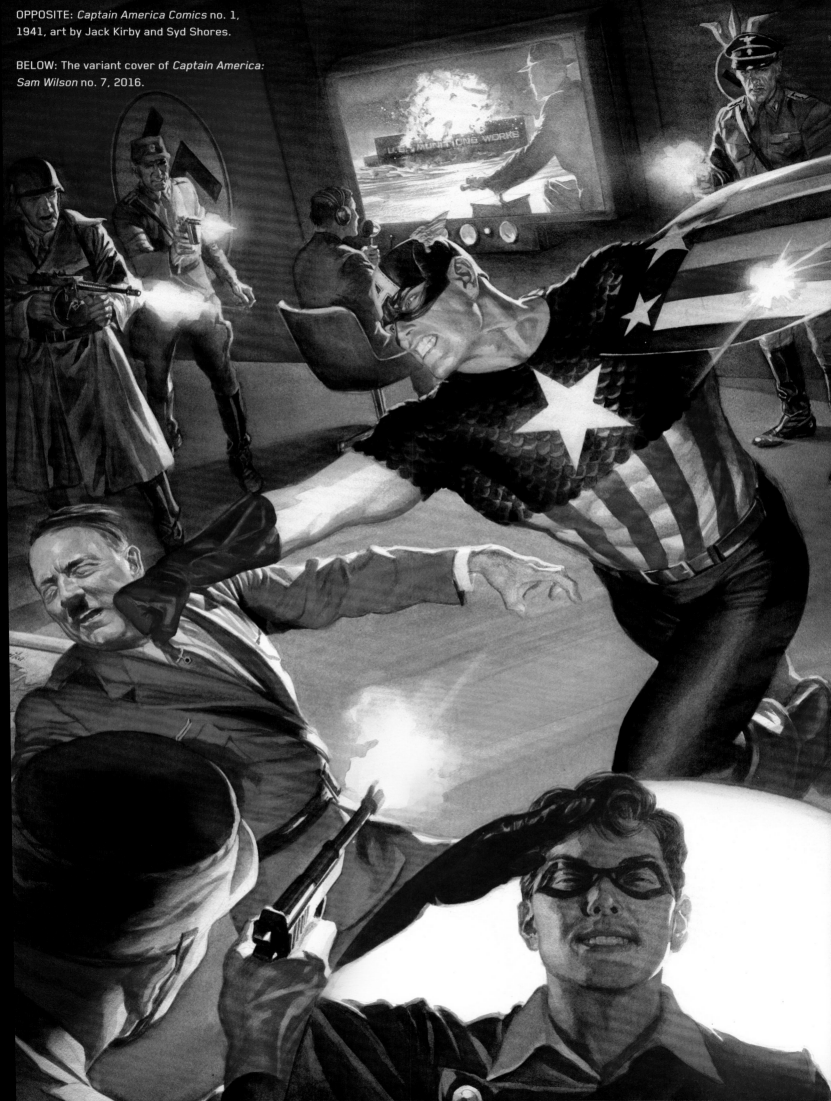

OPPOSITE: *Captain America Comics* no. 1, 1941, art by Jack Kirby and Syd Shores.

BELOW: The variant cover of *Captain America: Sam Wilson* no. 7, 2016.

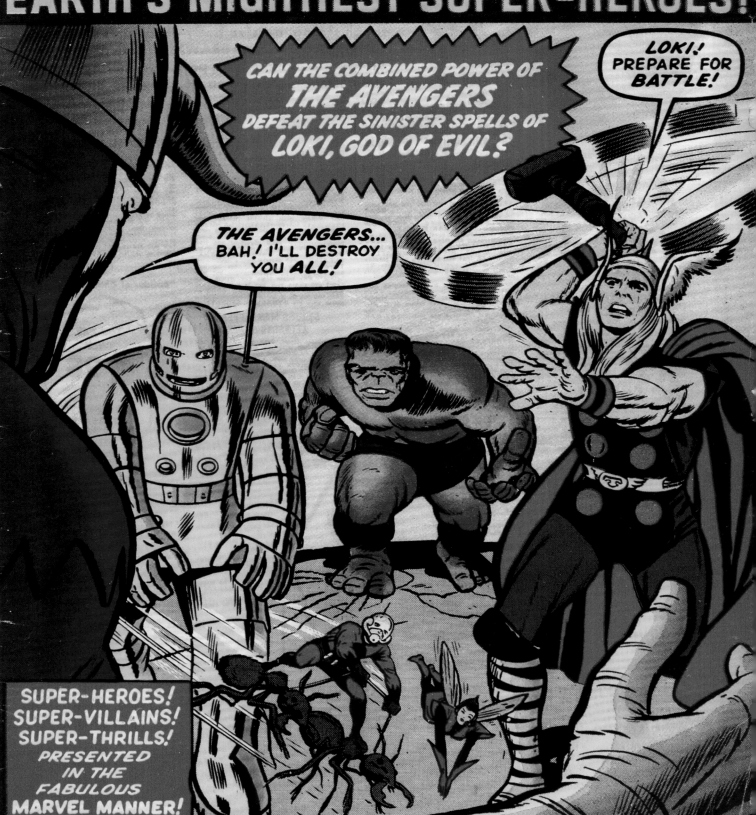

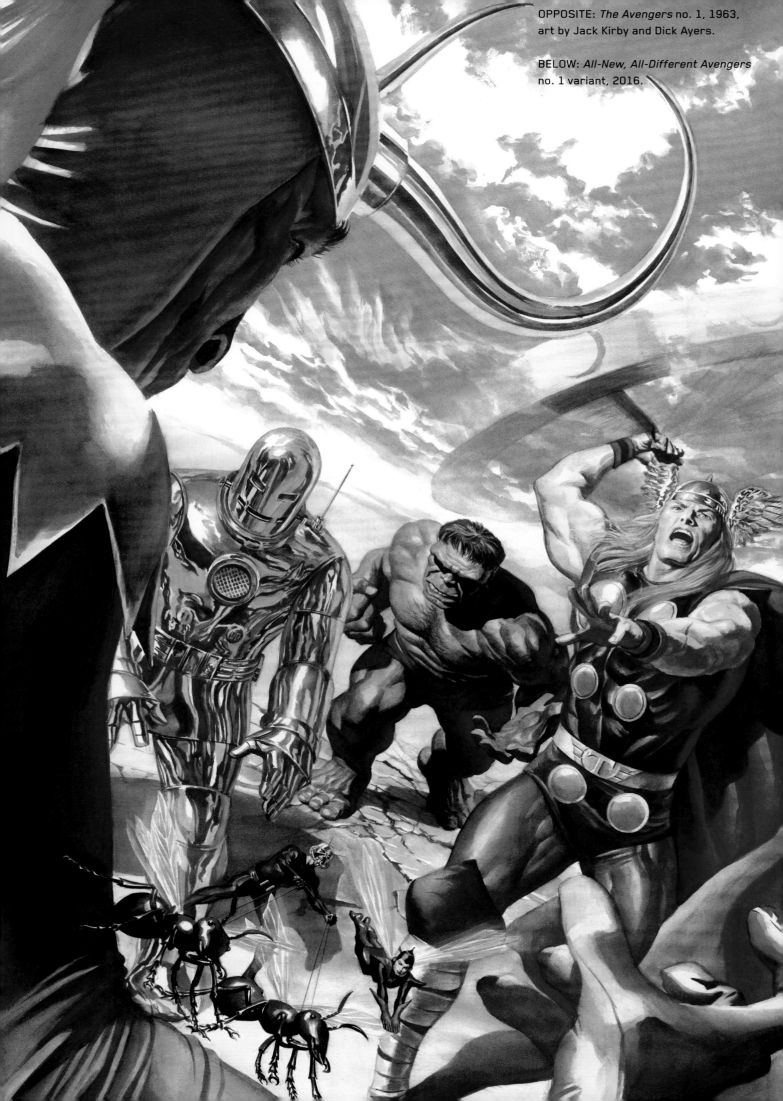

OPPOSITE: *The Avengers* no. 1, 1963, art by Jack Kirby and Dick Ayers.

BELOW: *All-New, All-Different Avengers* no. 1 variant, 2016.

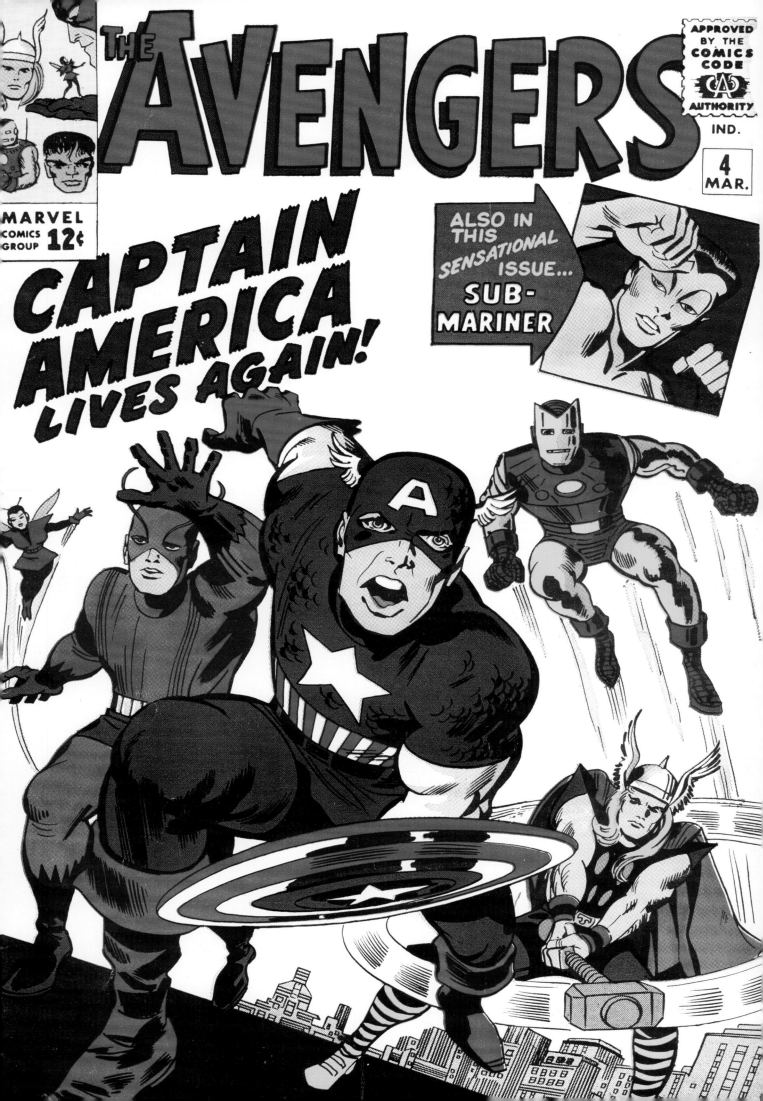

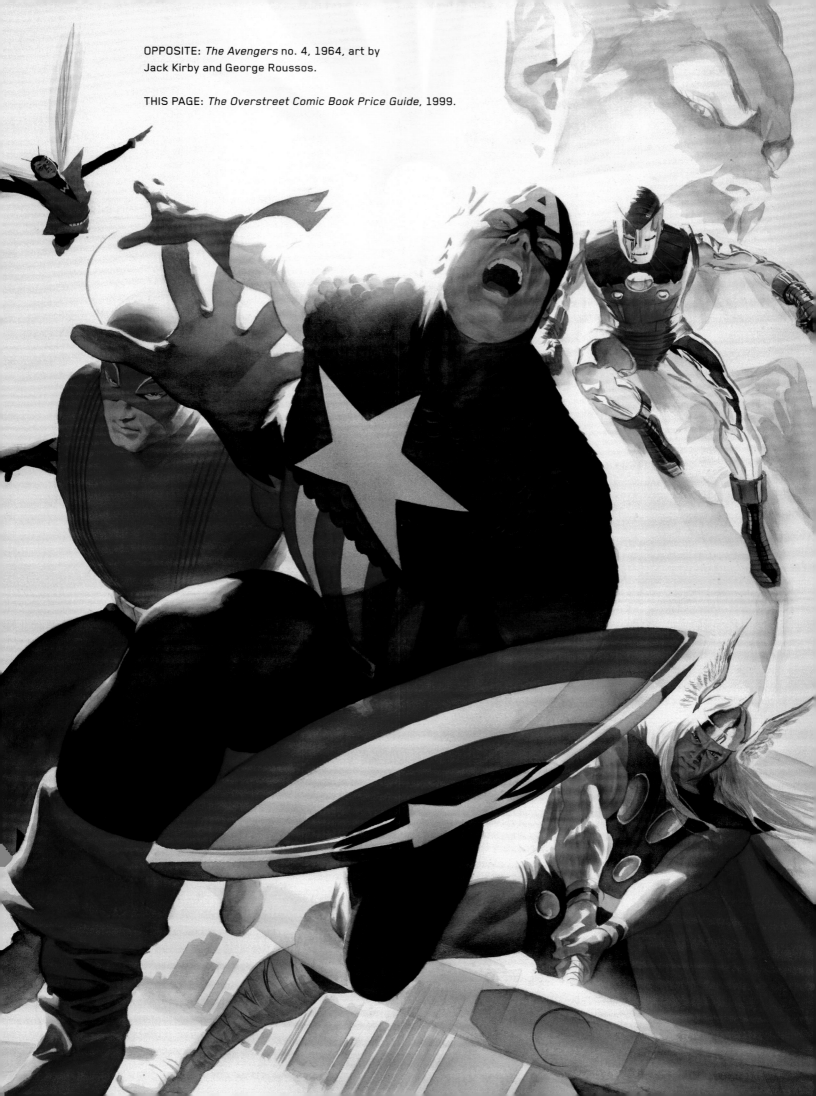

OPPOSITE: *The Avengers* no. 4, 1964, art by Jack Kirby and George Roussos.

THIS PAGE: *The Overstreet Comic Book Price Guide*, 1999.

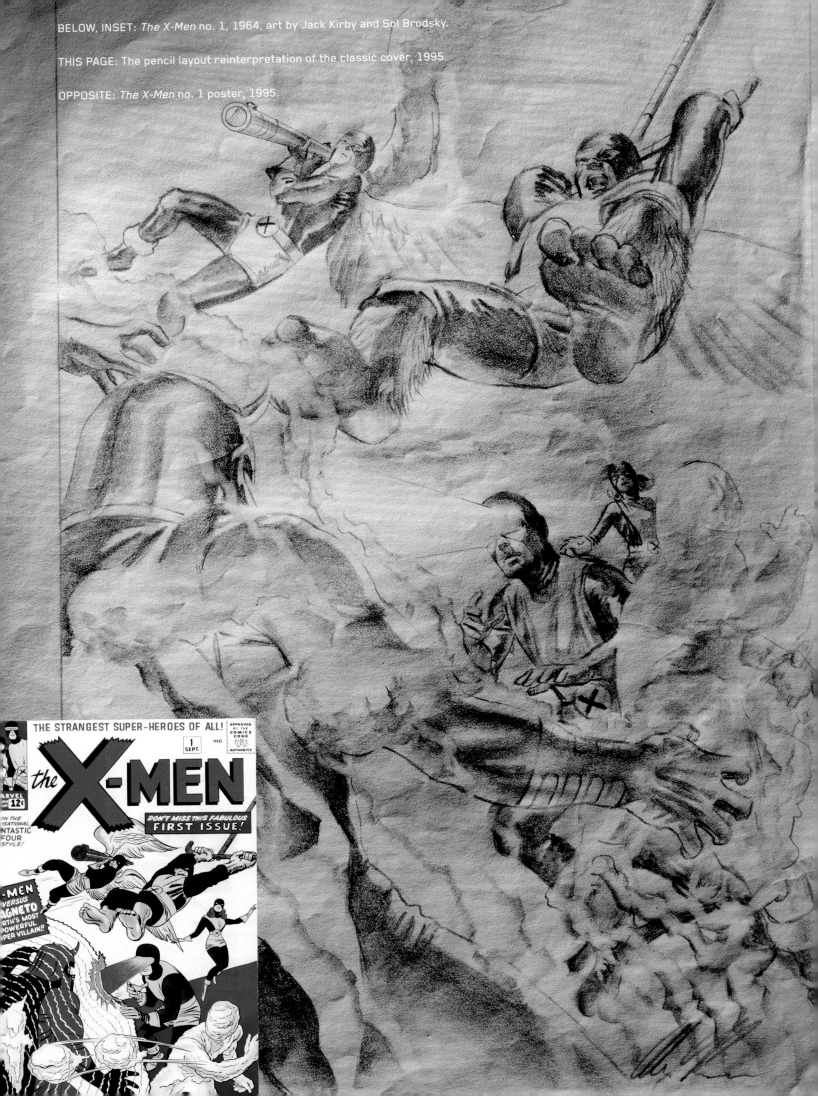

BELOW, INSET: *The X-Men* no. 1, 1964, art by Jack Kirby and Sol Brodsky.

THIS PAGE: The pencil layout reinterpretation of the classic cover, 1995.

OPPOSITE: *The X-Men* no. 1 poster, 1995.

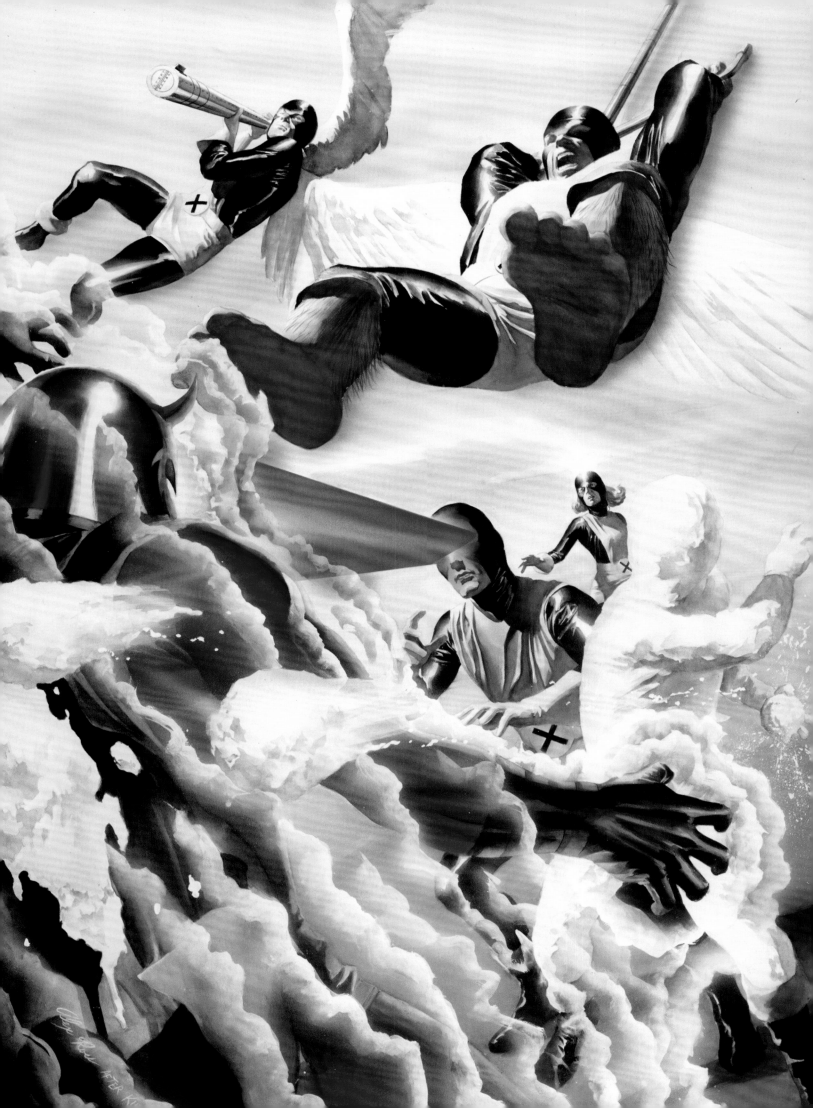

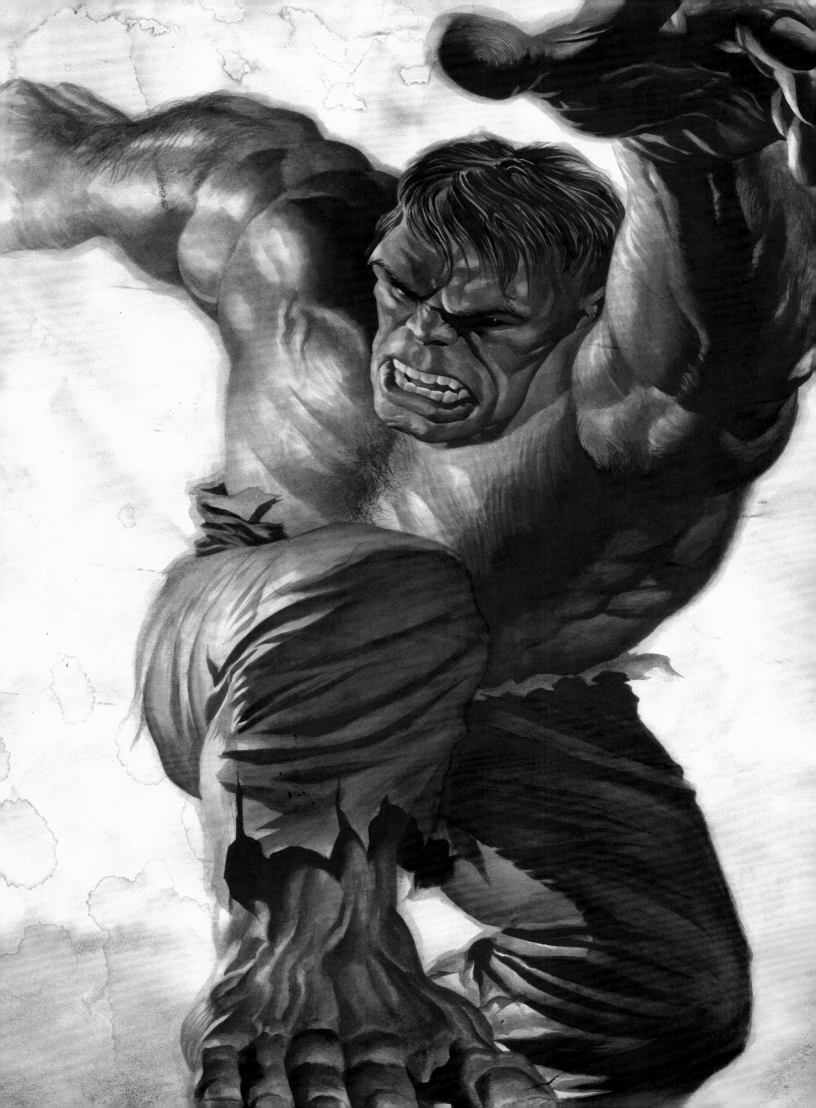

OPPOSITE: "Hulk Smash" giclée print, 2017, re-creating a Marvel fan club poster by Jack Kirby, 1966.

THIS PAGE: Kirby-based Hulk head sculpt by Alex, modifying a doll for modeling reference.

JOHN ROMITA SR.

After Steve Ditko abruptly left *Amazing Spider-Man* as the main artist in 1966, Marvel editor in chief Stan Lee hired John Romita to replace him, and thus a new era of comics art was born. Romita, a longtime veteran of romance and assorted superhero comics, was reluctant to fill the role, but soon adapted and gave the web-slinger a whole new muscular, fleshed-out look. The result put *Amazing Spider-Man,* long the number two title behind *The Fantastic Four,* out in front. It also eventually made Romita the de facto art director of the entire Marvel Comics line, a position that had never really existed before in the company's history. His work inspired an entire generation of aspiring comics artists, especially a certain young master Ross, who, upon the release of his own *Marvels* series, got to meet the man himself.

"He gave me the greatest meeting-your-hero experience that I could ever hope for. It was at the first convention I was brought to, for *Marvels*; he approached me in the signing line to greet me. Amazing! He was the art director for Marvel at the time. It was the greatest compliment; his flattery meant the world to me. To my mind he was a pinnacle of artistic achievement." And what exactly was it about his work that touched you? "I always perceived the careful precision of John's work as the most iconic version of any of the Marvel characters that he touched. It reminded me of my mother's work—that 1950s idealism. His people were the most beautiful, and his talent was so versatile and dramatic. He evolved from doing romance comics into superhero comics in such a seamless and natural way; he had that range, from a lilting swoon to a hypermasculine stance."

BELOW: Cover sketch for *Marvels* no. 0 by John Romita Sr., 1994.

RIGHT: Finished cover to *Marvels* no. 0, 1994.

OPPOSITE PAGE, TOP LEFT: Corner box art for *Marvel Team-Up* no. 49, 1976, by John Romita Sr.

OPPOSITE PAGE: New edition cover for *Marvels* hardcover, 2008.

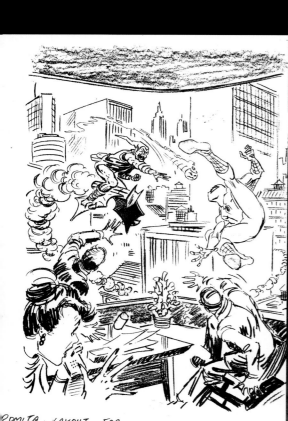

ROMITA LAYOUT FOR FINISHED PAINTING

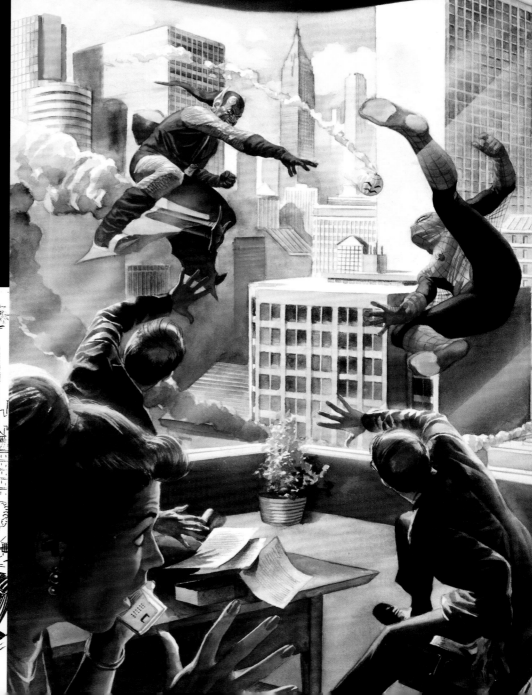

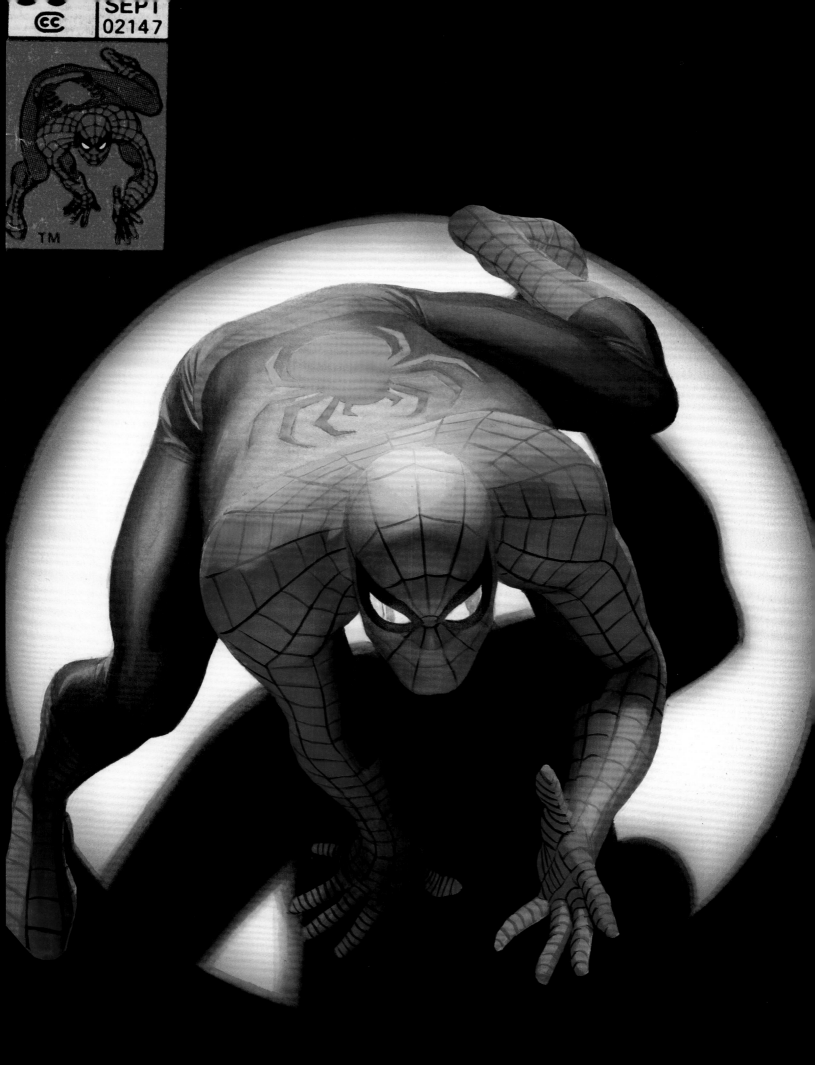

"And I not only got to meet him, I then got to *work* with him—on the cover of *Marvels* no. 0, and on a print he did the pencils for—of Spider-Man in midair battle with the Green Goblin, which I then painted. I'll never forget riding in a car with him on the way to do a cosigning of the print. I got to hear his take on all of the lore of the Marvel bull pen, and it was absolutely amazing. He was responsive to all of my questions, and I received an unwritten book's worth of comics history from the perspective of this wonderful person whose work meant so much to me."

RIGHT: Multiple panels from *Marvels* no. 4, where John Romita Sr. posed for his own cameo as a cabbie who takes Phil Sheldon to the classic fight between Spider-Man and the Green Goblin that Romita and Gil Kane illustrated, 1994.

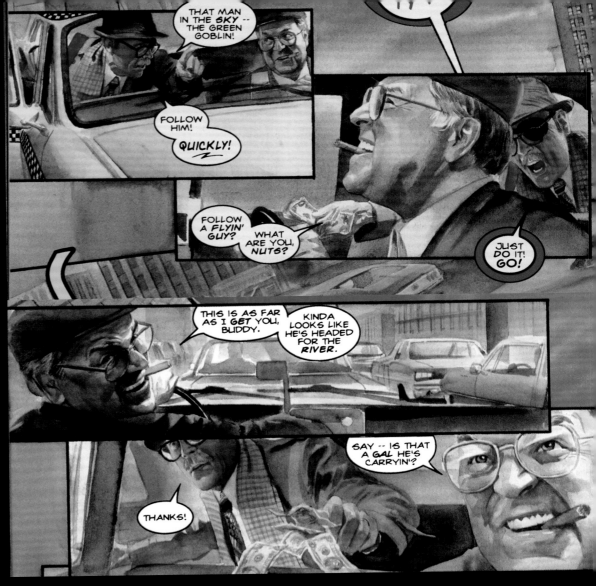

BELOW: "Mighty Marvels Heroes and Villains" lithograph provided an opportunity to paint over John's pencils to celebrate his numerous character designs, 2004.

OPPOSITE PAGE: Alex first painted over Romita for this lithograph print of Spider-Man versus the Green Goblin, 1995

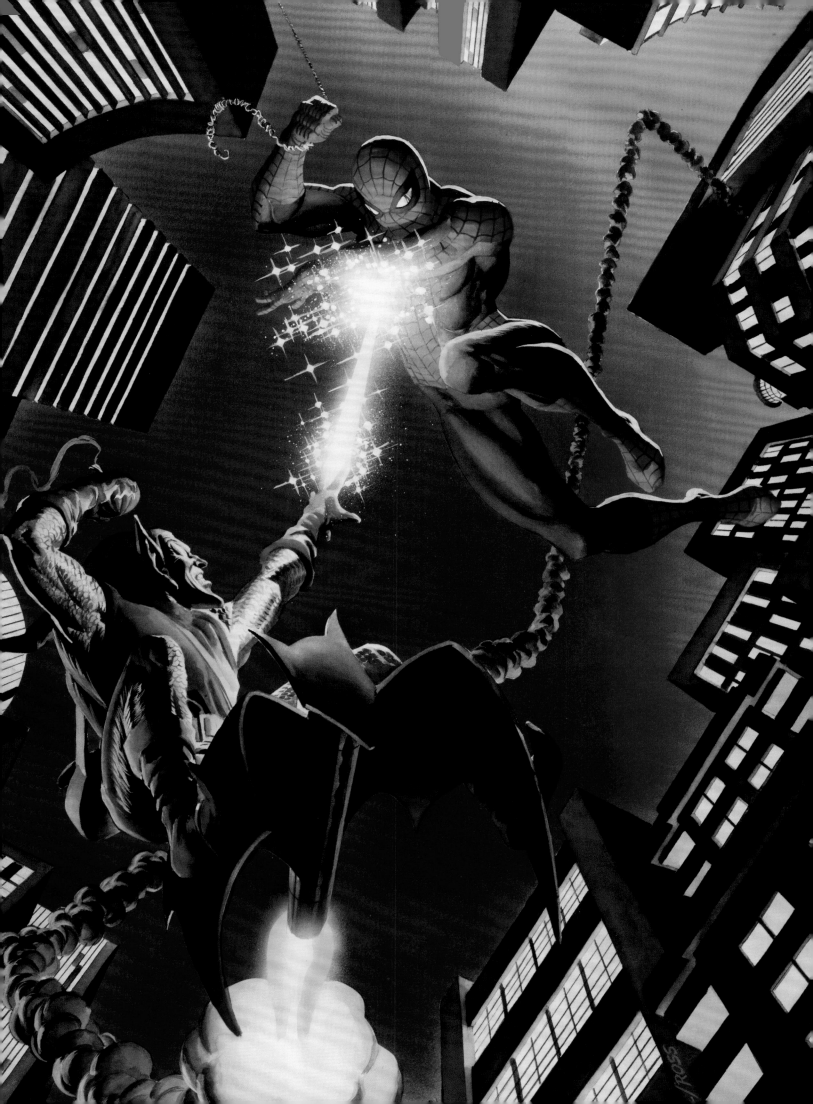

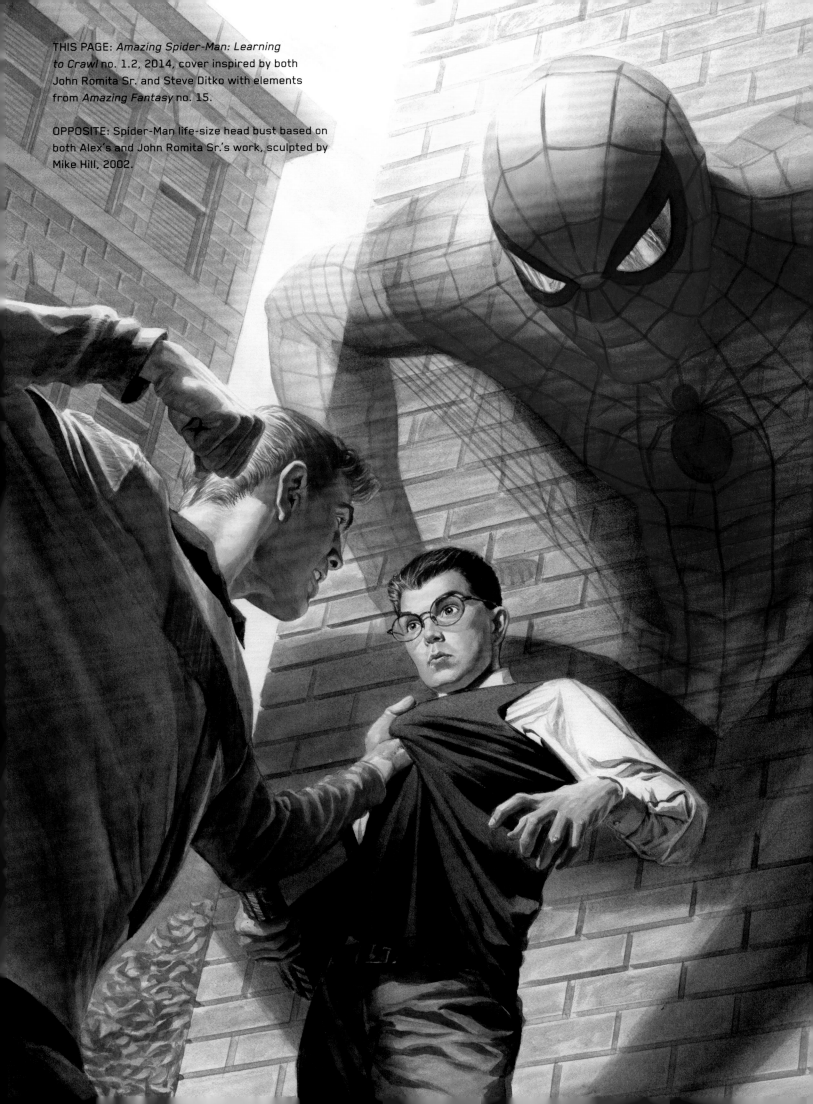

THIS PAGE: *Amazing Spider-Man: Learning to Crawl* no. 1.2, 2014, cover inspired by both John Romita Sr. and Steve Ditko with elements from *Amazing Fantasy* no. 15.

OPPOSITE: Spider-Man life-size head bust based on both Alex's and John Romita Sr.'s work, sculpted by Mike Hill, 2002.

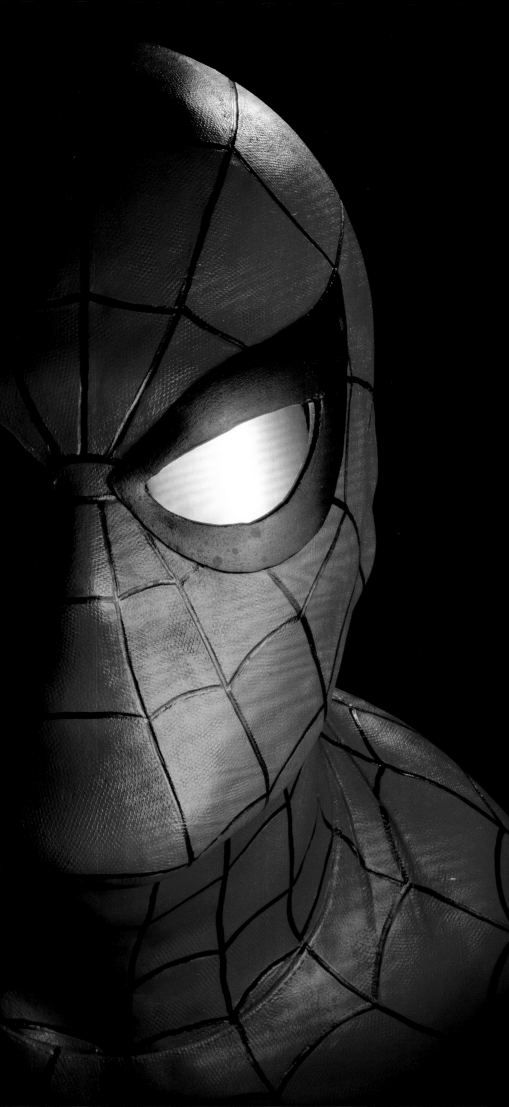

SPIDEY

"Here's what we all know about Spider-Man: Peter Parker didn't make the right choice when he first got his powers, and he lives on to regret it, forever. The mistake of not stopping the thug who then killed his Uncle Ben blew back on him immediately, and he has been trying to make up for that ever since—he misused the gifts he was given, and that's his great shame."

Okay, so we've got the motivation. Switching gears, what about the design? "I consider the Spider-Man mask, as depicted by John Romita Sr., to be the greatest costume design in comics history." Why? "Every time I saw it, I felt it was the best version. Not that I don't appreciate Ditko's, I do, but it's because of Romita that I wanted to translate what he did exactly into three dimensions—the placing of the web lines, the shape of the eyes, exactly as he had done. There was a geo-

metric perfection to his interpretation of this character that I needed to emulate."

Which brings us back to Spidey on *The Electric Company* TV show, for which Romita created most of the comics images. What did seeing Spider-Man for the first time live on TV make you feel, as a four-year-old? "It was just transformative—that completely covered body, no trace of exposed flesh, was the most exciting thing I'd ever seen. Spider-Man was *the* design, for me, by which all others would be measured."

The show's spin-off *Spidey Super Stories* magazines were the first comic books Alex ever got from his mother, Lynette, because she thought they would excite him to learn how to read. It was a nice try, but what they *really* did was teach him to start learning how to *see* . . .

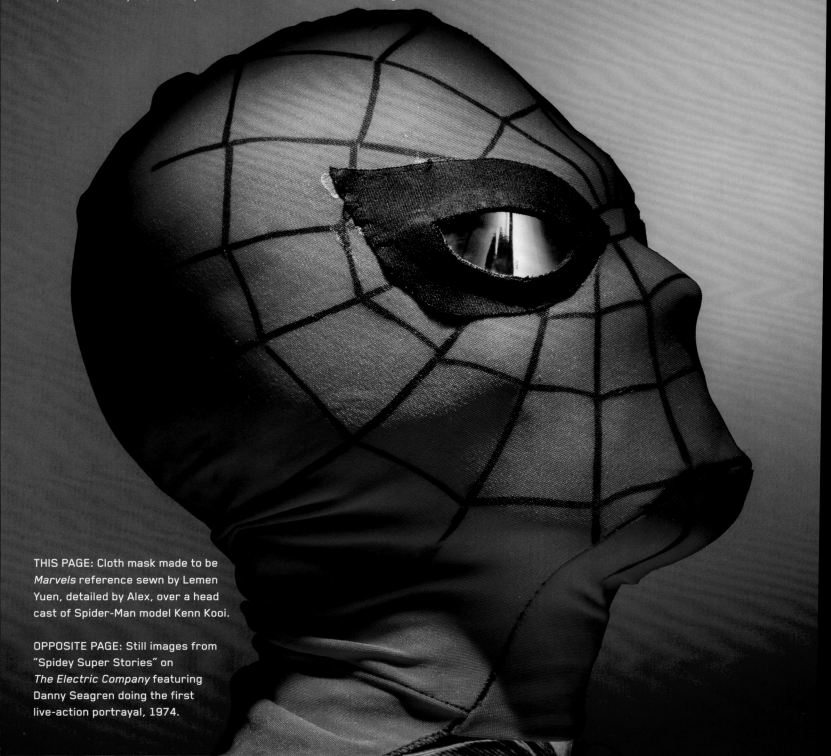

THIS PAGE: Cloth mask made to be *Marvels* reference sewn by Lemen Yuen, detailed by Alex, over a head cast of Spider-Man model Kenn Kooi.

OPPOSITE PAGE: Still images from "Spidey Super Stories" on *The Electric Company* featuring Danny Seagren doing the first live-action portrayal, 1974.

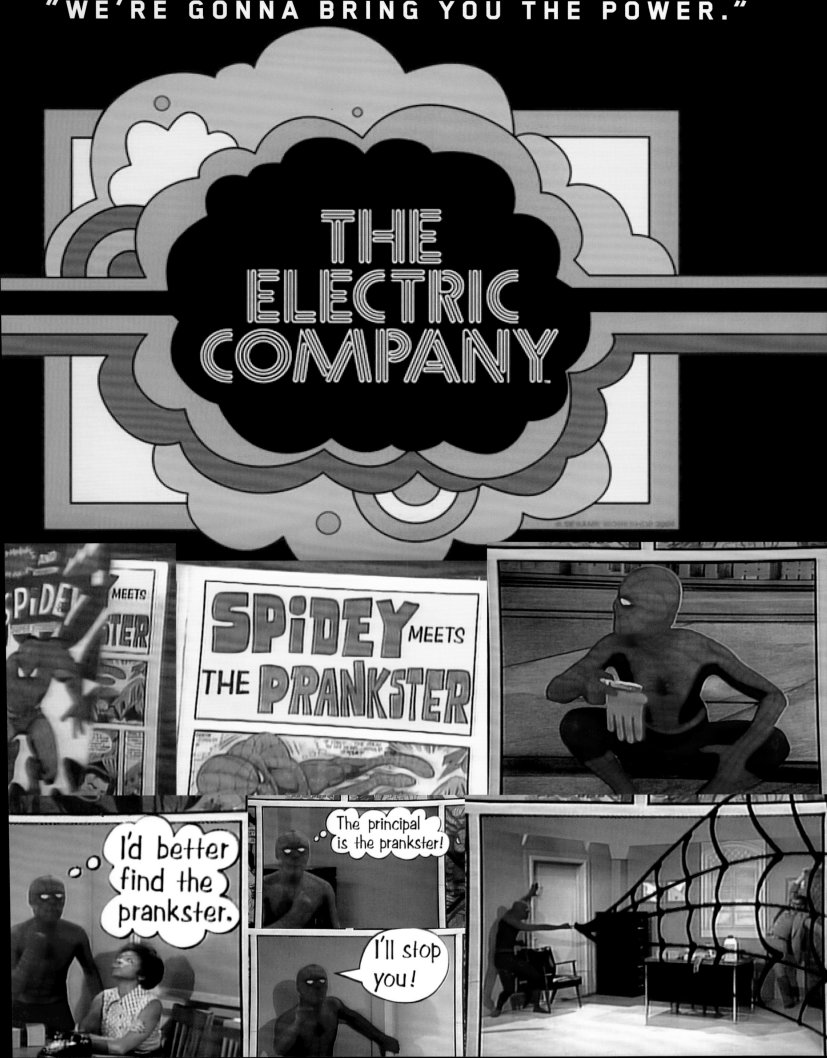

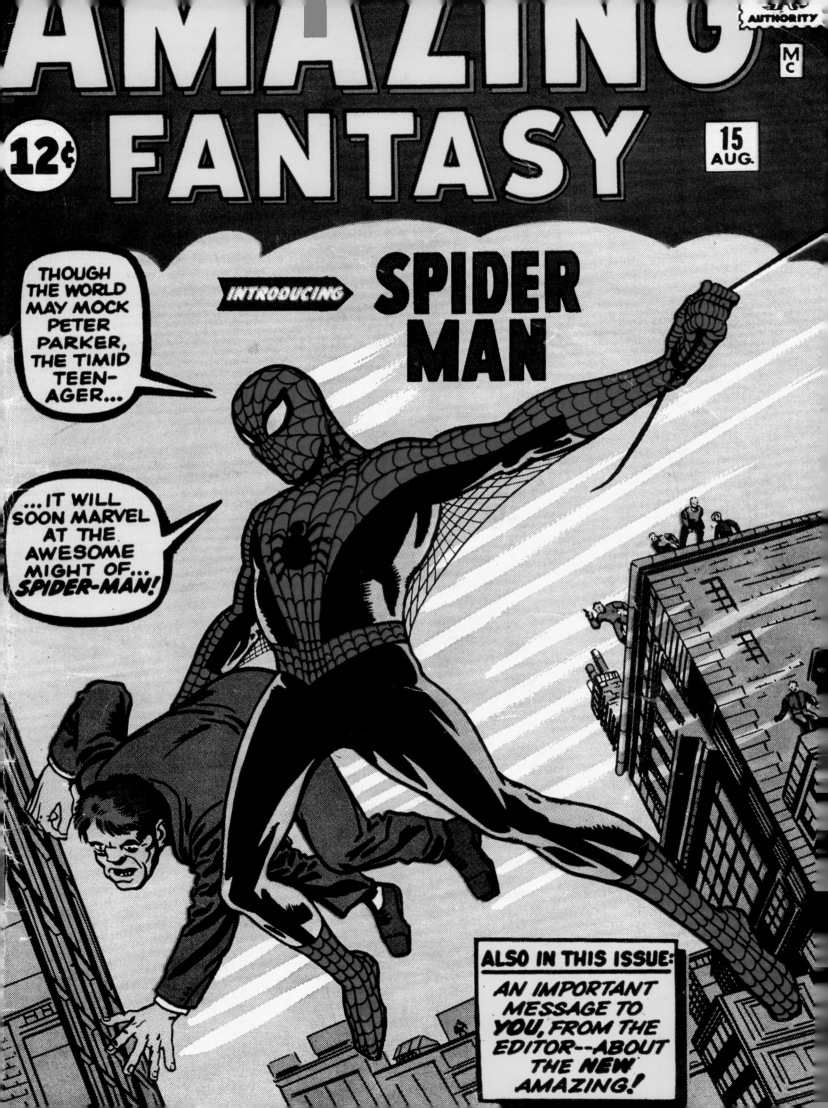

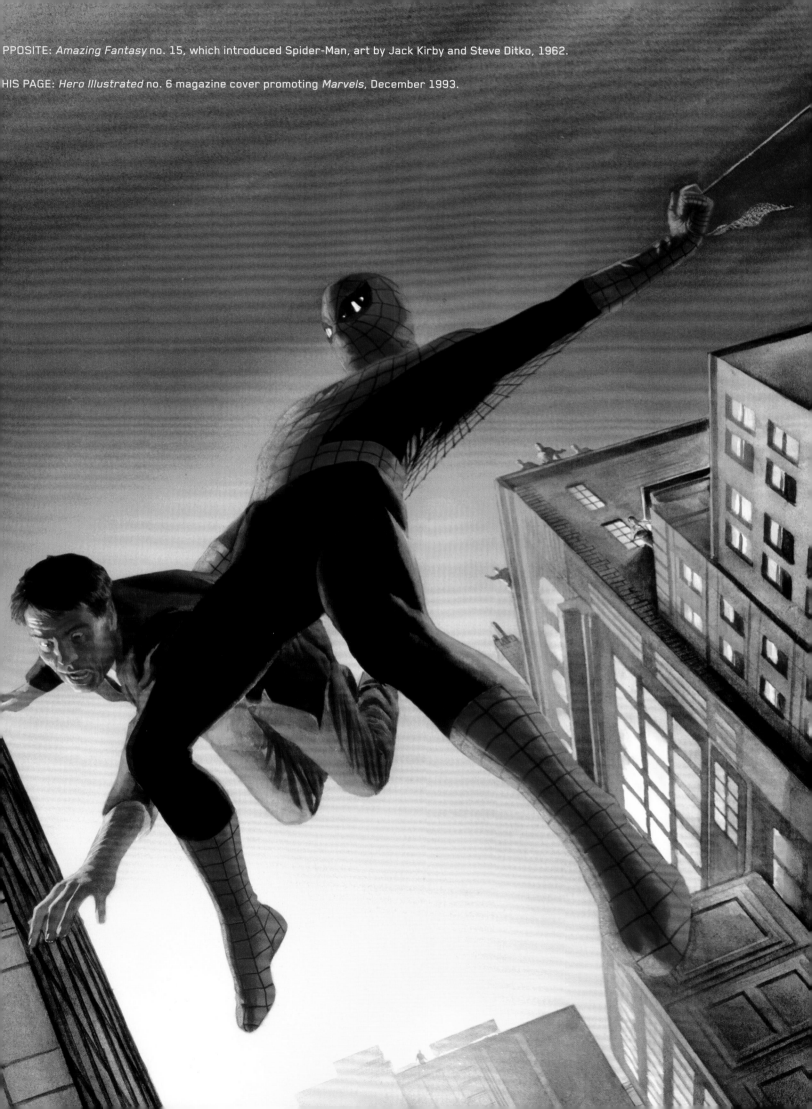

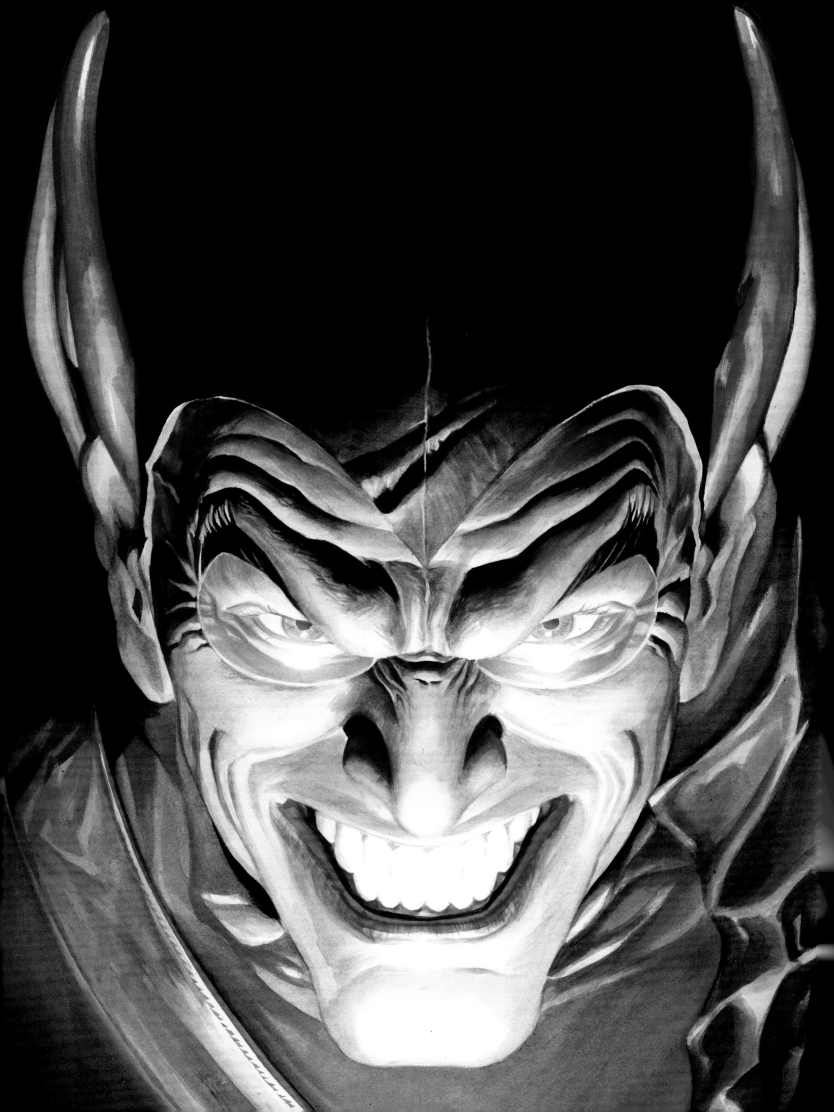

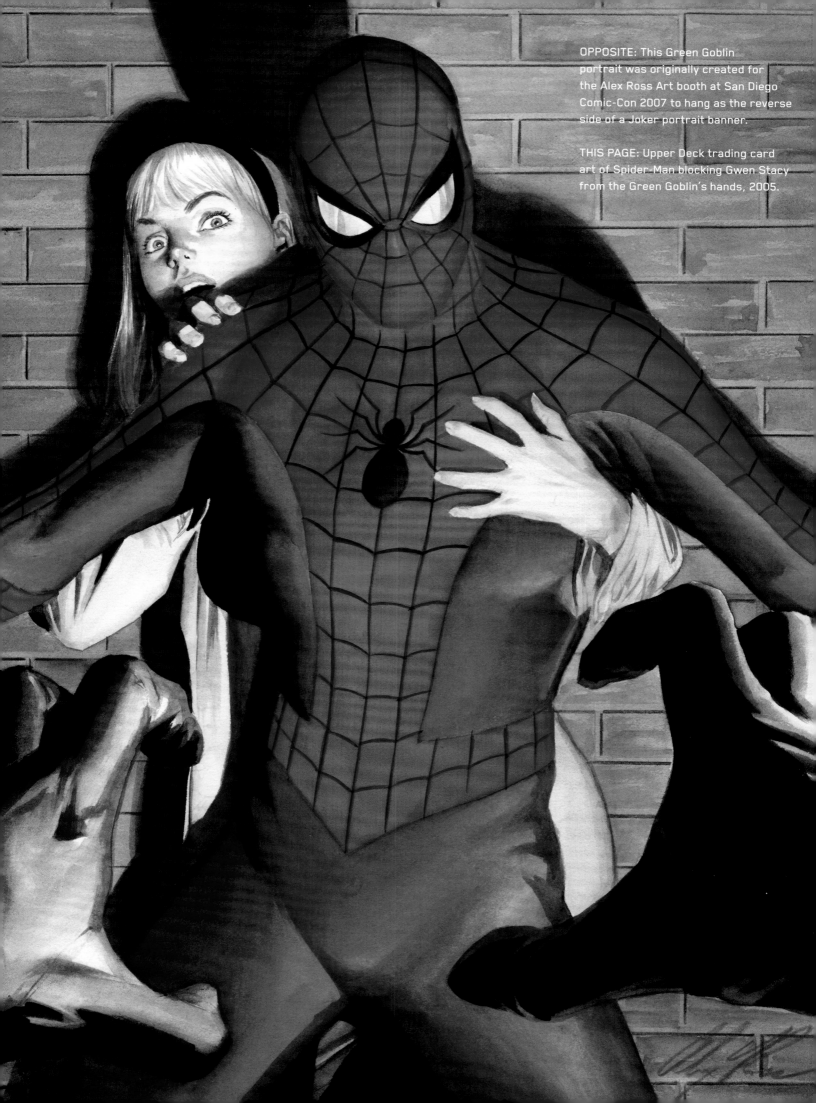

OPPOSITE: This Green Goblin portrait was originally created for the Alex Ross Art booth at San Diego Comic-Con 2007 to hang as the reverse side of a Joker portrait banner.

THIS PAGE: Upper Deck trading card art of Spider-Man blocking Gwen Stacy from the Green Goblin's hands, 2005.

the AMAZING SPIDER-MAN

This updated version of the *Amazing Spider-Man* is based on the idea that now Spider-Man has money. Lots of it.

"Whereas my depiction of him in *Marvels* wore humble handmade clothes, in this case he can afford to develop a state-of-the-art, sleek synthetic suit with lots of gadgets, because the concept is that Peter Parker has become a young billionaire tech genius (sound familiar?). I thought it would be a worthwhile pursuit, because the problem it presented was how to combine my traditional notions of the character with what is possible today.

No more mirrored lenses—now they are glowing, and refer to the white-eyed aesthetic of the comics that I had been avoiding because I didn't think it was realistic.

"The challenge was to render a more metallic finish to the costume, which would illuminate his features in a fresh way. There is no wrinkle in this suit. I kept the face the same, but the web lines would now be completely taut. This effect would be an exaggeration of what Romita and Ditko did—instead of curved lines they would be stretched tight. It would feel more like a computer grid pattern."

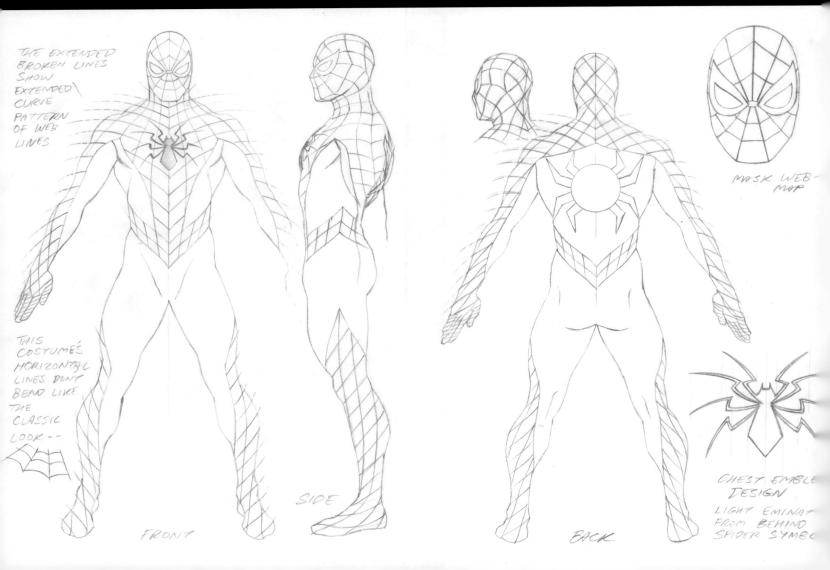

THE EXTENDED BROKEN LINES SHOW EXTENDED CURVE PATTERN OF WEB LINES

THIS COSTUME'S HORIZONTAL LINES DON'T BEND LIKE THE CLASSIC LOOK --

MASK WEB-MAP

CHEST EMBLEM DESIGN

LIGHT EMINAT FROM BEHIND SPIDER SYMBOL

FRONT

SIDE

BACK

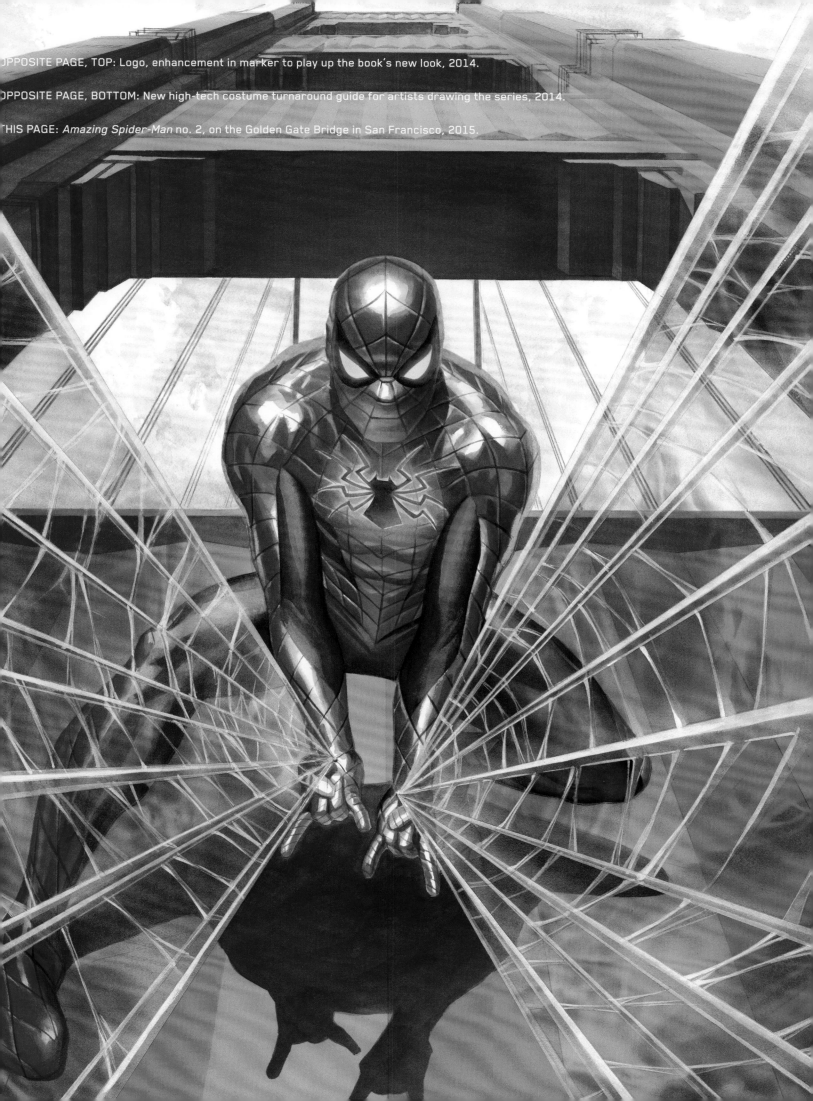

OPPOSITE PAGE, TOP: Logo, enhancement in marker to play up the book's new look, 2014.

OPPOSITE PAGE, BOTTOM: New high-tech costume turnaround guide for artists drawing the series, 2014.

THIS PAGE: *Amazing Spider-Man* no. 2, on the Golden Gate Bridge in San Francisco, 2015.

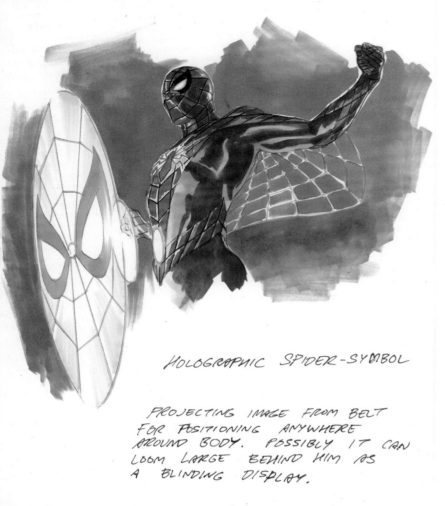

HOLOGRAPHIC SPIDER-SYMBOL

PROJECTING IMAGE FROM BELT FOR POSITIONING ANYWHERE AROUND BODY. POSSIBLY IT CAN LOOM LARGE BEHIND HIM AS A BLINDING DISPLAY.

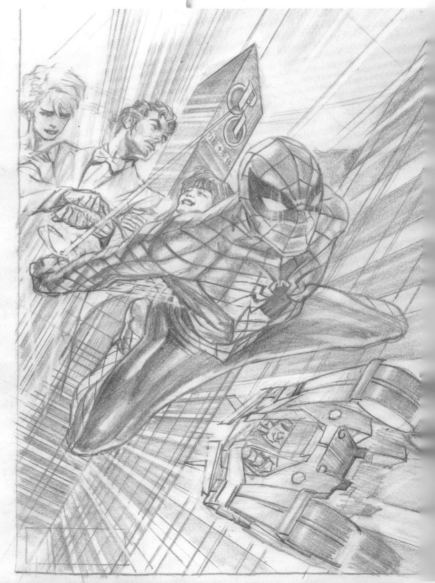

ABOVE: Proposed holographic abilities for the new costume, never used, 2014.

RIGHT AND BELOW: First cover thumbnail and Parker Industries logo and motto in Chinese.

OPPOSITE PAGE: *Amazing Spider-Man* no. 1 featuring the hero in Shanghai and with his new Spider-Mobile, 2015.

力量 + 责任

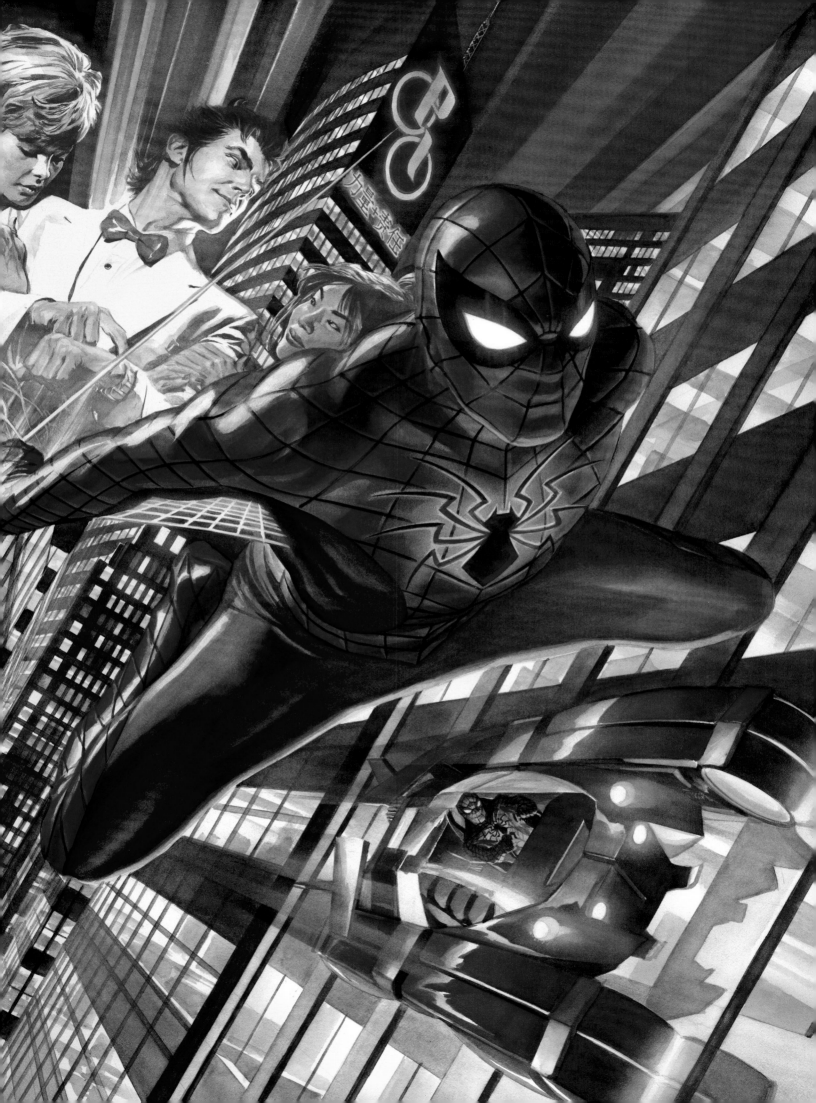

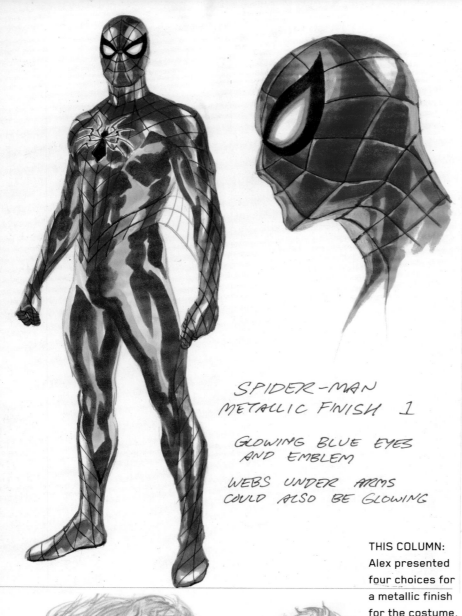

SPIDER-MAN
METALLIC FINISH 1

GLOWING BLUE EYES
AND EMBLEM

WEBS UNDER ARMS
COULD ALSO BE GLOWING

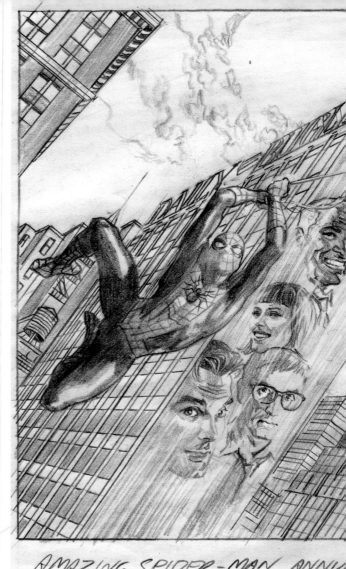

AMAZING SPIDER-MAN ANNU

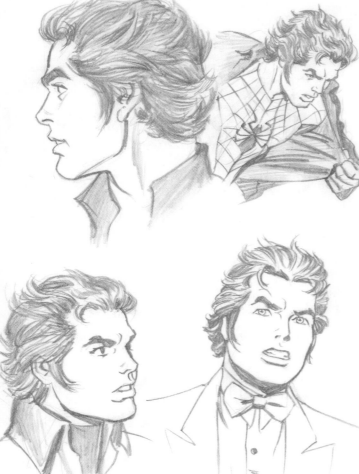

THIS COLUMN: Alex presented four choices for a metallic finish for the costume, including an unused holographic projection style and the out-of-costume Peter Parker hair and face style guide influenced by John Romita Sr.'s newspaper strip work, 2014.

COLUMN, RIGHT: Sketch and finished cover for *Amazing Spider-Man Annual* no. 42, 2018.

OPPOSITE PAGE: Cover to *Amazing Spider-Man: Learning to Crawl* no. 1.5, 2014.

PETER'S HAIRCUT

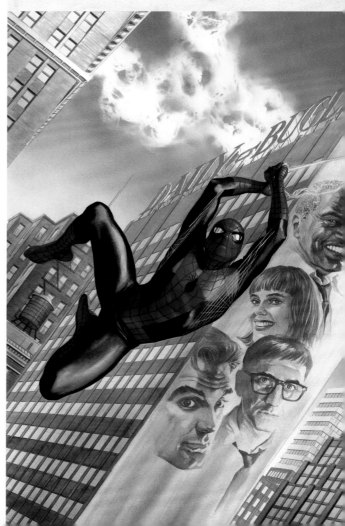

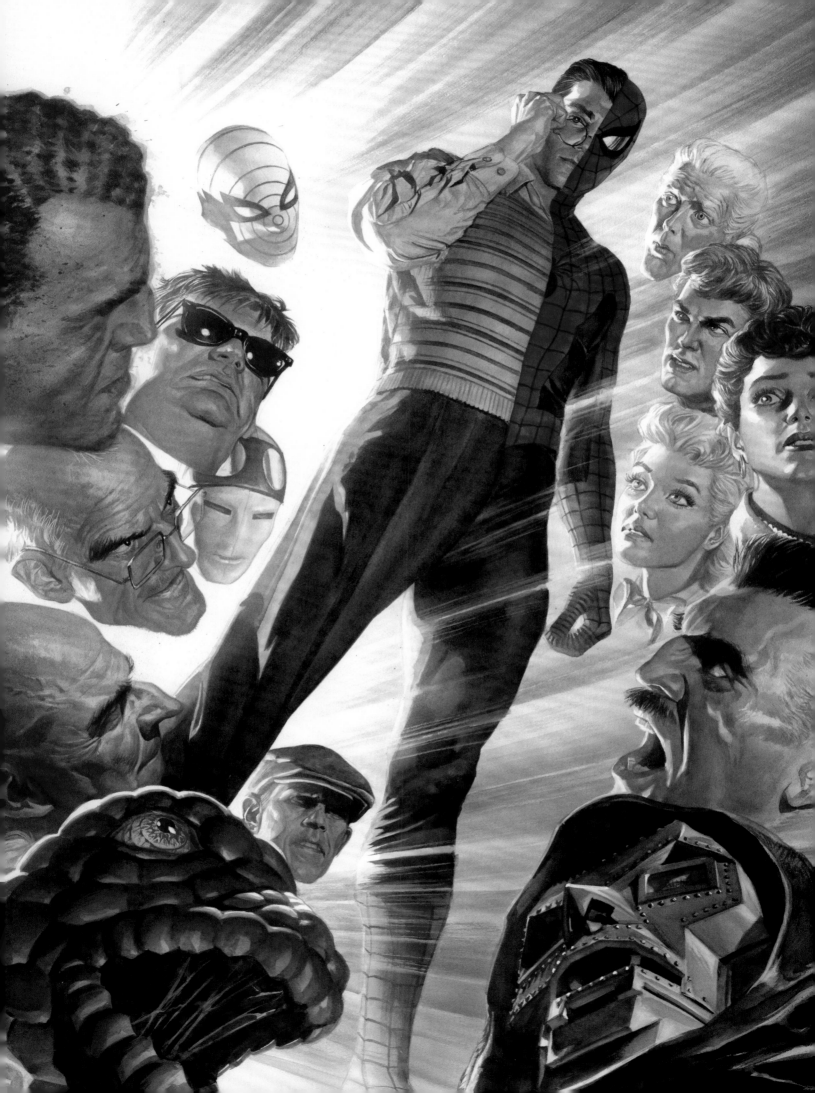

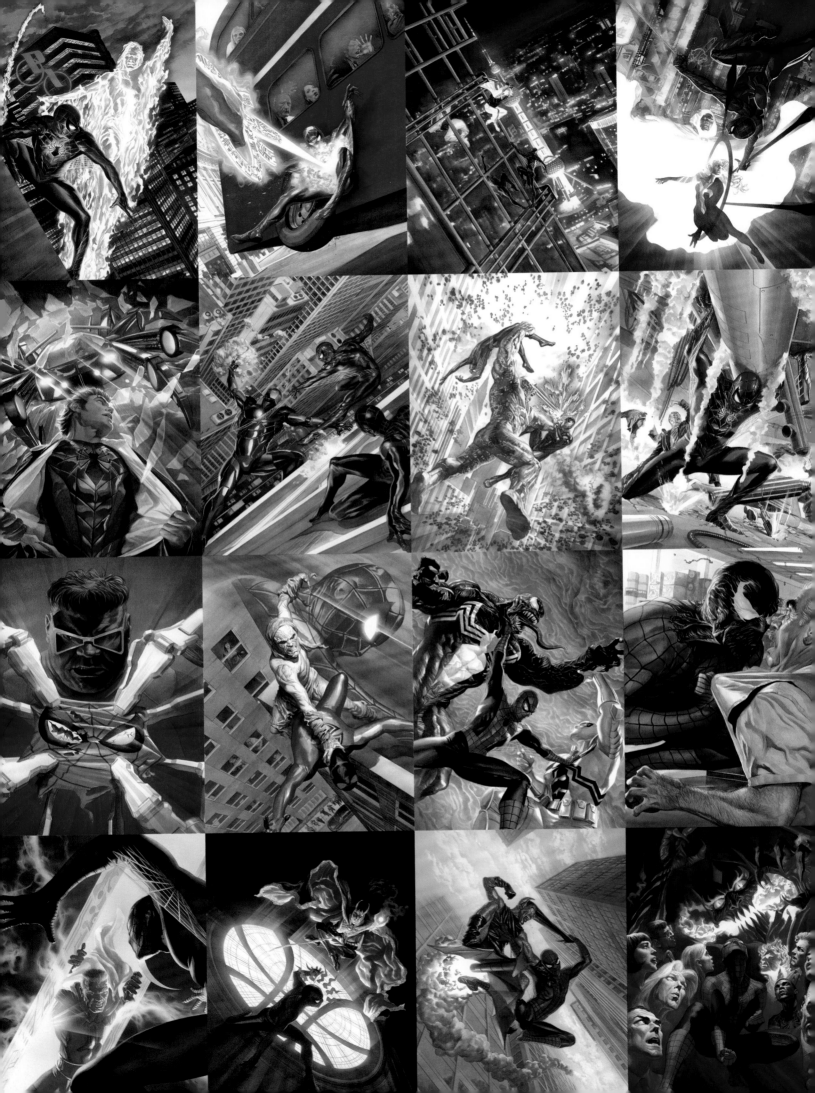

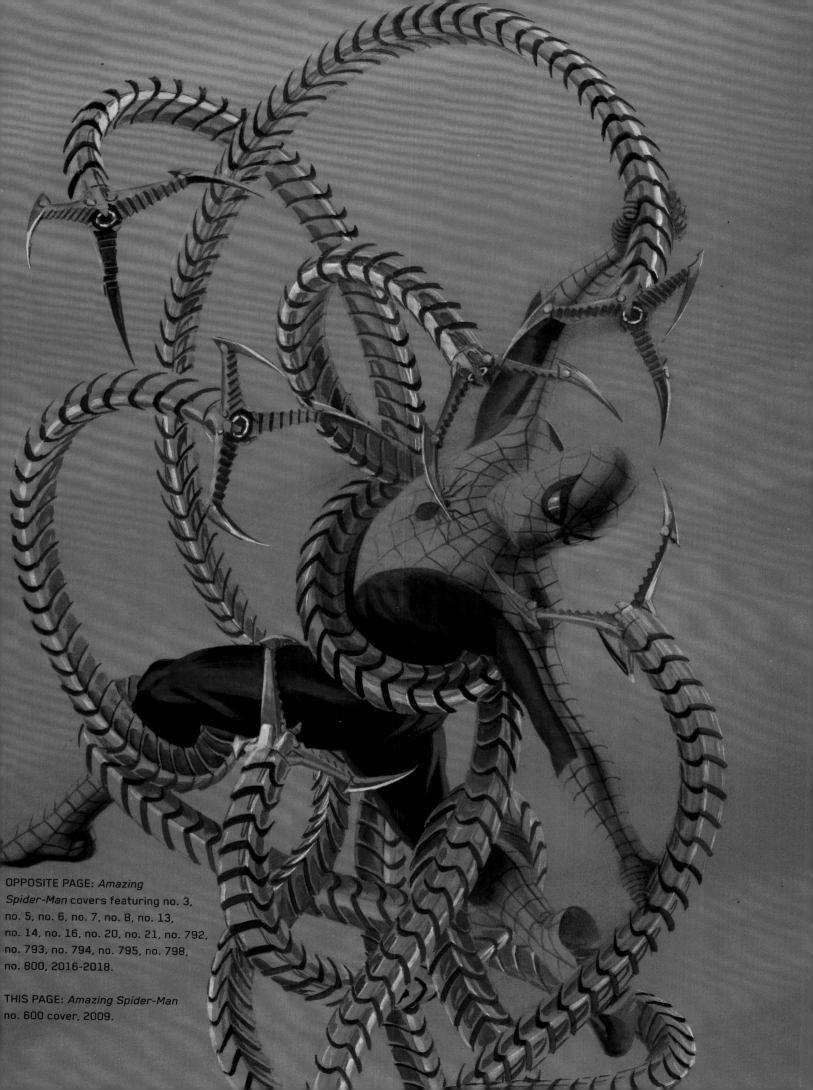

OPPOSITE PAGE: *Amazing
Spider-Man* covers featuring no. 3,
no. 5, no. 6, no. 7, no. 8, no. 13,
no. 14, no. 16, no. 20, no. 21, no. 792,
no. 793, no. 794, no. 795, no. 798,
no. 800, 2016-2018.

THIS PAGE: *Amazing Spider-Man*
no. 600 cover, 2009.

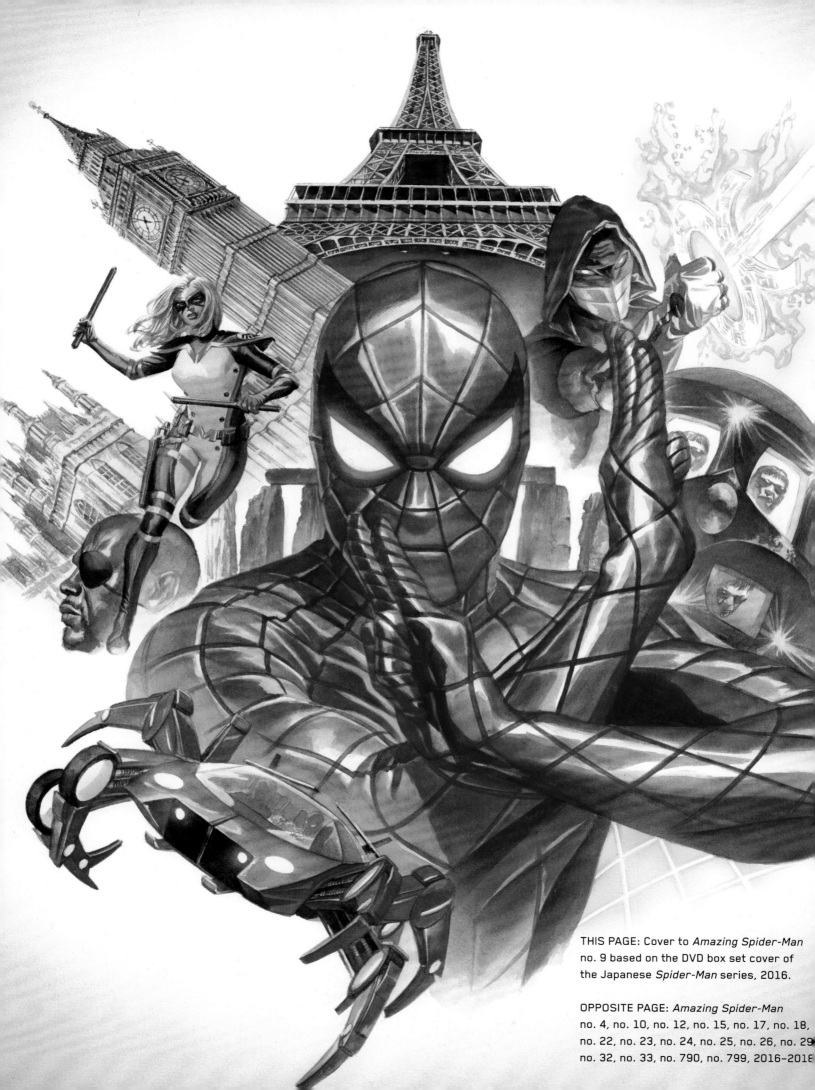

THIS PAGE: Cover to *Amazing Spider-Man* no. 9 based on the DVD box set cover of the Japanese *Spider-Man* series, 2016.

OPPOSITE PAGE: *Amazing Spider-Man* no. 4, no. 10, no. 12, no. 15, no. 17, no. 18, no. 22, no. 23, no. 24, no. 25, no. 26, no. 29, no. 32, no. 33, no. 790, no. 799, 2016–2018.

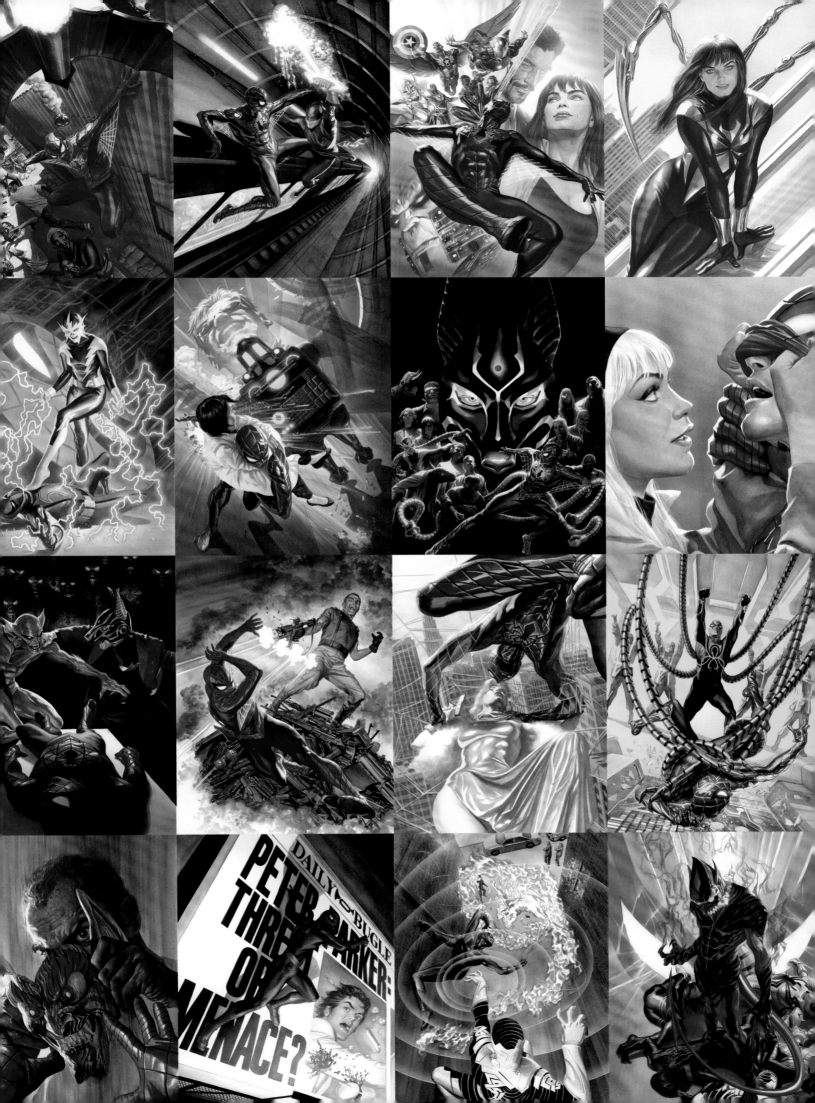

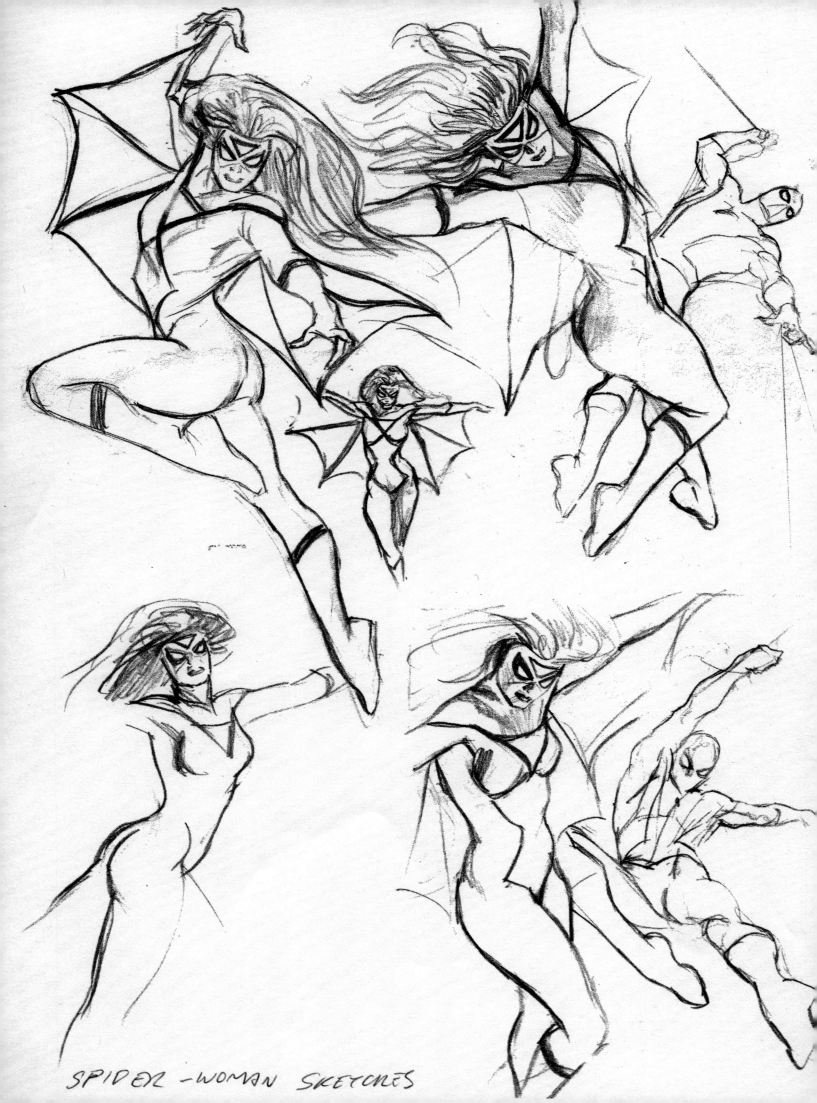

SPIDER-WOMAN SKETCHES

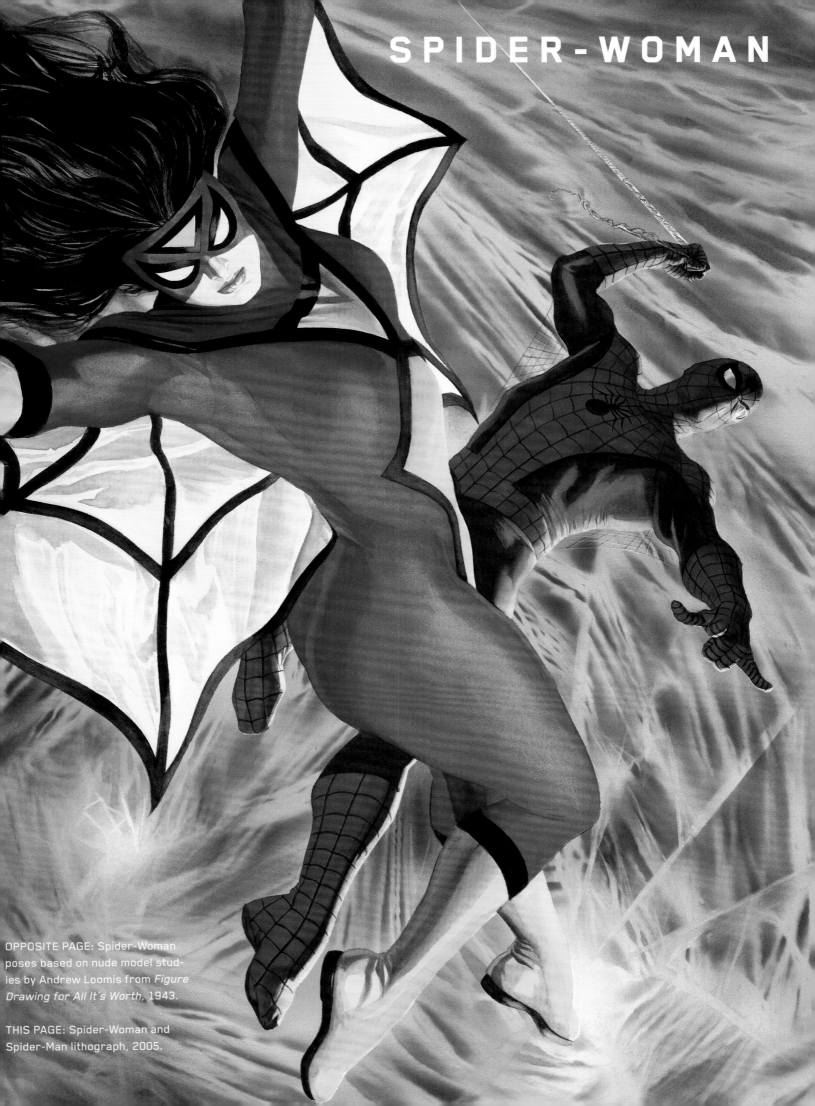

OPPOSITE PAGE: Spider-Woman
poses based on nude model stud-
ies by Andrew Loomis from *Figure
Drawing for All It's Worth*, 1943.

THIS PAGE: Spider-Woman and
Spider-Man lithograph, 2005.

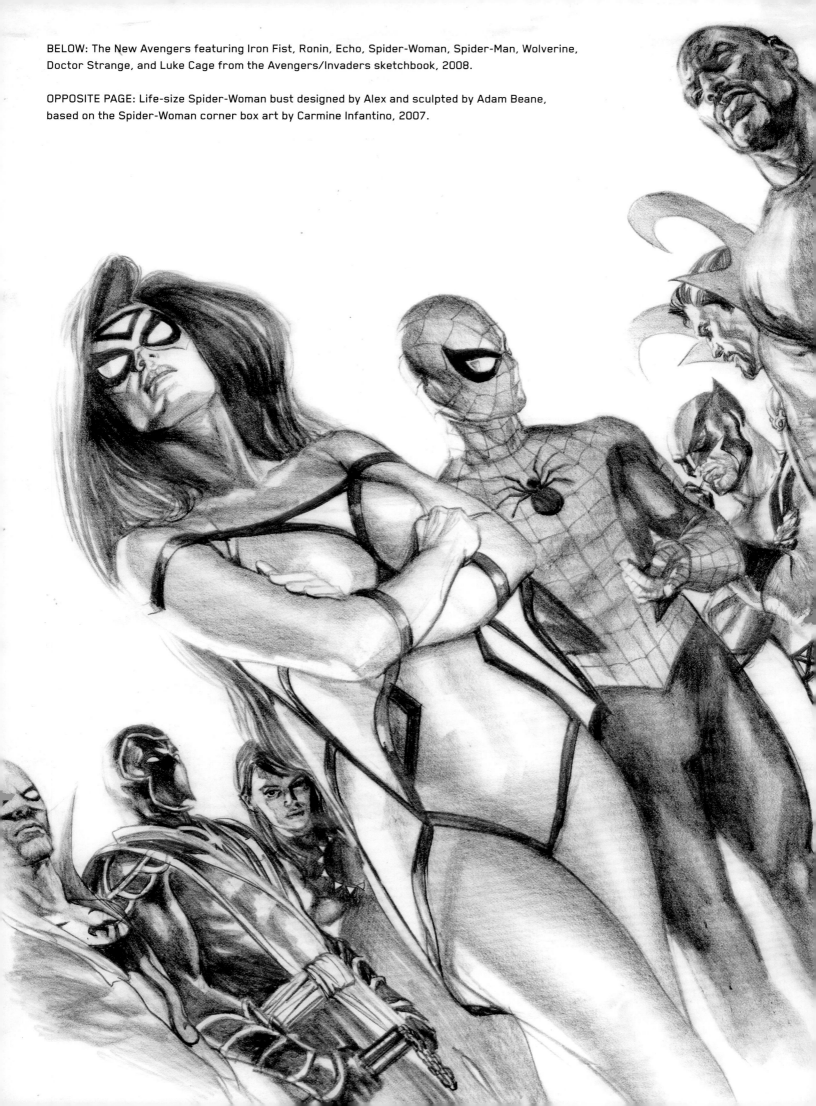

BELOW: The New Avengers featuring Iron Fist, Ronin, Echo, Spider-Woman, Spider-Man, Wolverine, Doctor Strange, and Luke Cage from the Avengers/Invaders sketchbook, 2008.

OPPOSITE PAGE: Life-size Spider-Woman bust designed by Alex and sculpted by Adam Beane, based on the Spider-Woman corner box art by Carmine Infantino, 2007.

1960s was not strong on female leads. There was the Wasp and Invisible Girl and Marvel Girl, but they were reflections of their male counterparts. Marvel had no Wonder Woman. Spider-Woman and She-Hulk were created in the 1970s simply to establish copyrights to their names, but I think the characters have gone on to tran-

literally strong women in the Marvel Universe with starring roles, including the new version of Captain Marvel. But Spider-Woman remains one of Alex's favorites to draw. "Even though I felt her costume design was largely unrelated to Spider-Man's (aside from the eyes), she was so attractive to me as a kid."

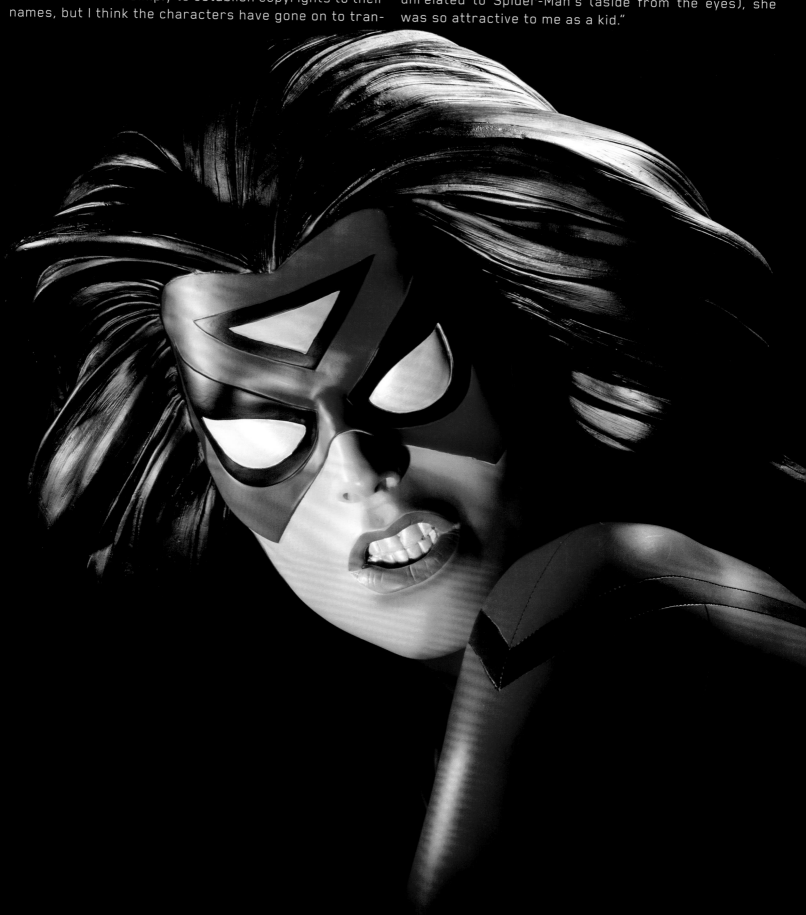

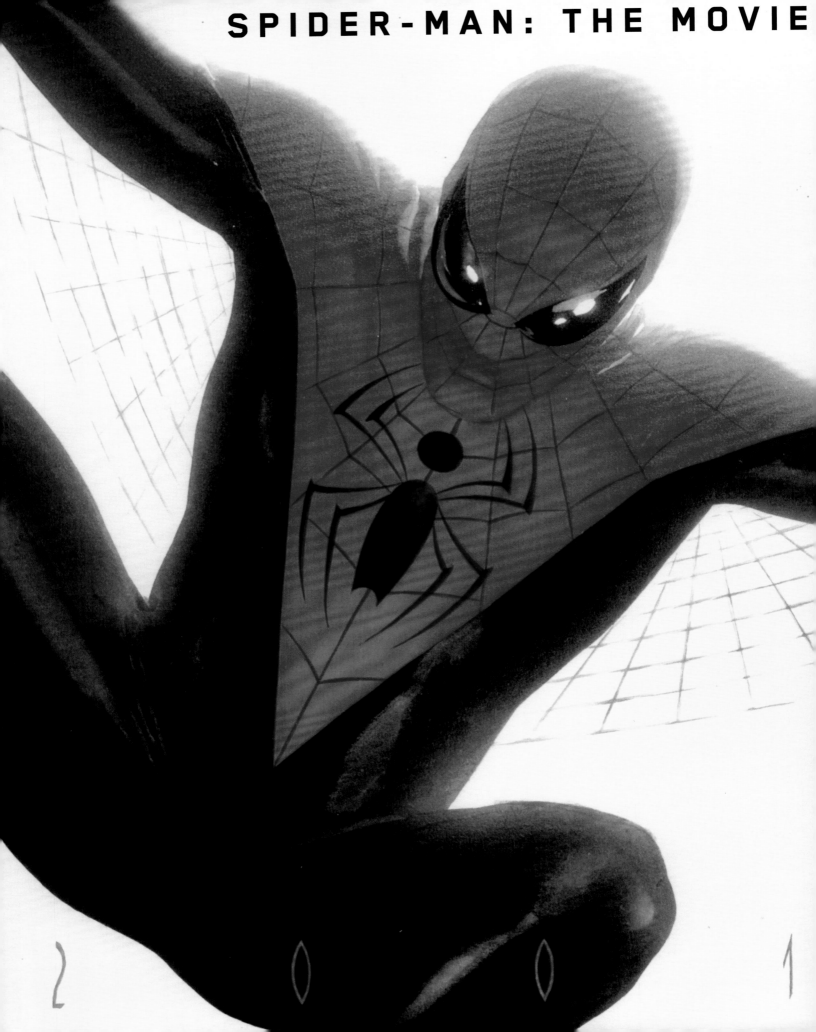

Shortly after Sony Pictures announced in 2001 that it would be producing the first big-budget Spider-Man film, Marvel reached out to Alex about contributing ideas for the costume design. He immediately thought of a concept that the artist David Williams had come up with, well before the movie was in development. Ross thought it was perfect, and with Williams' permission, he adapted the scheme in his own drawing style and submitted it. "This had so many of the elements that make the Spider-Man costume what it is," Alex explained, "walking the fine line between classic and contemporary. The pitch made it all the way up to the director (Sam Raimi), and apparently prototypes were made. But that was as far as it got."

He adds: "The final movie costume that they *did* use (with the raised rubber webbing) came from a trading card series that appeared in the mid-1990s painted by the Hildebrandt Brothers."

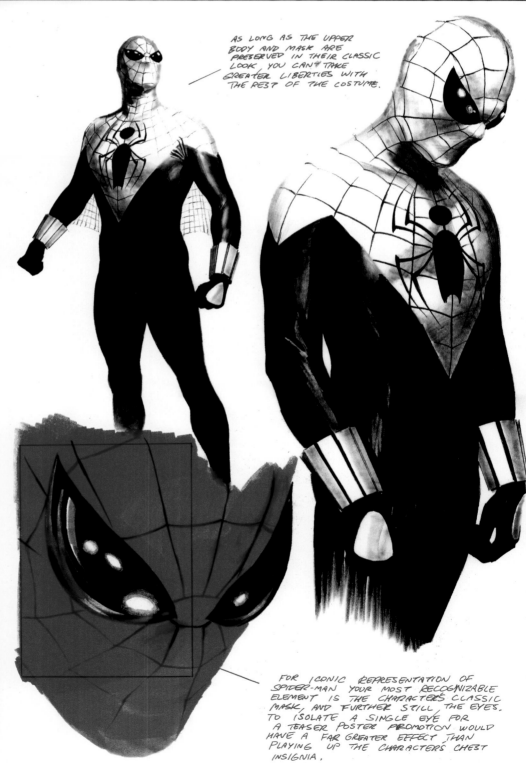

AS LONG AS THE UPPER BODY AND MASK ARE PRESERVED IN THEIR CLASSIC LOOK, YOU CAN TAKE GREATER LIBERTIES WITH THE REST OF THE COSTUME.

FOR ICONIC REPRESENTATION OF SPIDER-MAN YOUR MOST RECOGNIZABLE ELEMENT IS THE CHARACTER'S CLASSIC MASK, AND FURTHER STILL, THE EYES. TO ISOLATE A SINGLE EYE FOR A TEASER POSTER PROMOTION WOULD HAVE A FAR GREATER EFFECT THAN PLAYING UP THE CHARACTER'S CHEST INSIGNIA.

SPIDER-MAN 2: OPENING CREDITS

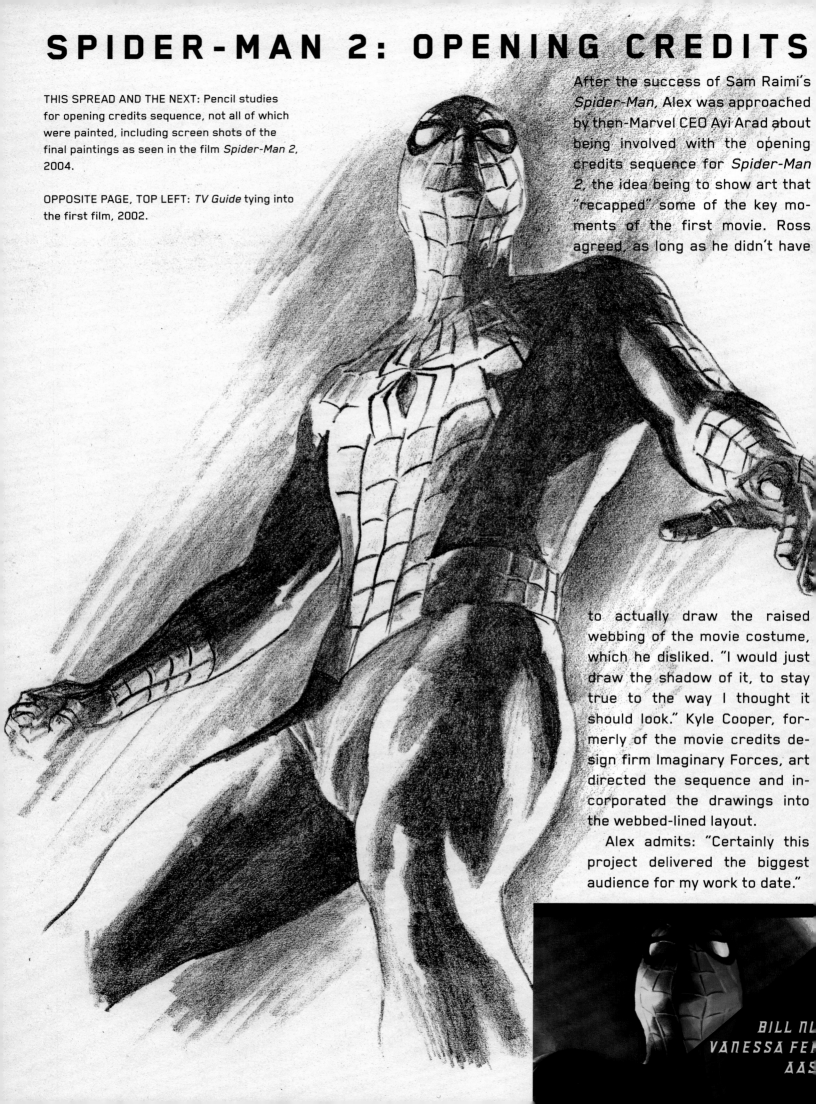

THIS SPREAD AND THE NEXT: Pencil studies for opening credits sequence, not all of which were painted, including screen shots of the final paintings as seen in the film *Spider-Man 2*, 2004.

OPPOSITE PAGE, TOP LEFT: *TV Guide* tying into the first film, 2002.

After the success of Sam Raimi's *Spider-Man*, Alex was approached by then-Marvel CEO Avi Arad about being involved with the opening credits sequence for *Spider-Man 2*, the idea being to show art that "recapped" some of the key moments of the first movie. Ross agreed, as long as he didn't have to actually draw the raised webbing of the movie costume, which he disliked. "I would just draw the shadow of it, to stay true to the way I thought it should look." Kyle Cooper, formerly of the movie credits design firm Imaginary Forces, art directed the sequence and incorporated the drawings into the webbed-lined layout.

Alex admits: "Certainly this project delivered the biggest audience for my work to date."

BILL N[
VANESSA FE[
AAS[

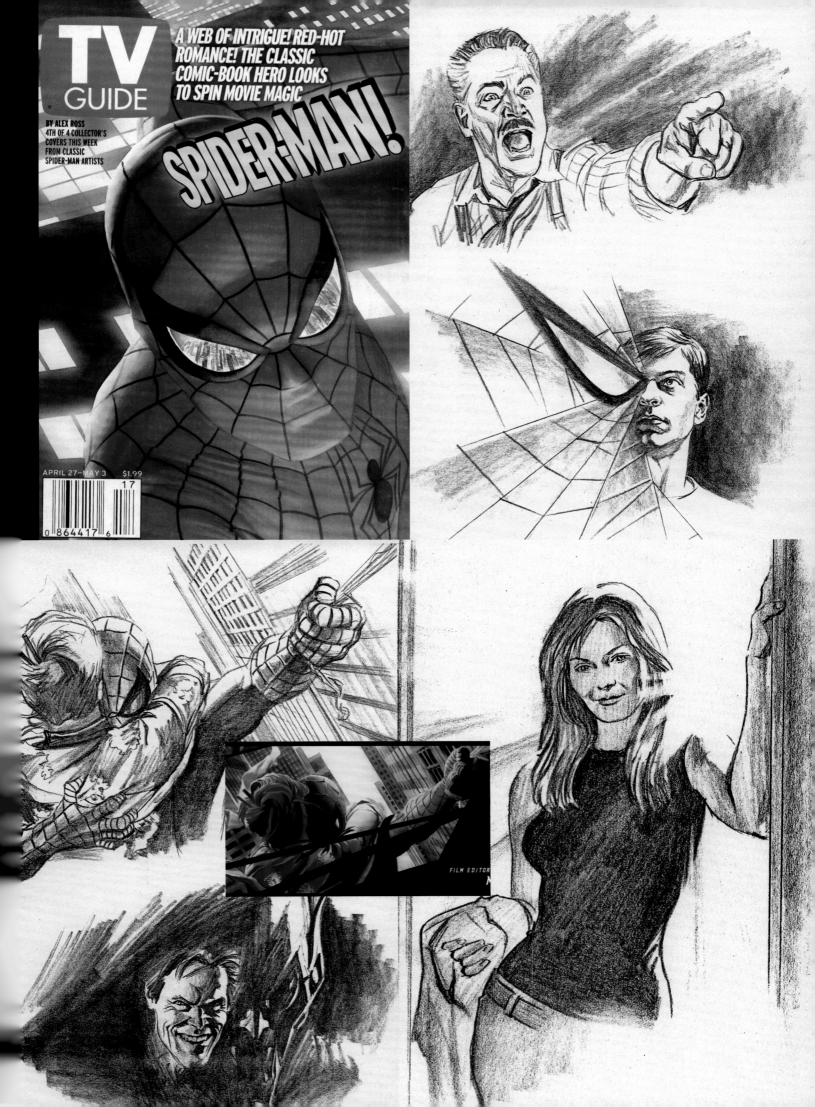

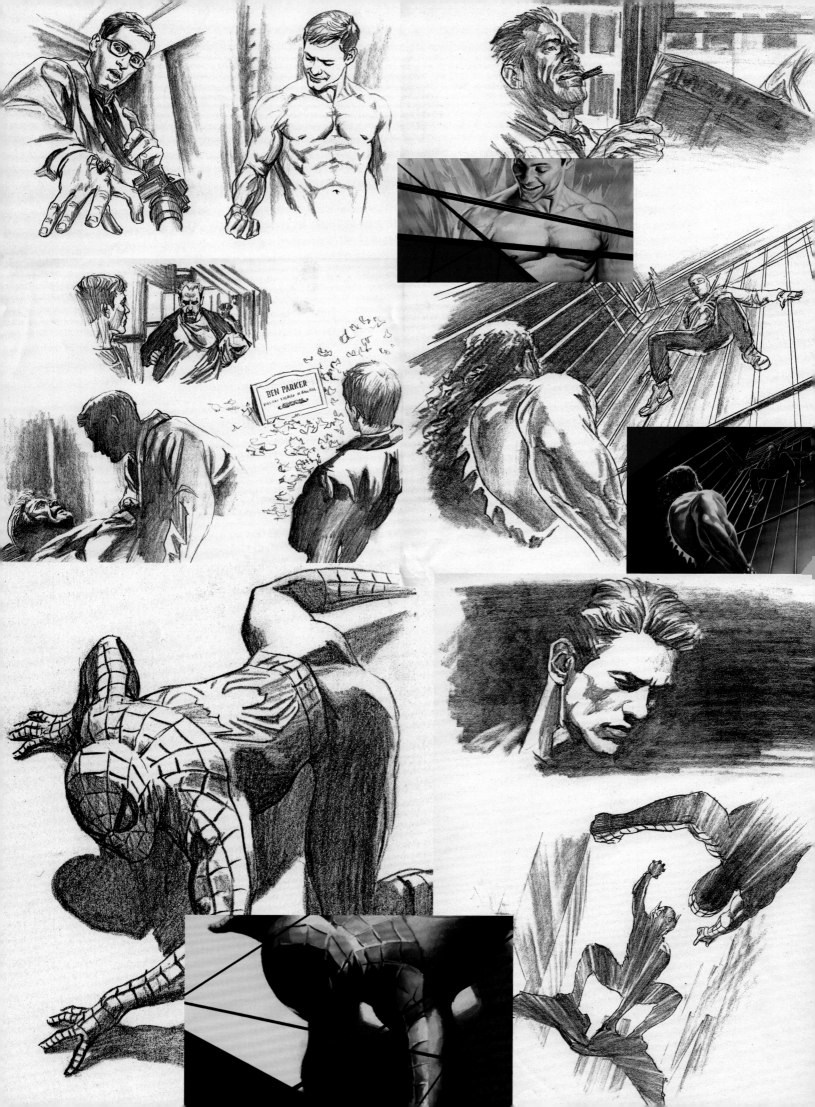

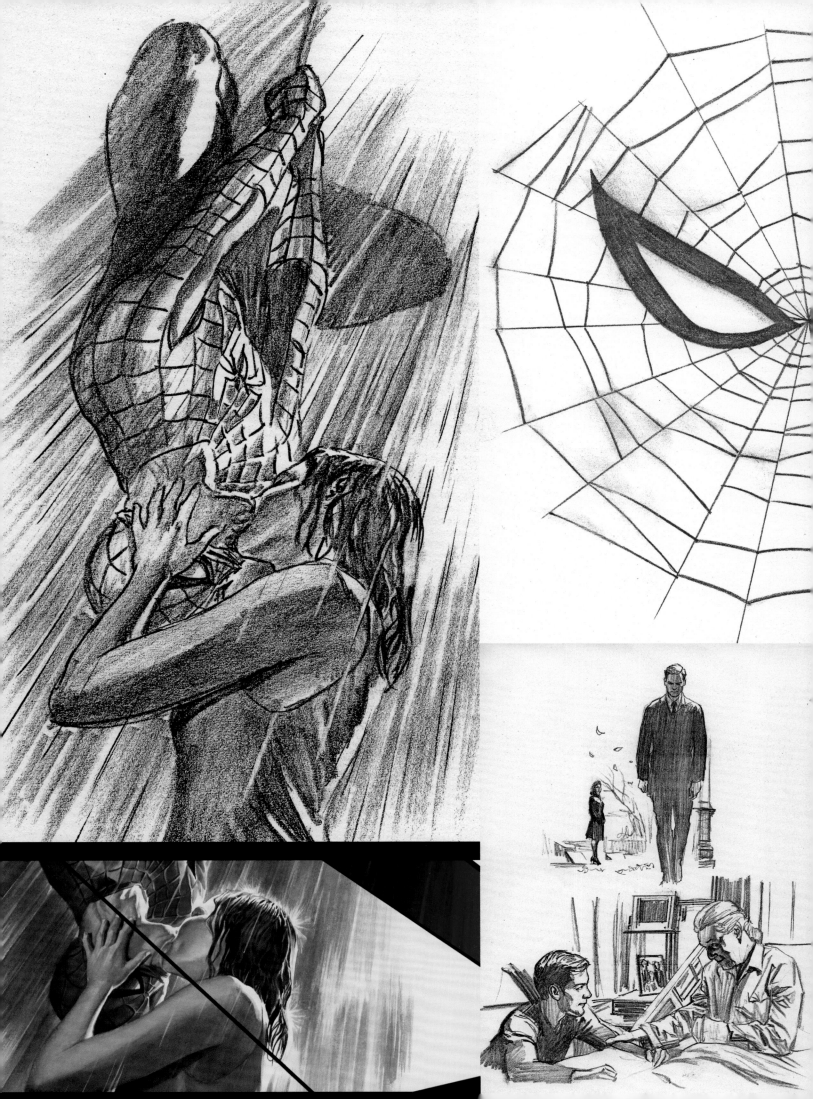

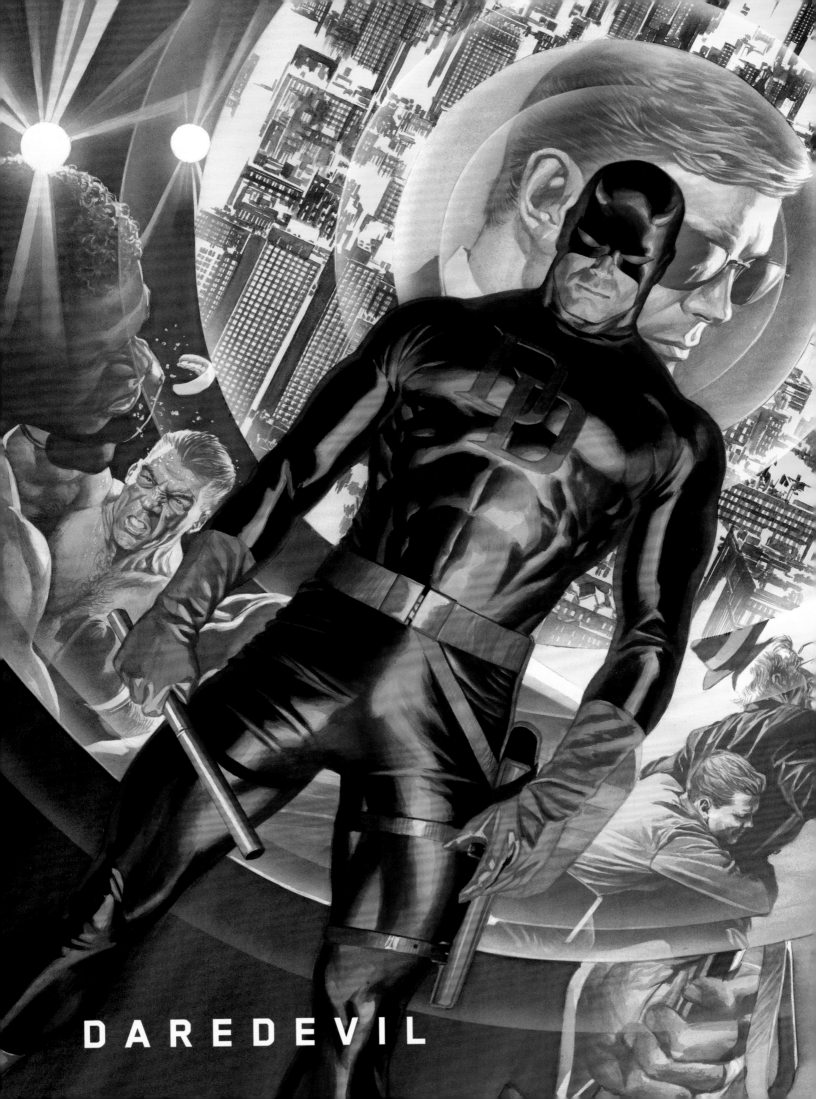

DAREDEVIL

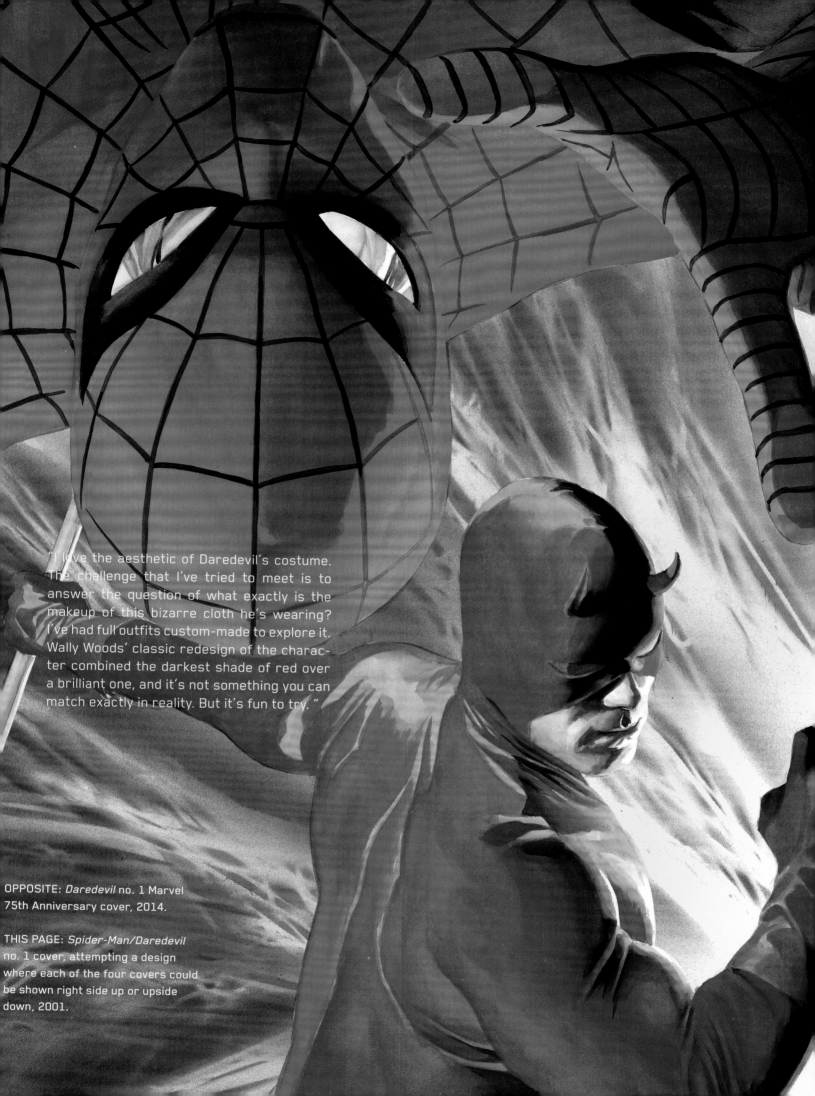

"I love the aesthetic of Daredevil's costume. The challenge that I've tried to meet is to answer the question of what exactly is the makeup of this bizarre cloth he's wearing? I've had full outfits custom-made to explore it. Wally Woods' classic redesign of the character combined the darkest shade of red over a brilliant one, and it's not something you can match exactly in reality. But it's fun to try. "

OPPOSITE: *Daredevil* no. 1 Marvel 75th Anniversary cover, 2014.

THIS PAGE: *Spider-Man/Daredevil* no. 1 cover, attempting a design where each of the four covers could be shown right side up or upside down, 2001.

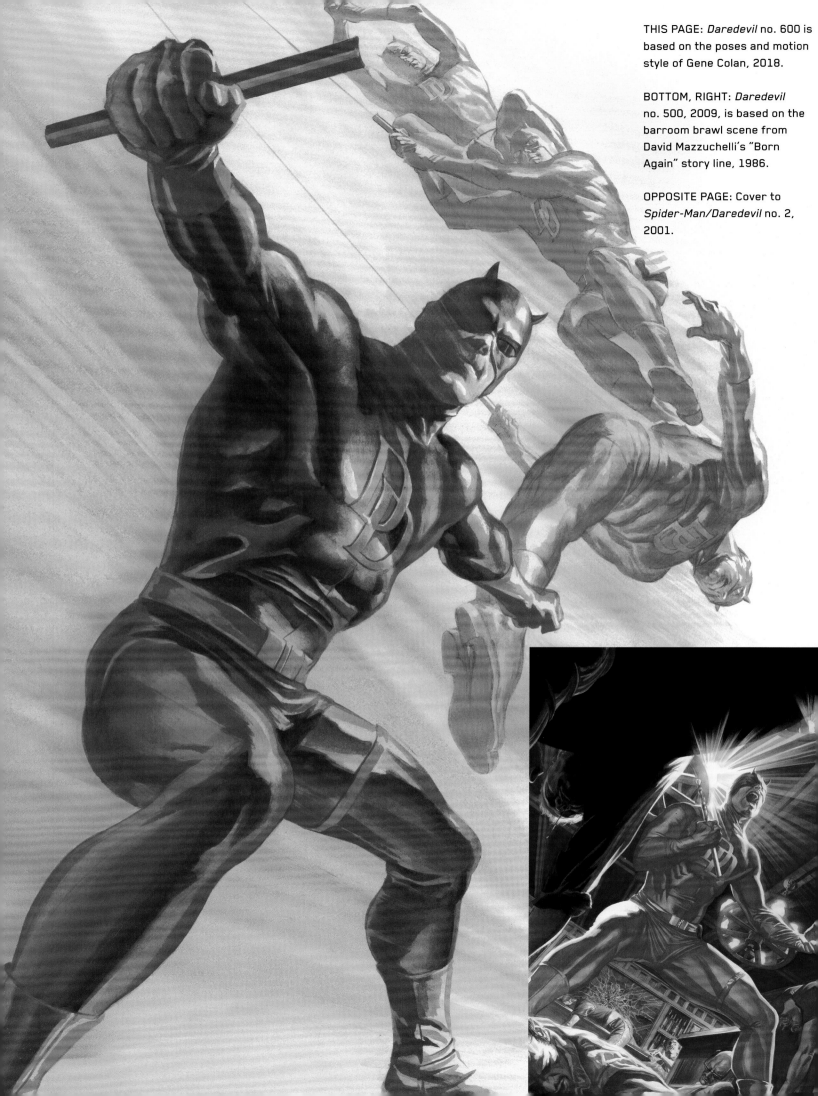

THIS PAGE: *Daredevil* no. 600 is based on the poses and motion style of Gene Colan, 2018.

BOTTOM, RIGHT: *Daredevil* no. 500, 2009, is based on the barroom brawl scene from David Mazzuchelli's "Born Again" story line, 1986.

OPPOSITE PAGE: Cover to *Spider-Man/Daredevil* no. 2, 2001.

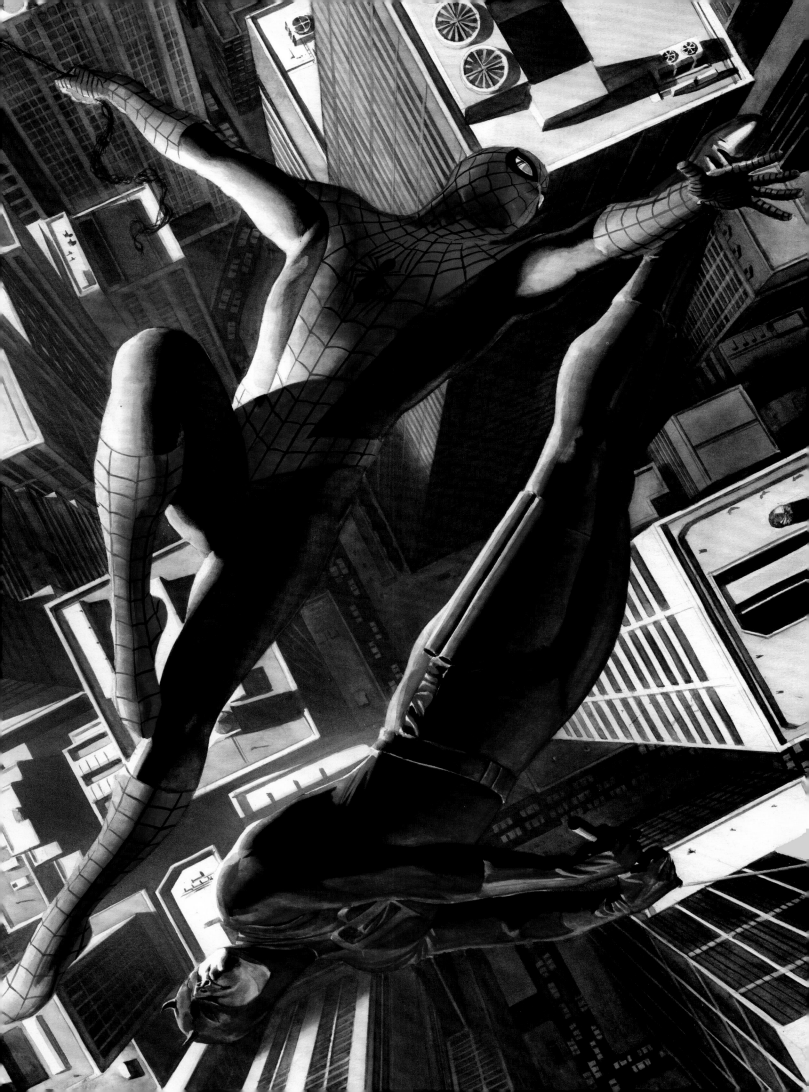

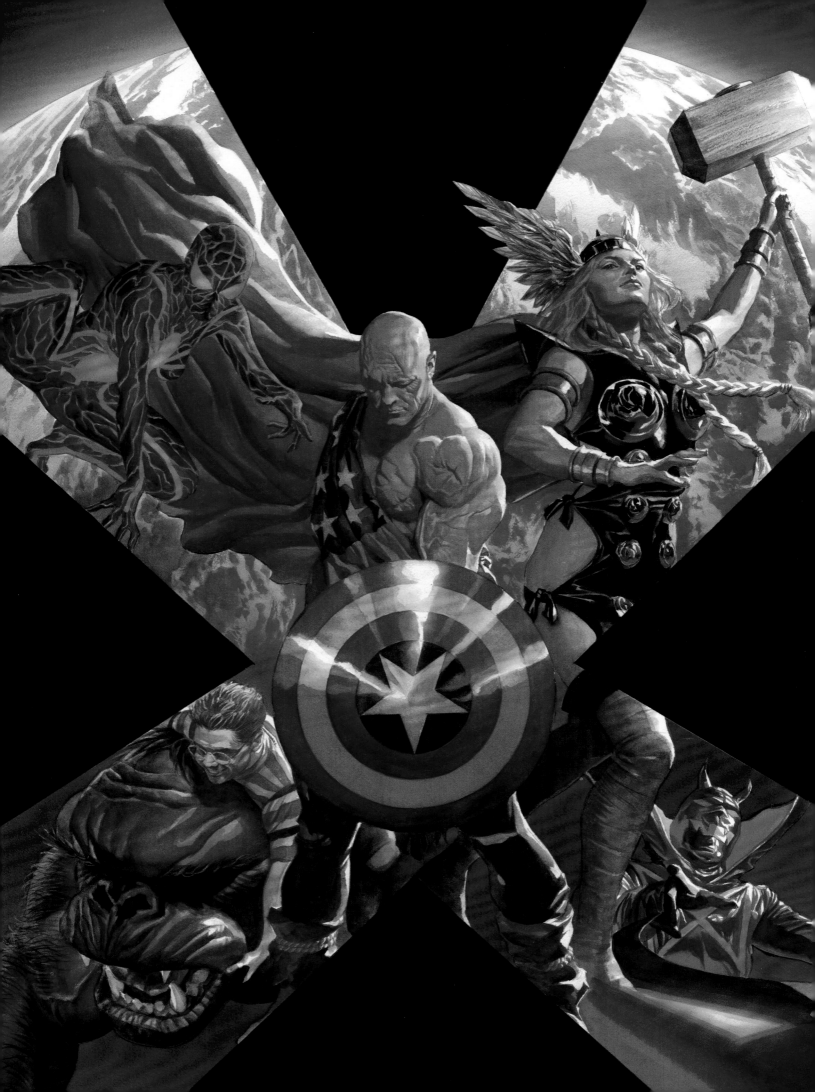

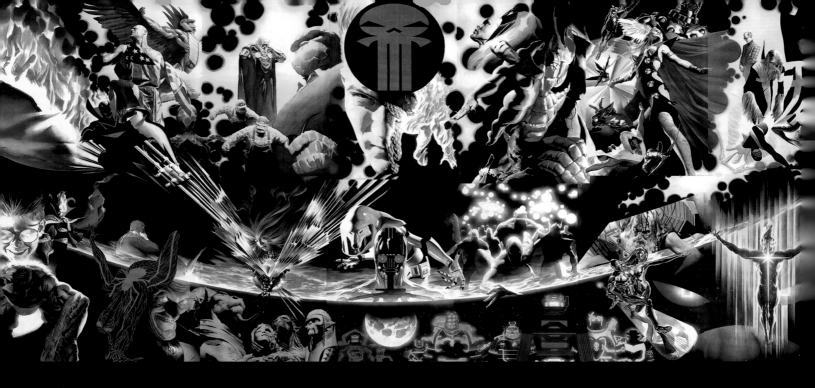

THE *EARTH X* TRILOGY

ALEX ROSS ON THE *EARTH X* TRILOGY:

t all started as a joke. I had a request from *Wizard* magazine n the mid-'90s to create a sketchbook of "Marvel versions" of my future look at DC's heroes in the then-recent *Kingdom Come* limited series. I didn't take it seriously at first, only imagining that not all superhero characters are going to age well in Spandex costumes. I pictured an overweight Spider-Man in my mind, and little else. When DC Comics editorial was then going to proceed with a *Kingdom Come* follow-up without me, I felt the urge to distract people from what DC might do by revisiting this idea. Being that *Wizard* was the most popular comics news magazine of the day, I knew that whatever did would get attention. Once I sat down with a blank sheet of paper and scribbled out my first-stab feeling toward the Marvel characters, I had the epiphany that this was now a real project.

Feeling that the future of the Marvel Universe demanded a unique point of view, I hit upon the idea of their world going a step further than the superhero preponderance of *Kingdom Come;* this time *everyone* is mutated and *everybody* has superpowers. For so many years, the *X-Men* and related books have been the best-selling comics for Marvel as well as the rest of the industry . . . and I was sick of them. Not because they weren't done well, but because I felt that the concept of how the "born super" were relatable due to the universal issues of prejudice and alienation (for which they were metaphors) had begun to wear thin for me over time. Making the world full of nothing but mutants blows the concept up, deflating the X-Men a bit, but thus creating Earth X.

In a future where the superhuman is all there is, the old original superheroes are revealed in a different light. There is no need for secret identities, the world is far more chaotic, and the sense of what you fight for is in question. This idea is what we built all of the individual character takes upon. The simple idea of getting older was applied to a few key characters, like Captain America's stripped-down, battle-scarred, literally flag-draped-self, and Spider-Man's retired, out-of-shape, dispirited characterization. There was far more changeover of generation with new characters like the exhibition stuntman Daredevil or Spider-Man's grown daughter, Venom. Most of the classic Marvel characters were dead and gone in this story.

Ultimately the plan for how this story came together in its structure was added by my friend and collaborator Jim Krueger. Jim was a talented writer whom I had known for some time and enjoyed talking ideas over with. I threw my basic X-world premise at him with the challenge of answering the big story question of WHY. Jim came back with an answer that thoroughly inspired me. As it's been twenty years since our work came out, I'm going to go ahead and tell it here. Without relating all of how Jim's idea interwove the Inhumans, mutants, or the giant Celestials, it revealed that all of superhumanity and superheroes had one common origin. They were all products of DNA planted in the human species during prehistoric times, leading to an "enhanced" humanity later. The purpose of this was to supercharge our life-forms to contain a better protective immune system for the Earth while it housed and gestated an immense, implanted alien life-form at its core. The planet got knocked up by aliens, and they remade mankind into powerful white blood cells to

OPPOSITE PAGE: *Earth X Trilogy Omnibus: Alpha* hardcover painting, 2018.

THIS PAGE: All 14 covers of the *Earth X* series assembled in two tiers to create one monster image inspired by the covers to the

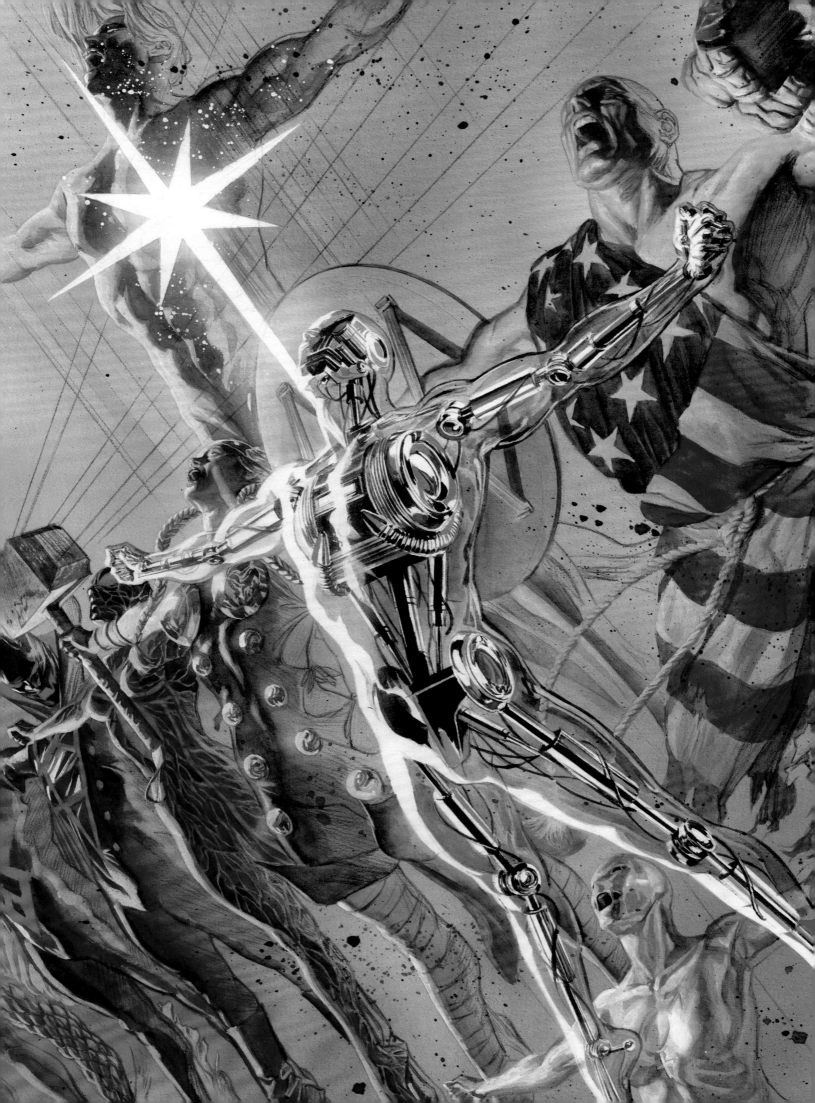

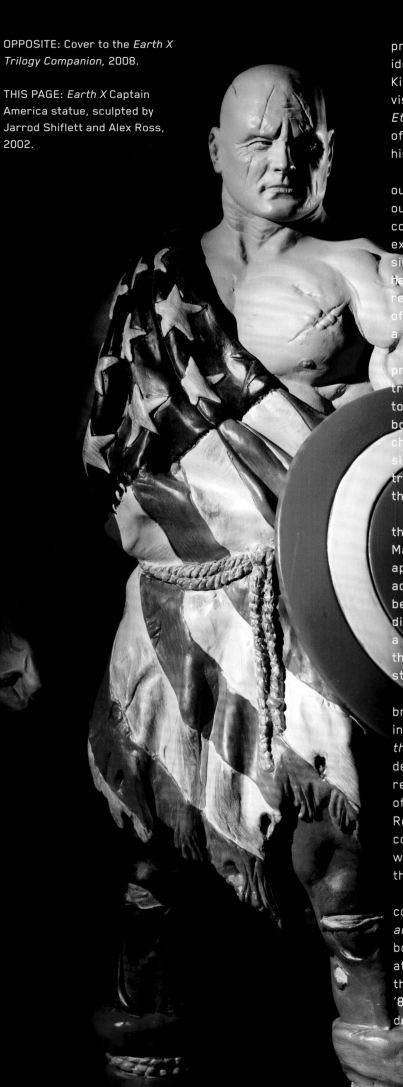

protect Mother Earth from outside infection. Best of all, the idea had some legitimacy, because we got most of it from Jack Kirby. Kirby had tinkered with Early Man history, ancient alien visitation, and genetic engineering in his late '70s series *The Eternals*. Connecting that work with his earlier establishing of the mutant genes in X-Men and countless other corners of his creativity at Marvel made this project come alive for us.

Realistically, if you read our *Earth X* series, it mainly follows our earthbound heroes and their conflicts that orbit around our larger concept. It felt audacious to define an entire interconnected fictional universe by one unifying science-fictional explanation. I understand that it wouldn't be everyone's desire to accept this answer for each individual story they may have always seen as more disconnected. We thought we were real clever, of course. So clever were we that we thought of extending the possibilities of our one series into three—a trilogy.

I should mention of course that given the length of the project as a 12-issue series bracketed by two 48-page introductory no. 0 and closing no. X issues, I couldn't commit to doing the interior art chores myself. My passion for the book would be maintained within the pencil designs for each character and painted covers for what would be more than sixty separate comics and collections through the extended trilogy. Given the overall project's full length, it proves to be the longest single work I was part of.

One key thing that prompted our greater ambitions with the series' reach was how we would delve into each major Marvel hero and villain's history. In fact, each future design approach was meant to answer questions we saw with a character's essential drama coming full circle. Often they were being returned later in life to where they came from. Even the dispirited Peter Parker evolves within our series to become a policeman (albeit a well-known, spider-powered one), like the one he shirked responsibility from when his career first started.

Having too many ideas for one already overly long series brings up the question: Why didn't we just make it an ongoing book? As Jim and I imagined this as our very own *Lord of the Rings* trilogy, the separating of themes came from our desire to see each have a spotlight. Both of us drew from our respective religious backgrounds; we sought to adapt themes of biblical weight. For myself, I was building on the book of Revelation's metaphor of *Kingdom Come* by having *Earth X* contain an end-of-the-world theme. Because we couldn't fully work in Marvel's Captain Mar-Vell in our first tale, that guided the *Universe X* series to a bit of a "second coming" metaphor.

The final payoff from Revelation that we could conceive connecting to was "The War in Heaven," which informed *Paradise X*. Aside from these grandiose intentions, the three books would correspond character focus to creative eras at Marvel, first with *Earth X* primarily using the '60s heroes, then *Universe X* the '70s heroes, and finally *Paradise X* the '80s heroes. We started all this in the '90s and didn't hold that decade with quite the same reverence as those of our youth.

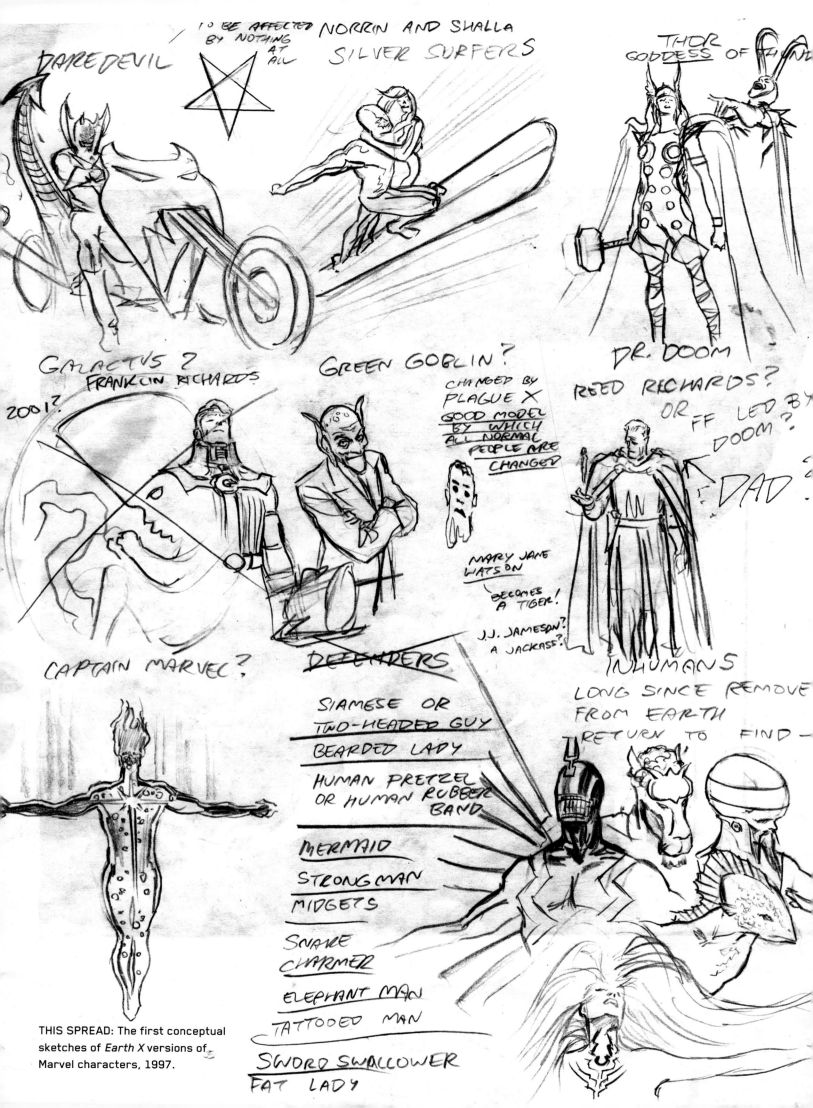

THIS SPREAD: The first conceptual sketches of *Earth X* versions of Marvel characters, 1997.

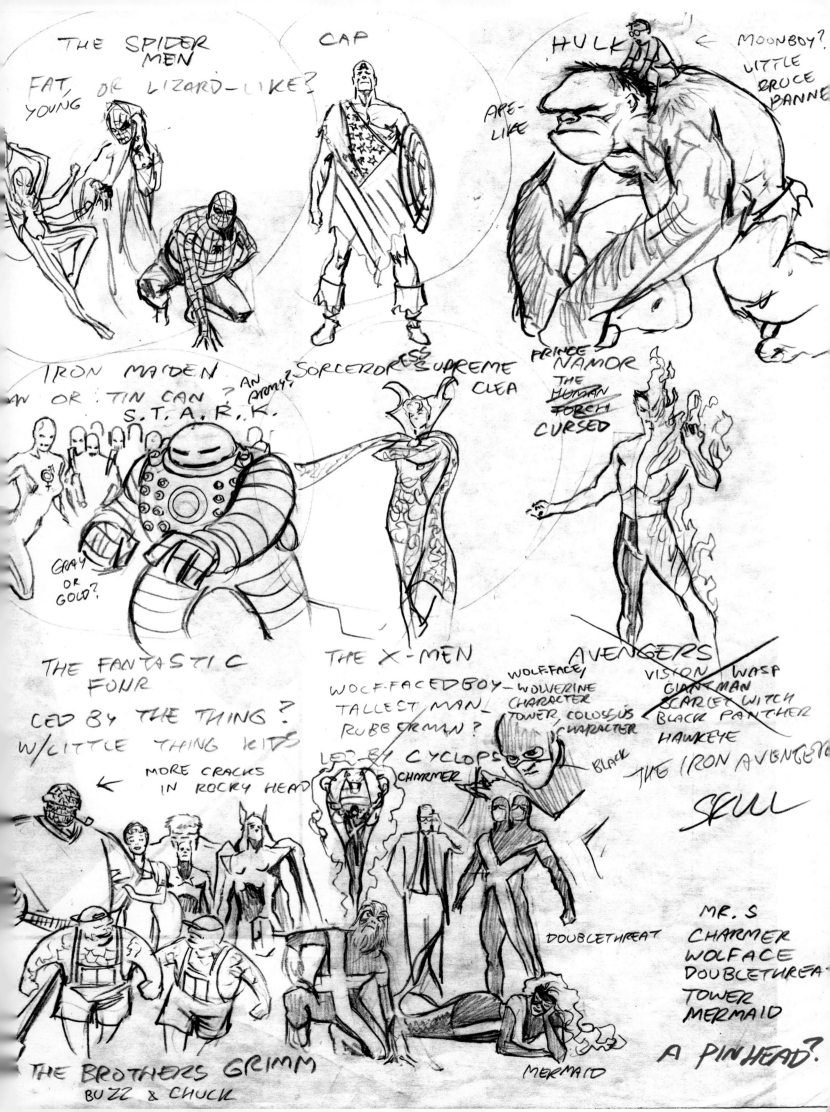

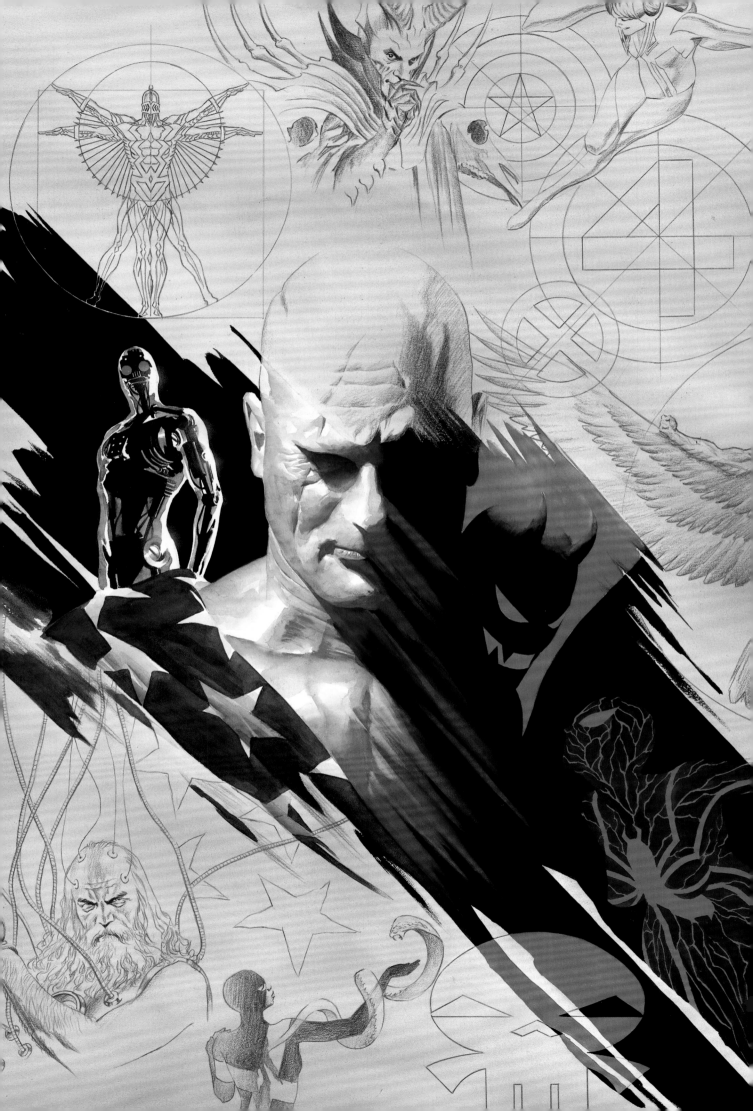

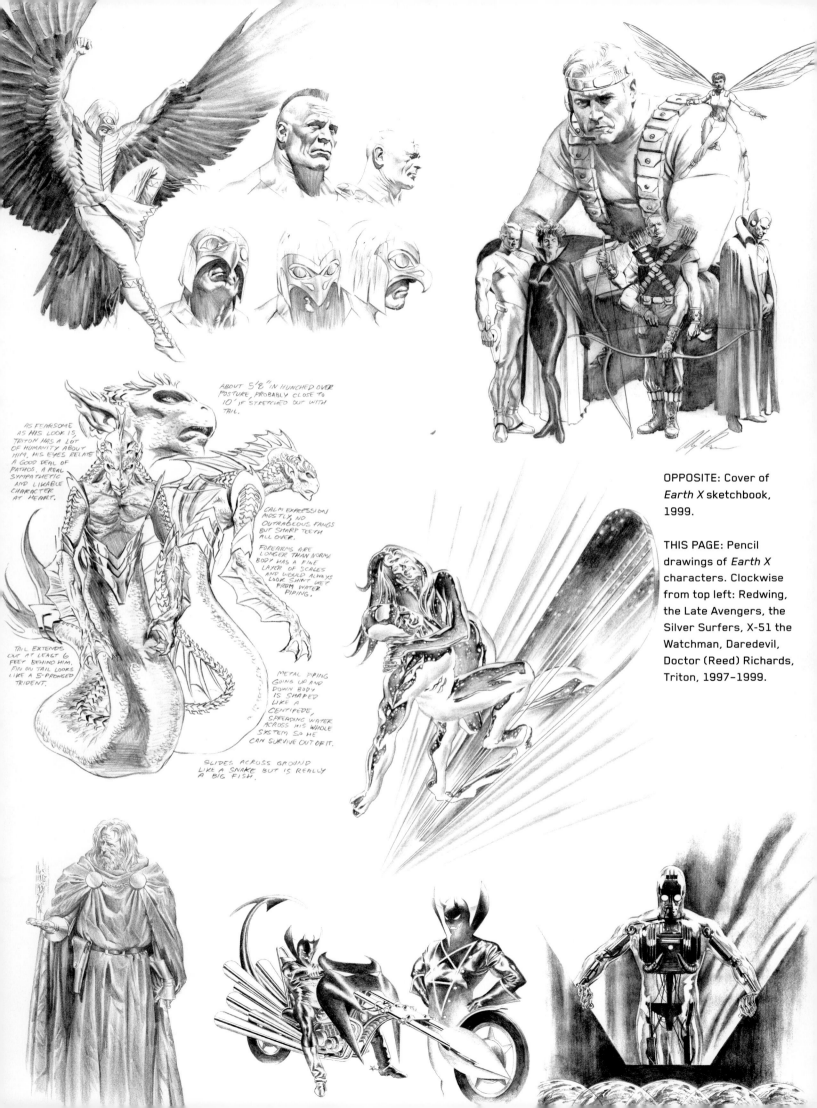

ABOUT 5'8" IN HUNCHED OVER POSTURE, PROBABLY CLOSE TO 10' IF STRETCHED OUT WITH TAIL.

AS FEARSOME AS HIS LOOK IS, TRITON HAS A LOT OF HUMANITY ABOUT HIM. HIS EYES RELATE A GOOD DEAL OF PATHOS. A REAL SYMPATHETIC AND LIKABLE CHARACTER AT HEART.

CALM EXPRESSION MOSTLY, NO OUTRAGEOUS FANGS BUT SHARP TEETH ALL OVER.

FOREARMS ARE LONGER THAN NORMAL BODY HAS A FINE LAYER OF SCALES AND WOULD ALWAYS LOOK SHINY WET FROM WATER PIPING.

TAIL EXTENDS OUT AT LEAST 6 FEET BEHIND HIM. FIN ON TAIL LOOKS LIKE A 5-PRONGED TRIDENT.

METAL PIPING GOING UP AND DOWN BODY IS SHAPED LIKE A CENTIPEDE, SPREADING WATER ACROSS HIS WHOLE SYSTEM SO HE CAN SURVIVE OUT OF IT.

SLIDES ACROSS GROUND LIKE A SNAKE BUT IS REALLY A BIG FISH.

OPPOSITE: Cover of *Earth X* sketchbook, 1999.

THIS PAGE: Pencil drawings of *Earth X* characters. Clockwise from top left: Redwing, the Late Avengers, the Silver Surfers, X-51 the Watchman, Daredevil, Doctor (Reed) Richards, Triton, 1997–1999.

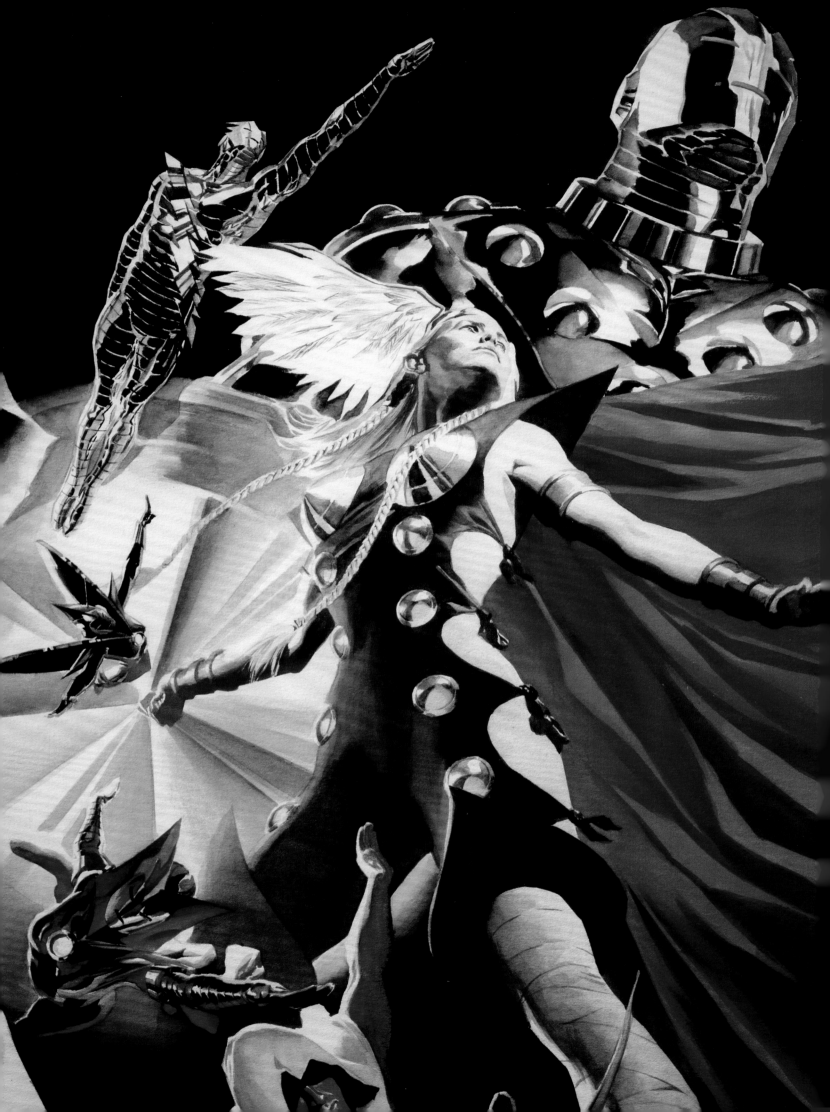

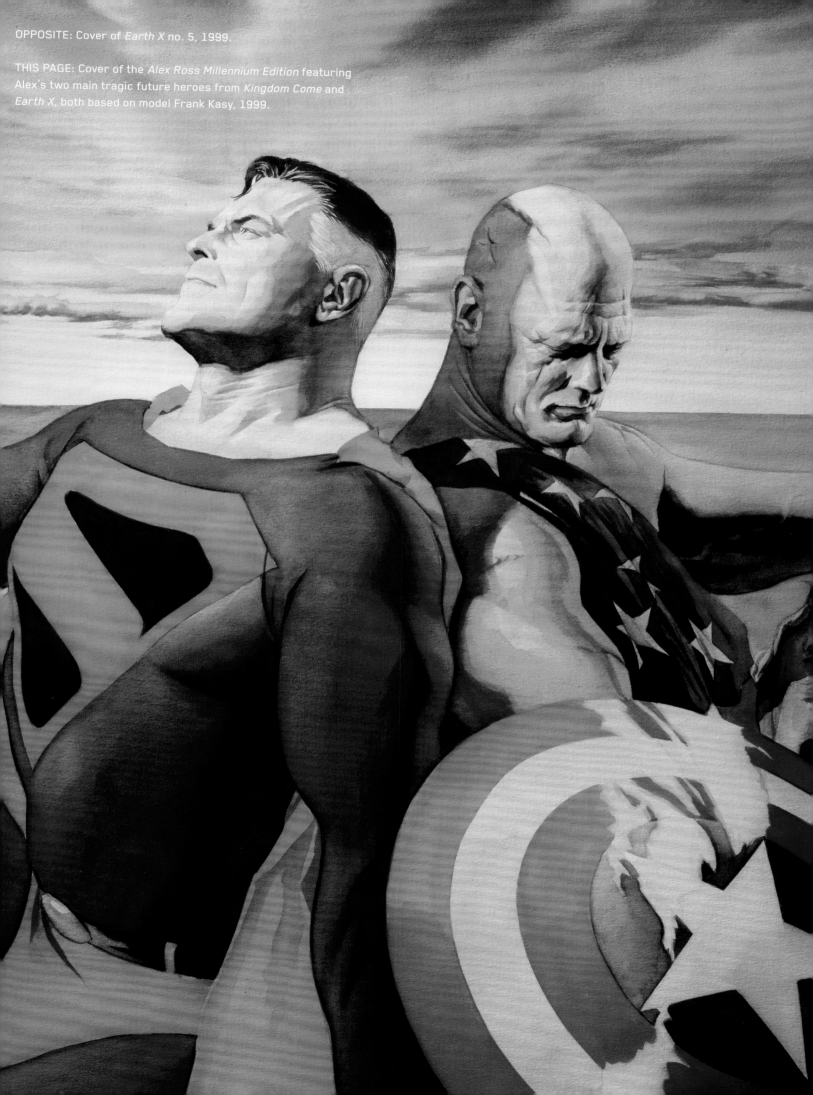

OPPOSITE: Cover of *Earth X* no. 5, 1999.

THIS PAGE: Cover of the *Alex Ross Millennium Edition* featuring
Alex's two main tragic future heroes from *Kingdom Come* and
Earth X, both based on model Frank Kasy, 1999.

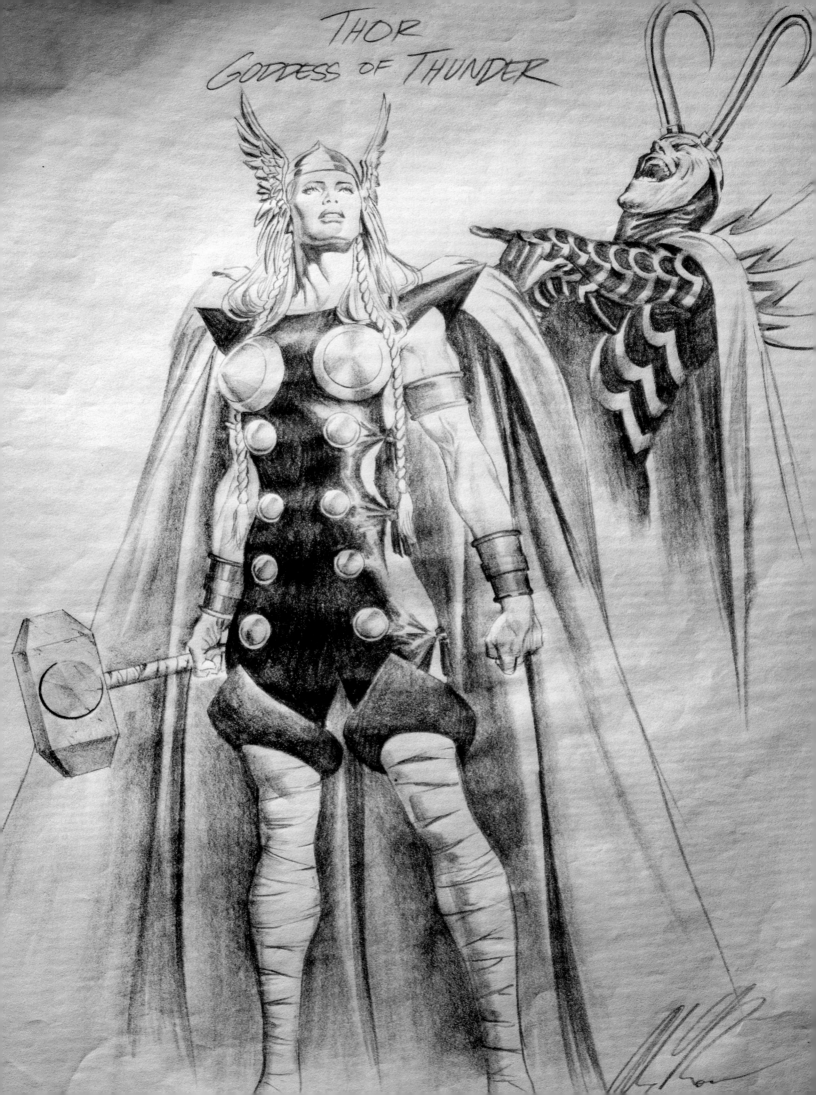

THOR
GODDESS OF THUNDER

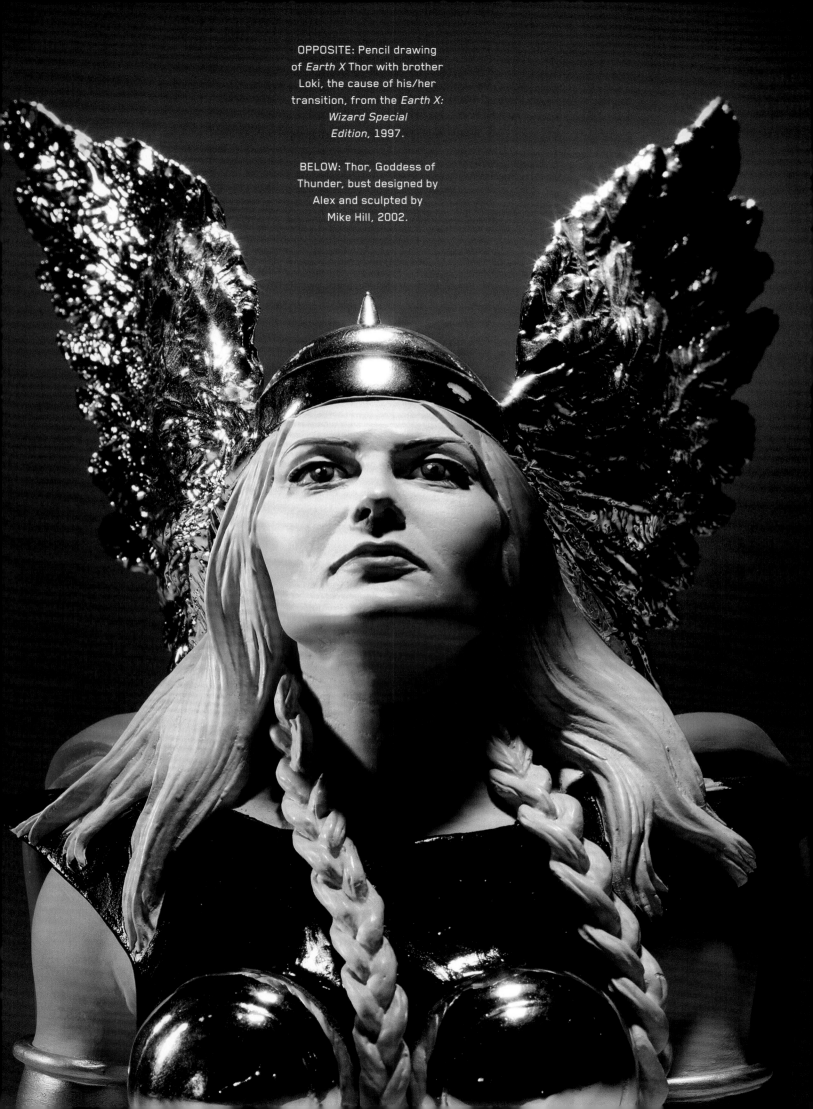

OPPOSITE: Pencil drawing of *Earth X* Thor with brother Loki, the cause of his/her transition, from the *Earth X: Wizard Special Edition*, 1997.

BELOW: Thor, Goddess of Thunder, bust designed by Alex and sculpted by Mike Hill, 2002.

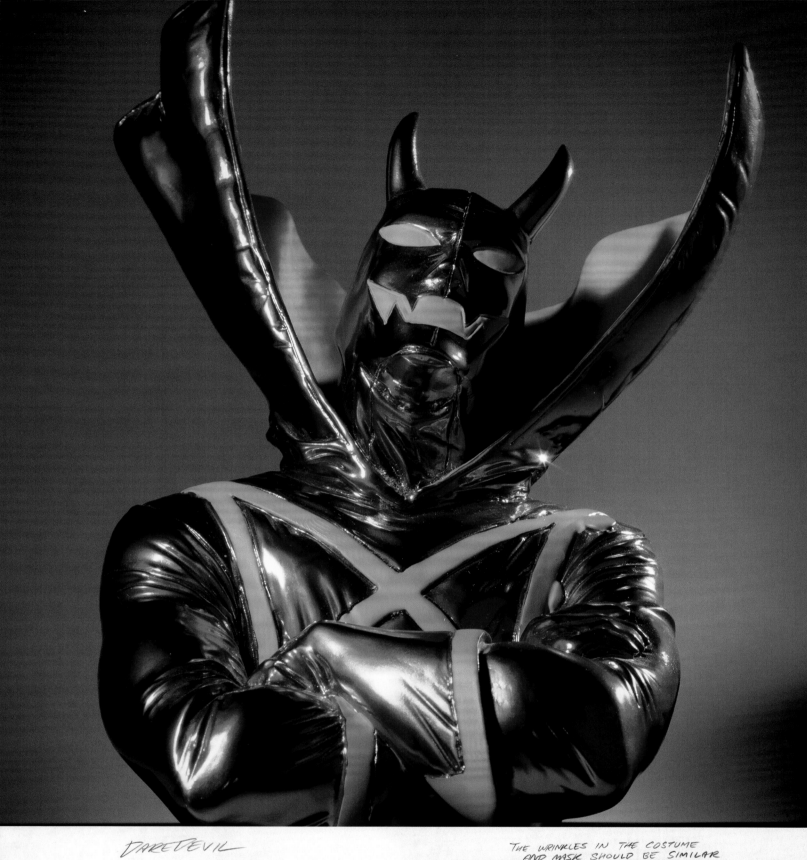

DAREDEVIL

THE WRINKLES IN THE COSTUME
AND MASK SHOULD BE SIMILAR
TO THE PHOTO REFERENCE.

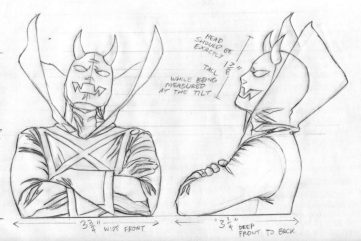

HEIGHT
OF
SCULPT
TO THE
TOP OF
HIS HEAD
IS 4 1/2"
TALL

HEAD
SHOULD BE
EXACTLY 1 7/8"
TALL
WHILE BEING
MEASURED
AT THE TILT

3 3/4" WIDE FRONT

3 1/4" DEEP
FRONT TO BACK

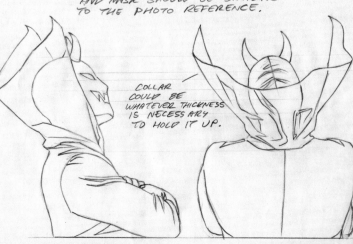

COLLAR
COULD BE
WHATEVER THICKNESS
IS NECESSARY
TO HOLD IT UP.

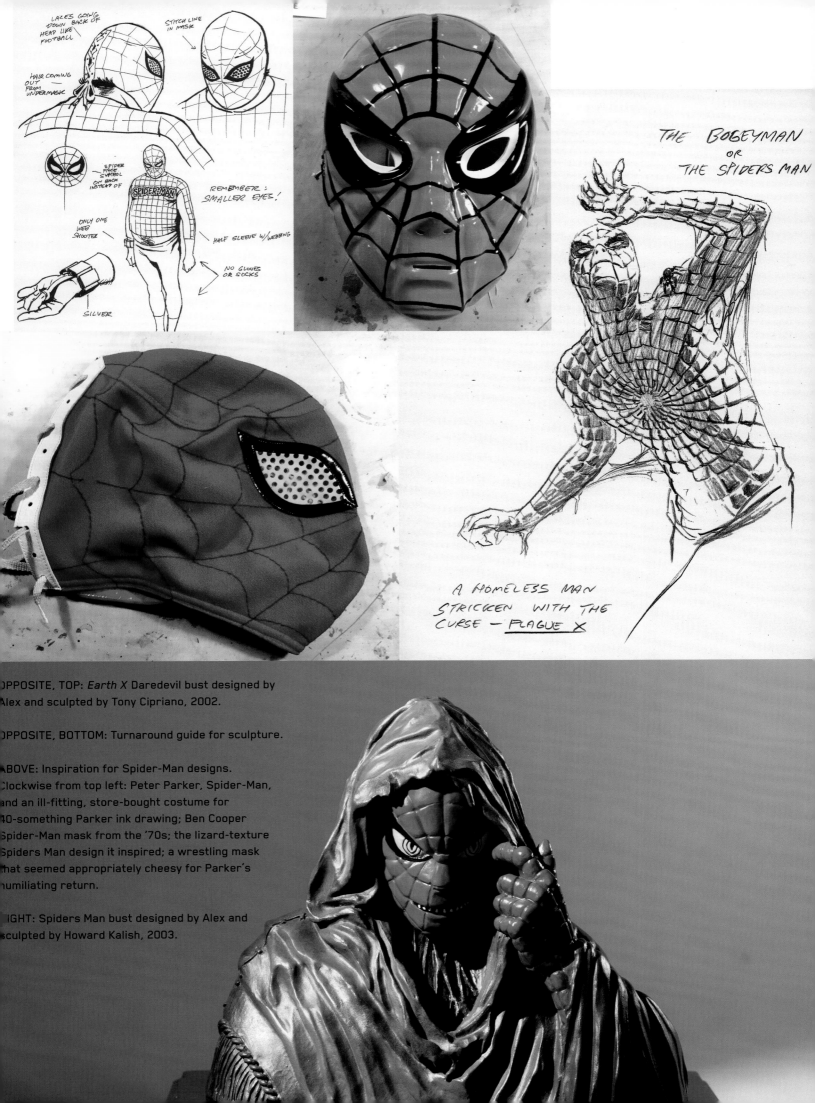

LACES GOING DOWN BACK OF HEAD LIKE FOOTBALL

STITCH LINE IN MASK

HAIR COMING OUT FROM UNDERMASK

SPIDER FACE SYMBOL ON BACK INSTEAD OF

REMEMBER: SMALLER EYES!

ONLY ONE WEB SHOOTER

SPIDER-MAN

HALF SLEEVE W/WEBBING

NO GLOVES OR SOCKS

SILVER

THE BOGEYMAN OR THE SPIDERS MAN

A HOMELESS MAN STRICKEN WITH THE CURSE — PLAGUE X

OPPOSITE, TOP: *Earth X* Daredevil bust designed by Alex and sculpted by Tony Cipriano, 2002.

OPPOSITE, BOTTOM: Turnaround guide for sculpture.

ABOVE: Inspiration for Spider-Man designs. Clockwise from top left: Peter Parker, Spider-Man, and an ill-fitting, store-bought costume for 40-something Parker ink drawing; Ben Cooper Spider-Man mask from the '70s; the lizard-texture Spiders Man design it inspired; a wrestling mask that seemed appropriately cheesy for Parker's humiliating return.

RIGHT: Spiders Man bust designed by Alex and sculpted by Howard Kalish, 2003.

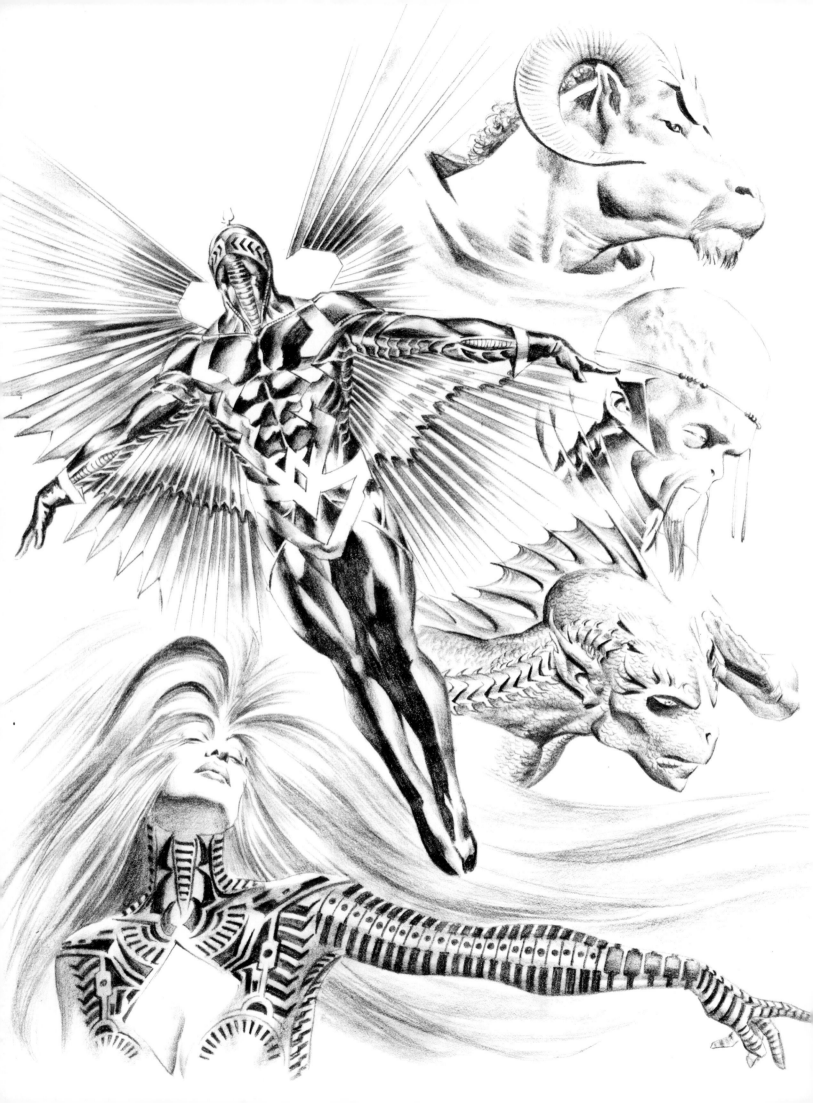

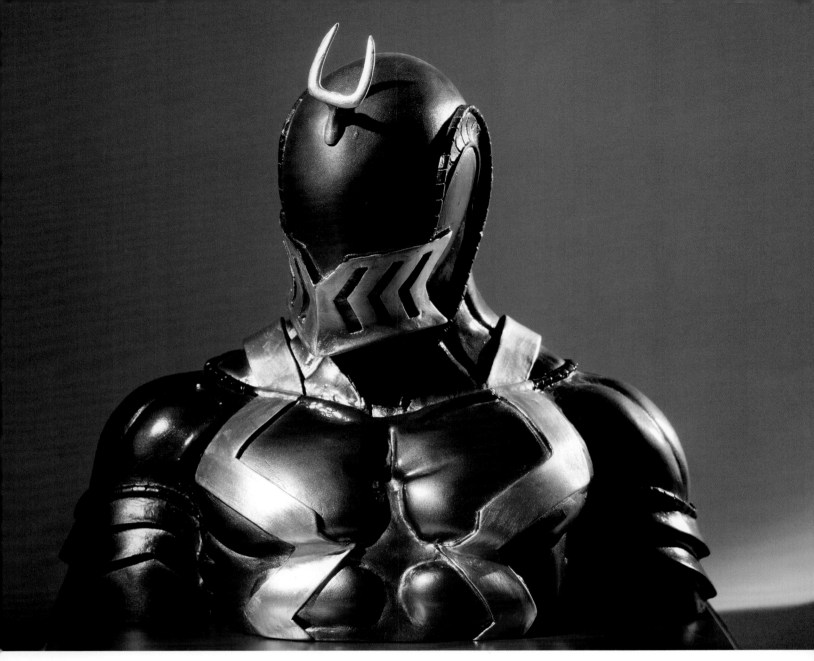

OPPOSITE: *Earth X* further
evolved the Inhumans to be more
so; pencil drawing from the
Earth X: Wizard Special Edition,
1997.

ABOVE: *Earth X* Black Bolt bust
designed by Alex and sculpted
by Howard Kalish, 2001.

RIGHT: Ink drawing guide
of Black Bolt showing the
inspiration from artist H. R.
Giger's *Alien* film design, 1999.

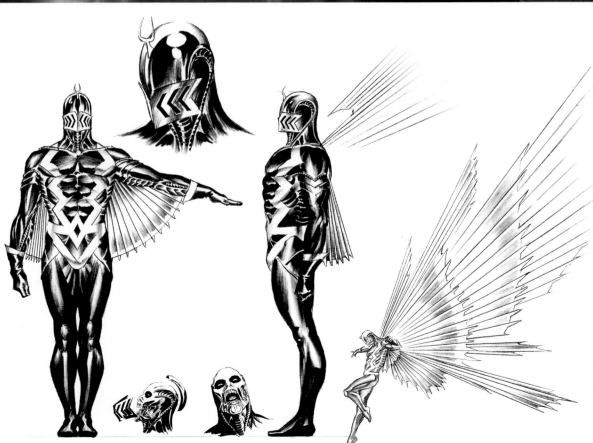

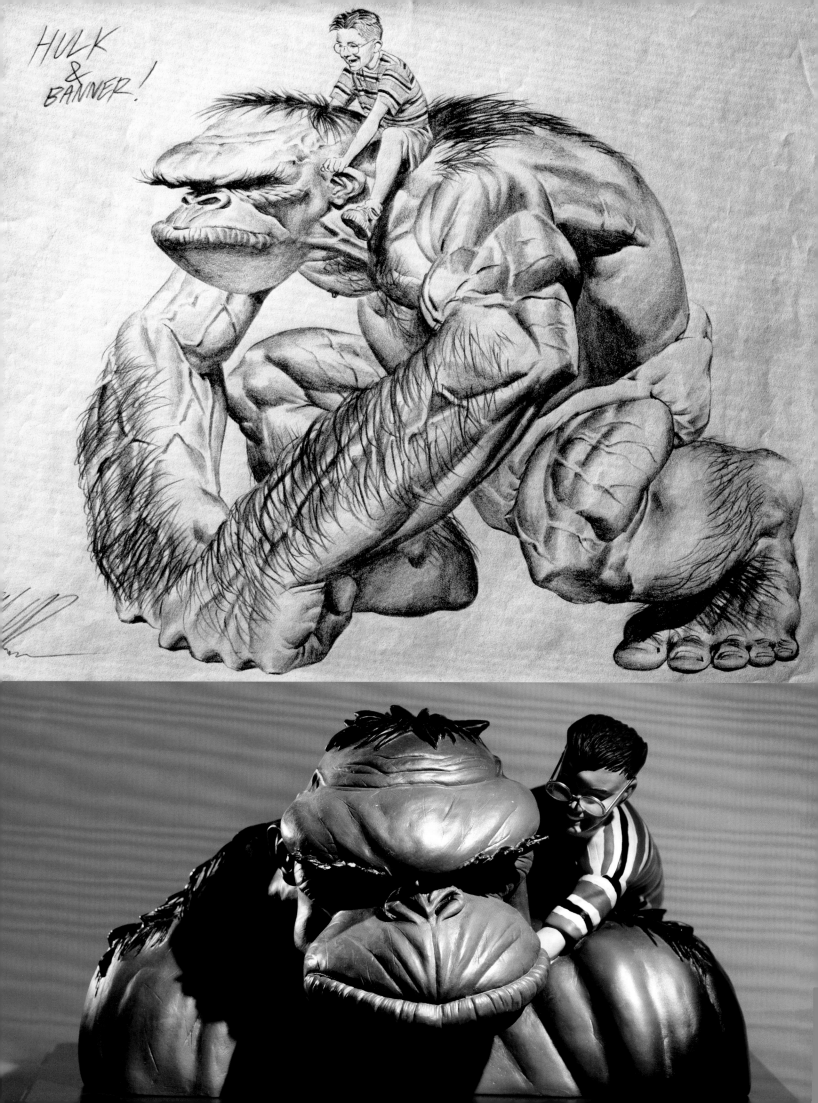

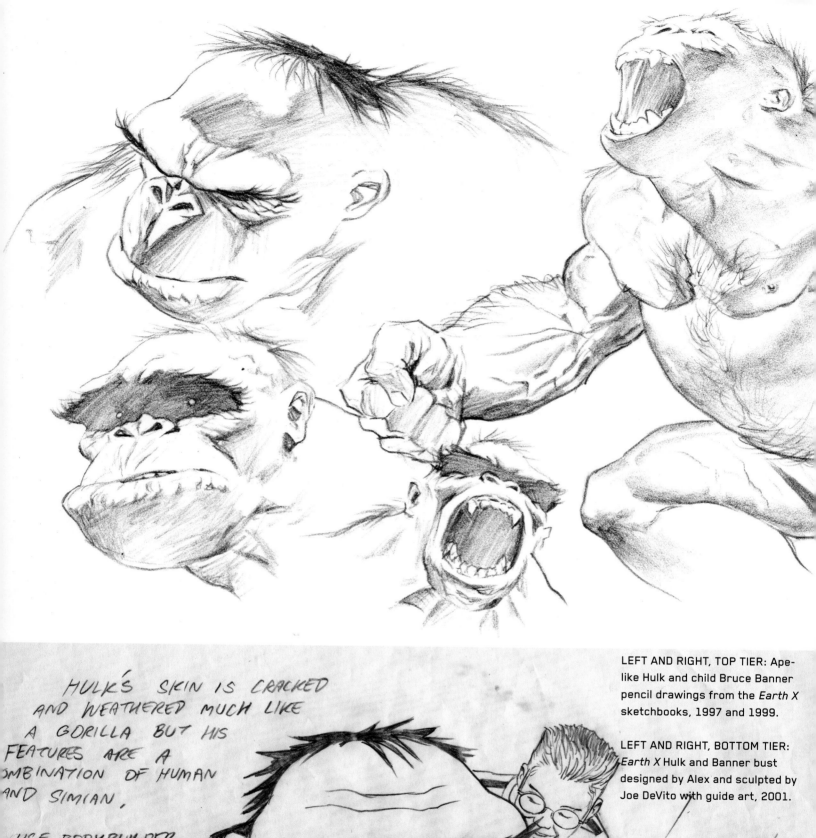

HULK'S SKIN IS CRACKED
AND WEATHERED MUCH LIKE
A GORILLA BUT HIS
FEATURES ARE A
COMBINATION OF HUMAN
AND SIMIAN.

USE BODYBUILDER
REFERENCE FOR
SHOULDER
DETAILS

LEFT AND RIGHT, TOP TIER: Ape-like Hulk and child Bruce Banner pencil drawings from the *Earth X* sketchbooks, 1997 and 1999.

LEFT AND RIGHT, BOTTOM TIER: *Earth X* Hulk and Banner bust designed by Alex and sculpted by Joe DeVito with guide art, 2001.

BANNER'S
HEAD IS
APPROX. 1½"
TALL
W/ HAIR

FRONT

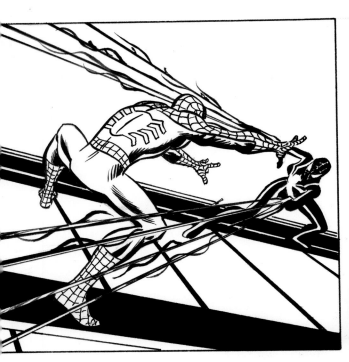
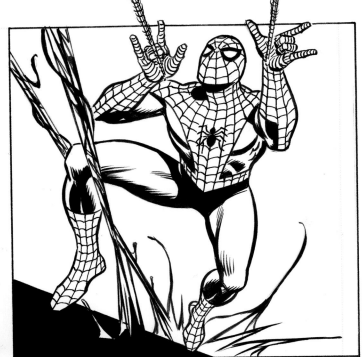
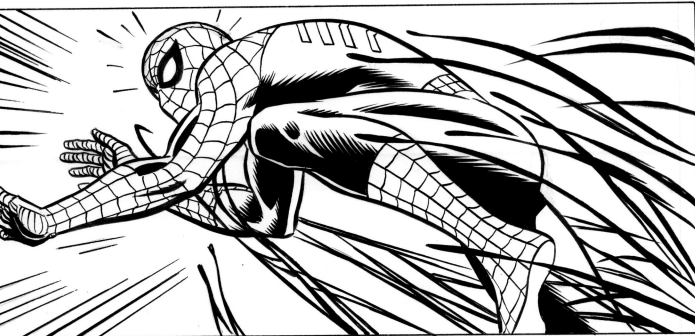

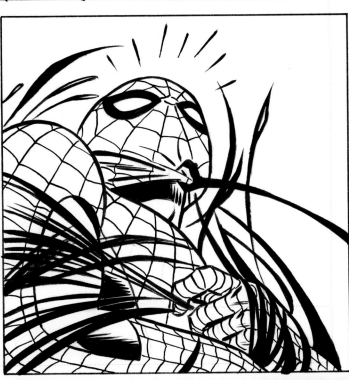

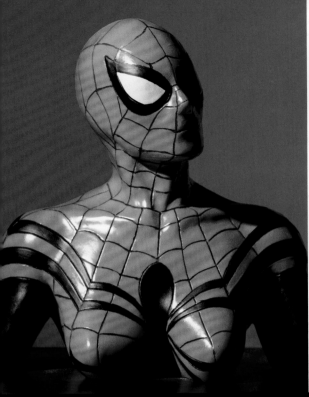

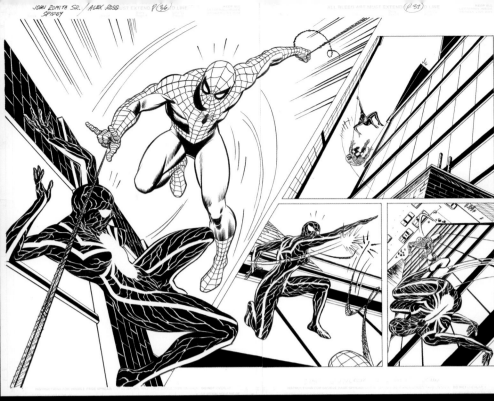

ABOVE LEFT: Spider-Girl bust sculpted by Alex Ross, 2001.

ABOVE RIGHT: Double-page spread with Ross/Romita collaboration from *Spidey* special, 2001.

BOTTOM LEFT: Medical illustration of a human circulatory system on a record album jacket that was always in Alex's home, which directly inspired the *Earth X* Venom design.

BOTTOM RIGHT: *Earth X* Venom bust sculpted by Alex Ross, 2001.

"Among the special *Earth X* comics issues that we created to tie into our larger story, we had one called *Spidey*, which focused on a dream life of Peter Parker that he never actually lived. It explored themes like: What if Gwen Stacy had not died, and Peter settled down with her? What if they had a family? And what if Peter's daughter, Venom, entered her father's dream to see the life and family that he desired, not the one she and her late mother, Mary Jane Watson, were part of?"

John Romita Sr. inked the figures of Peter's imaginary "Spider-Son" facing his counterpart, Venom, the villain-symbiote-affected child that Peter Parker really had.

OPPOSITE: A Ross/Romita collaboration where the background details and Venom figures are inked by Alex, and John Romita Sr. inked the Spider-Man figures for *Universe X: Spidey* no. 1, 2001.

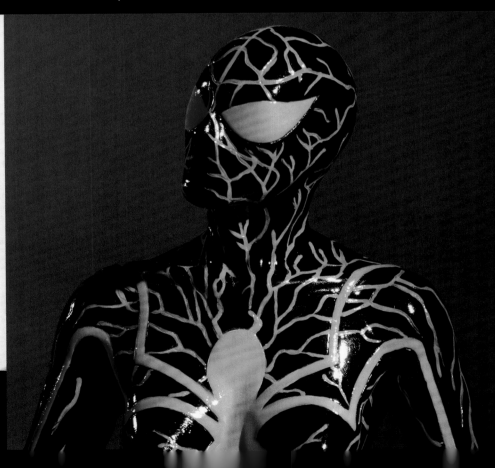

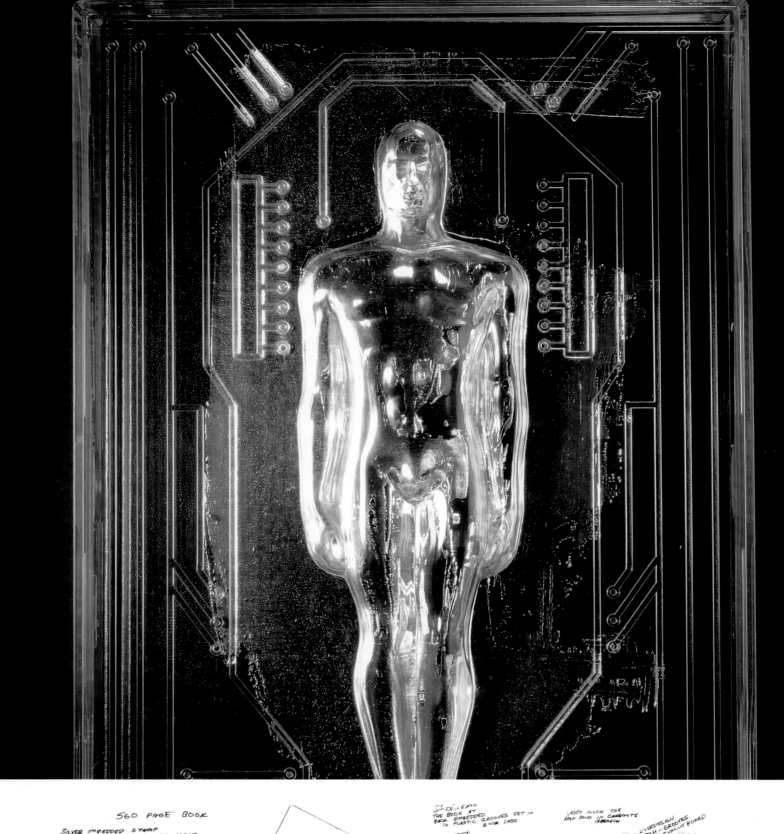
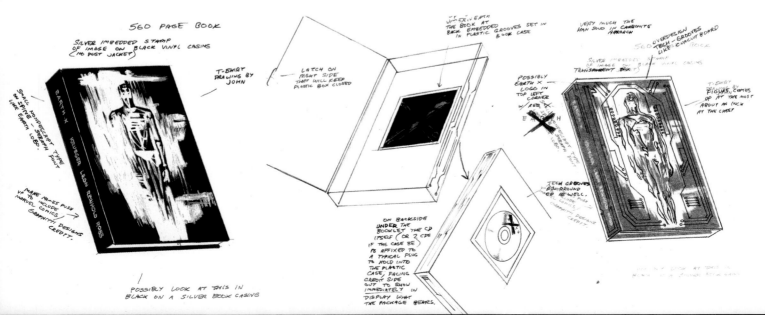

This was a huge X-cess, if you will, but Alex is grateful to Bob Chapman and his Graphitti Designs publishing company (in conjunction with Marvel) for making this edition of *Earth X* happen.

"It's very indulgent, but I wanted all the material that we made for *Earth X* to be collected into one volume, so why not make it as over stuffed and unwieldy as the whole project itself?"

This included no less than a full-scale music video/trailer (on a CD-ROM, remember those?), with a soundtrack by Scott Vladimir Licina and featuring film of Alex's models for specific characters—Frank Kasy as Cap and Alex's nephew Max Rocans as the Skull (bottom).

The clear acrylic box that housed the book was sculpted by Alex, in the shape of the X-51 android character, who represents the overseeing observer/watcher of all of the story's events.

The result is what we now call an immersive multimedia experience, capturing the entirety of what Alex and his *Earth X* team created for this epic series.

OPPOSITE, TOP: Acrylic box sculpted by Alex for the *Earth X* Deluxe Edition.

OPPOSITE, BOTTOM: Designs for the box.

VIDEO IMAGES BELOW: The *Earth X* video is Alex's only directing experience where he used both live models and animation he personally funded. The Daredevil animation is by Jack Liddon. The Captain Marvel, X-51, Hulk and Banner, Black Bolt, and Skull animations were all by Dave Riske.

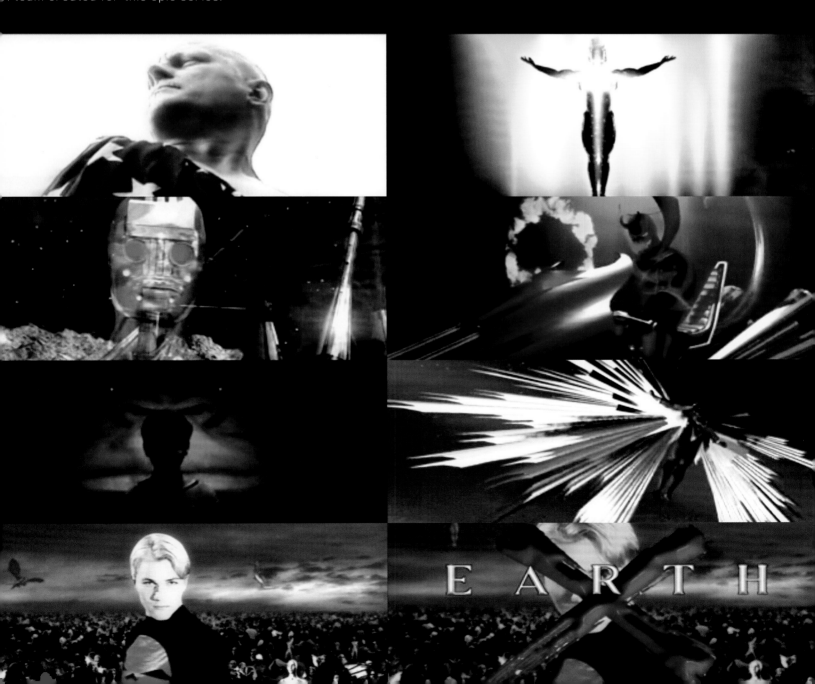

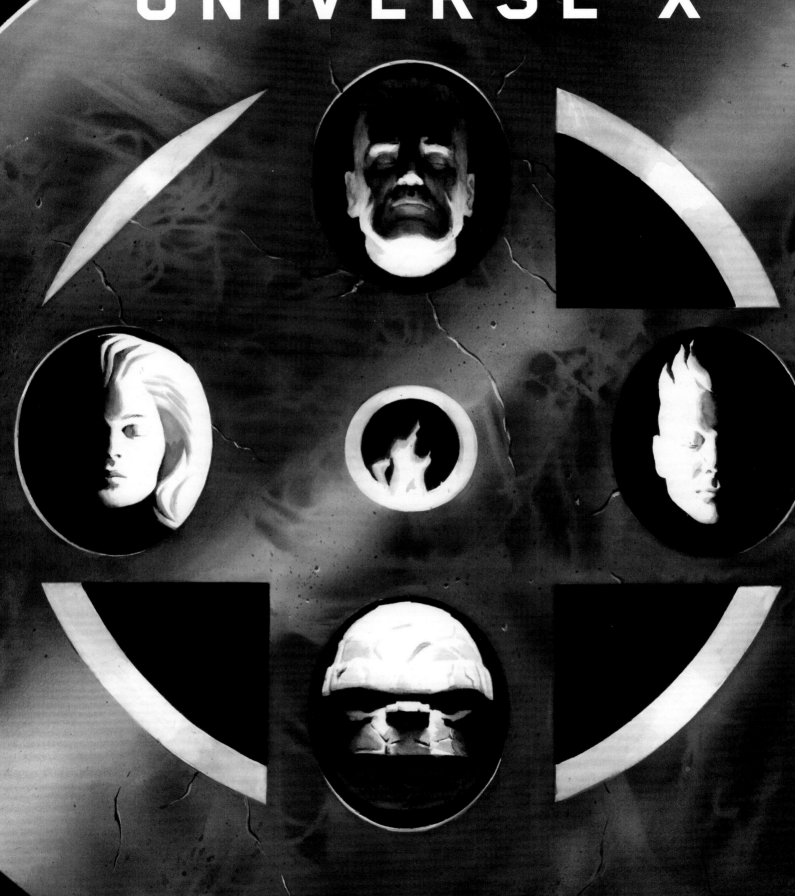

OPPOSITE: Cover to *Universe X: 4* no. 1, 2000.

BELOW: Alex adapted the back cover from the band Laibach's 1992 album *Kapital* for his Fantastic Four statue tribute cover.

RIGHT: All 14 issues of *Universe X* (no. 0, no. 1–no. 12, and no. X) assembled to create one monster image like the previous *Earth X* series, but this time as a vertical composition focusing on the body of the starry afterlife form of the late Captain Marvel, 2000–2001.

FOLLOWING SPREAD: Captain Marvel is split between two places in the *Universe X* story. One form is his new, three-year-old body on Earth and the other is in the land of the dead. This rift is illustrated between the trade paperback covers to *Universe X* Vols. 1 and 2, 2002.

"We hoped to delve into corners of Marvel's mythology that no one had dared do before, so in *Universe X*, we later explored where we go when we die. As a cheeky commentary on life's irony, the afterlife looks the same for our heroes as where they came from, and they think all the people who aren't there are the ones who have died! Eventually the story concludes with the destruction of the embodiment of death herself." —A. R.

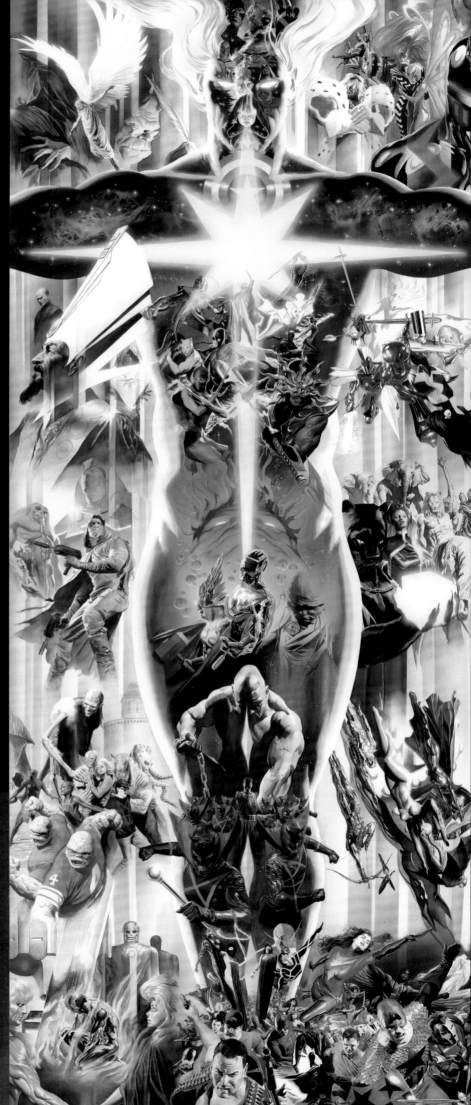

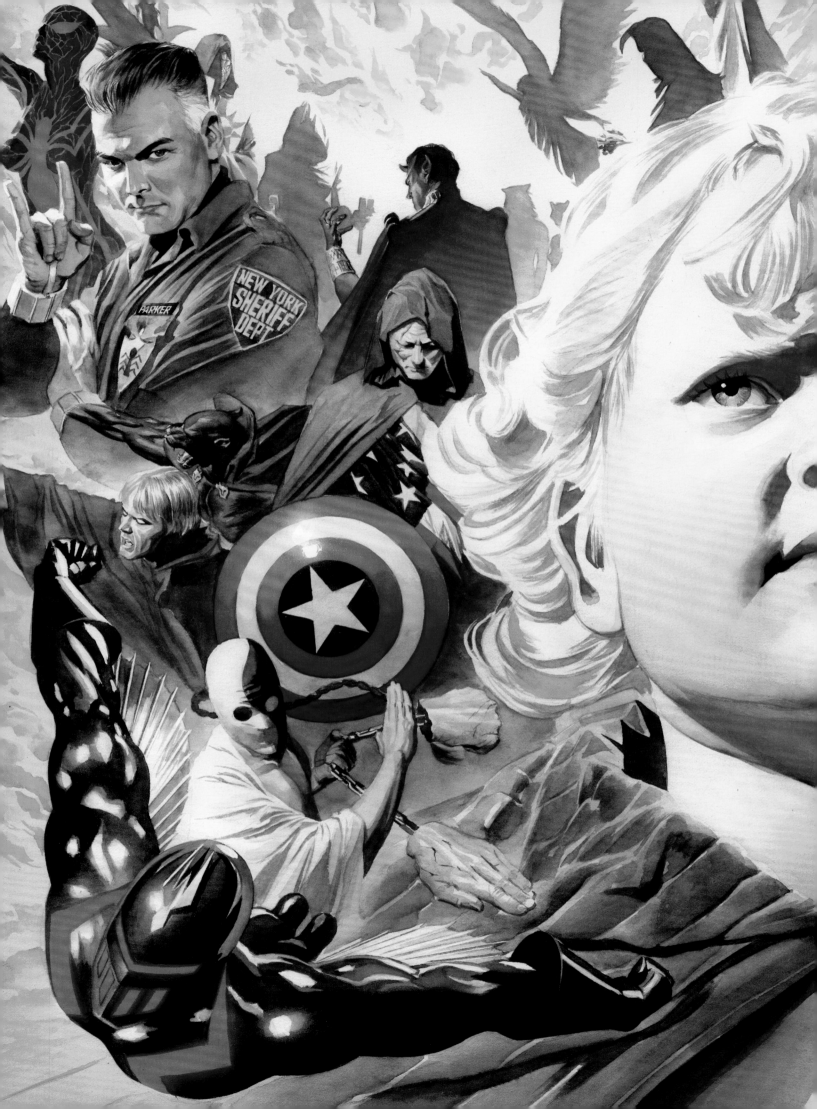

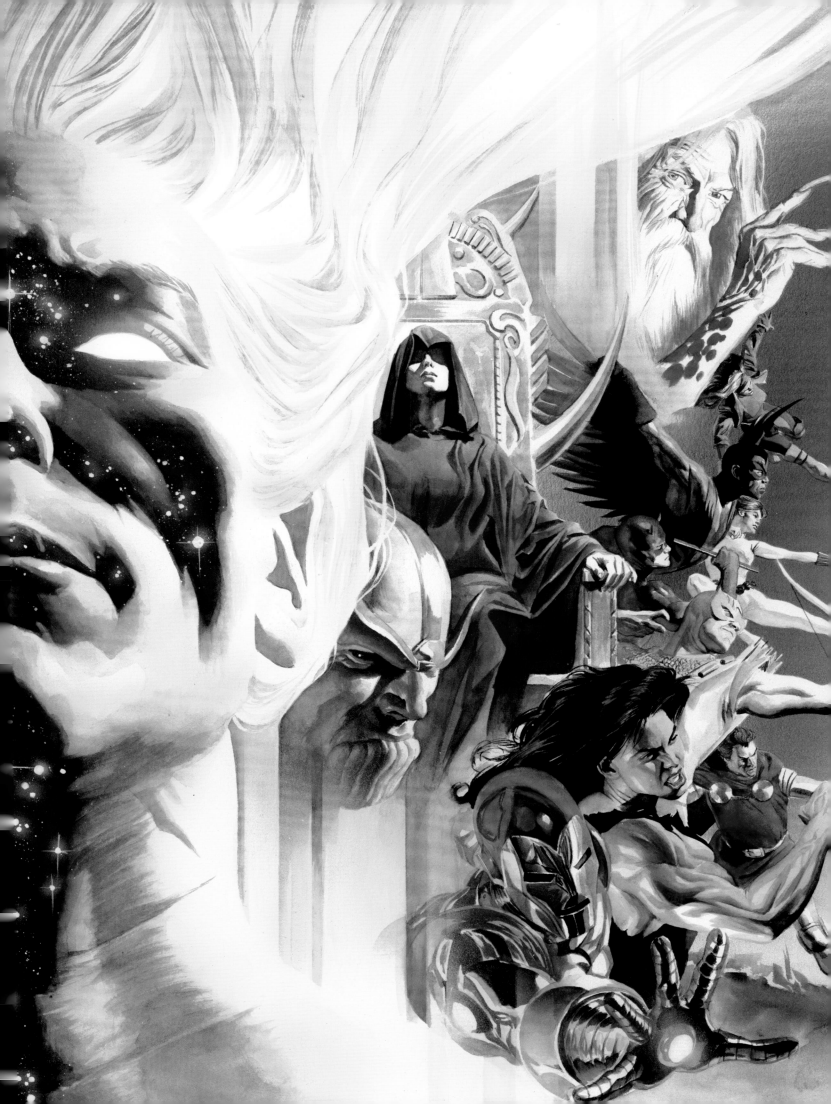

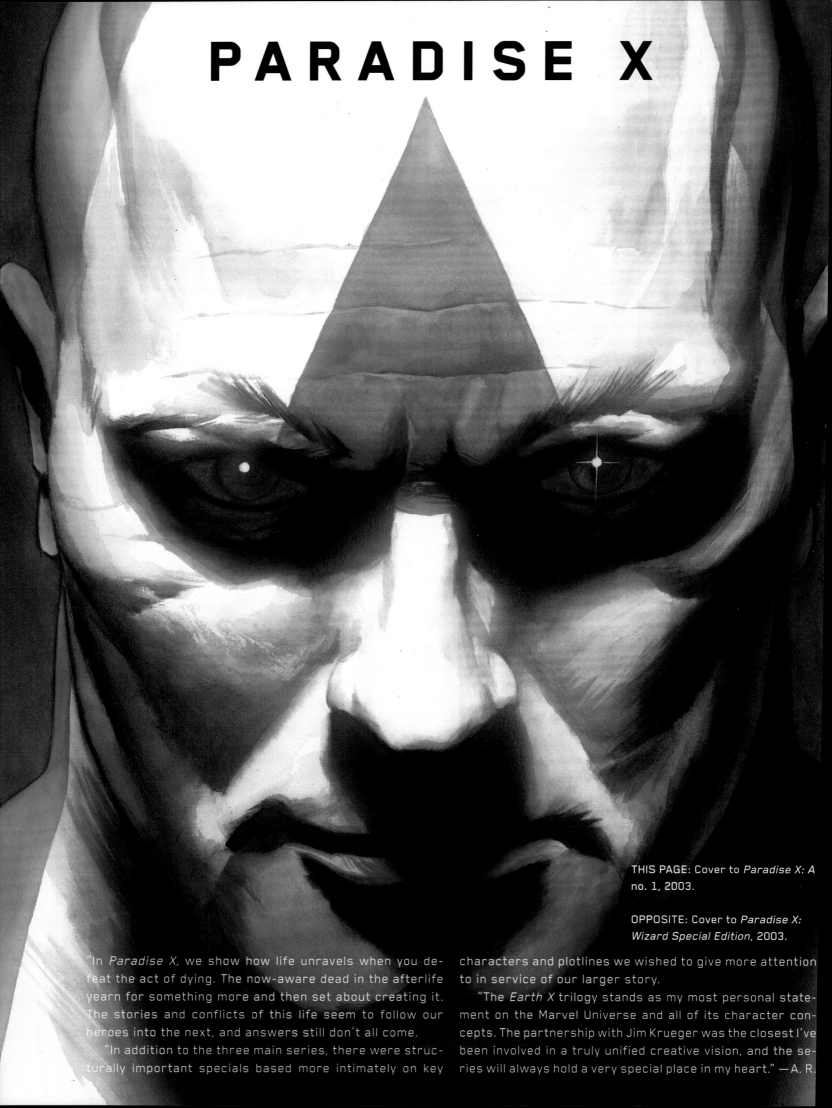

PARADISE X

THIS PAGE: Cover to *Paradise X: A* no. 1, 2003.

OPPOSITE: Cover to *Paradise X: Wizard Special Edition*, 2003.

"In *Paradise X,* we show how life unravels when you defeat the act of dying. The now-aware dead in the afterlife yearn for something more and then set about creating it. The stories and conflicts of this life seem to follow our heroes into the next, and answers still don't all come.

"In addition to the three main series, there were structurally important specials based more intimately on key characters and plotlines we wished to give more attention to in service of our larger story.

"The *Earth X* trilogy stands as my most personal statement on the Marvel Universe and all of its character concepts. The partnership with Jim Krueger was the closest I've been involved in a truly unified creative vision, and the series will always hold a very special place in my heart." —A. R.

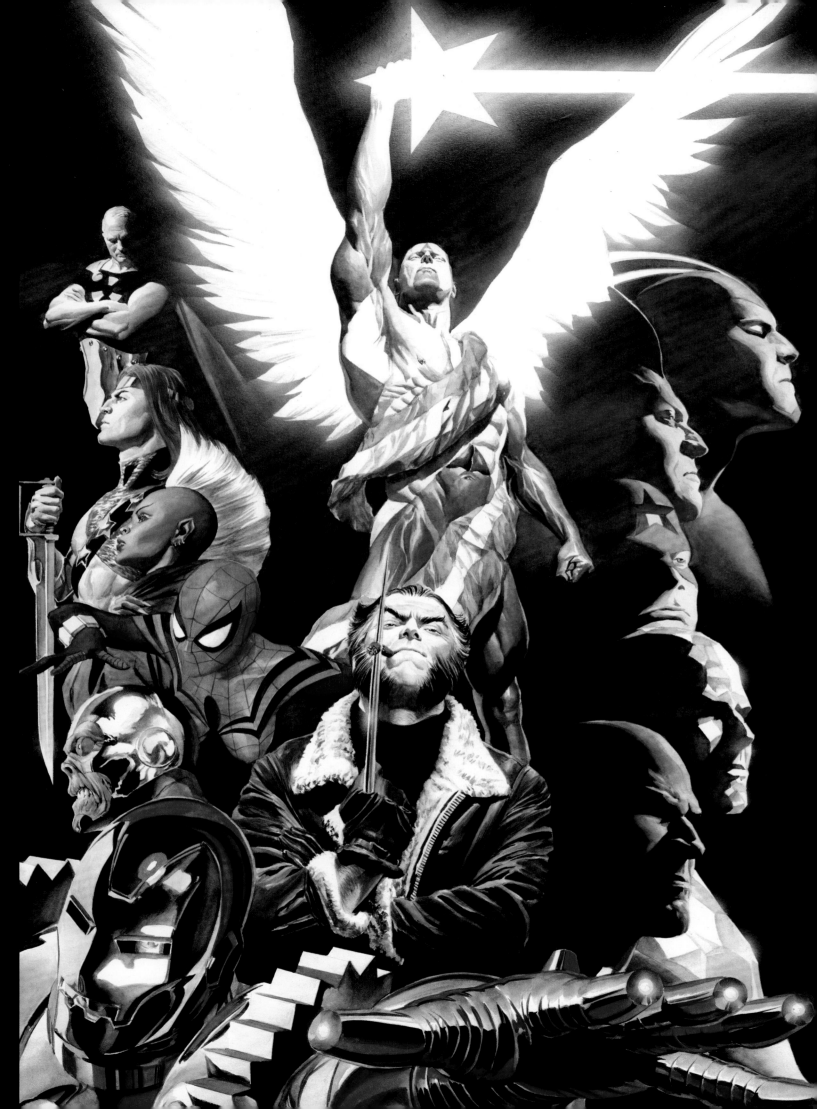

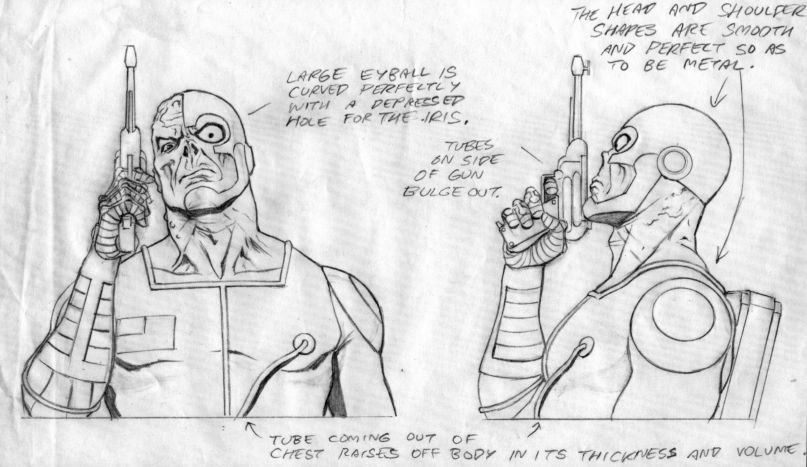

LARGE EYBALL IS CURVED PERFECTLY WITH A DEPRESSED HOLE FOR THE IRIS.

TUBES ON SIDE OF GUN BULGE OUT.

THE HEAD AND SHOULDER SHAPES ARE SMOOTH AND PERFECT SO AS TO BE METAL.

TUBE COMING OUT OF CHEST RAISES OFF BODY IN ITS THICKNESS AND VOLUME

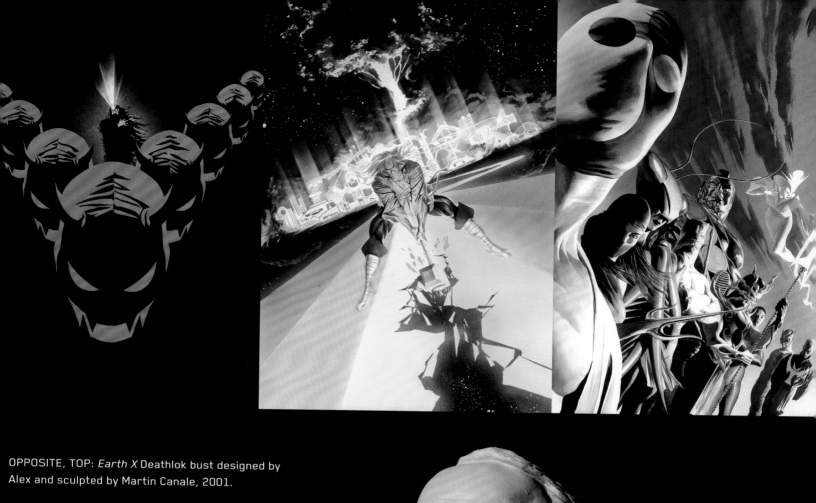

OPPOSITE, TOP: *Earth X* Deathlok bust designed by Alex and sculpted by Martin Canale, 2001.

OPPOSITE, BOTTOM: Guide art for Deathlok bust, 2001.

ABOVE: Covers for one-shot specials that tie in to the series, left to right: *Paradise X: Devils* no. 1, 2002; *Paradise X: Ragnarok* no. 2, 2003; *Paradise X: Xen* no. 1, 2002.

RIGHT: *Earth X* Hyperion bust designed by Alex and sculpted by Tony Cipriano and Joe Simon, 2002.

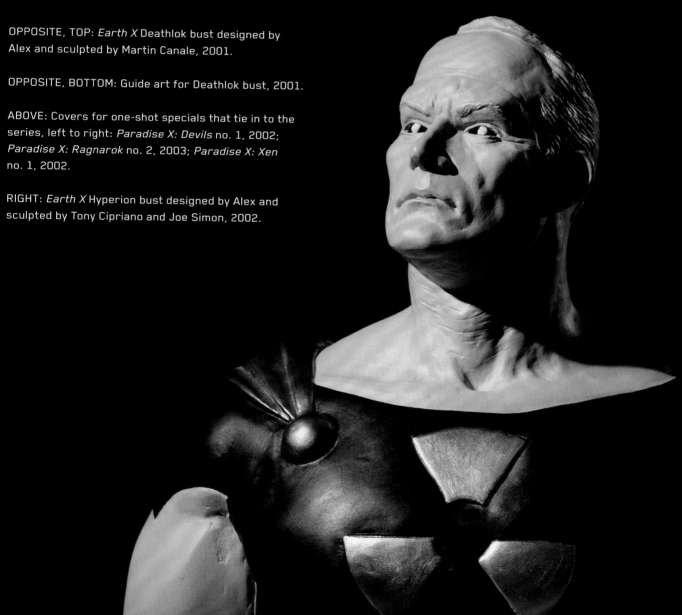

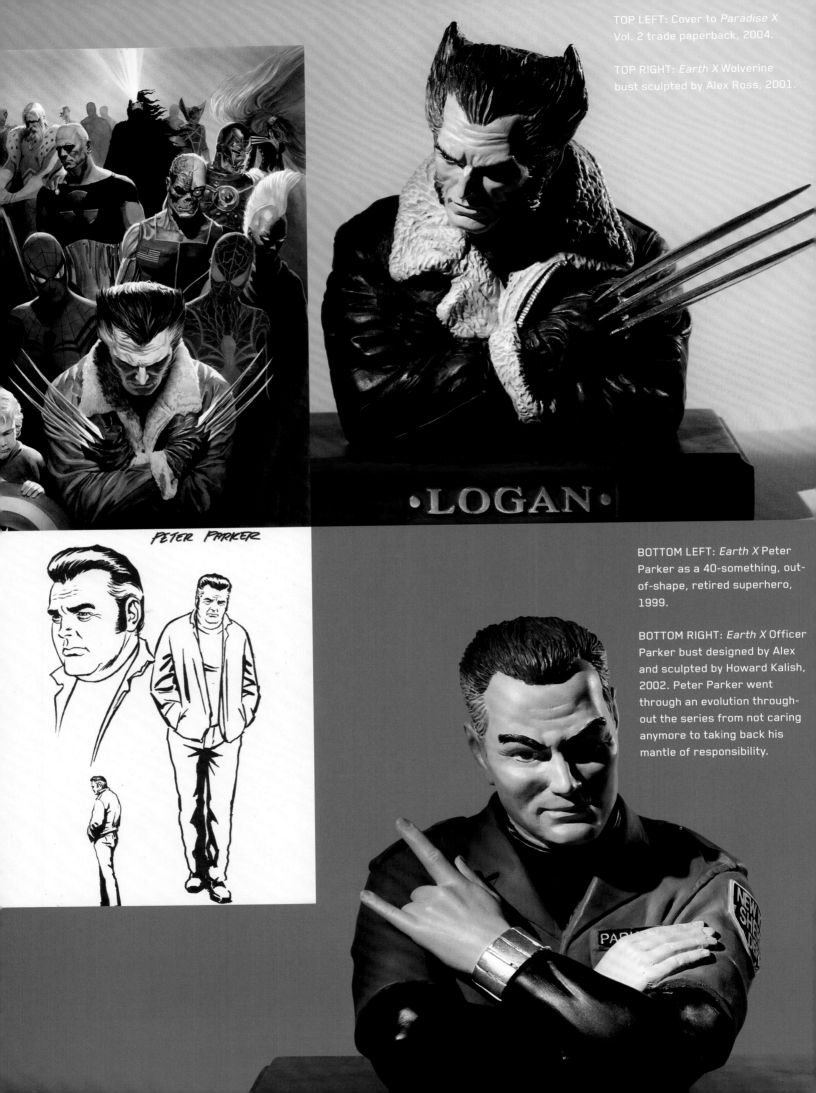

TOP LEFT: Cover to *Paradise X* Vol. 2 trade paperback, 2004.

TOP RIGHT: *Earth X* Wolverine bust sculpted by Alex Ross, 2001.

PETER PARKER

·LOGAN·

BOTTOM LEFT: *Earth X* Peter Parker as a 40-something, out-of-shape, retired superhero, 1999.

BOTTOM RIGHT: *Earth X* Officer Parker bust designed by Alex and sculpted by Howard Kalish, 2002. Peter Parker went through an evolution throughout the series from not caring anymore to taking back his mantle of responsibility.

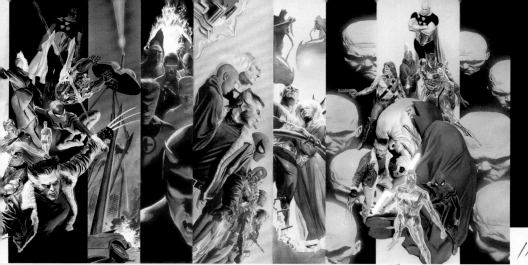

LEFT: Covers for the prelude miniseries *Paradise X: Heralds* no. 1–no. 3, 2001–2002. *Heralds* introduced an assembly of characters from other well-known alternate futures who joined the *Earth X* characters in a larger tribute to all corners of Marvel's storytelling.

THIS PAGE, MIDDLE: Guide art for Iron Man 2020 bust.

BELOW: *Earth X* Iron Man 2020 bust designed by Alex and sculpted by Pablo Viggiano, 2003.

IRON MAN 2020

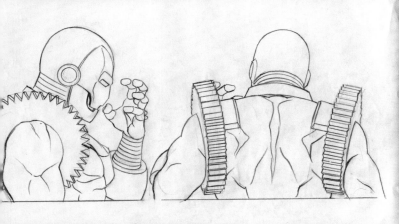
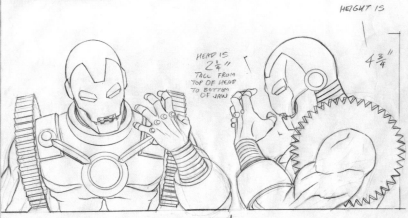

HEAD IS 2¼" TALL FROM TOP OF HEAD TO BOTTOM OF JAW

HEIGHT IS 4¾"

FIGURE IS 6¼" WIDE

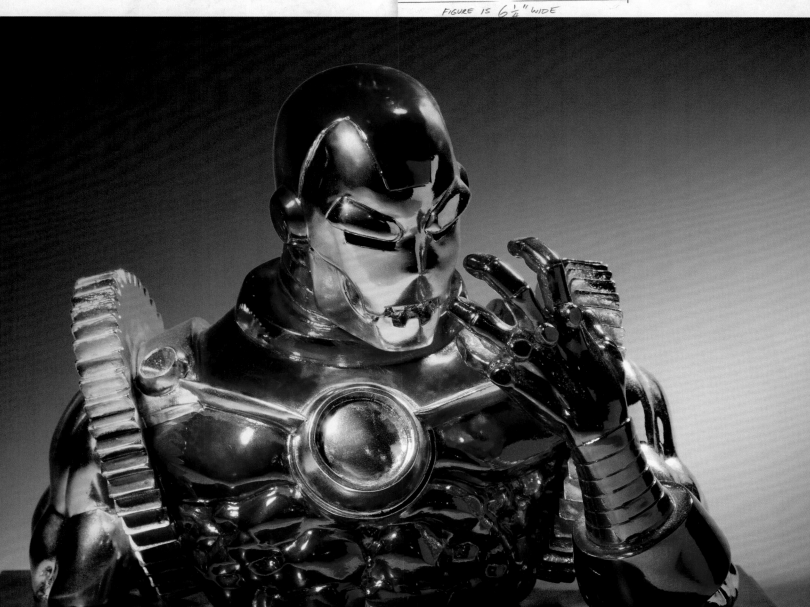

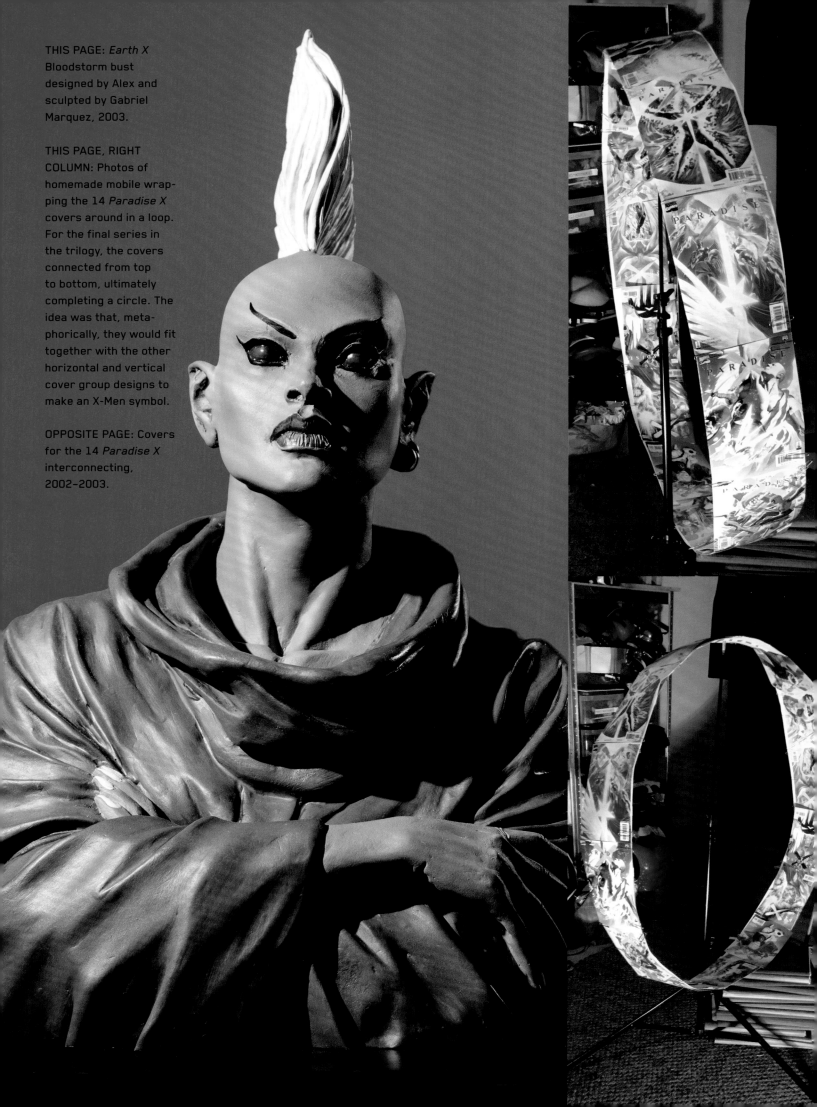

THIS PAGE: *Earth X* Bloodstorm bust designed by Alex and sculpted by Gabriel Marquez, 2003.

THIS PAGE, RIGHT COLUMN: Photos of homemade mobile wrapping the 14 *Paradise X* covers around in a loop. For the final series in the trilogy, the covers connected from top to bottom, ultimately completing a circle. The idea was that, metaphorically, they would fit together with the other horizontal and vertical cover group designs to make an X-Men symbol.

OPPOSITE PAGE: Covers for the 14 *Paradise X* interconnecting, 2002–2003.

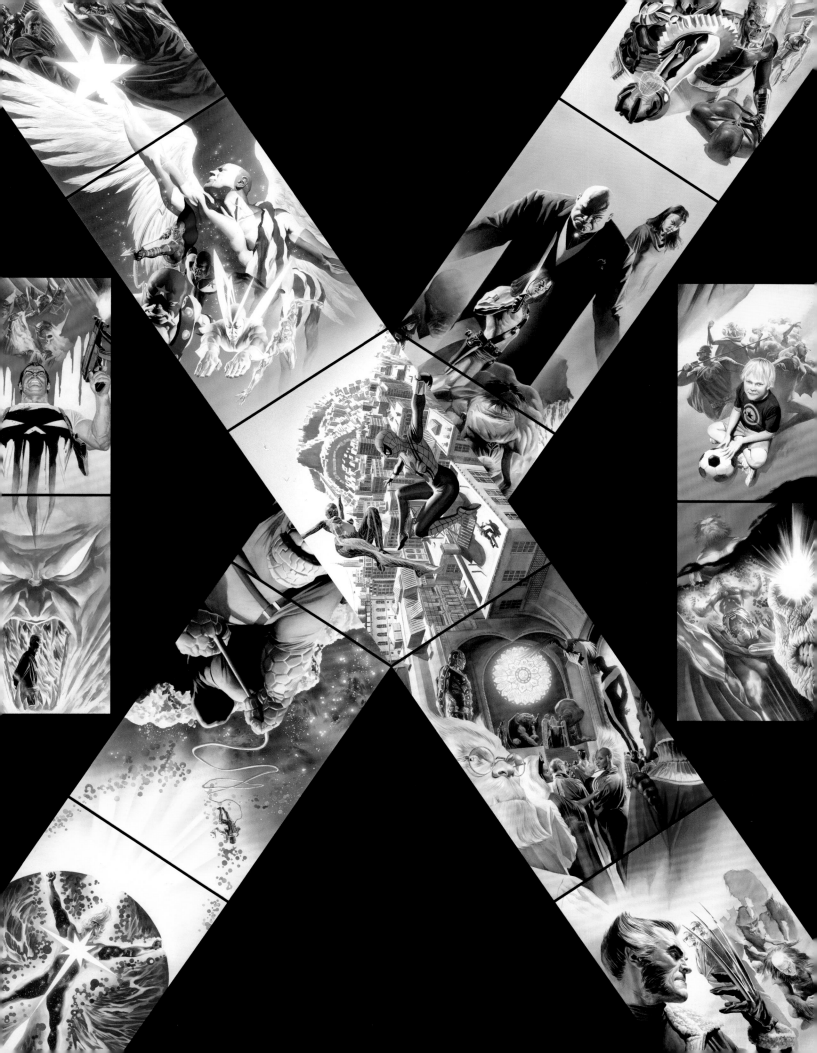

AVENGERS

The Avengers represent the A-team for the Marvel Universe, their counterpart to the "Justice League," if one can use a naughty rival comparison.

"It's a collective of everything that embodies the company (Marvel), the grab bag of all these famous characters gathered together in one group." Okay, so what then is the fundamental difference between the Justice League and the Avengers? "The Justice League represents Order. But there's a sense of Chaos to the Avengers," says Alex, "and that's what makes them a little more interesting. Captain America embodies the spirit of Superman but not necessarily the physicality, the demigod

abilities. At the same time, Thor could be seen as a combination of Superman *and* Wonder Woman, except with his thriving homeworld of Asgard he has his own version of a Krypton that he can always go back to. And then of course Hawkeye is the counterpart to Green Arrow, and Iron Man to Batman—two humans without superpowers, but with considerable skills they've taught themselves."

The image on this spread is from 2008, and it's worth noting that this is a portrait of nine figures, not seven. The eyes of Hank Pym/Giant Man/Goliath loom behind them, and the Wasp hovers in front of Iron Man.

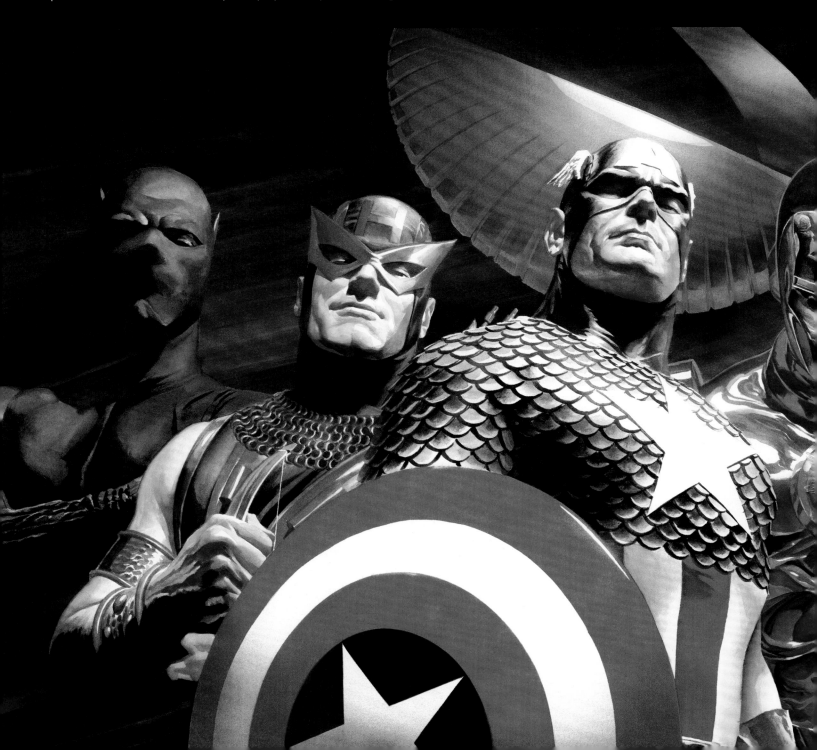

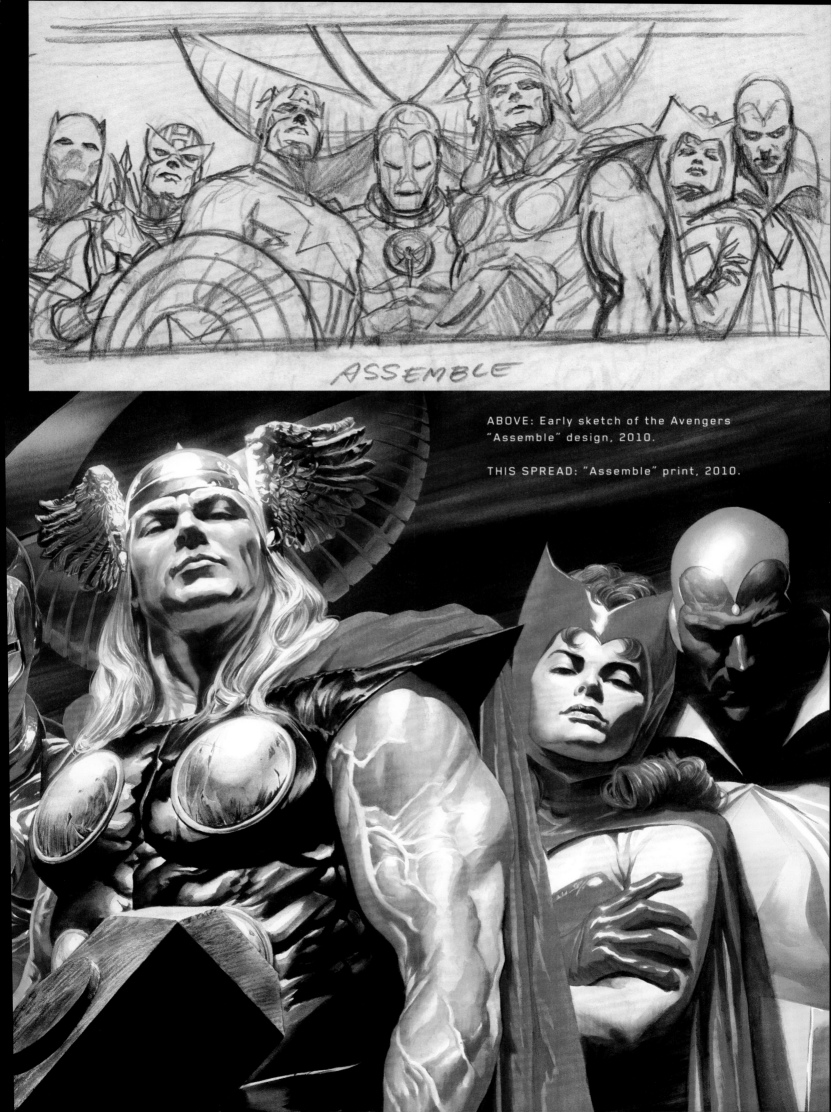

ABOVE: Early sketch of the Avengers "Assemble" design, 2010.

THIS SPREAD: "Assemble" print, 2010.

ASSEMBLE

The inclusion of Black Panther among the lineup (far left) is interesting, because at the time he would not have been considered one of the early defining members of the group. So why include him? "Because the rotating cast of the team was always in a state of flux, and when you get Black Panther added at the same time (late 1960s) as the Vision (far right) it becomes really exciting. They felt like the most important members, to me, in terms of rounding out the team."

Indeed. One is an African prince from the fictional country of Wakanda, and the other is an android character (created by the villainous robot Ultron to infiltrate and destroy the team) who wanted to turn good and become human. Now *there's* diversity.

On this spread is a digitally created sculpt of Alex's painting. "It's always interesting to see how these images will be reinterpreted in three dimensions, as what I do provides the illusion of that in two." Note that for whatever reason, the giant eyes of Goliath are not represented here. But the Wasp is.

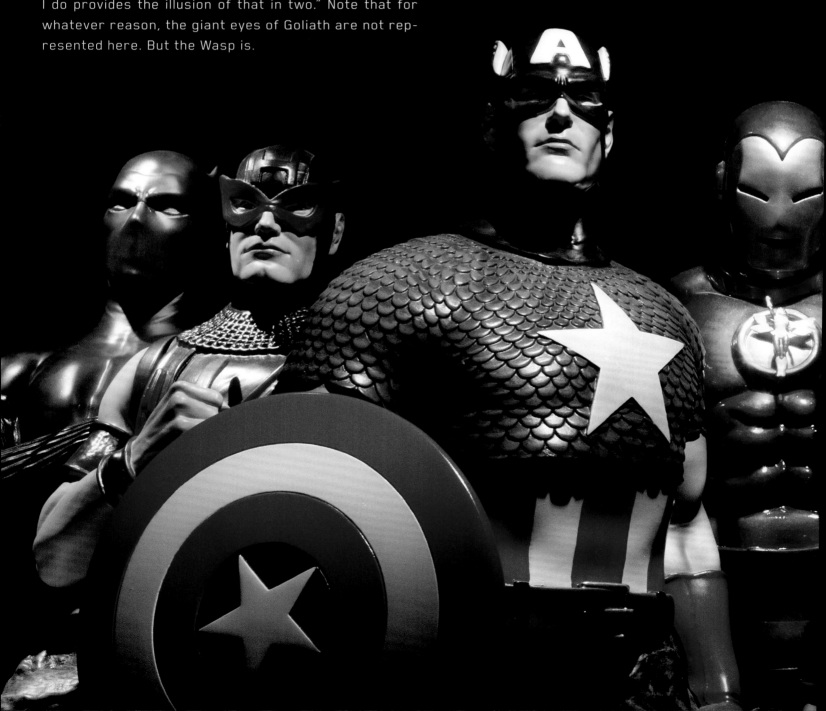

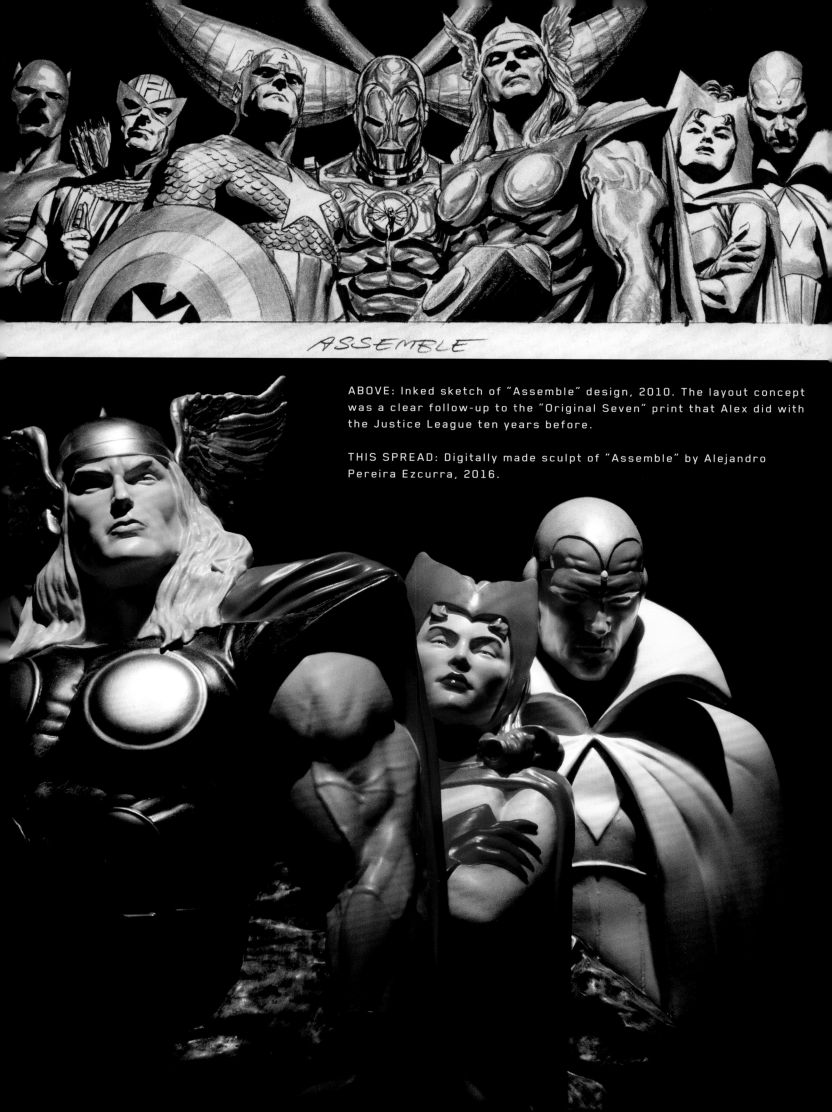

ASSEMBLE

ABOVE: Inked sketch of "Assemble" design, 2010. The layout concept was a clear follow-up to the "Original Seven" print that Alex did with the Justice League ten years before.

THIS SPREAD: Digitally made sculpt of "Assemble" by Alejandro Pereira Ezcurra, 2016.

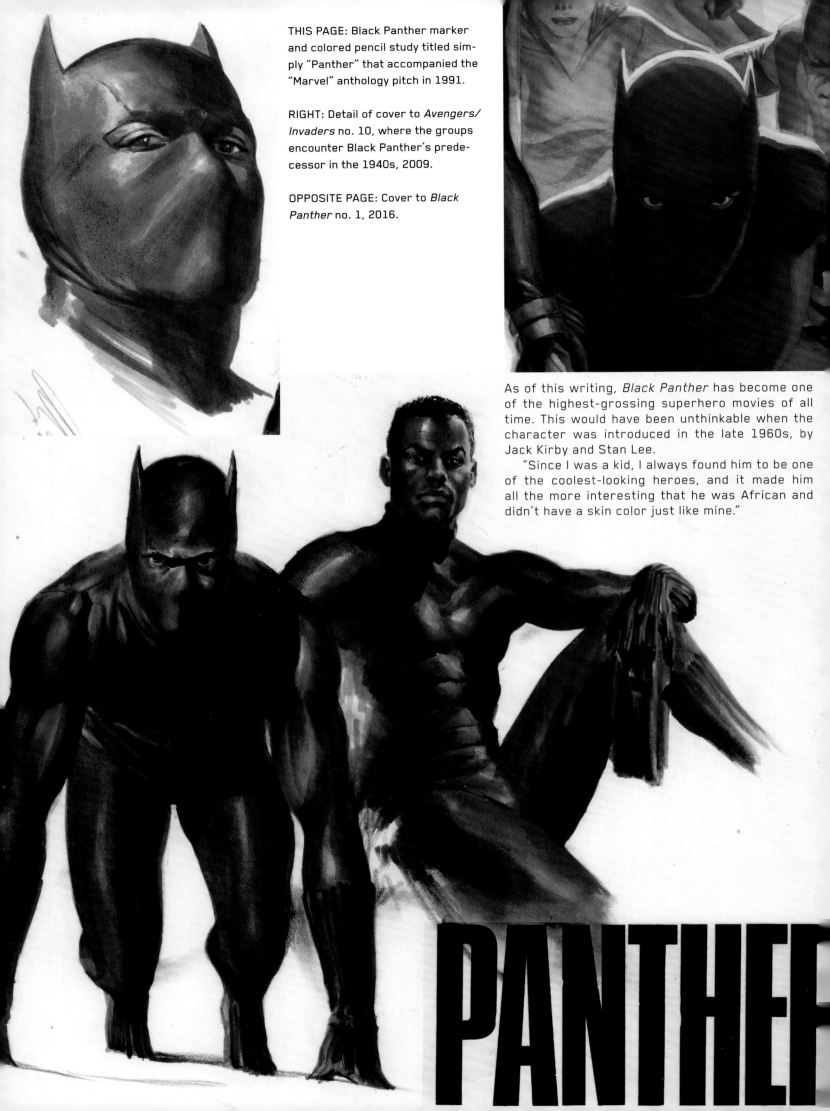

THIS PAGE: Black Panther marker and colored pencil study titled simply "Panther" that accompanied the "Marvel" anthology pitch in 1991.

RIGHT: Detail of cover to *Avengers/Invaders* no. 10, where the groups encounter Black Panther's predecessor in the 1940s, 2009.

OPPOSITE PAGE: Cover to *Black Panther* no. 1, 2016.

As of this writing, *Black Panther* has become one of the highest-grossing superhero movies of all time. This would have been unthinkable when the character was introduced in the late 1960s, by Jack Kirby and Stan Lee.

"Since I was a kid, I always found him to be one of the coolest-looking heroes, and it made him all the more interesting that he was African and didn't have a skin color just like mine."

PANTHER

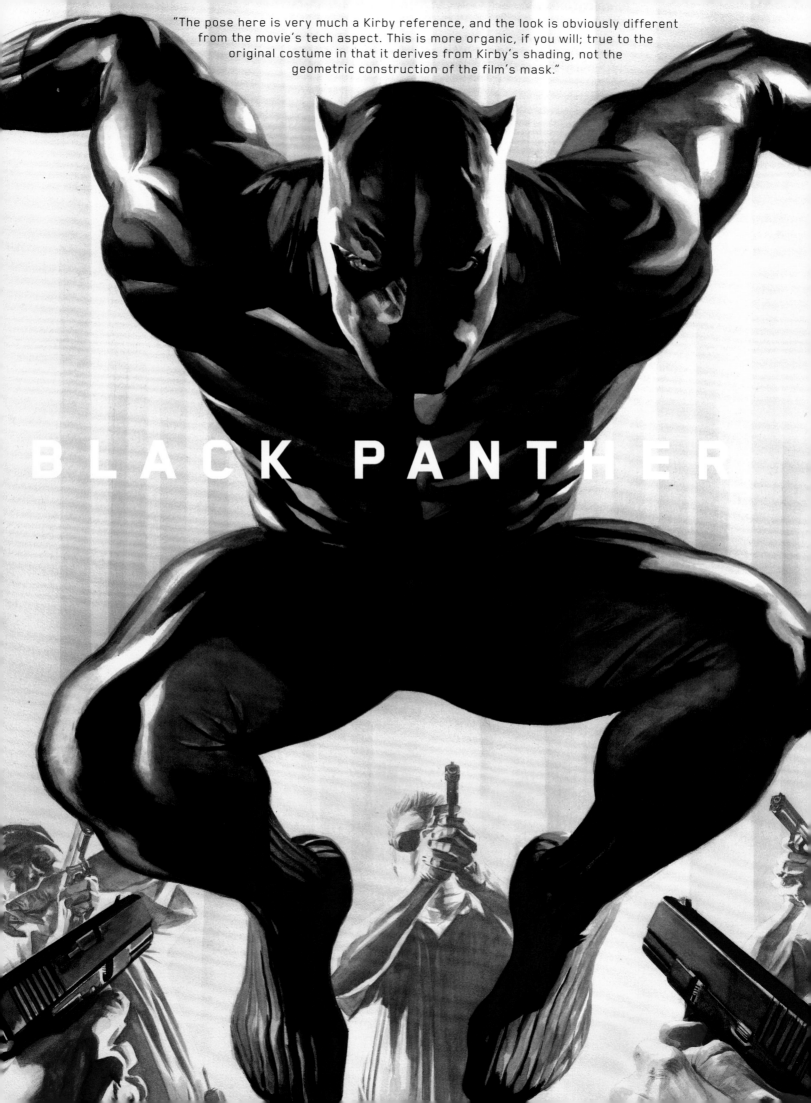

"The pose here is very much a Kirby reference, and the look is obviously different from the movie's tech aspect. This is more organic, if you will; true to the original costume in that it derives from Kirby's shading, not the geometric construction of the film's mask."

BLACK PANTHER

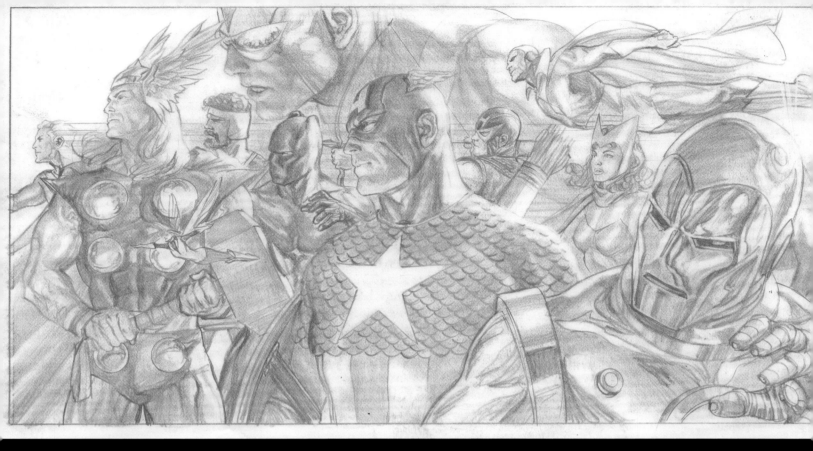

ABOVE: Pencil drawing of the Avengers for a print following a Justice League counterpart with all of the heroes facing right, so as to create a face-off, 2013.

BELOW: Finished print titled "Invincible," 2013.

OPPOSITE, TOP: Five interconnecting covers to the *All-New, All-Different Avengers* no. 1, Annual no. 1, Annual no. 1 variant, no. 14, and no. 15, with both thumbnail sketch and finished painting, 2016.

OPPOSITE, BOTTOM: Cover art for *All-New, All-Different Avengers* no. 4, no. 5, no. 12, *Avengers* no. 1, no. 2, no. 3, no. 5, no. 6, 2015–2017.

This spread represents the classic lineup of the Avengers on the left, and then a reimagining on the opposite, for a new run of covers.

"Much of comics and Marvel in particular is energized and motivated by change. Why not be open to it? After all, that's how breakthroughs are made—Wolverine was a one-off character with a cameo in an issue of *The Hulk*. They took a chance on that one, and he ended up becoming one of the biggest fan-favorites of all time. It's worth the risk to try new things, even though I often express my greatest enthusiasm for the most long-lasting versions of characters."

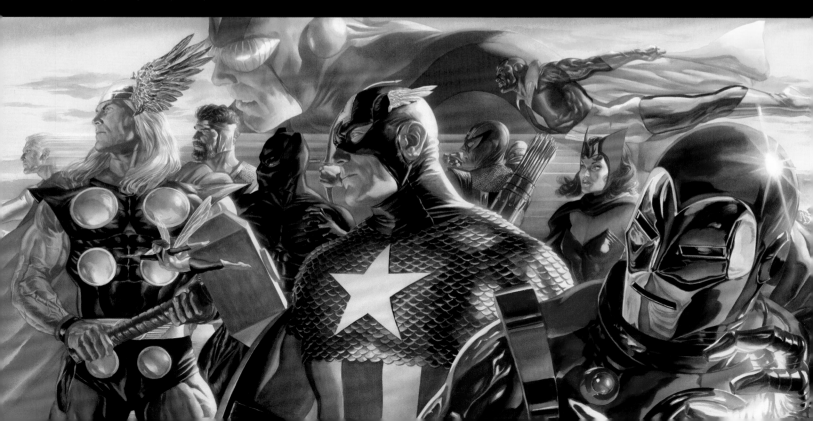

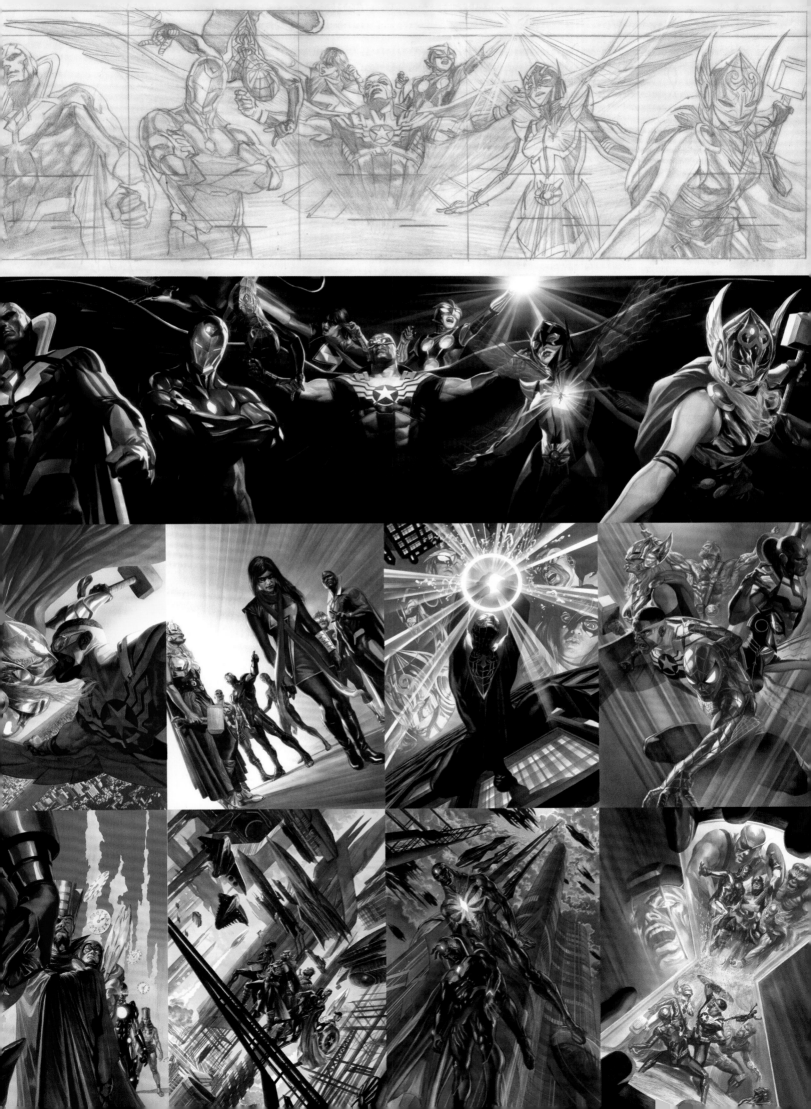

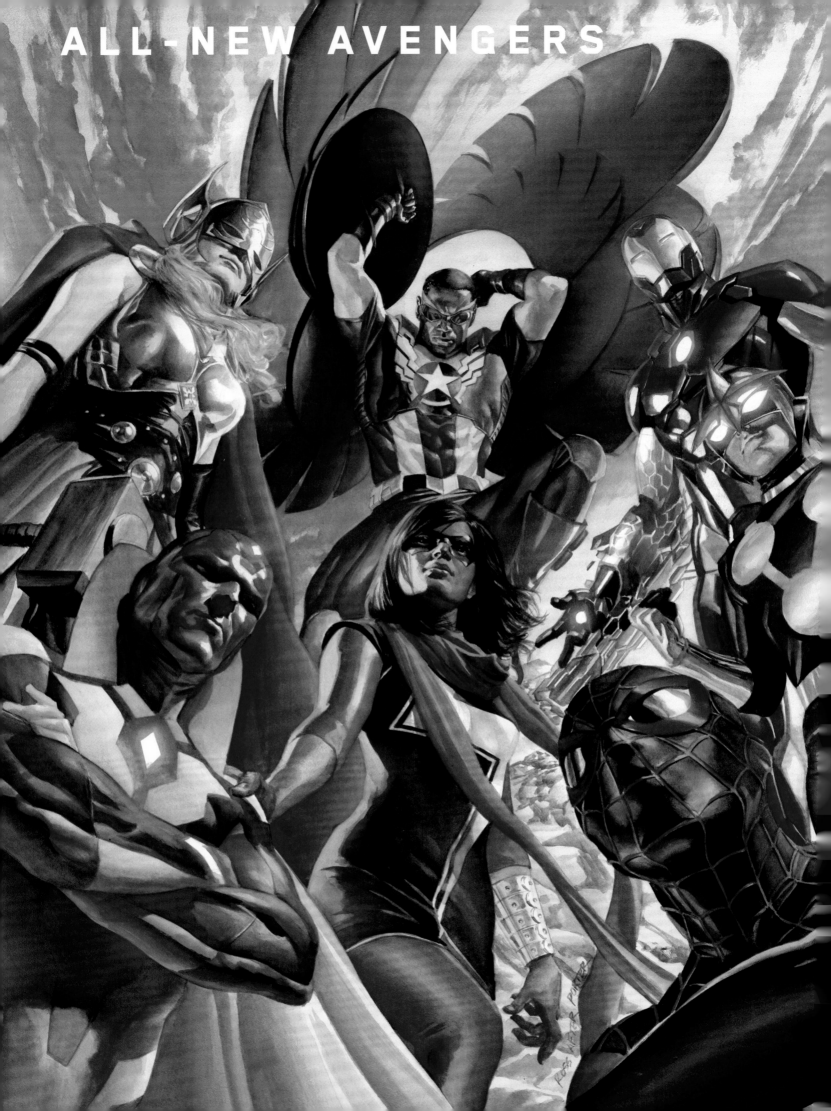

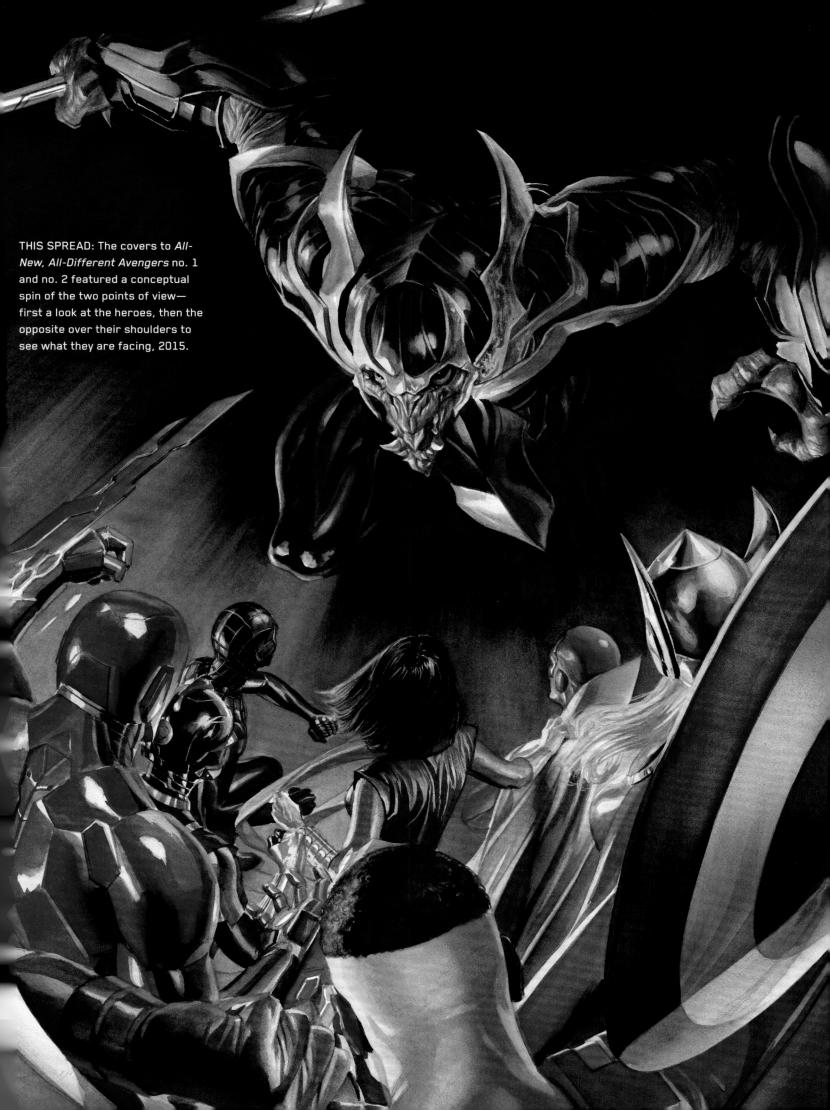

THIS SPREAD: The covers to *All-New, All-Different Avengers* no. 1 and no. 2 featured a conceptual spin of the two points of view—first a look at the heroes, then the opposite over their shoulders to see what they are facing, 2015.

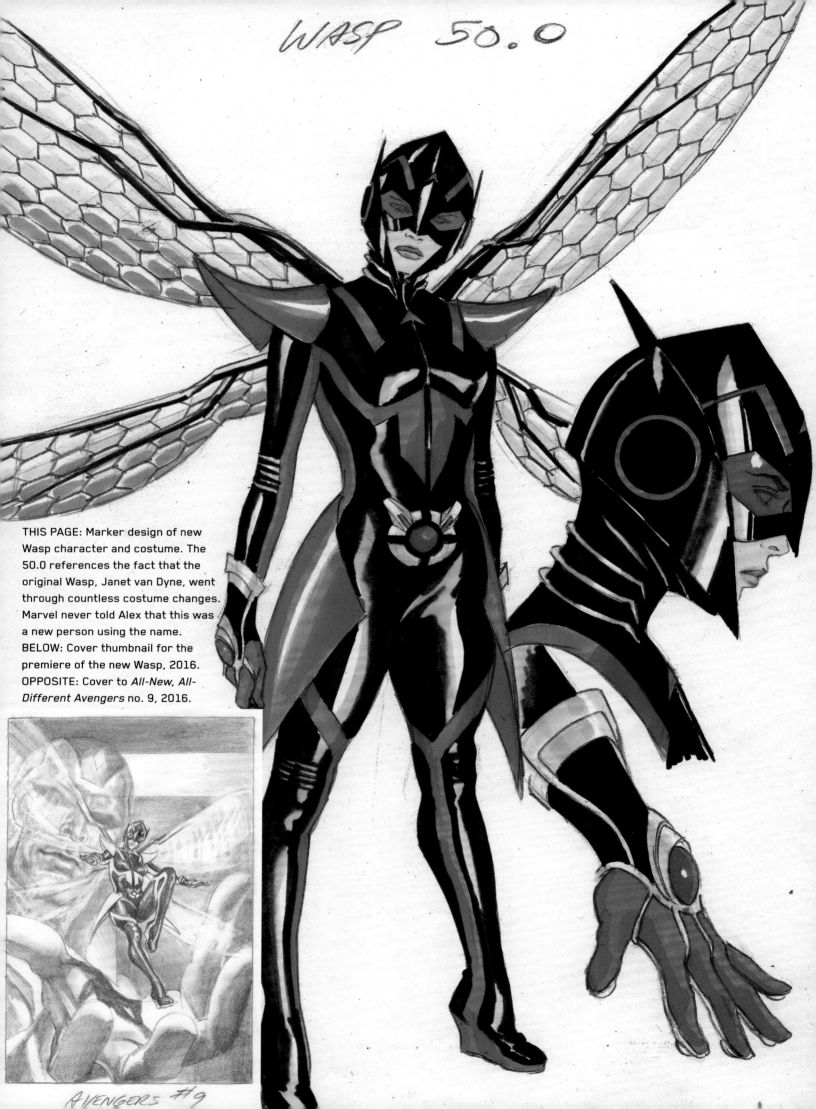

WASP 50.0

THIS PAGE: Marker design of new Wasp character and costume. The 50.0 references the fact that the original Wasp, Janet van Dyne, went through countless costume changes. Marvel never told Alex that this was a new person using the name.
BELOW: Cover thumbnail for the premiere of the new Wasp, 2016.
OPPOSITE: Cover to *All-New, All-Different Avengers* no. 9, 2016.

AVENGERS #9

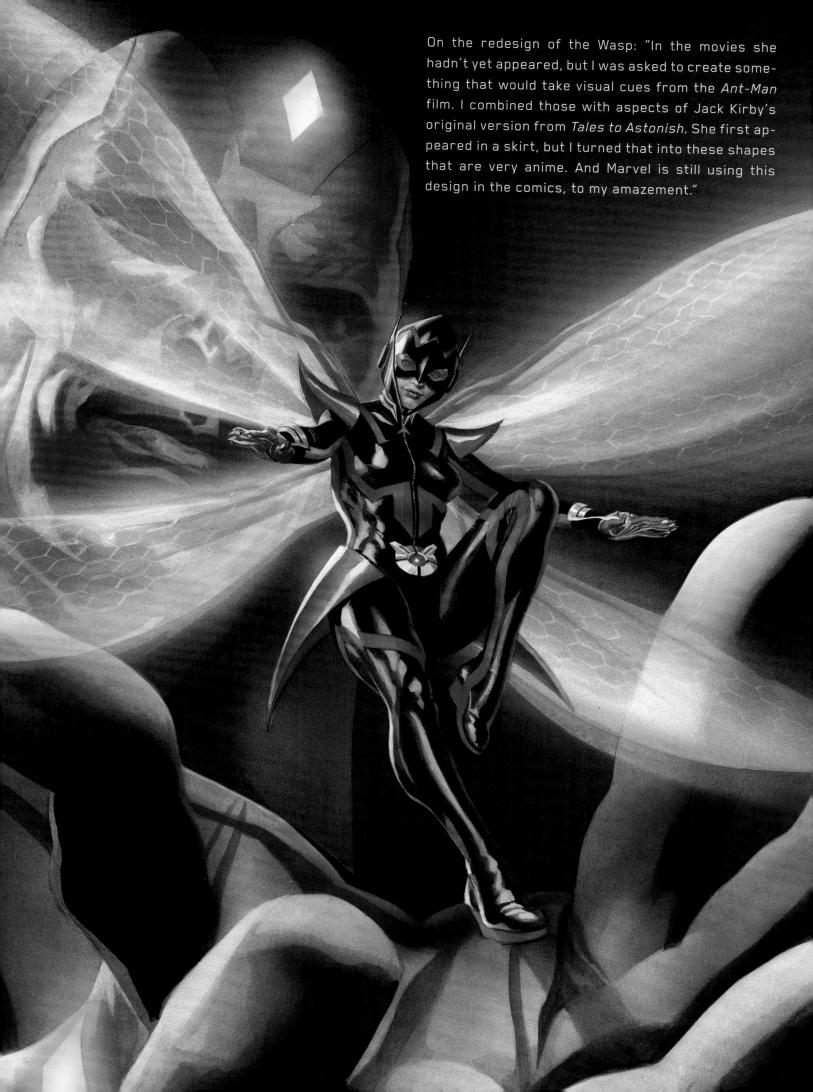

On the redesign of the Wasp: "In the movies she hadn't yet appeared, but I was asked to create something that would take visual cues from the *Ant-Man* film. I combined those with aspects of Jack Kirby's original version from *Tales to Astonish*. She first appeared in a skirt, but I turned that into these shapes that are very anime. And Marvel is still using this design in the comics, to my amazement."

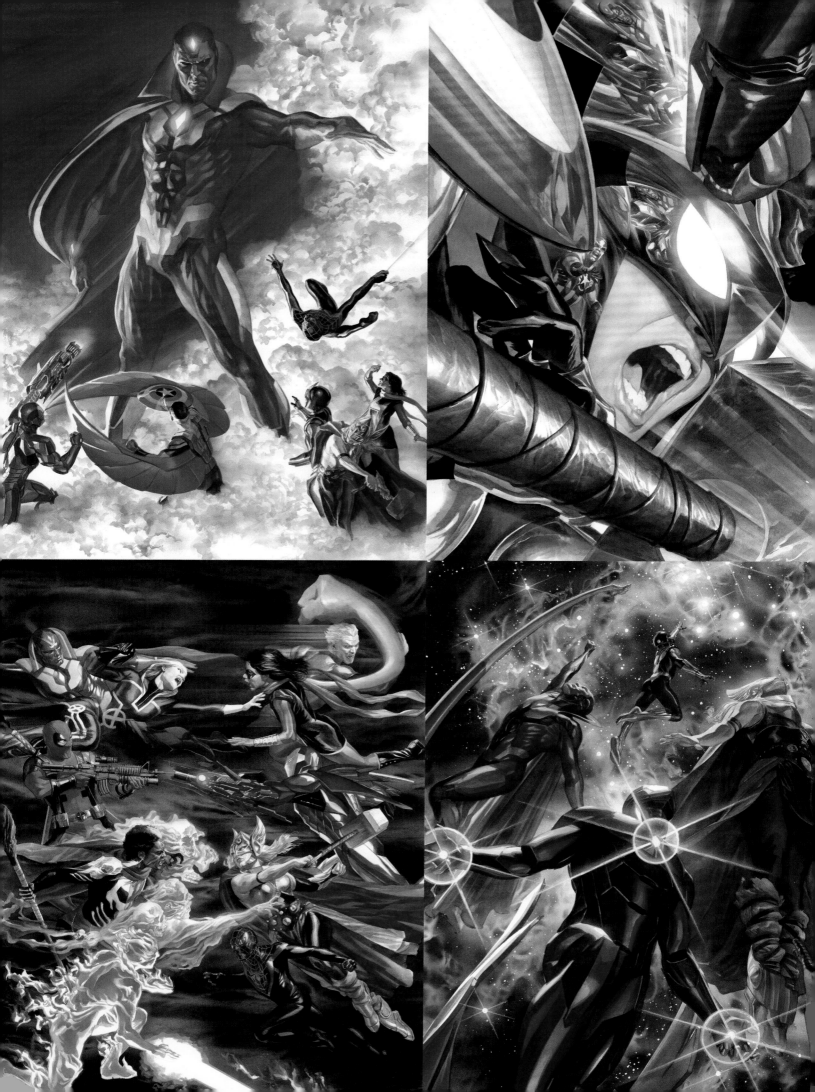

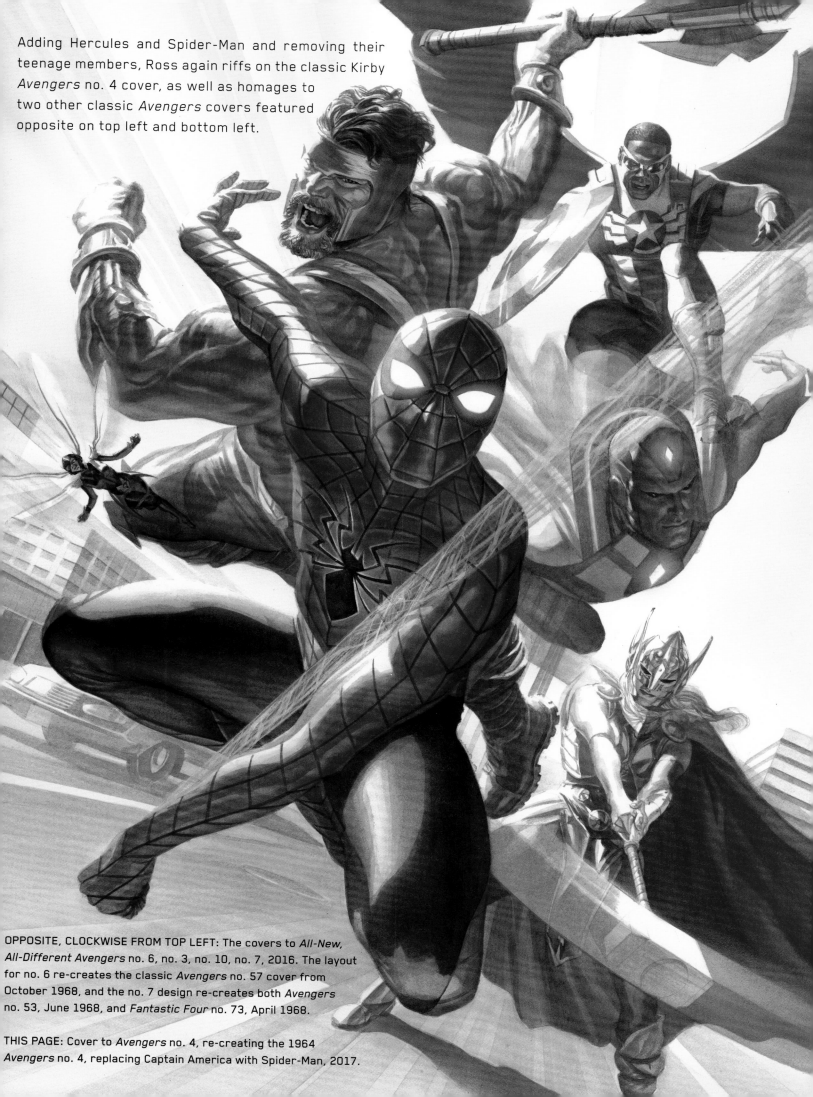

Adding Hercules and Spider-Man and removing their teenage members, Ross again riffs on the classic Kirby *Avengers* no. 4 cover, as well as homages to two other classic *Avengers* covers featured opposite on top left and bottom left.

OPPOSITE, CLOCKWISE FROM TOP LEFT: The covers to *All-New, All-Different Avengers* no. 6, no. 3, no. 10, no. 7, 2016. The layout for no. 6 re-creates the classic *Avengers* no. 57 cover from October 1968, and the no. 7 design re-creates both *Avengers* no. 53, June 1968, and *Fantastic Four* no. 73, April 1968.

THIS PAGE: Cover to *Avengers* no. 4, re-creating the 1964 *Avengers* no. 4, replacing Captain America with Spider-Man, 2017.

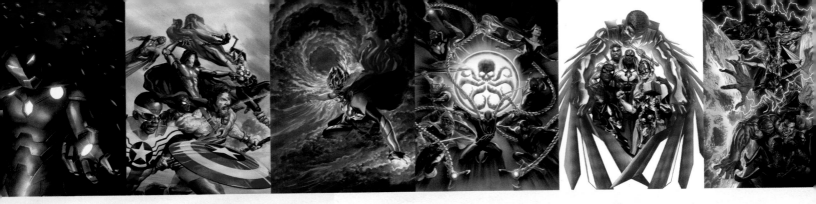

During this time, Alex returned the design of Falcon to a version of his classic original winged costume. The big red guy, by the way, is called the High Evolutionary. Yipes.

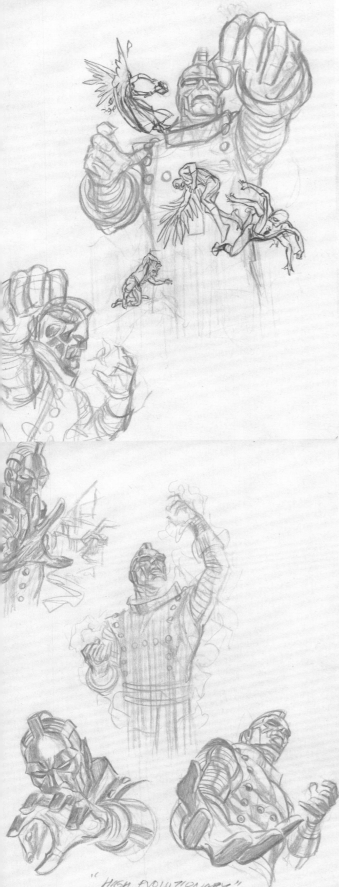

"HIGH EVOLUTIONARY"

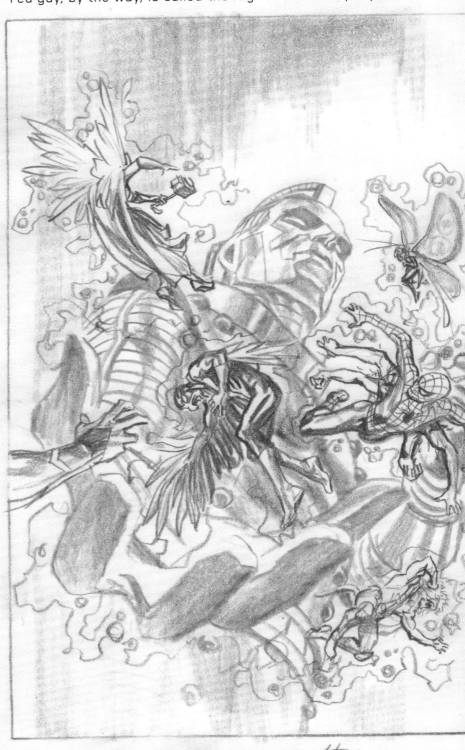

AVENGERS #12

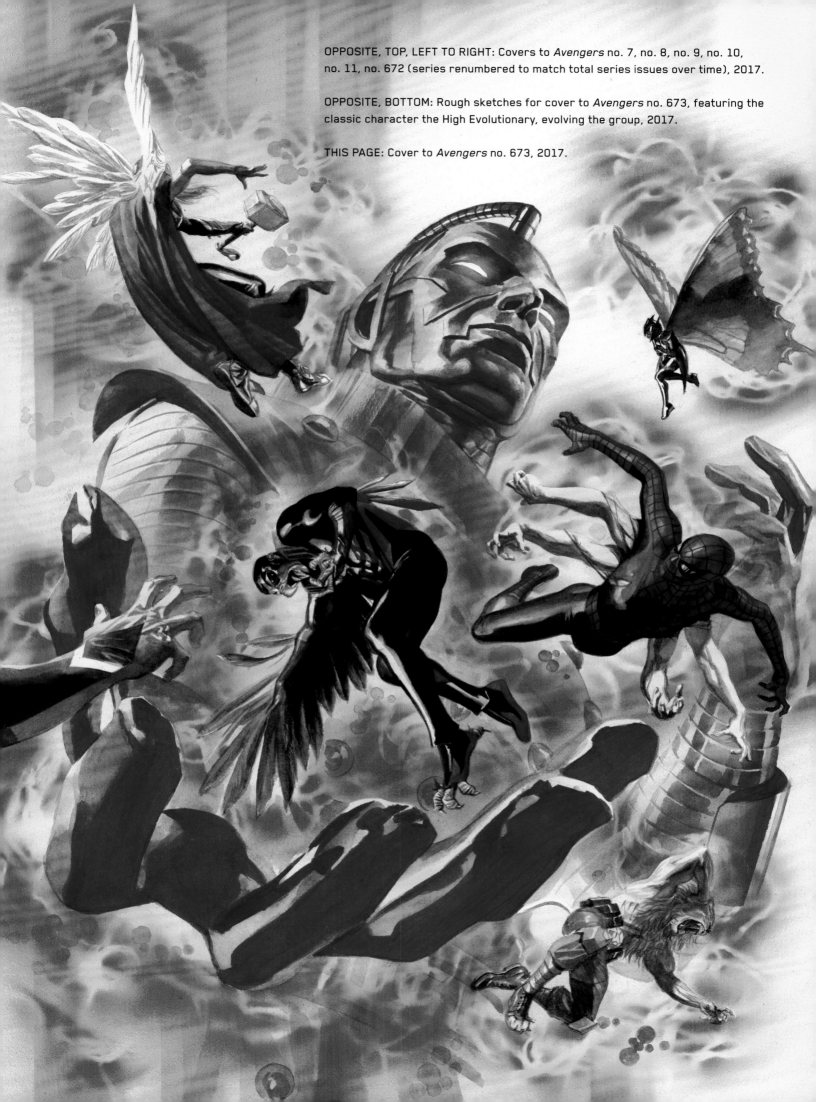

OPPOSITE, TOP, LEFT TO RIGHT: Covers to *Avengers* no. 7, no. 8, no. 9, no. 10, no. 11, no. 672 (series renumbered to match total series issues over time), 2017.

OPPOSITE, BOTTOM: Rough sketches for cover to *Avengers* no. 673, featuring the classic character the High Evolutionary, evolving the group, 2017.

THIS PAGE: Cover to *Avengers* no. 673, 2017.

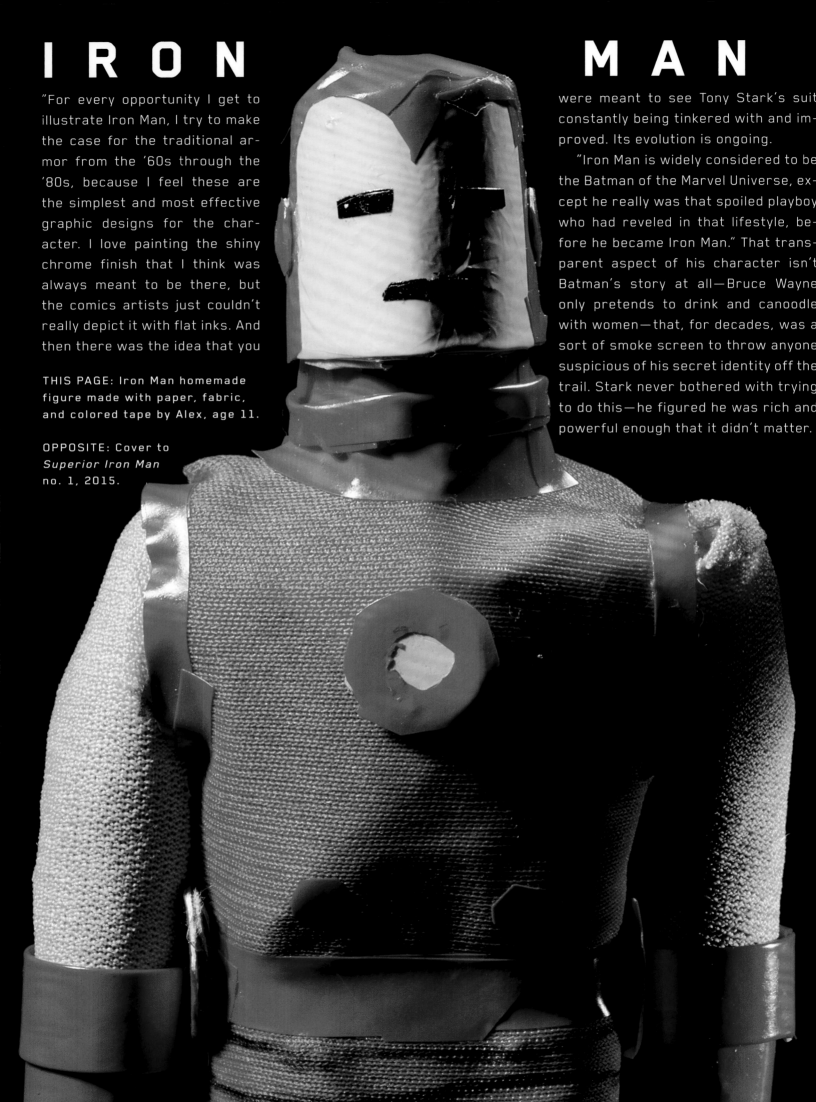

IRON MAN

"For every opportunity I get to illustrate Iron Man, I try to make the case for the traditional armor from the '60s through the '80s, because I feel these are the simplest and most effective graphic designs for the character. I love painting the shiny chrome finish that I think was always meant to be there, but the comics artists just couldn't really depict it with flat inks. And then there was the idea that you

THIS PAGE: Iron Man homemade figure made with paper, fabric, and colored tape by Alex, age 11.

OPPOSITE: Cover to *Superior Iron Man* no. 1, 2015.

were meant to see Tony Stark's suit constantly being tinkered with and improved. Its evolution is ongoing.

"Iron Man is widely considered to be the Batman of the Marvel Universe, except he really was that spoiled playboy who had reveled in that lifestyle, before he became Iron Man." That transparent aspect of his character isn't Batman's story at all—Bruce Wayne only pretends to drink and canoodle with women—that, for decades, was a sort of smoke screen to throw anyone suspicious of his secret identity off the trail. Stark never bothered with trying to do this—he figured he was rich and powerful enough that it didn't matter.

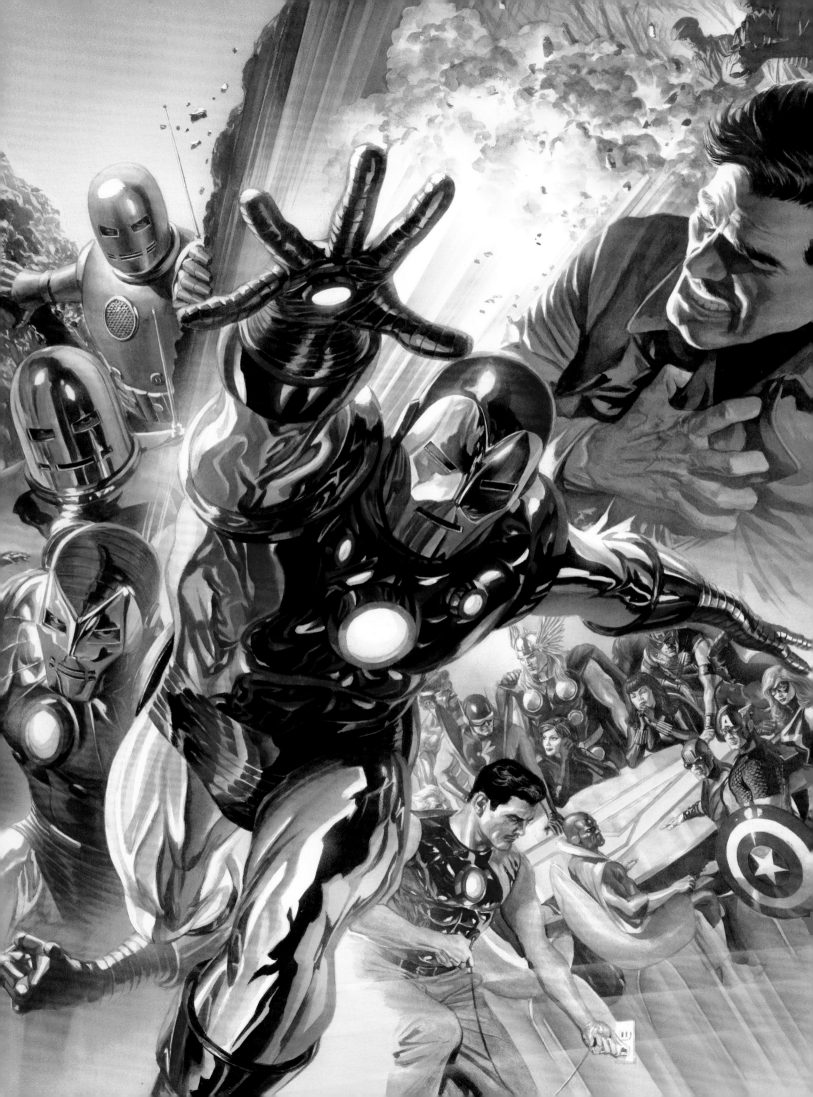

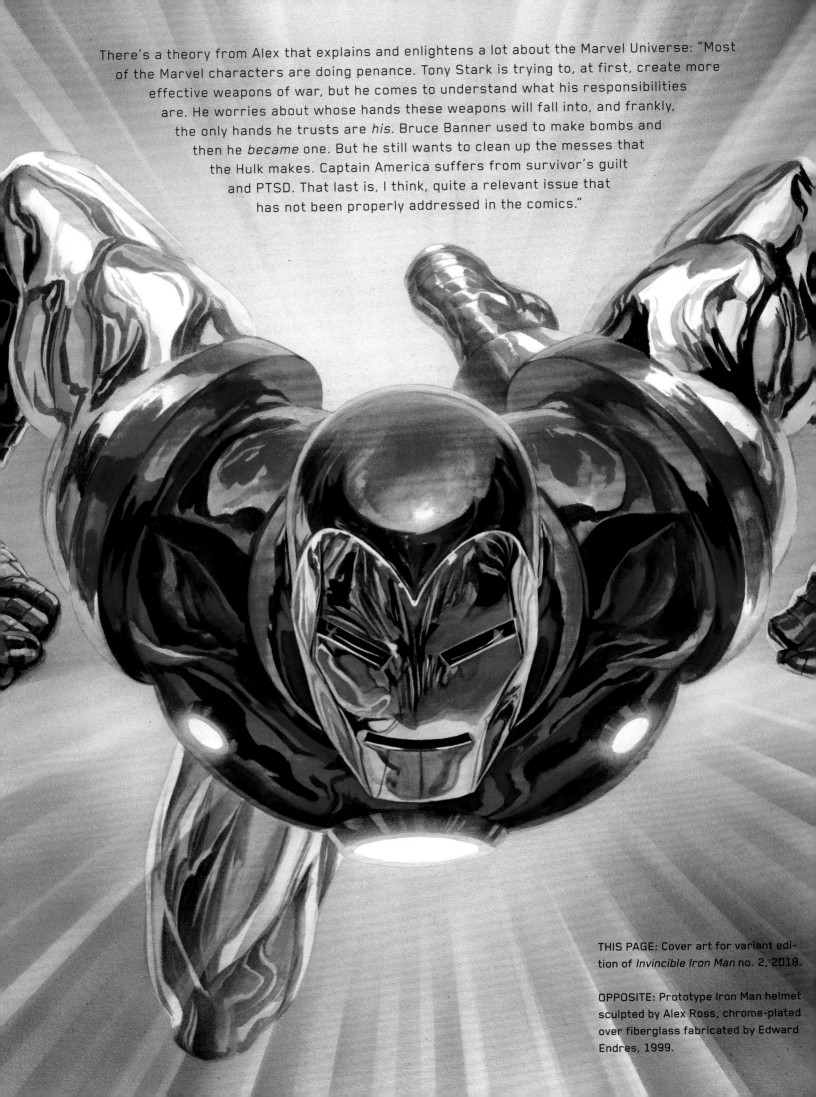

There's a theory from Alex that explains and enlightens a lot about the Marvel Universe: "Most of the Marvel characters are doing penance. Tony Stark is trying to, at first, create more effective weapons of war, but he comes to understand what his responsibilities are. He worries about whose hands these weapons will fall into, and frankly, the only hands he trusts are *his*. Bruce Banner used to make bombs and then he *became* one. But he still wants to clean up the messes that the Hulk makes. Captain America suffers from survivor's guilt and PTSD. That last is, I think, quite a relevant issue that has not been properly addressed in the comics."

THIS PAGE: Cover art for variant edition of *Invincible Iron Man* no. 2, 2018.

OPPOSITE: Prototype Iron Man helmet sculpted by Alex Ross, chrome-plated over fiberglass fabricated by Edward Endres, 1999.

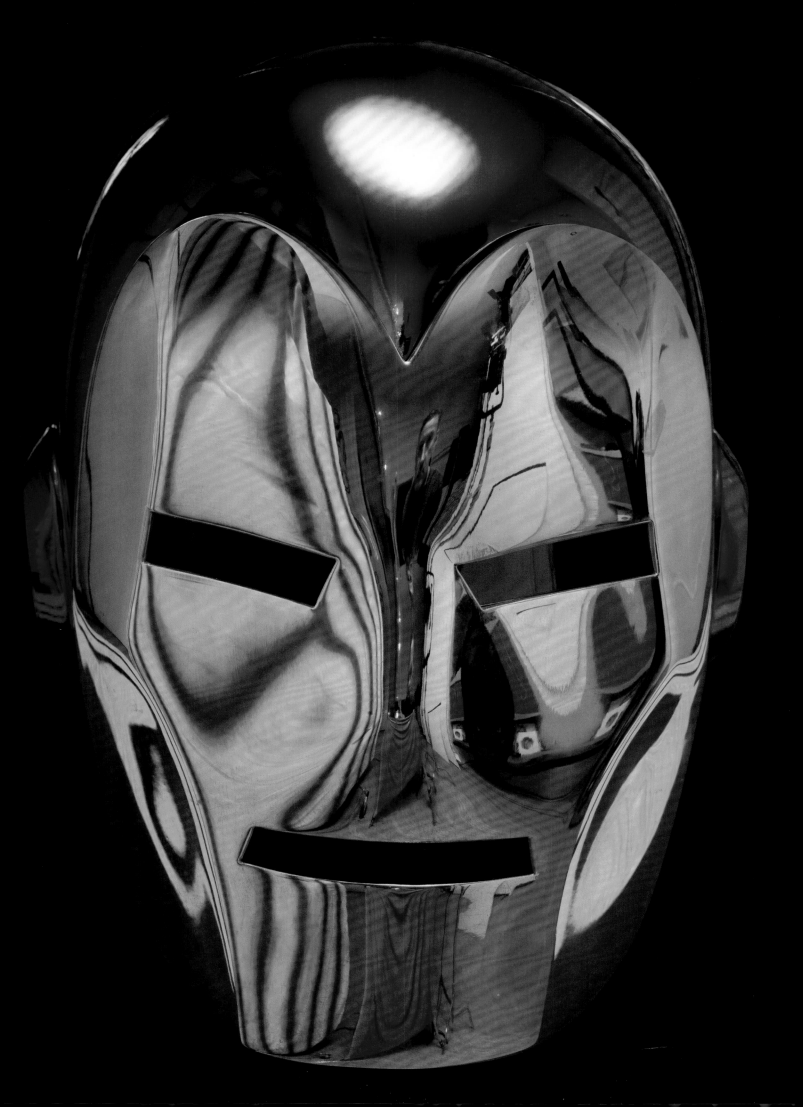

IRON MAN

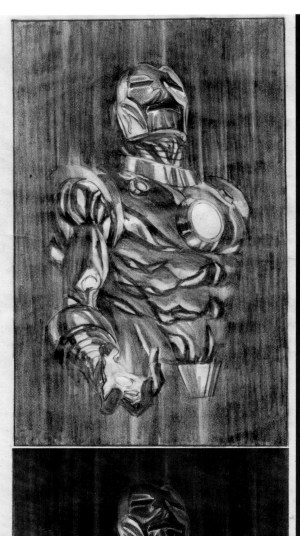

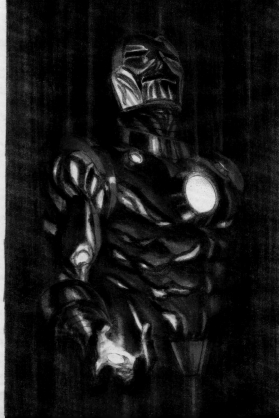

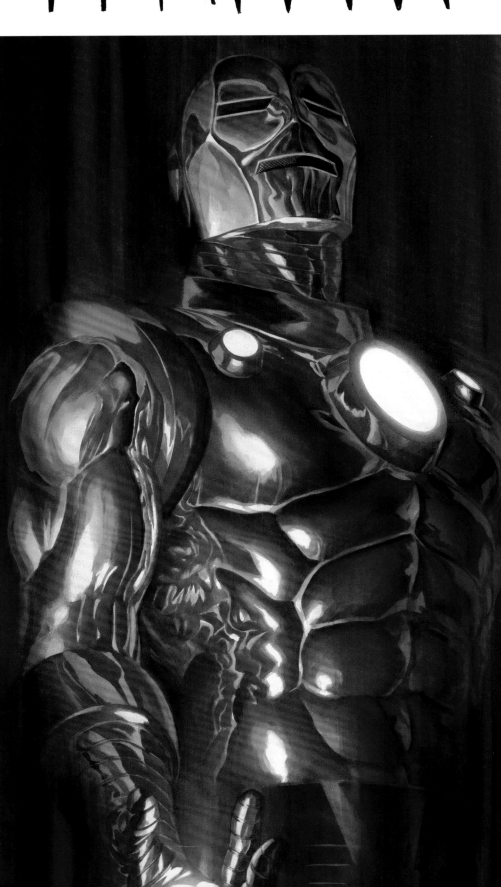

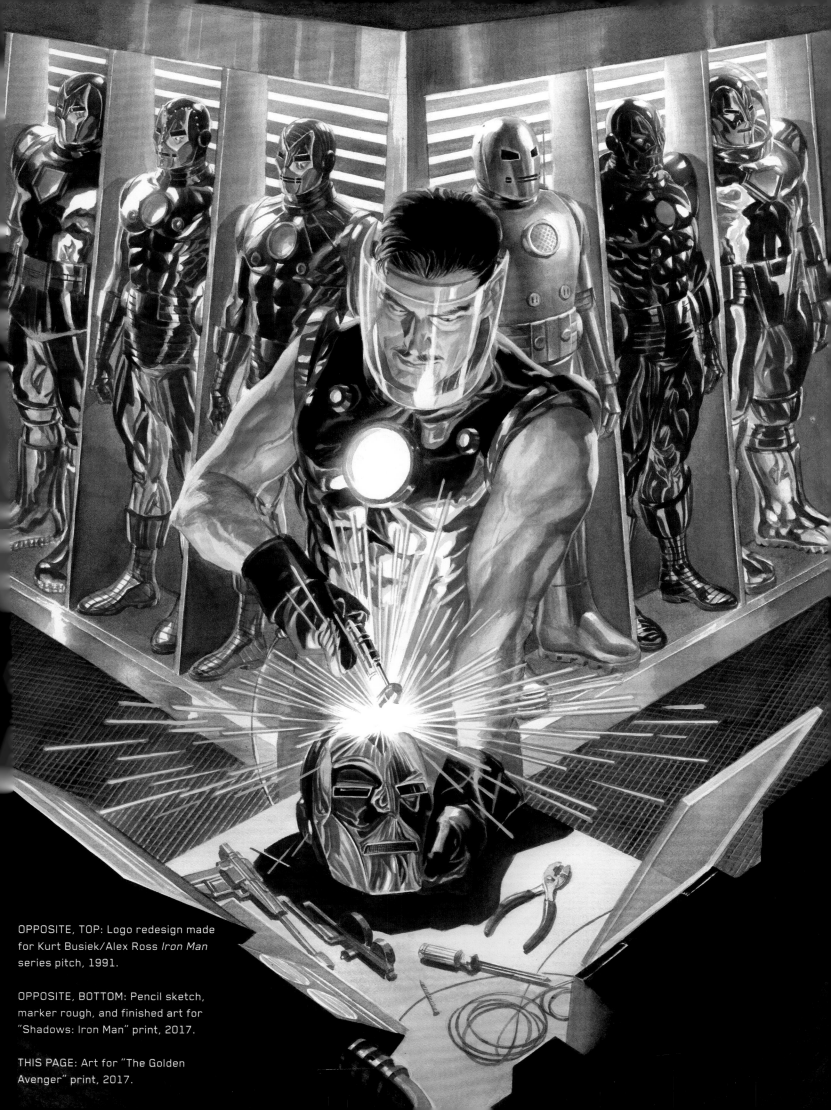

OPPOSITE, TOP: Logo redesign made for Kurt Busiek/Alex Ross *Iron Man* series pitch, 1991.

OPPOSITE, BOTTOM: Pencil sketch, marker rough, and finished art for "Shadows: Iron Man" print, 2017.

THIS PAGE: Art for "The Golden Avenger" print, 2017.

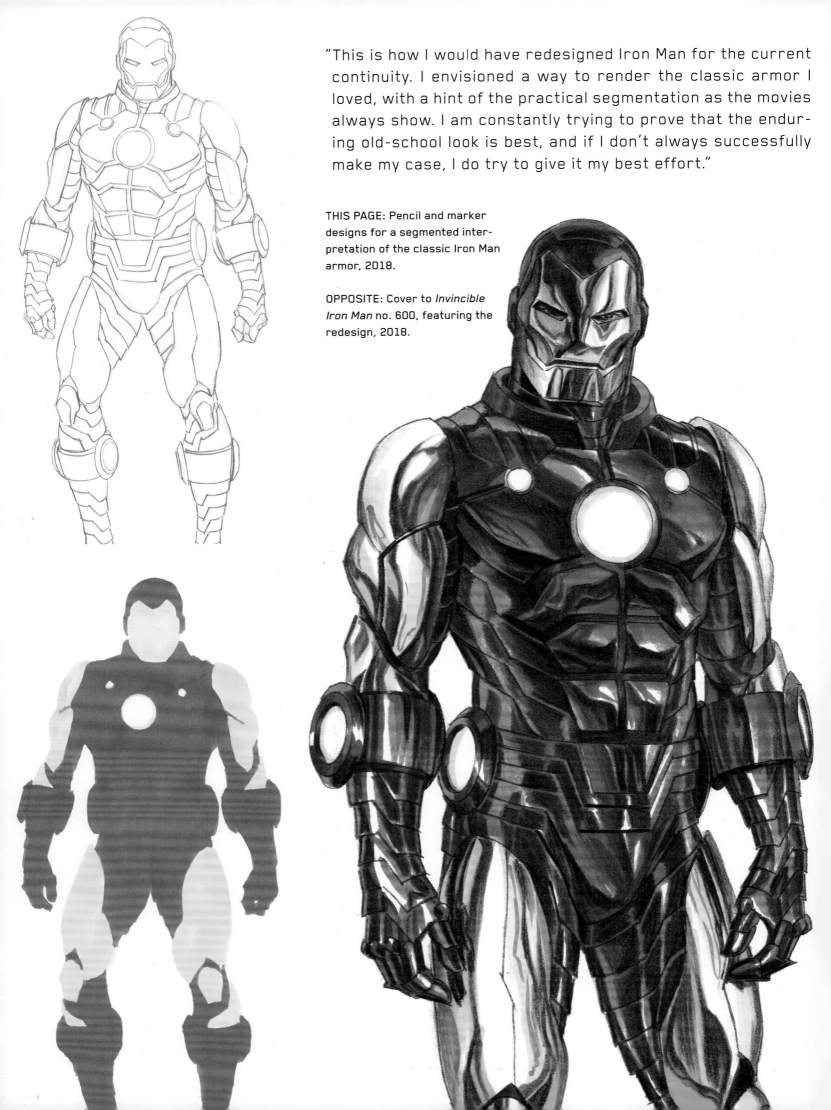

"This is how I would have redesigned Iron Man for the current continuity. I envisioned a way to render the classic armor I loved, with a hint of the practical segmentation as the movies always show. I am constantly trying to prove that the enduring old-school look is best, and if I don't always successfully make my case, I do try to give it my best effort."

THIS PAGE: Pencil and marker designs for a segmented interpretation of the classic Iron Man armor, 2018.

OPPOSITE: Cover to *Invincible Iron Man* no. 600, featuring the redesign, 2018.

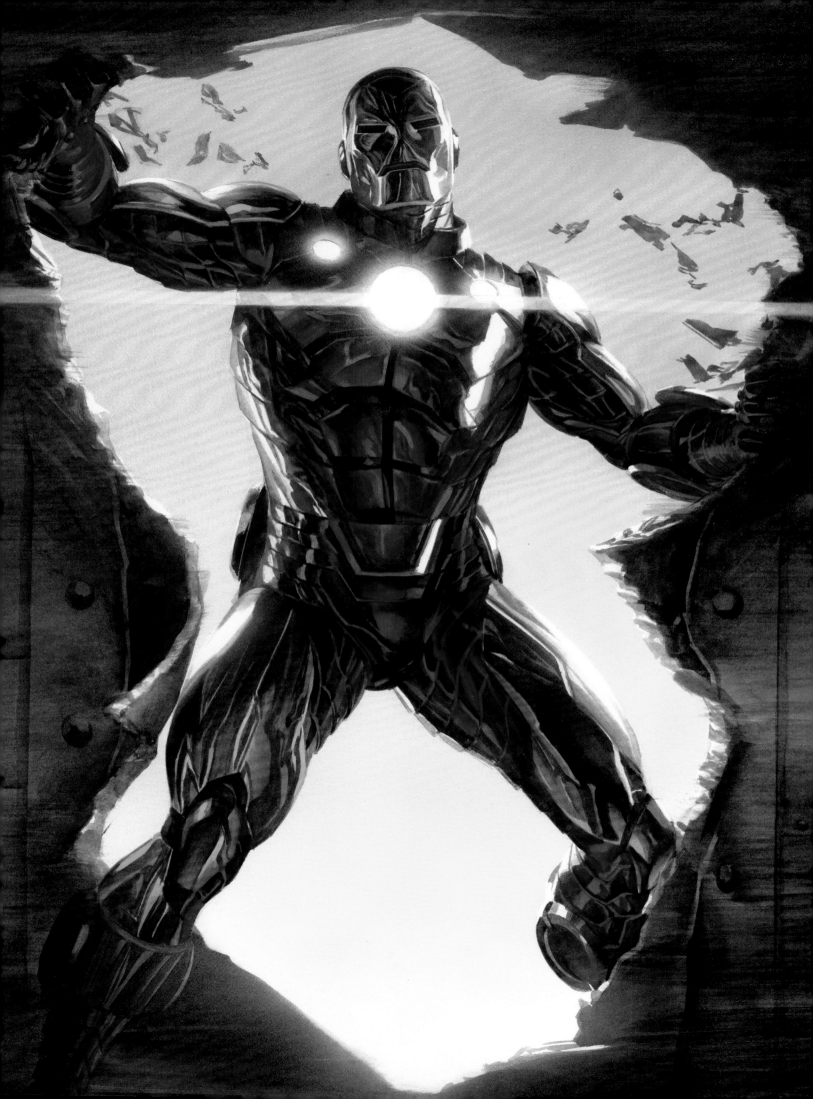

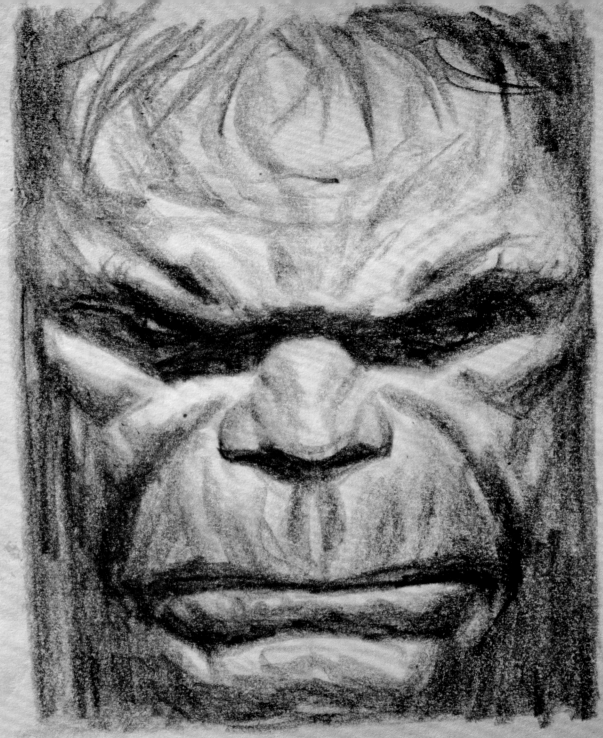

THE HULK

"I have one thing to say. No, three: Kirby, Kirby, Kirby. The massive physicality that we identify with the Hulk and the Thing is all because of Jack—you need his hand to make that work. The compressed body form he created, it's basically the world's most muscular giant baby shape. That was unique and so effective, no other comics artist could compete with it. It was the embodiment of brute energy, which was also infantilized in a way anyone could relate to. Who didn't, at some point in their childhood, feel persecuted or bullied or just too cooped up in some way that it just made you want to smash everything?"

The story of Dr. Bruce Banner and his angry, rampaging alter ego is a Jekyll and Hyde story for the Atomic Age. "Yes, it's the ego and the id, with our wanting to believe that might makes right. Which of course it doesn't. He's the strongest one there is, and yet he has a childlike simplicity that is truly poignant. He makes a lot of damage; but then again of course a *kid* can make a lot of damage."

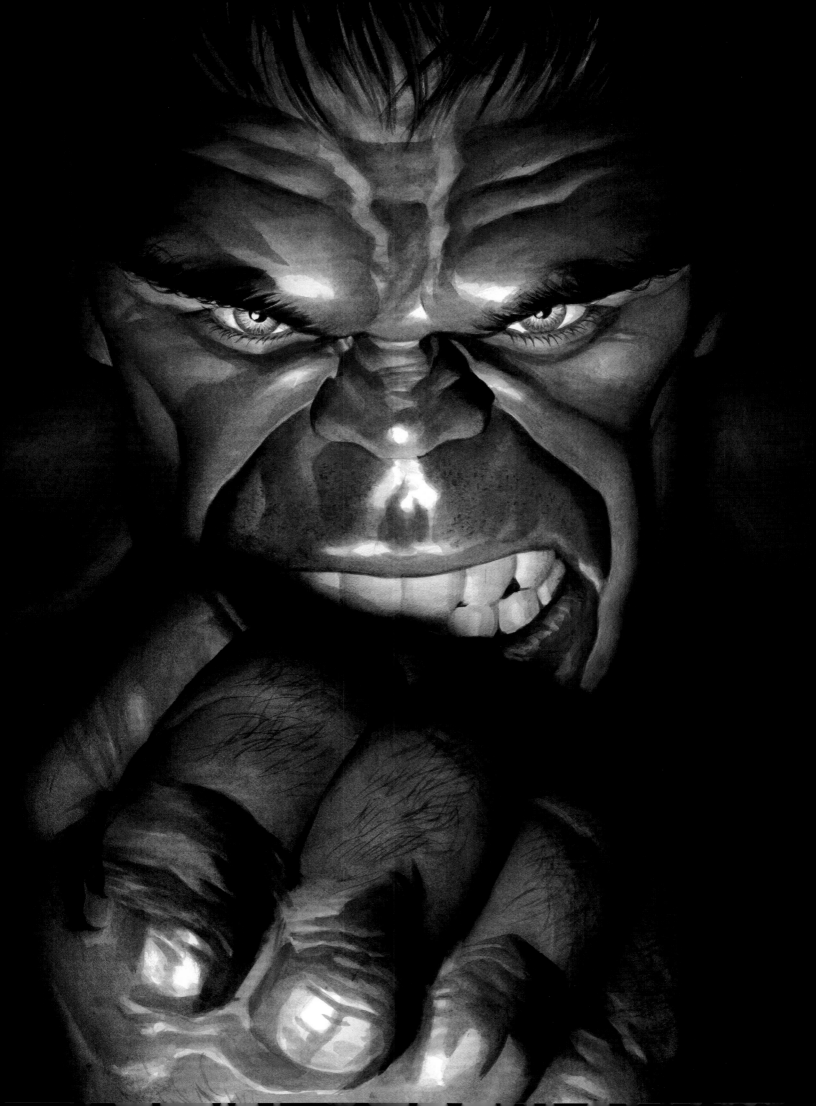

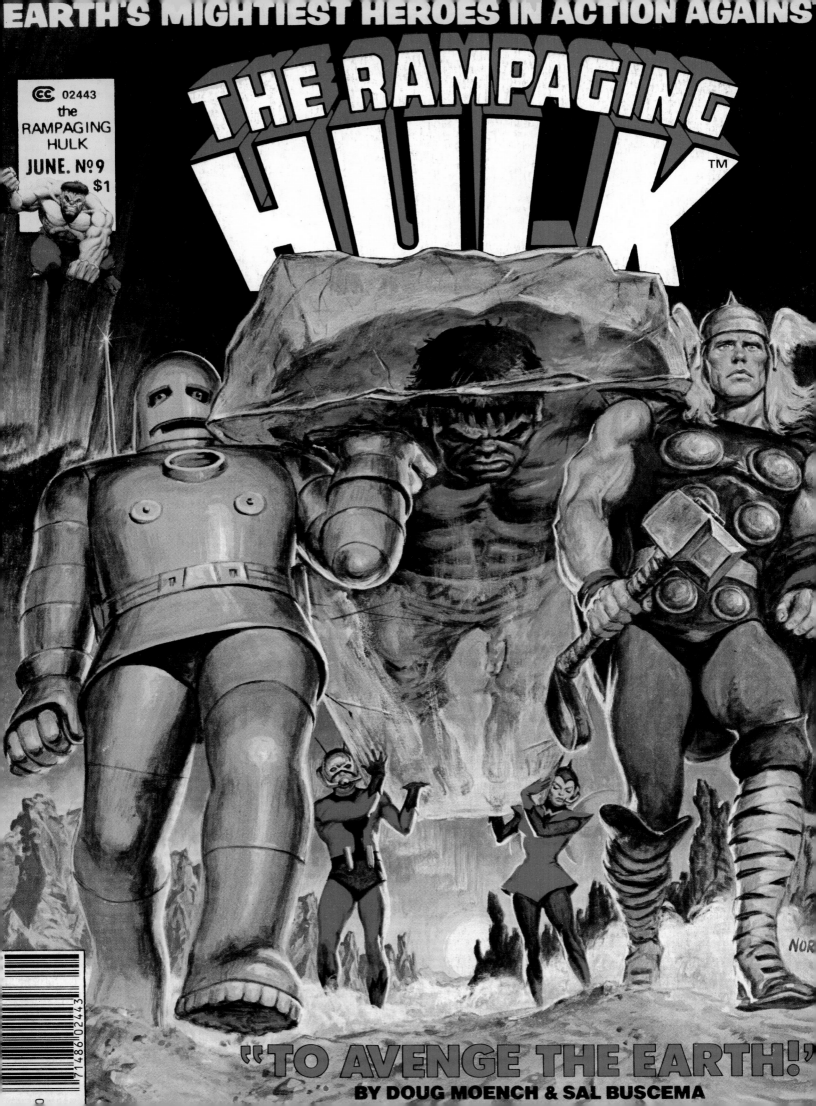

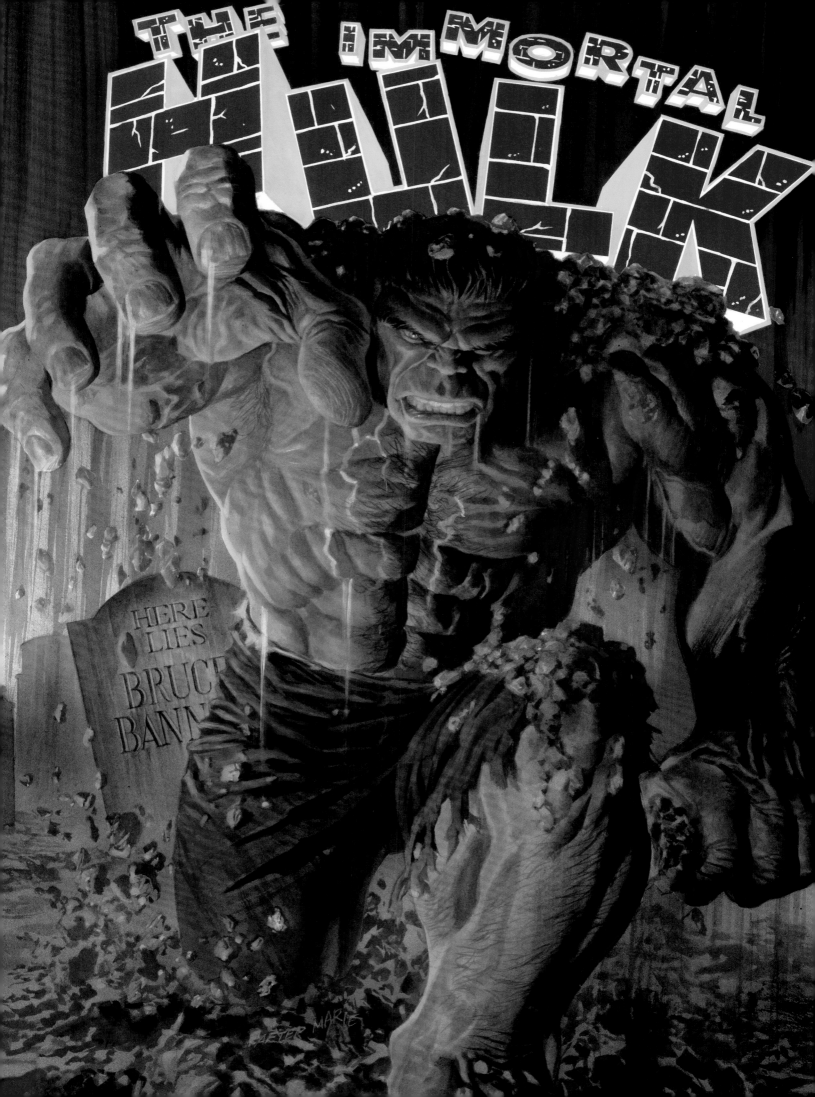

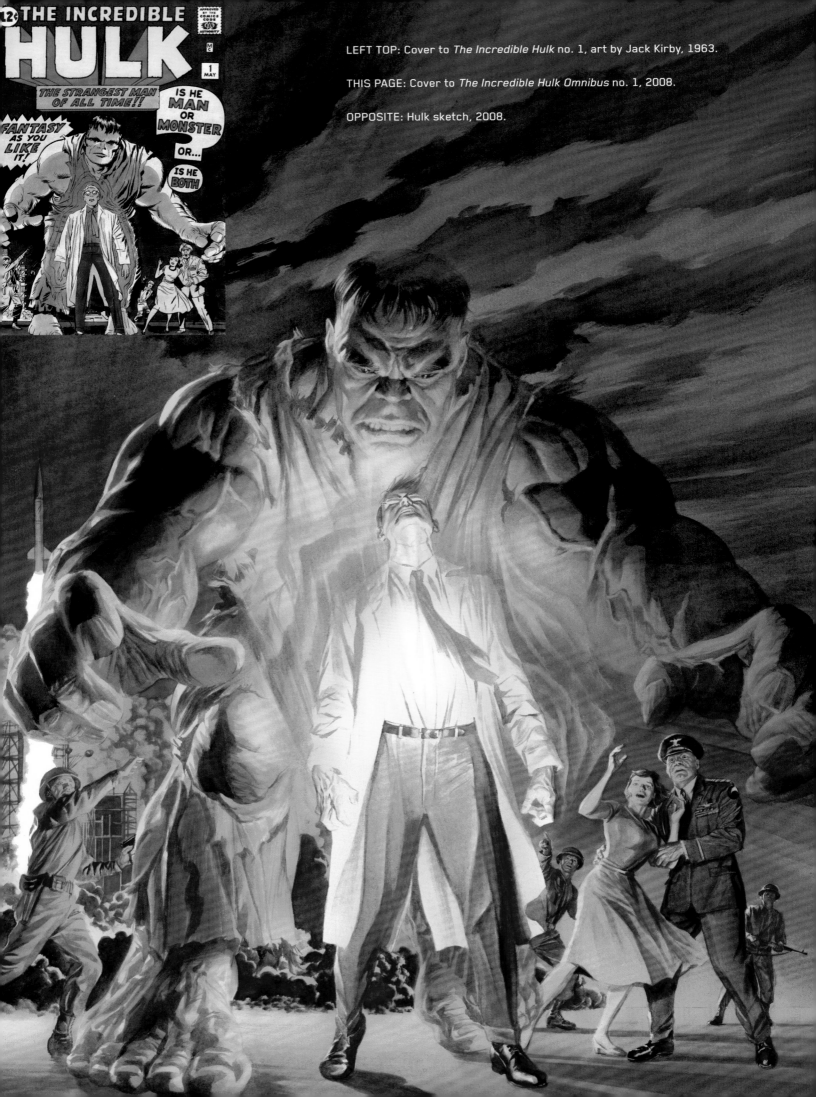

LEFT TOP: Cover to *The Incredible Hulk* no. 1, art by Jack Kirby, 1963.

THIS PAGE: Cover to *The Incredible Hulk Omnibus* no. 1, 2008.

OPPOSITE: Hulk sketch, 2008.

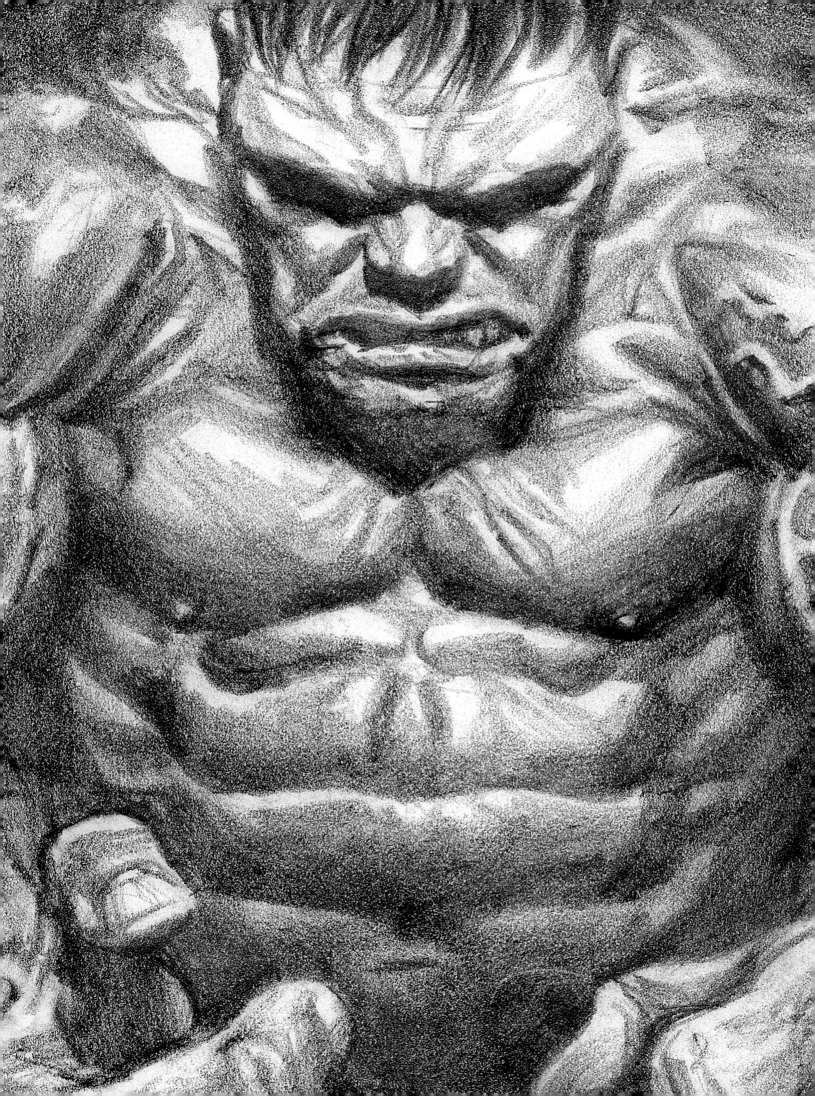

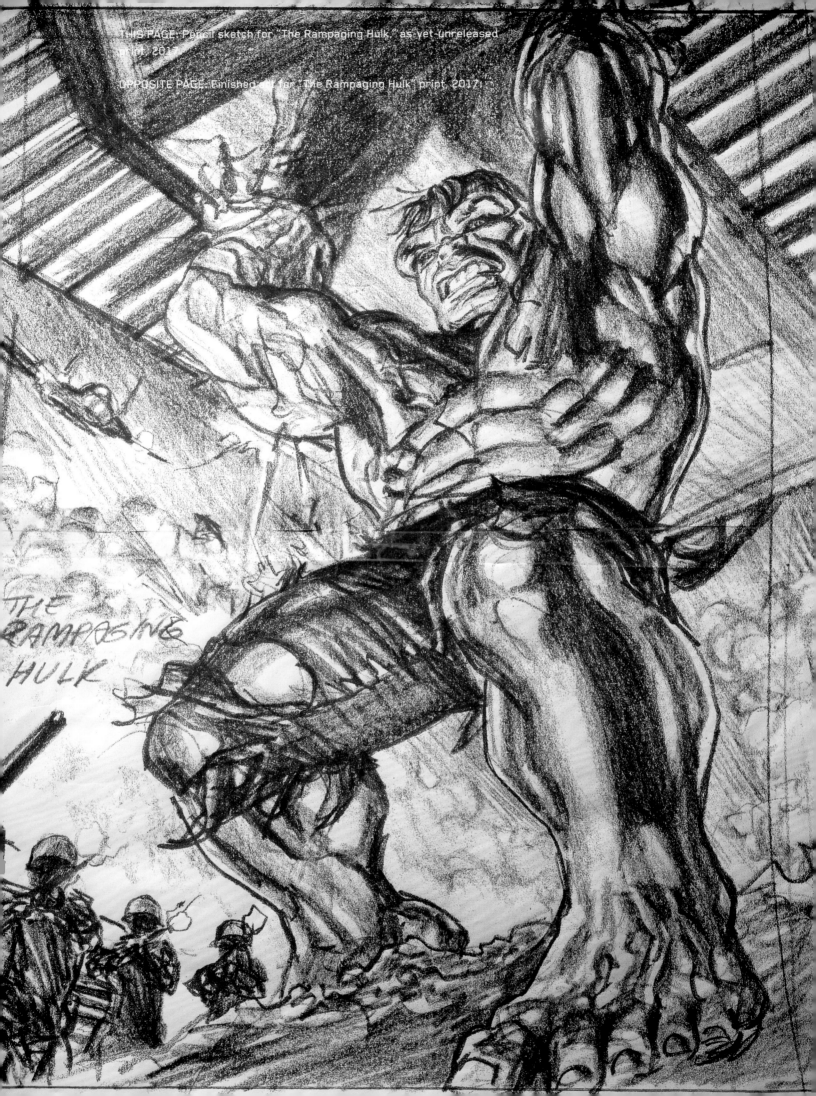

THE RAMPAGING HULK

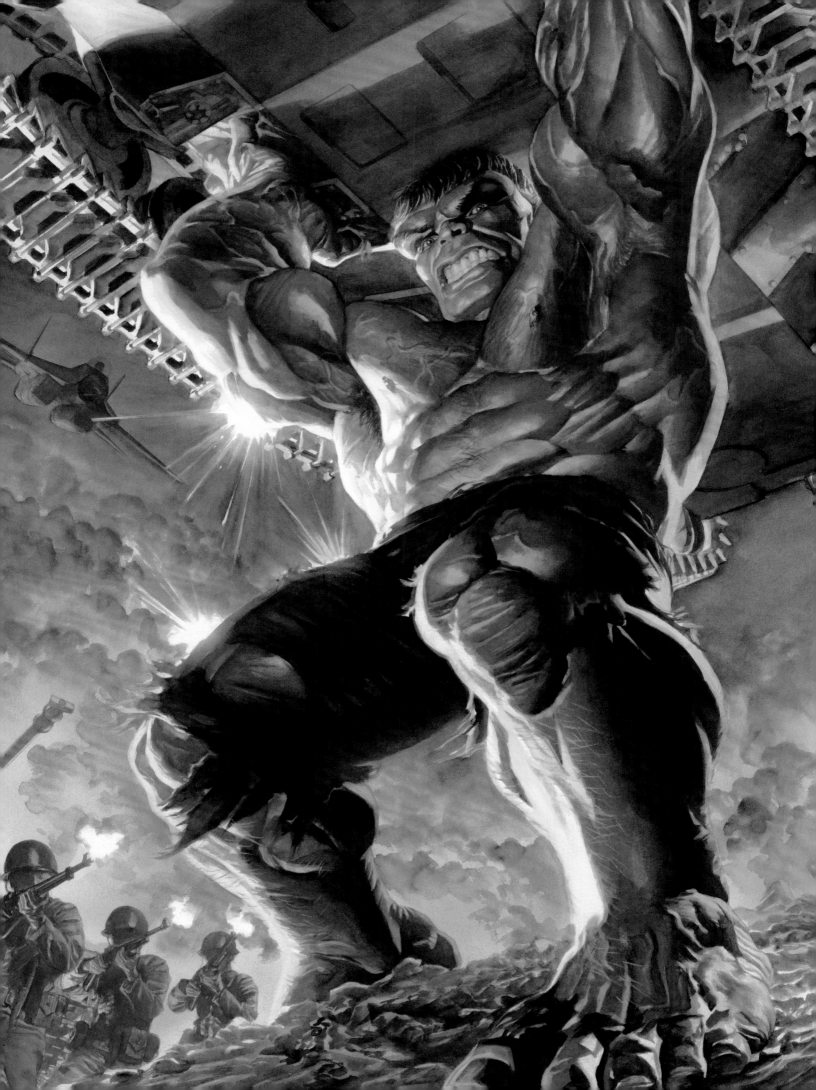

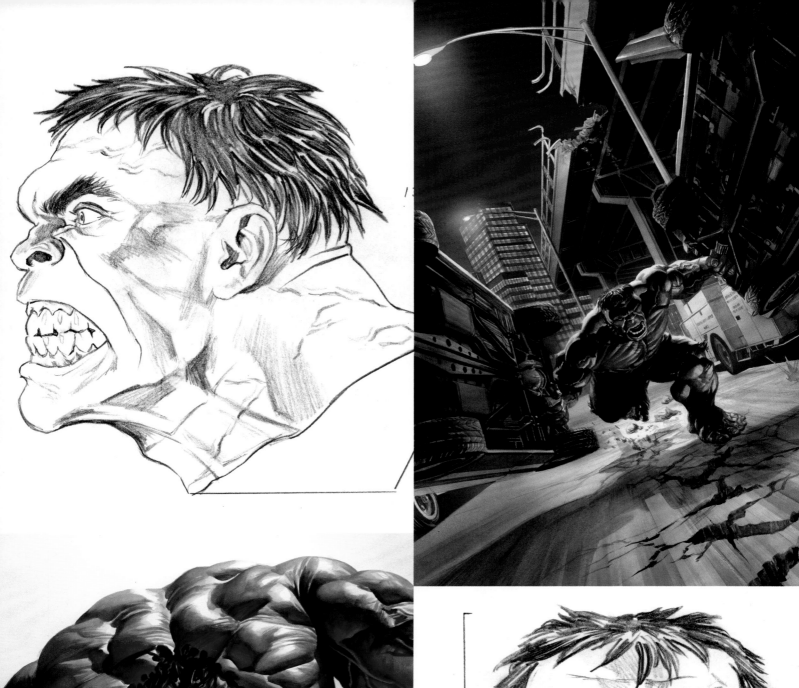
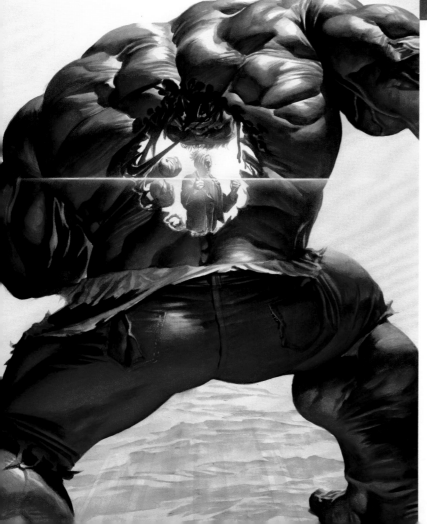
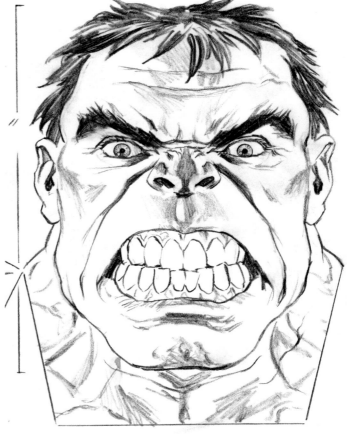

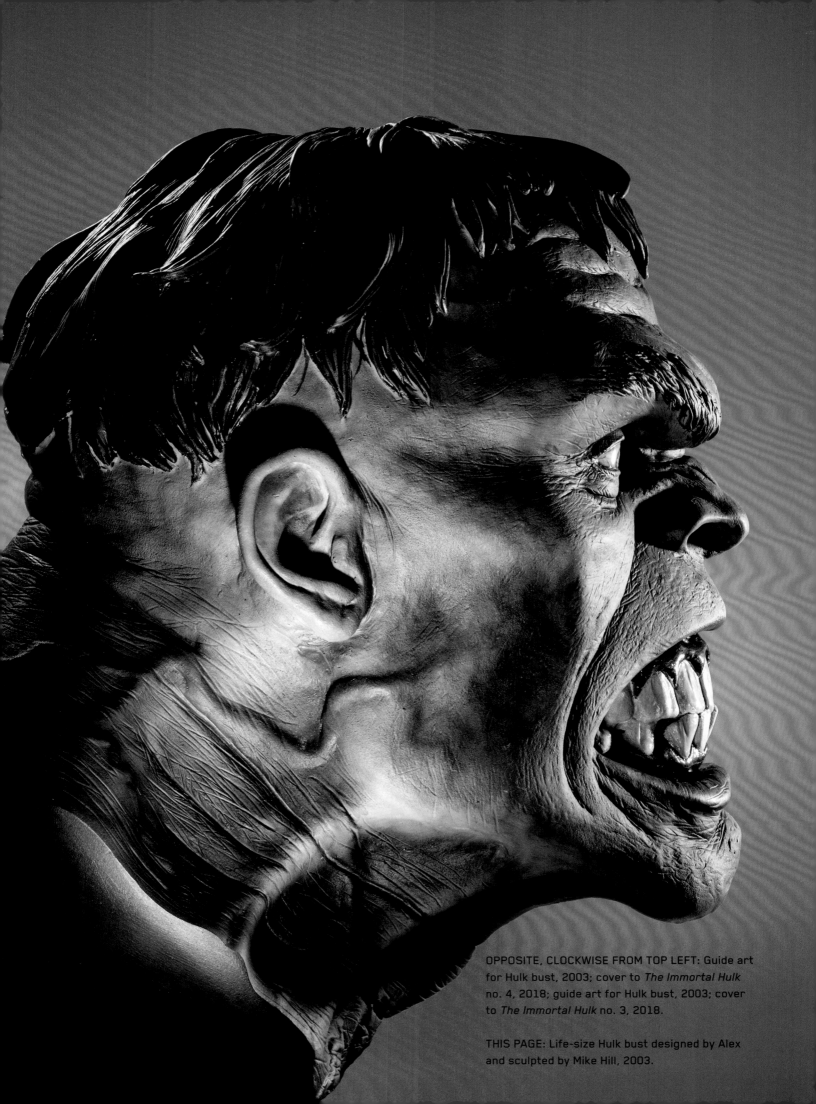

OPPOSITE, CLOCKWISE FROM TOP LEFT: Guide art for Hulk bust, 2003; cover to *The Immortal Hulk* no. 4, 2018; guide art for Hulk bust, 2003; cover to *The Immortal Hulk* no. 3, 2018.

THIS PAGE: Life-size Hulk bust designed by Alex and sculpted by Mike Hill, 2003.

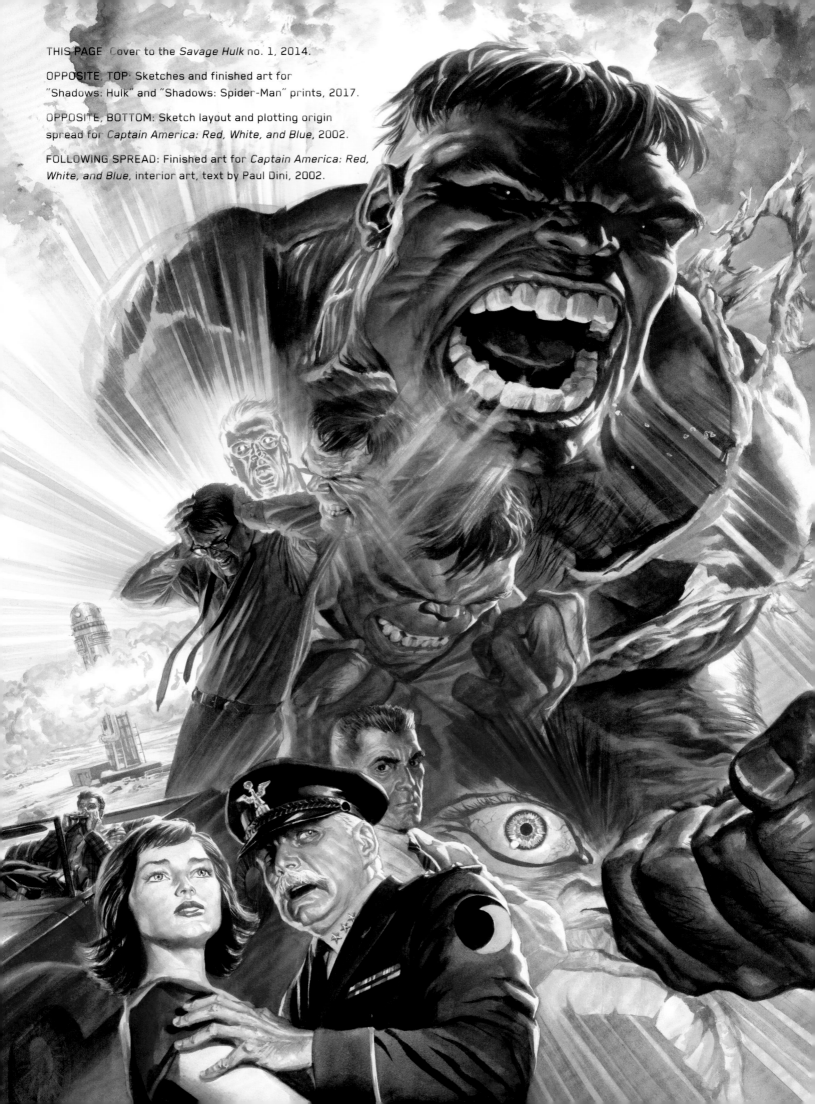

THIS PAGE Cover to the *Savage Hulk* no. 1, 2014.

OPPOSITE, TOP: Sketches and finished art for
"Shadows: Hulk" and "Shadows: Spider-Man" prints, 2017.

OPPOSITE, BOTTOM: Sketch layout and plotting origin
spread for *Captain America: Red, White, and Blue*, 2002.

FOLLOWING SPREAD: Finished art for *Captain America: Red,
White, and Blue*, interior art, text by Paul Dini, 2002.

NEW SHADOWS PIECE

MARVEL
THOR & HULK?
OR SPIDER-MAN?

SUPERGIRL & BATGIRL?
OR FLASH & GREEN LANTERN

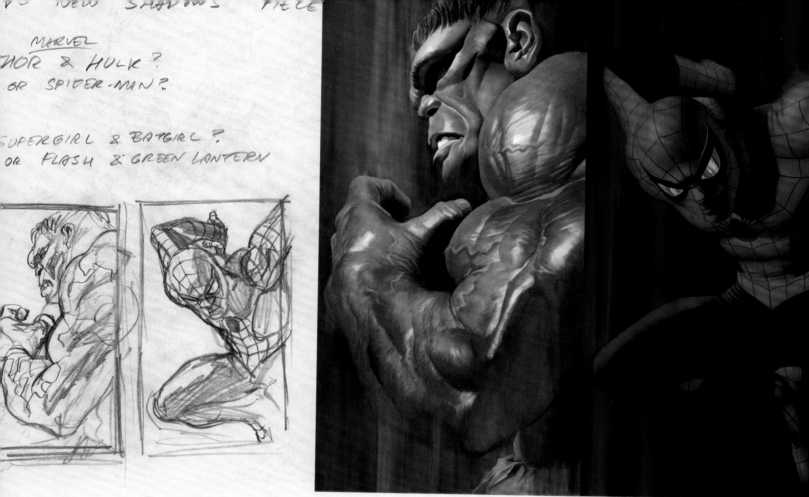

PANEL 1 — BIG BLUE SOLDIERS AT WAR SHOT

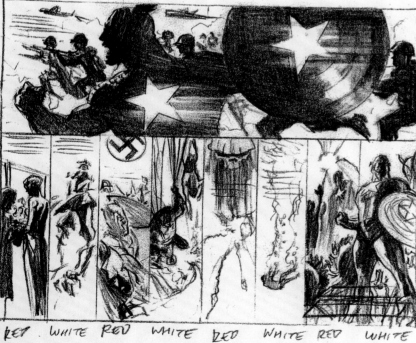

RED WHITE RED WHITE RED WHITE RED WHITE

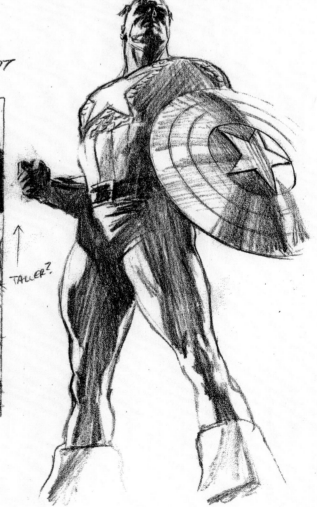

TALLER?

PANEL 2 — SERUM IS GIVEN TO SKINNY ROGERS
PANEL 3 — TRANSFORMING SHOT
PANEL 4 — AS CAP PUNCHING HITLER
PANEL 5 — CAP, BUCKY, NAMOR & TORCHES ATTACK NAZIS
PANEL 6 — SKULL LOOMS OVER ROCKET EXPLOSION
PANEL 7 — ROGERS BODY FALLS DEEP IN OCEAN
PANEL 8 — ESKIMOS W/ FROZEN IDOL
PANEL 9 — CAP W/ AVENGERS

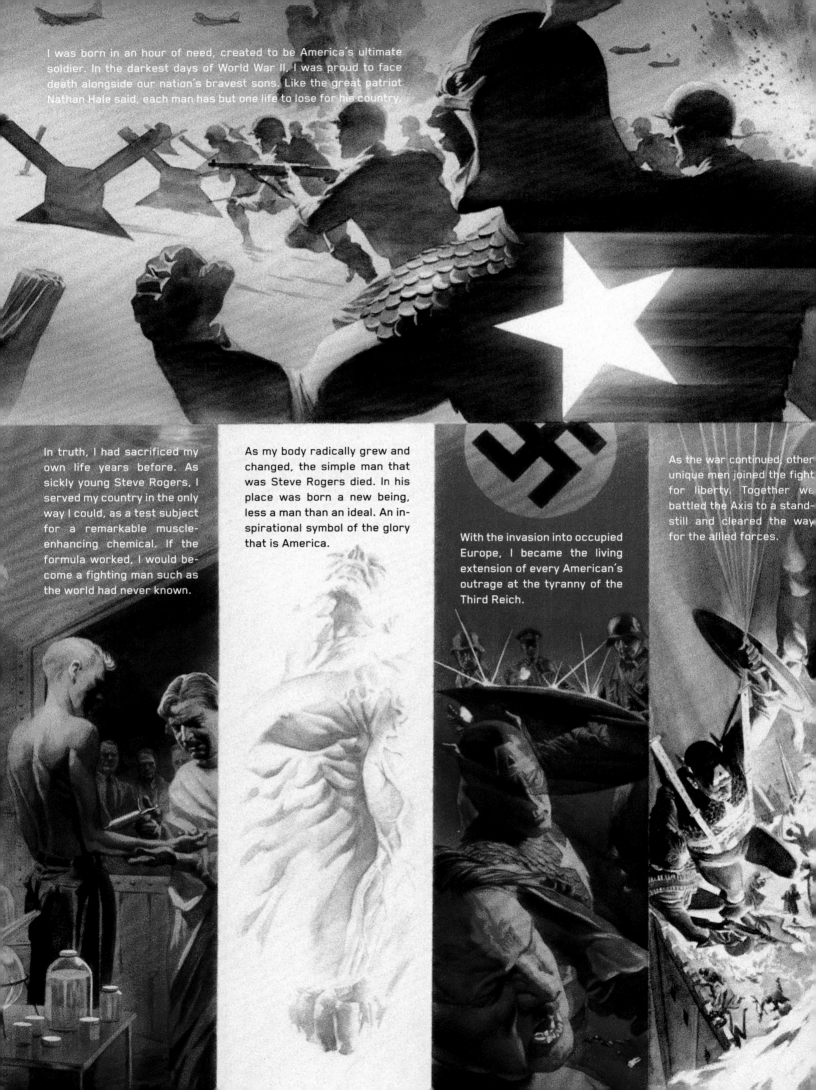

I was born in an hour of need, created to be America's ultimate soldier. In the darkest days of World War II, I was proud to face death alongside our nation's bravest sons. Like the great patriot Nathan Hale said, each man has but one life to lose for his country.

In truth, I had sacrificed my own life years before. As sickly young Steve Rogers, I served my country in the only way I could, as a test subject for a remarkable muscle-enhancing chemical. If the formula worked, I would become a fighting man such as the world had never known.

As my body radically grew and changed, the simple man that was Steve Rogers died. In his place was born a new being, less a man than an ideal. An inspirational symbol of the glory that is America.

With the invasion into occupied Europe, I became the living extension of every American's outrage at the tyranny of the Third Reich.

As the war continued, other unique men joined the fight for liberty. Together we battled the Axis to a stand-still and cleared the way for the allied forces.

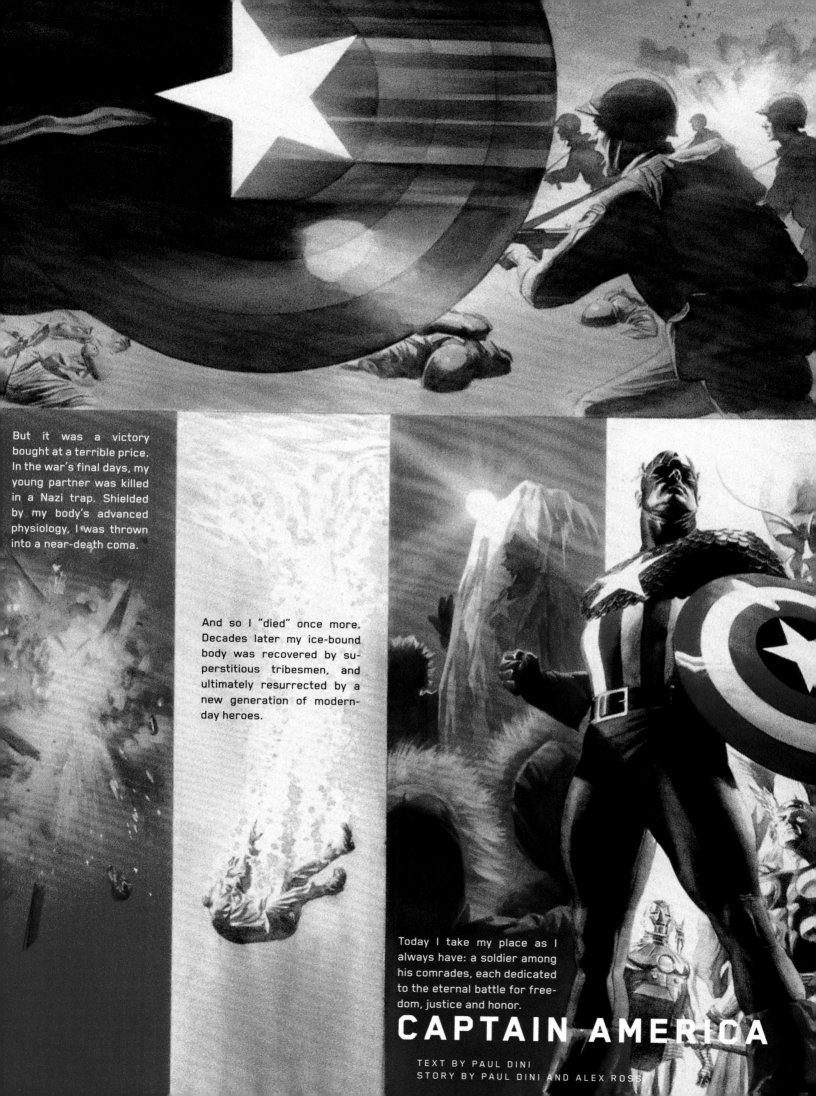

But it was a victory bought at a terrible price. In the war's final days, my young partner was killed in a Nazi trap. Shielded by my body's advanced physiology, I was thrown into a near-death coma.

And so I "died" once more. Decades later my ice-bound body was recovered by superstitious tribesmen, and ultimately resurrected by a new generation of modern-day heroes.

Today I take my place as I always have: a soldier among his comrades, each dedicated to the eternal battle for freedom, justice and honor.

CAPTAIN AMERICA

TEXT BY PAUL DINI
STORY BY PAUL DINI AND ALEX ROSS

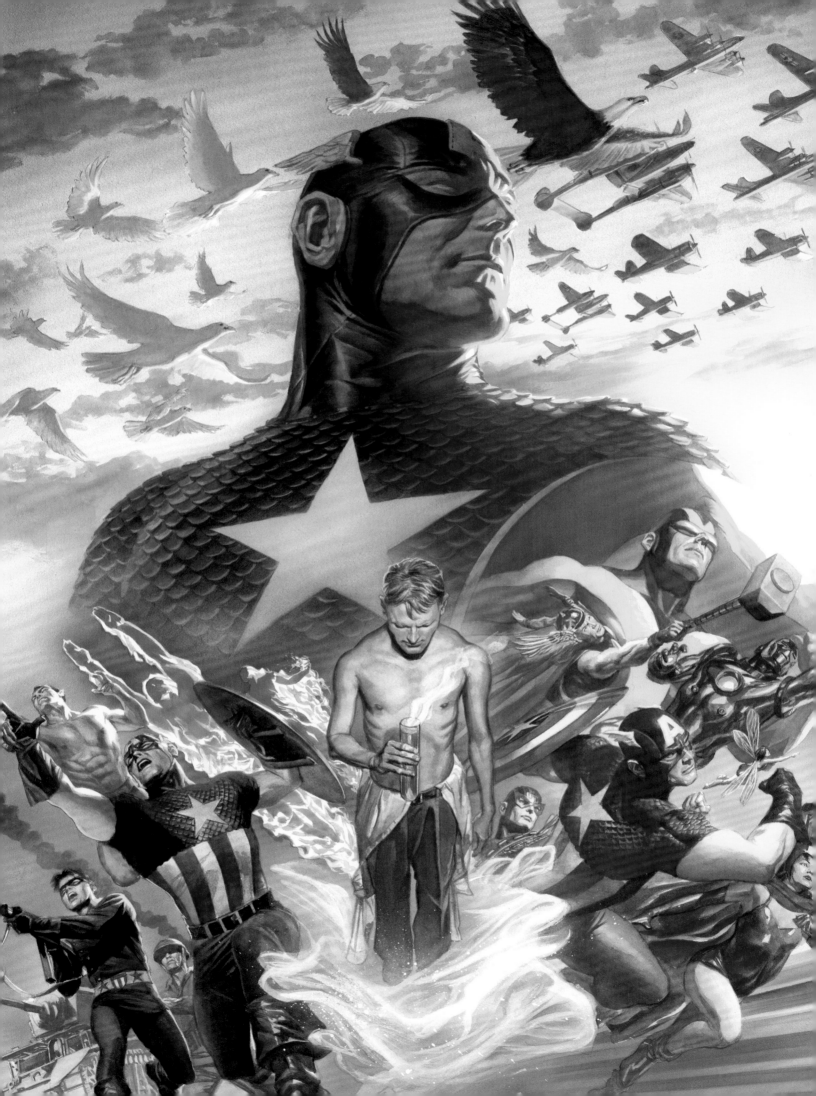

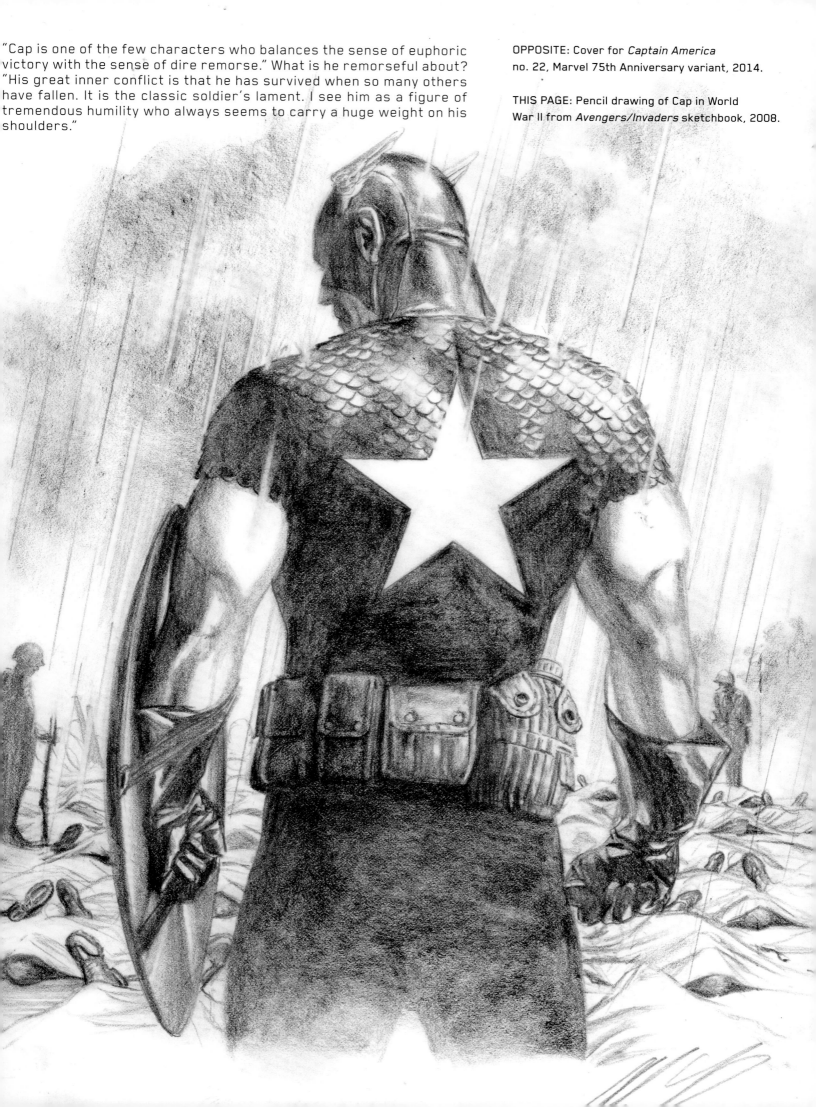

"Cap is one of the few characters who balances the sense of euphoric victory with the sense of dire remorse." What is he remorseful about? "His great inner conflict is that he has survived when so many others have fallen. It is the classic soldier's lament. I see him as a figure of tremendous humility who always seems to carry a huge weight on his shoulders."

OPPOSITE: Cover for *Captain America* no. 22, Marvel 75th Anniversary variant, 2014.

THIS PAGE: Pencil drawing of Cap in World War II from *Avengers/Invaders* sketchbook, 2008.

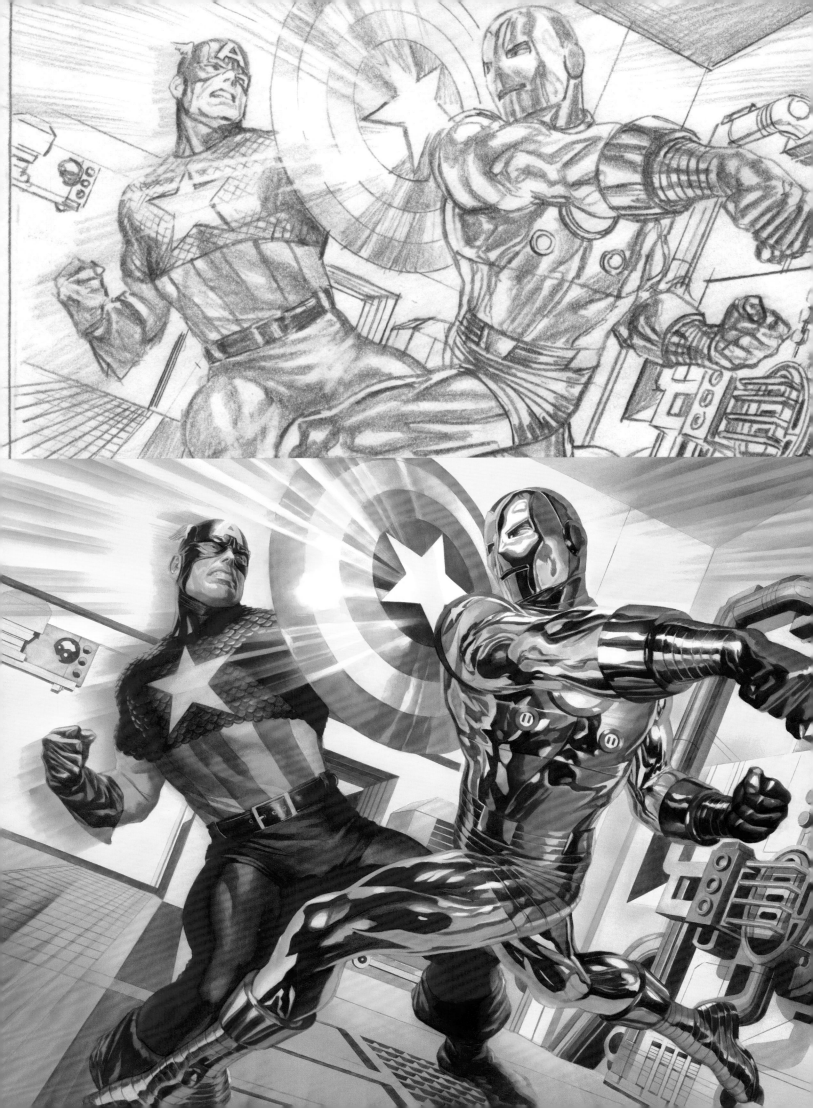

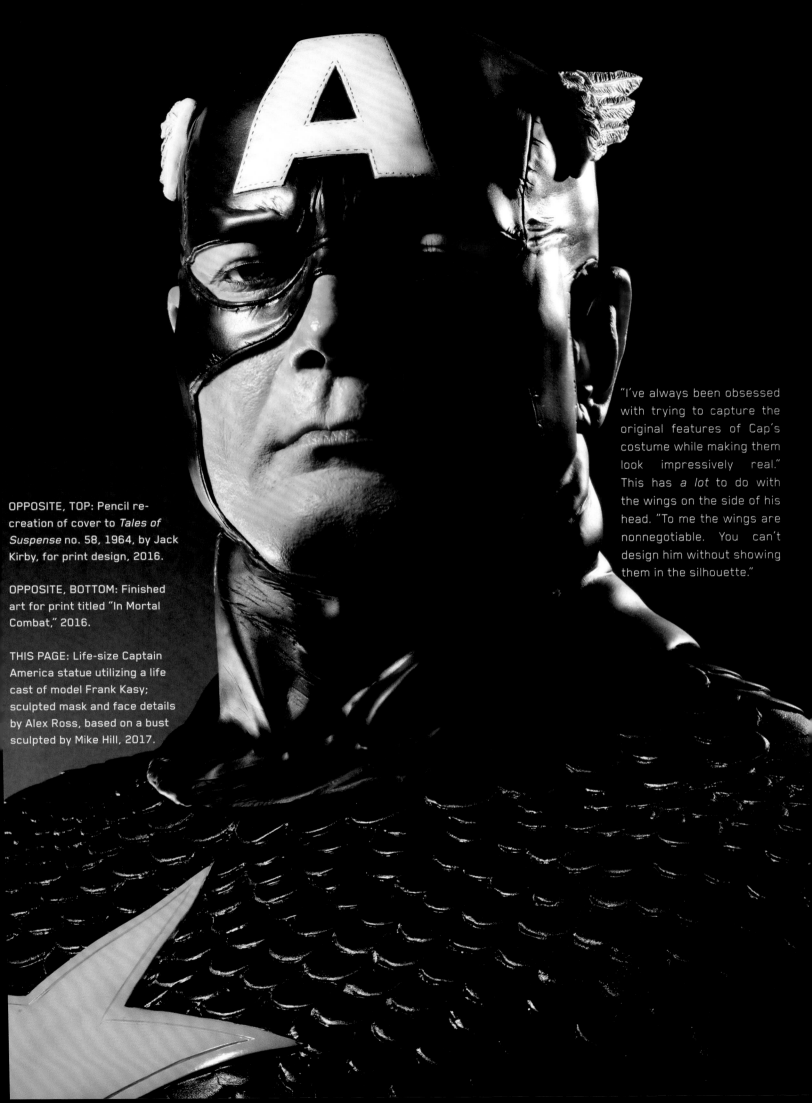

OPPOSITE, TOP: Pencil re-creation of cover to *Tales of Suspense* no. 58, 1964, by Jack Kirby, for print design, 2016.

OPPOSITE, BOTTOM: Finished art for print titled "In Mortal Combat," 2016.

THIS PAGE: Life-size Captain America statue utilizing a life cast of model Frank Kasy; sculpted mask and face details by Alex Ross, based on a bust sculpted by Mike Hill, 2017.

"I've always been obsessed with trying to capture the original features of Cap's costume while making them look impressively real." This has *a lot* to do with the wings on the side of his head. "To me the wings are nonnegotiable. You can't design him without showing them in the silhouette."

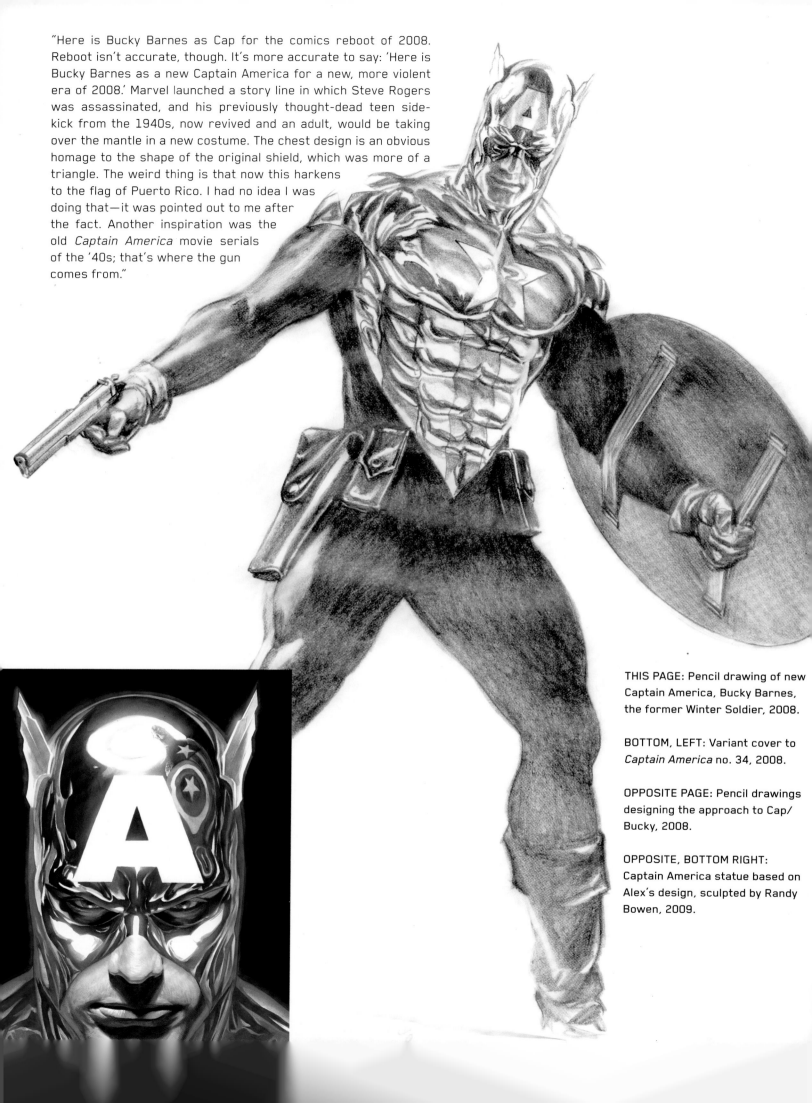

"Here is Bucky Barnes as Cap for the comics reboot of 2008. Reboot isn't accurate, though. It's more accurate to say: 'Here is Bucky Barnes as a new Captain America for a new, more violent era of 2008.' Marvel launched a story line in which Steve Rogers was assassinated, and his previously thought-dead teen sidekick from the 1940s, now revived and an adult, would be taking over the mantle in a new costume. The chest design is an obvious homage to the shape of the original shield, which was more of a triangle. The weird thing is that now this harkens to the flag of Puerto Rico. I had no idea I was doing that—it was pointed out to me after the fact. Another inspiration was the old *Captain America* movie serials of the '40s; that's where the gun comes from."

THIS PAGE: Pencil drawing of new Captain America, Bucky Barnes, the former Winter Soldier, 2008.

BOTTOM, LEFT: Variant cover to *Captain America* no. 34, 2008.

OPPOSITE PAGE: Pencil drawings designing the approach to Cap/Bucky, 2008.

OPPOSITE, BOTTOM RIGHT: Captain America statue based on Alex's design, sculpted by Randy Bowen, 2009.

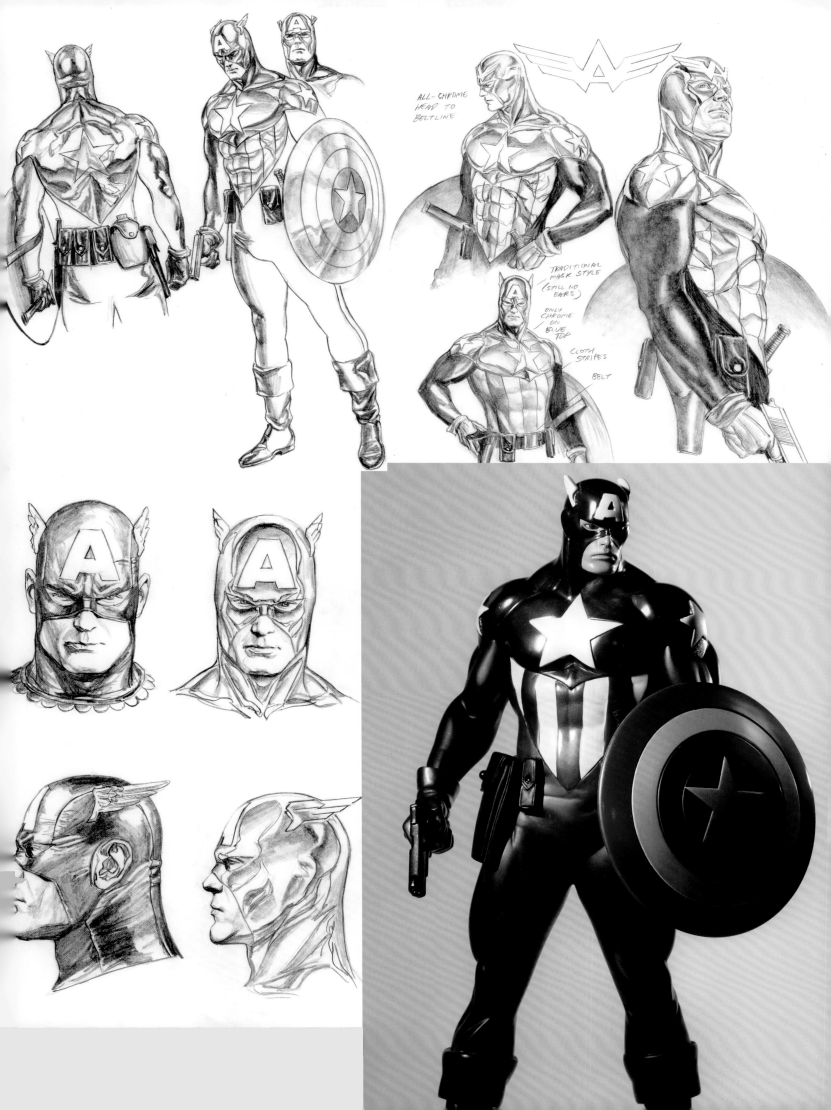

ALL-CHROME
HEAD TO
BELTLINE

TRADITIONAL
MASK STYLE
(STILL NO
EARS)

ONLY
CHROME
ON
BLUE
TOP

CLOTH
STRIPES

BELT

THIS PAGE, CLOCKWISE: Covers to *Captain America* no. 34, 2008; *Wizard* no. 220, 2010; *Avengers/Invaders* no. 7, 2009.

OPPOSITE PAGE: Cover to *Captain America: Reborn* no. 1, 2009.

FOLLOWING SPREAD: Wraparound cover (inspired by Jim Steranko) for *Captain America* no. 1, featuring Cap's allies the Invaders and Falcon, and his enemies—Red Skull, a Hydra agent and robot, A.I.M., Baron Zemo, the Sleeper, the Living Laser, Batroc, the Swordsman, the Acrobat, and the Trapster, 2018.

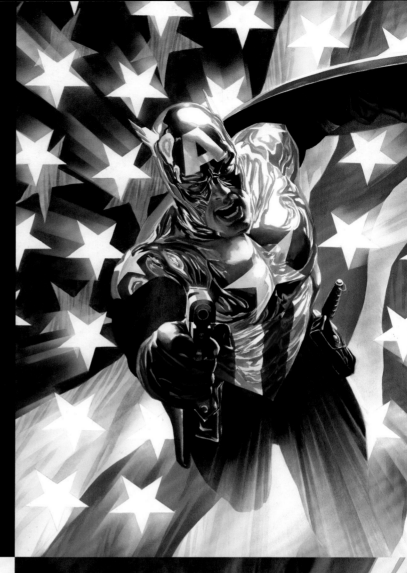

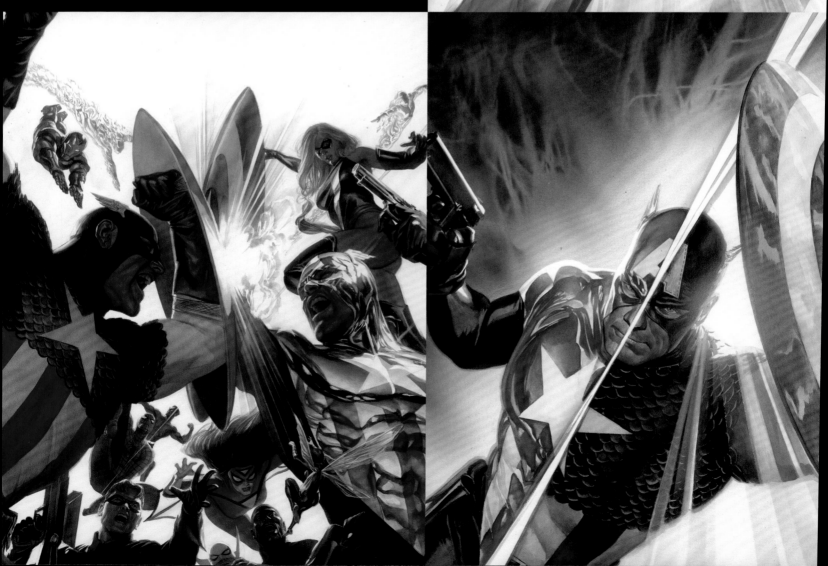

"This is meant to be an assault, an expression of exuberance that Cap feels upon returning. It's the Cap who is sturdy, stronger, more vital. He needs to look like the American Flag personified. The screaming is a release, a triumphant rise from the grave."

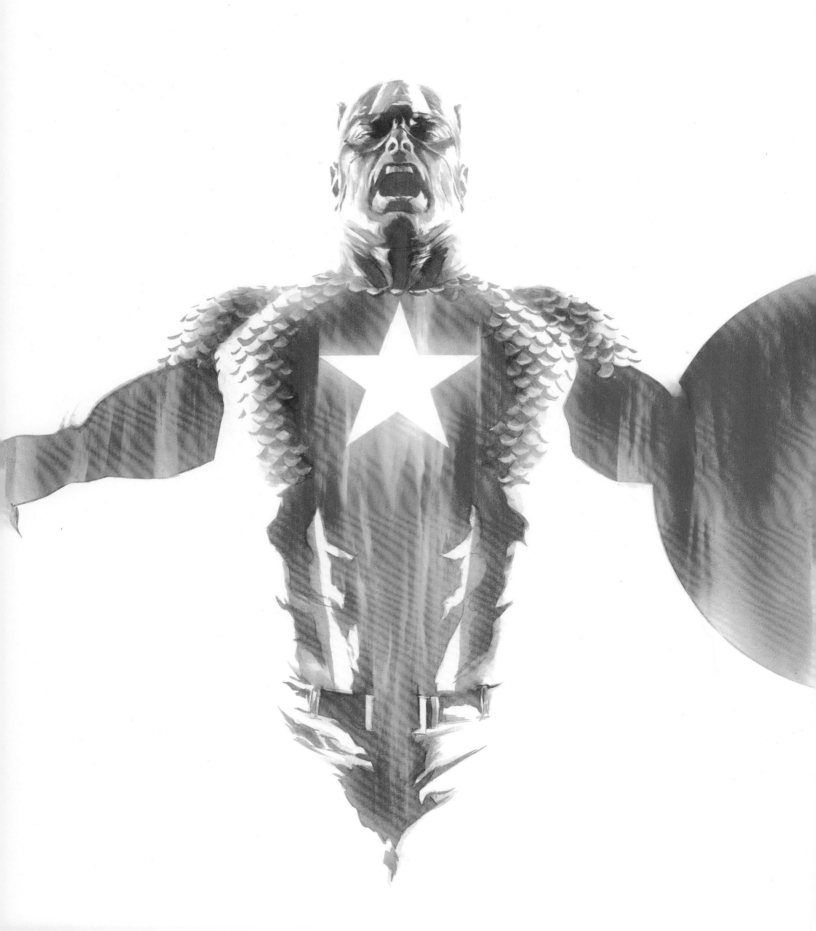

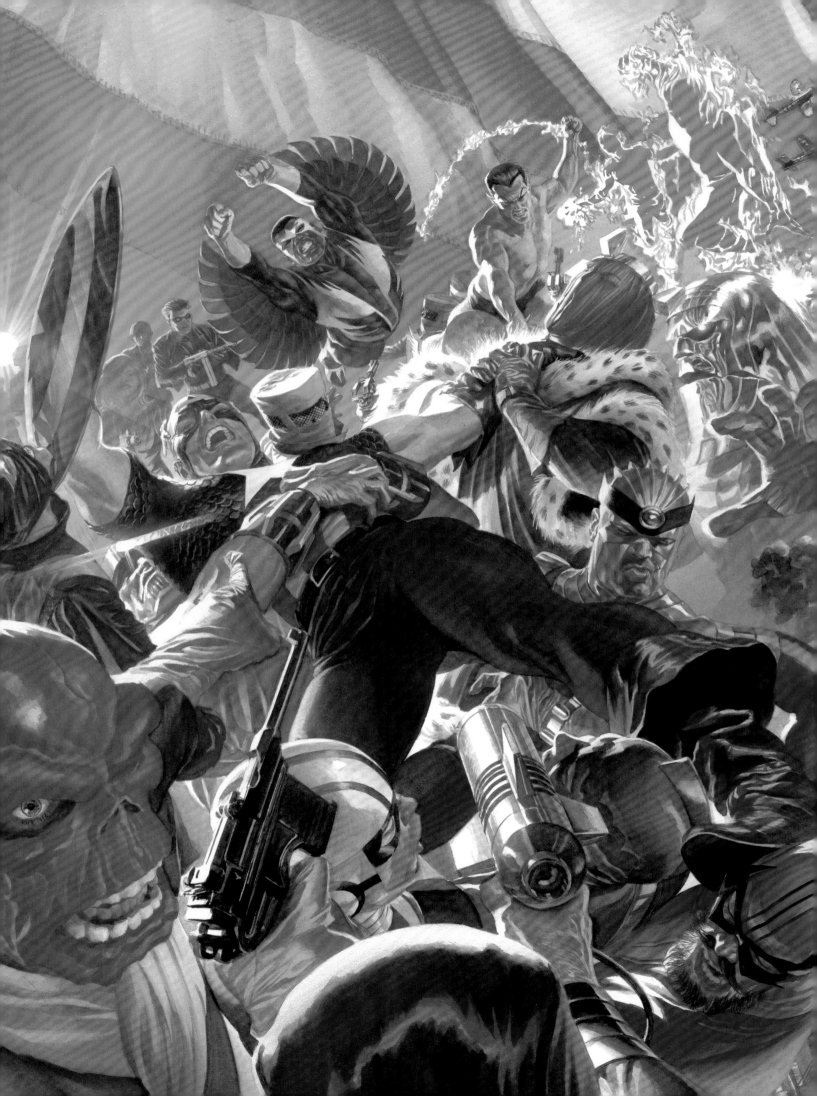

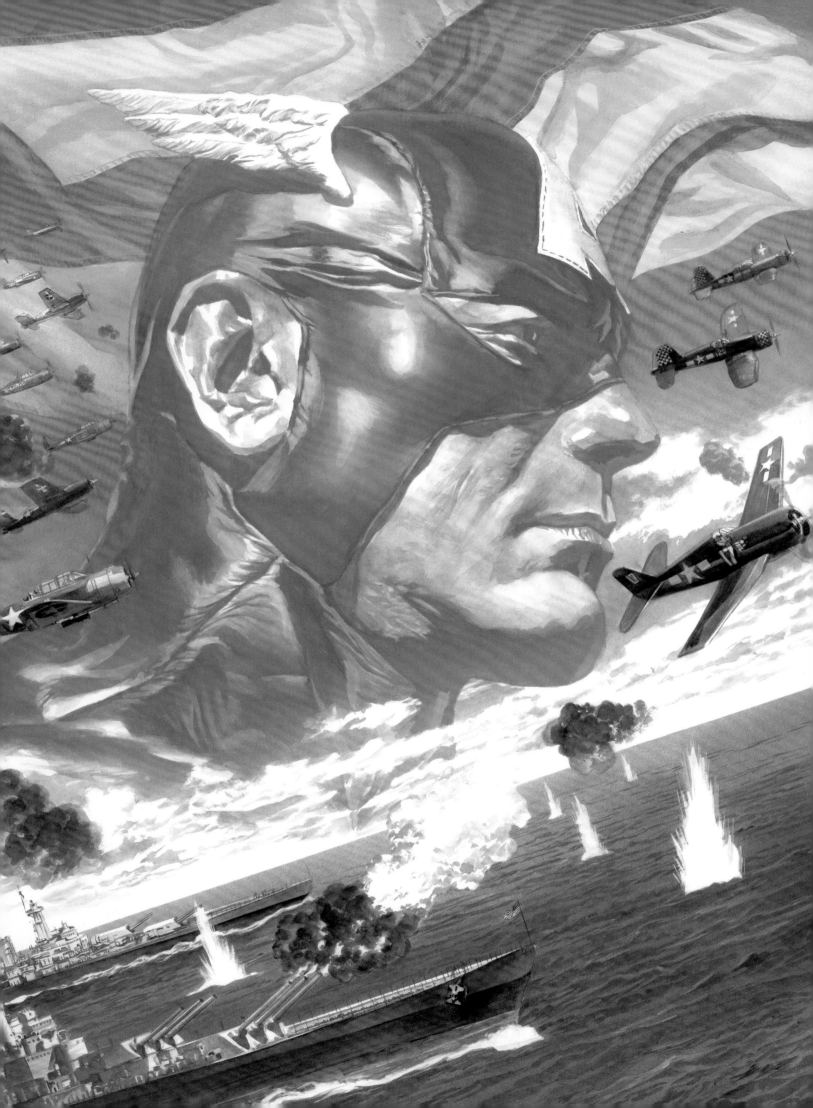

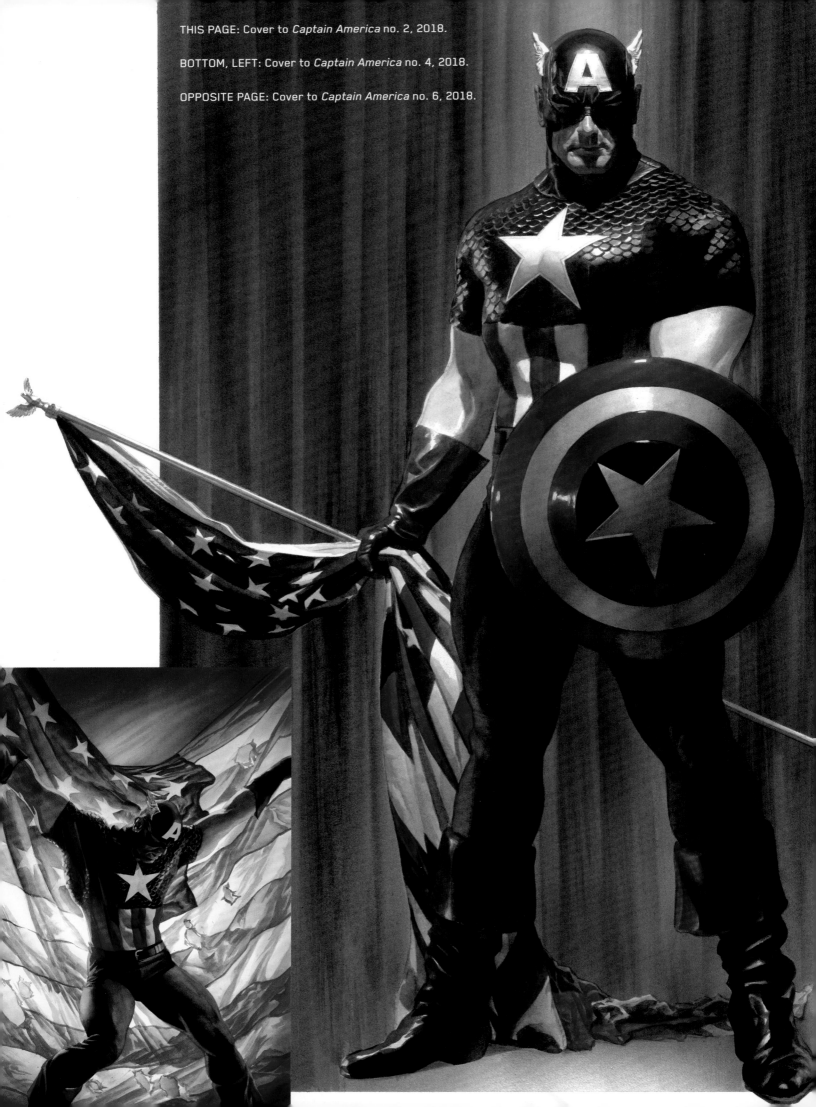

THIS PAGE: Cover to *Captain America* no. 2, 2018.

BOTTOM, LEFT: Cover to *Captain America* no. 4, 2018.

OPPOSITE PAGE: Cover to *Captain America* no. 6, 2018.

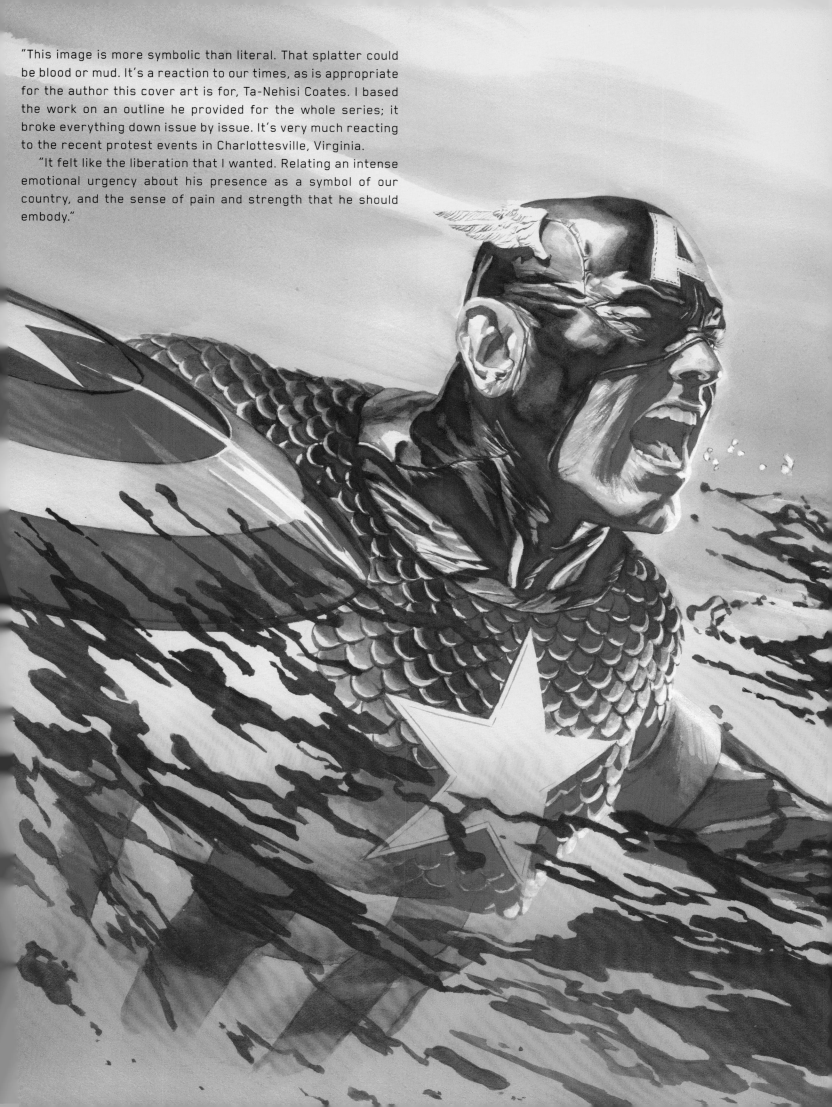

"This image is more symbolic than literal. That splatter could be blood or mud. It's a reaction to our times, as is appropriate for the author this cover art is for, Ta-Nehisi Coates. I based the work on an outline he provided for the whole series; it broke everything down issue by issue. It's very much reacting to the recent protest events in Charlottesville, Virginia.

"It felt like the liberation that I wanted. Relating an intense emotional urgency about his presence as a symbol of our country, and the sense of pain and strength that he should embody."

AVENGERS/INVADERS

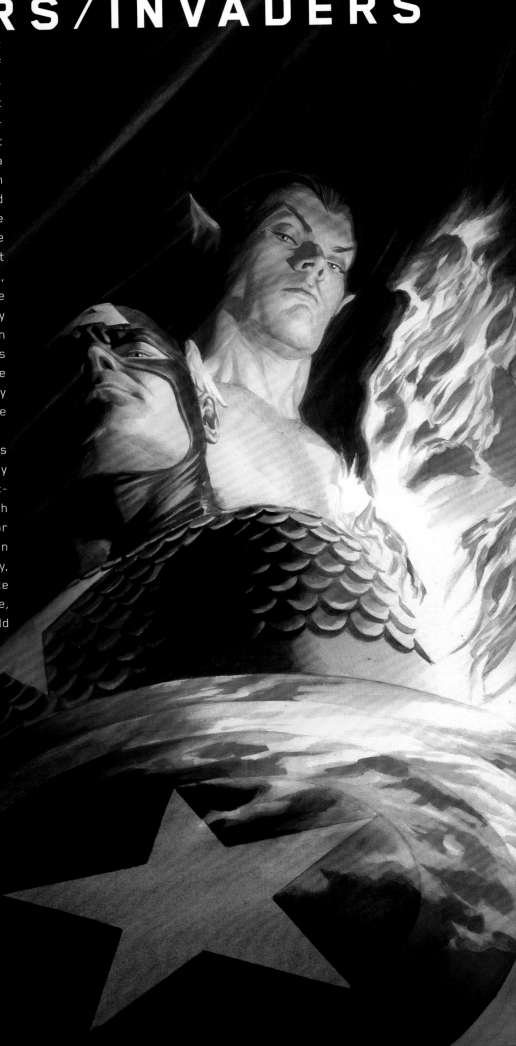

In 2008, Dynamite Entertainment worked out a packaging deal with Marvel for a group of limited series involving Alex co-plotting stories and creating covers for a plotline that began with the original Invaders characters crossing over with the Avengers. "That meant that we had to use time travel as a narrative component. It was a unique point in Marvel history, because they had just killed Captain America in continuity but now we were able to bring him back. We were able to make permanent changes in our project by resurrecting the Human Torch's sidekick, Toro, who was otherwise killed off in the 1960s. With his revival, we set off to fully rebuild the then-destroyed original Human Torch in our second series, *The Torch*. Plus we were able to unite the original with the modern Fantastic Four Human Torch and, by adding Toro, have a trinity of Torches in the modern day. I loved that.

"We reunited all five original Invaders in the *Invaders Now!* series. That was very important to me." Why? "I loved the characters as a kid, but because half of them (both of the sidekicks) were considered dead or transformed (don't ask about the Human Torch) in then-current Marvel continuity, they couldn't truly re-form the group. Once Marvel said Bucky wasn't dead anymore, I figured that this is where things should lead. I got to complete what they started."

THIS PAGE: Cover to *Wizard* no. 194, 2007.

OPPOSITE PAGE: Cover to *Avengers/Invaders* no. 1 featuring the five original Invaders descending like giants (an allusion to the 1940s covers of Alex Schomburg) on members of both the New and the Mighty Avengers teams, 2008.

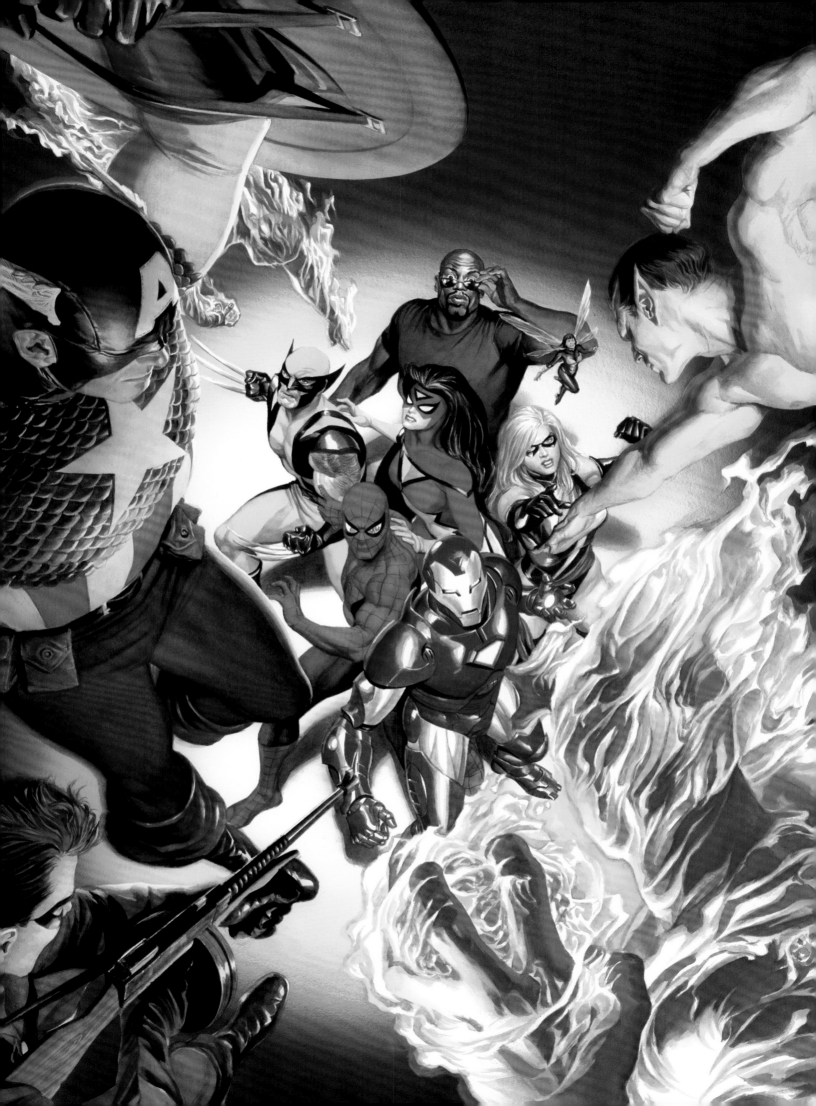

ABOVE: Covers for *Avengers/Invaders* no. 2, no. 4, no. 5, no. 6, no. 8, no. 10, no. 11, and no. 12, 2008–2009.

LEFT: Pencil drawing of the time-traveling Invaders from the *Avengers/Invaders* sketchbook, 2008.

OPPOSITE: Cover to *Invaders Now!* no. 2, where all five of the original Invaders are permanently revived in the present-day continuity, 2010.

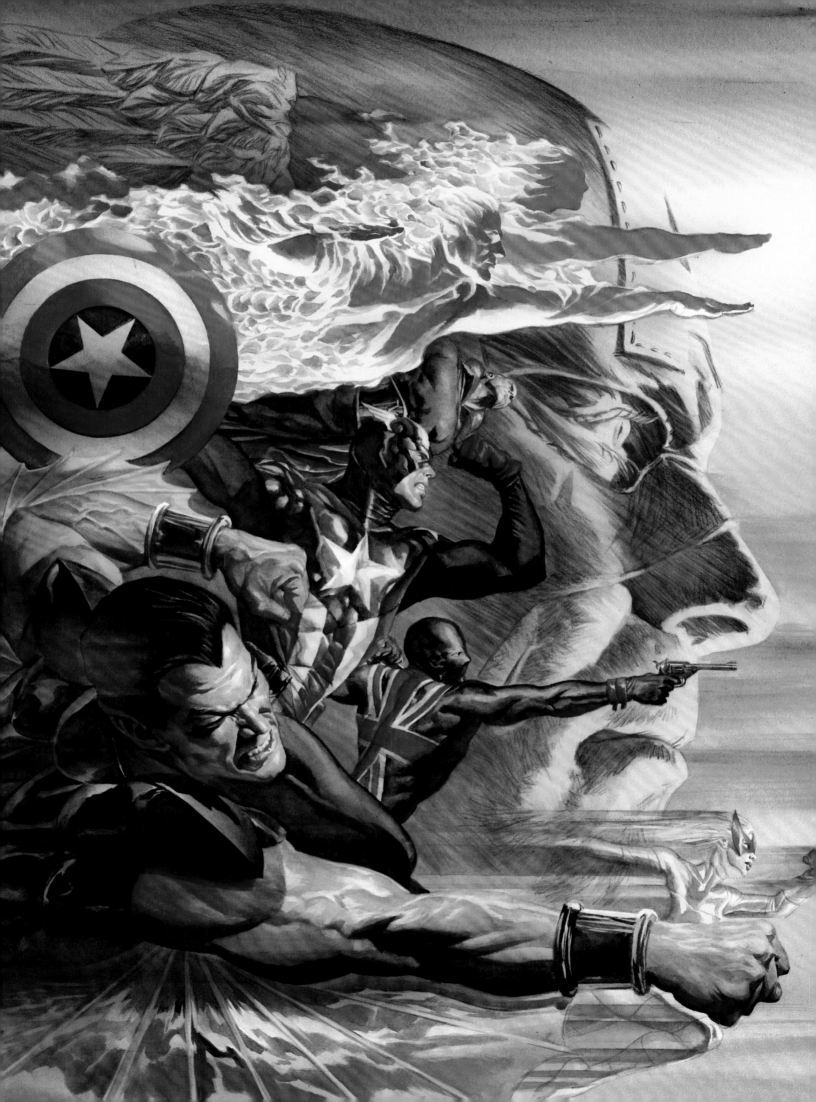

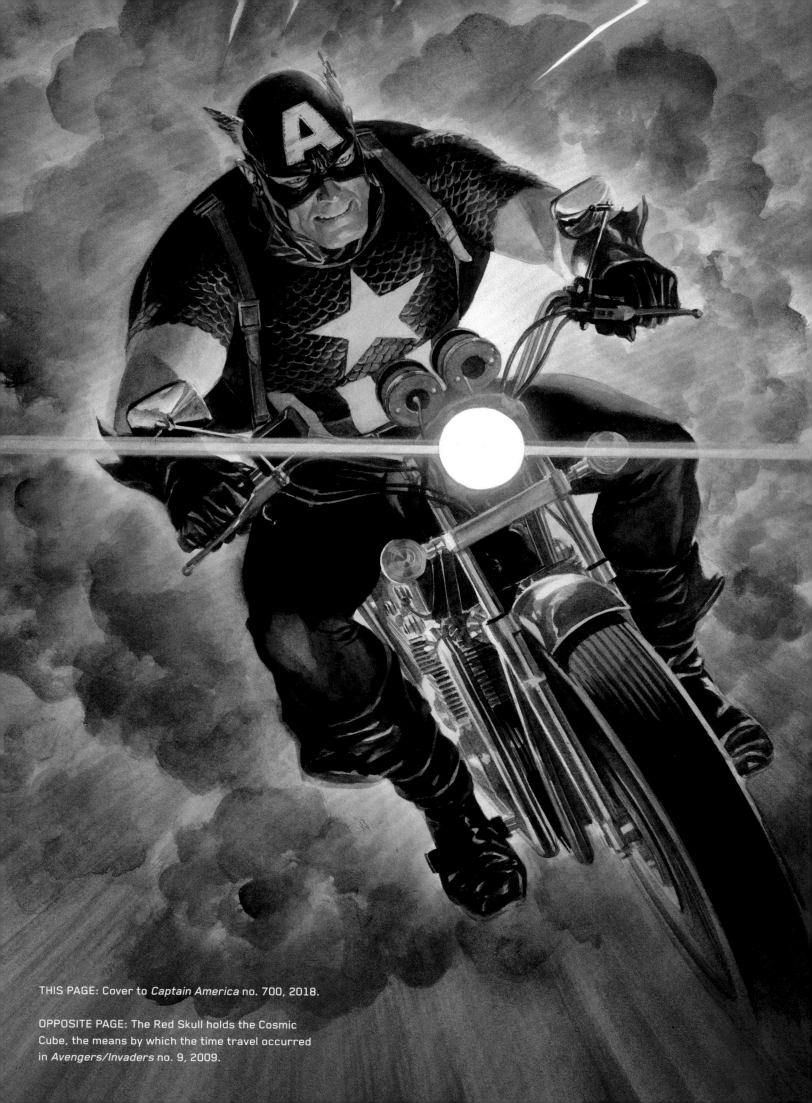

THIS PAGE: Cover to *Captain America* no. 700, 2018.

OPPOSITE PAGE: The Red Skull holds the Cosmic Cube, the means by which the time travel occurred in *Avengers/Invaders* no. 9, 2009.

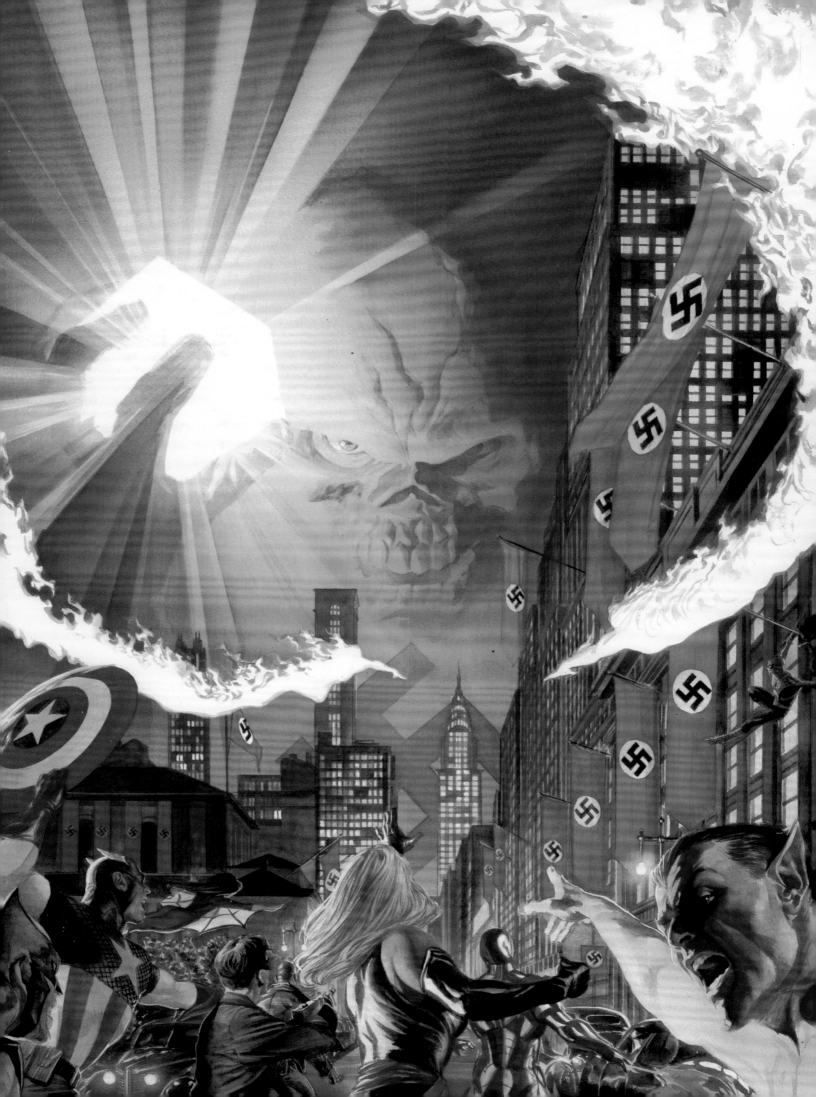

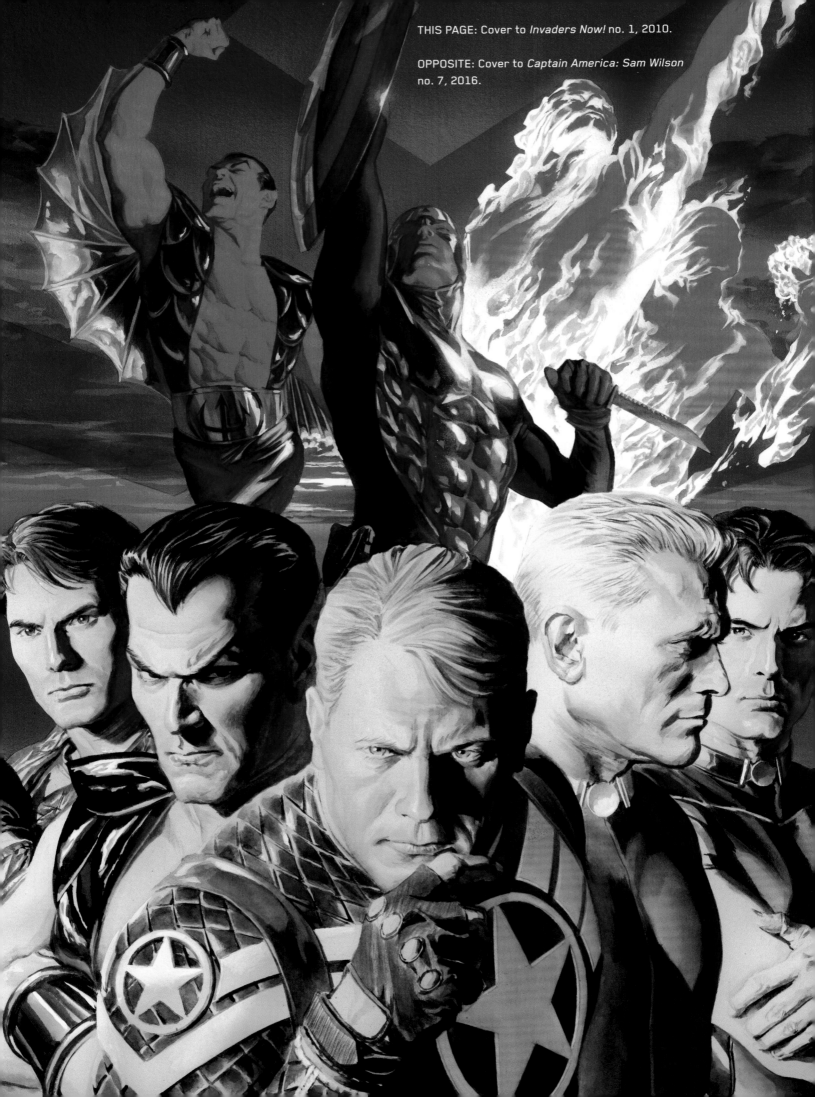

THIS PAGE: Cover to *Invaders Now!* no. 1, 2010.

OPPOSITE: Cover to *Captain America: Sam Wilson* no. 7, 2016.

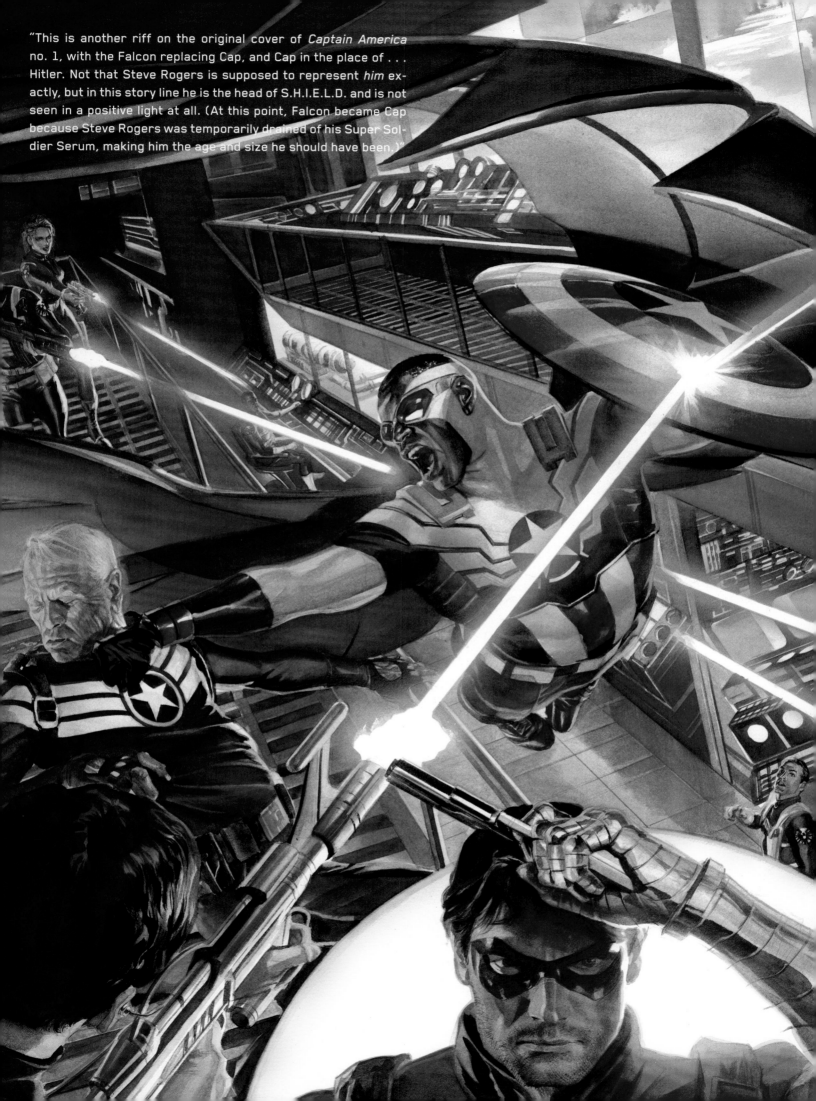

"This is another riff on the original cover of *Captain America* no. 1, with the Falcon replacing Cap, and Cap in the place of . . . Hitler. Not that Steve Rogers is supposed to represent *him* exactly, but in this story line he is the head of S.H.I.E.L.D. and is not seen in a positive light at all. (At this point, Falcon became Cap because Steve Rogers was temporarily drained of his Super Soldier Serum, making him the age and size he should have been.)"

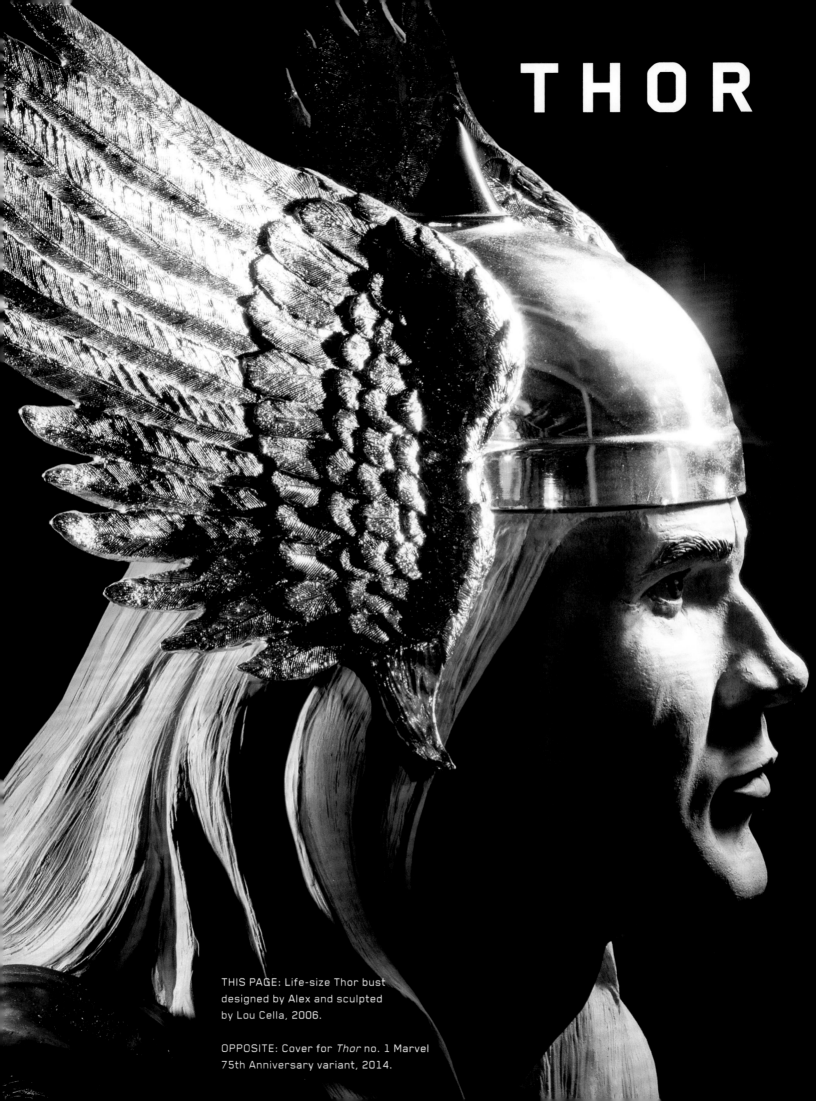

THOR

THIS PAGE: Life-size Thor bust designed by Alex and sculpted by Lou Cella, 2006.

OPPOSITE: Cover for *Thor* no. 1 Marvel 75th Anniversary variant, 2014.

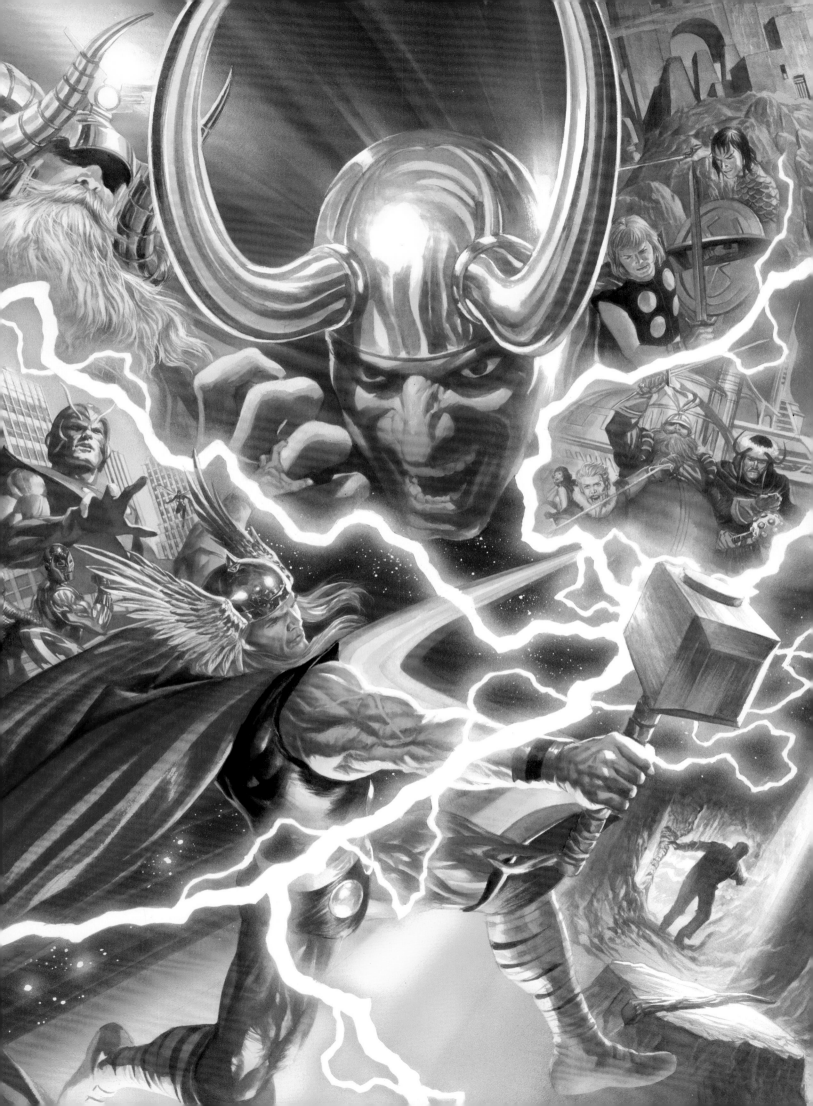

THIS PAGE: Pencil sketch and finished art for "Shadows: Thor" print, 2017.

OPPOSITE PAGE: Cover for *Paradise X: Ragnarok* no. 1, 2003

FOLLOWING SPREAD: "Tales of Asgard" print featuring Thor's enemies—Loki, Enchantress, Executioner, and Hela—and his allies—Odin, the Warriors Three, Sif, Heimdall, and Balder, 2018.

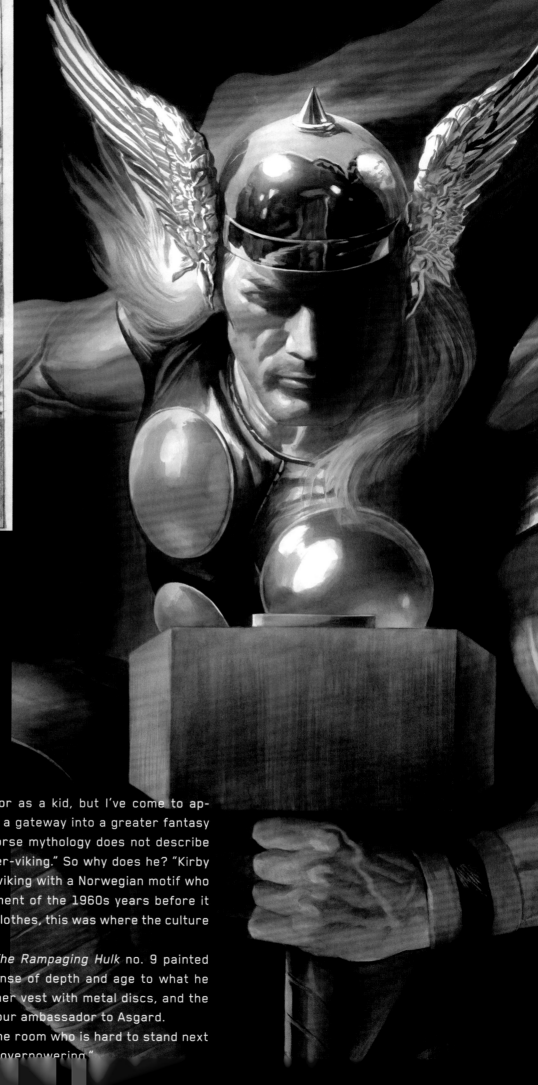

"I didn't have a strong draw to Thor as a kid, but I've come to appreciate this idea that he himself is a gateway into a greater fantasy world. It's funny, though, classic Norse mythology does not describe him looking like a shaven blond super-viking." So why does he? "Kirby interpreted him as a sort of super-viking with a Norwegian motif who seemed to embody the youth movement of the 1960s years before it happened. The long hair, the garish clothes, this was where the culture was going to go with men's styles.

"My depiction harkens back to *The Rampaging Hulk* no. 9 painted cover by Earl Norem. There is a sense of depth and age to what he is wearing in that image. It's a leather vest with metal discs, and the veins in his arms are bulging. He is our ambassador to Asgard.

"I see him as the biggest guy in the room who is hard to stand next to. He's six-foot-six at least. Totally overpowering."

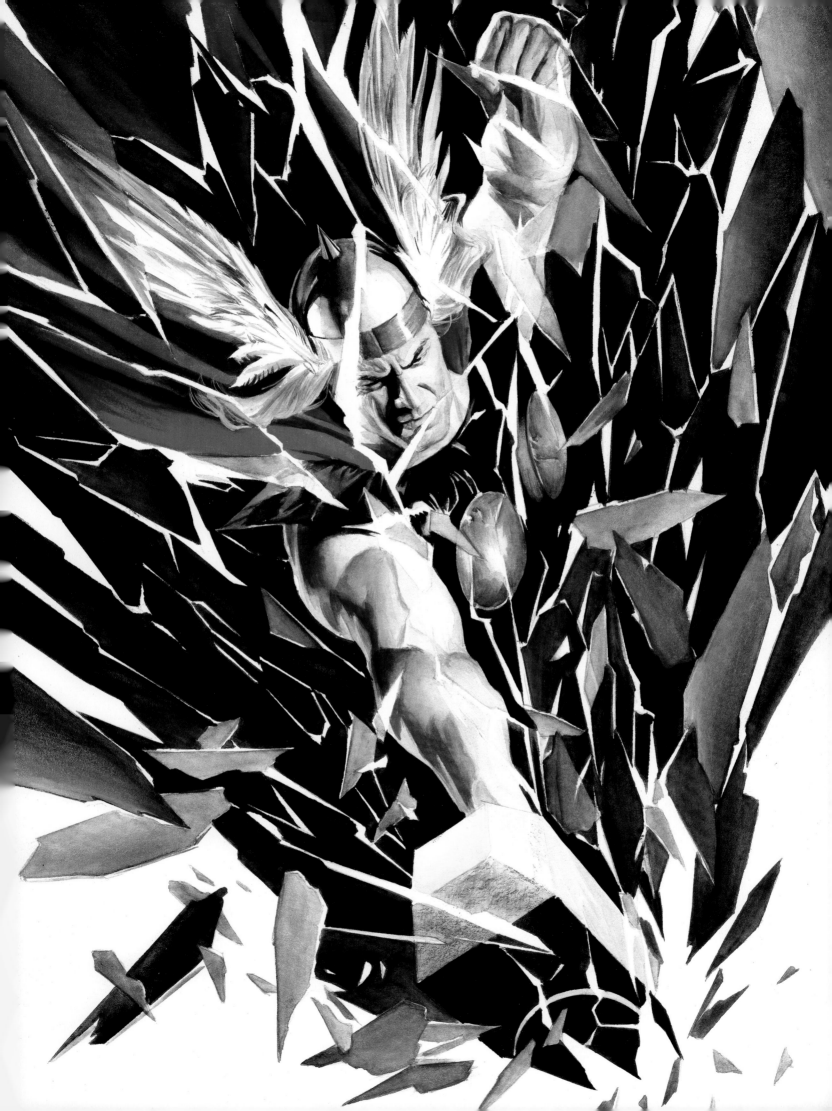

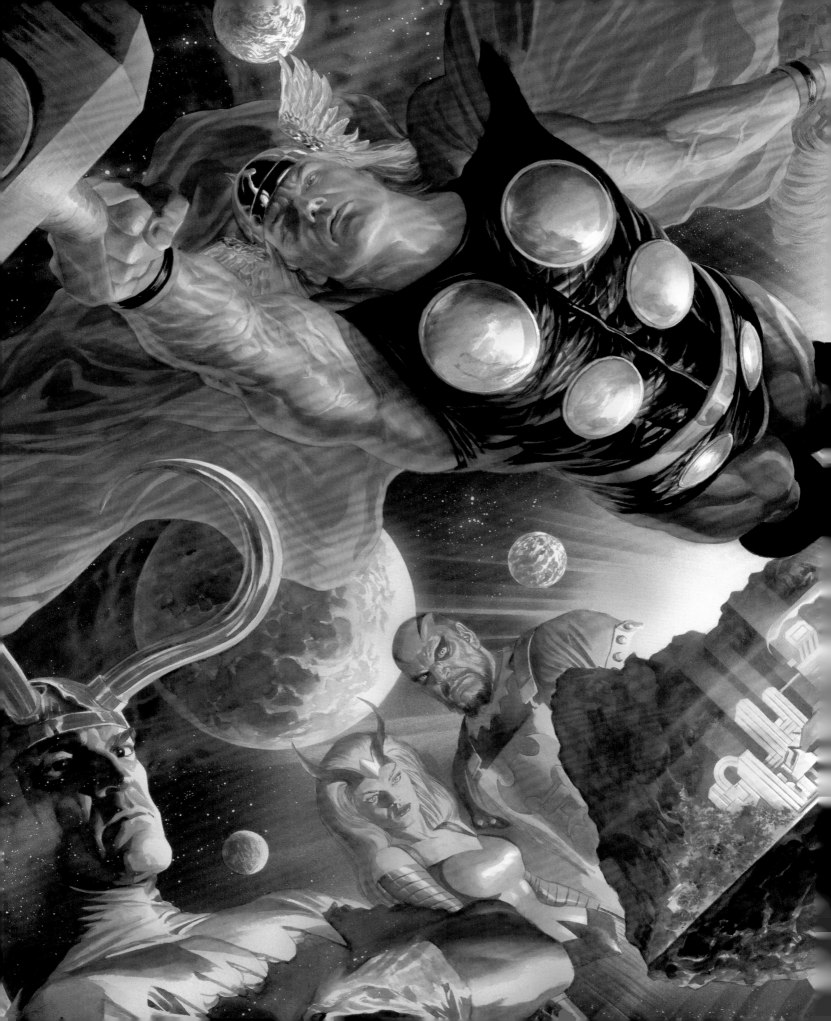

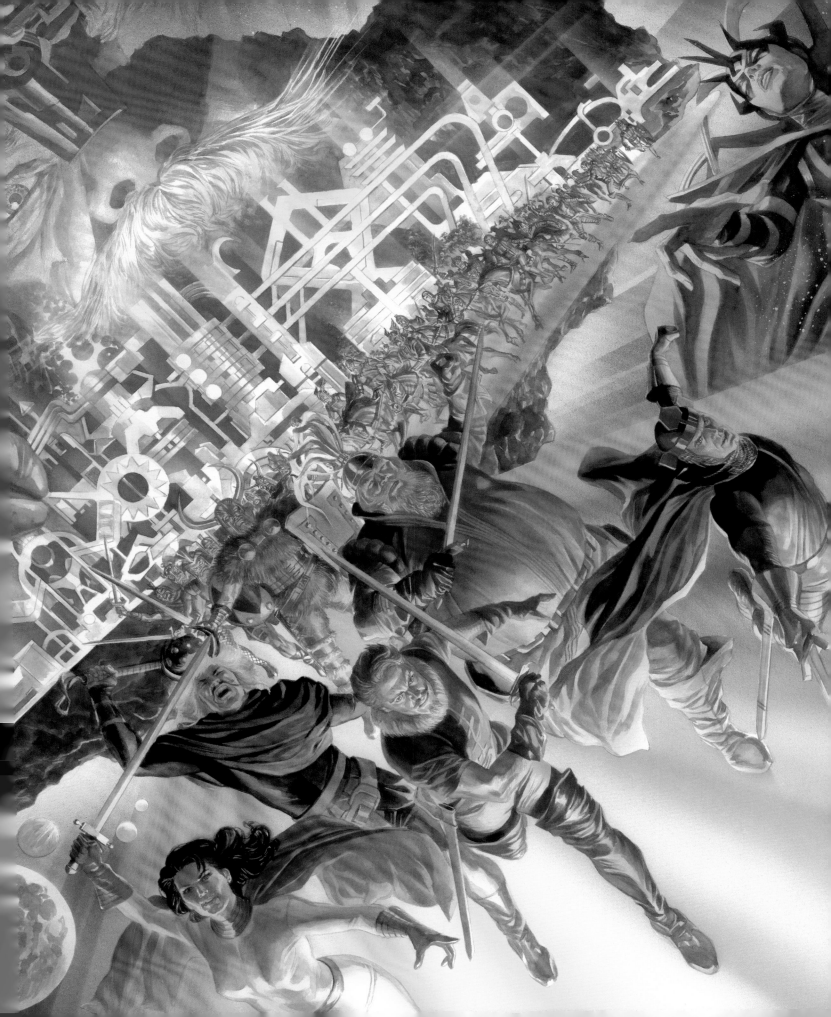

THOR #700?
AFTER BUCKLER

LEFT: Sketch re-creation of *Thor* no. 229, 1974, by Rich Buckler, for *Thor* no. 700, 2017.

BOTTOM, RIGHT: Thor portrait sketch, 2010.

OPPOSITE: Finished Thor portrait, 2018.

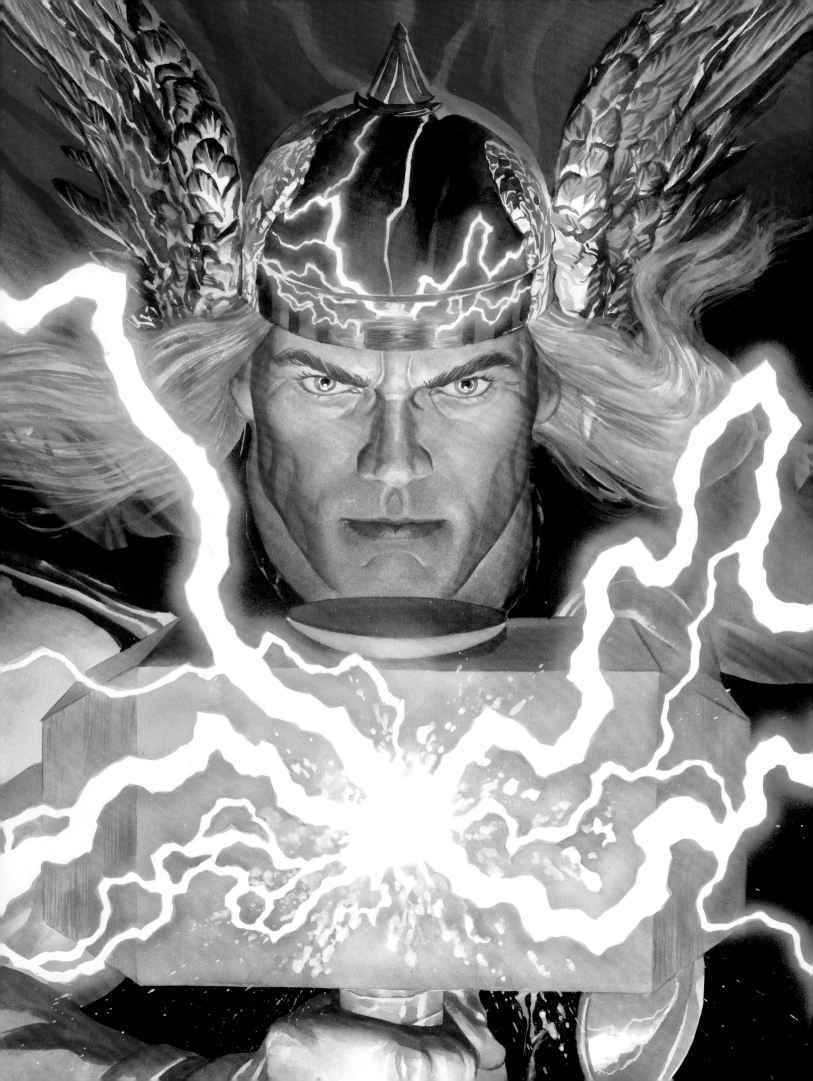

MARVELS

CAP

EARTH

UNIVERSE

PARADISE

A PARADISE X SPECIAL · A UNIVERSE X SPECIAL

SPIDEY

LOGOS!

"When I first started with a tweak to the existing company logo for *Marvels* (opposite, upper left), it was key to crafting the frame design that would integrate with the cover artwork and feature both dramatically." Did you study lettering in school? "Never. There was no course for it at the Academy. I figured out how to render typography out of pure intuition—you search out shapes based on what you have a gut feeling for. A lot of logo design is thievery; I could reference where all of these come from. The *Iron Men* logo is just the original *Iron Man* logo without all the detail. I can't claim that all of these are winners, I can just claim that they're fun to do."

THIS SPREAD: *Marvels*, 1992; *Cap*, 2001; *Earth X*, 1997; *Universe X*, 2000; *Paradise X*, 2003; *Xen*, 2002; *Spidey*, 2001; *Heralds*, 2001; *Devils*, 2003; *Beasts*, 2001; *Iron Men*, 2001; *Squadron Supreme*, 1997.

HERALDS

PG 1

DEVILS

A UNIVERSE X SPECIAL

BEASTS

IRON MEN

SQUADRON SUPREME

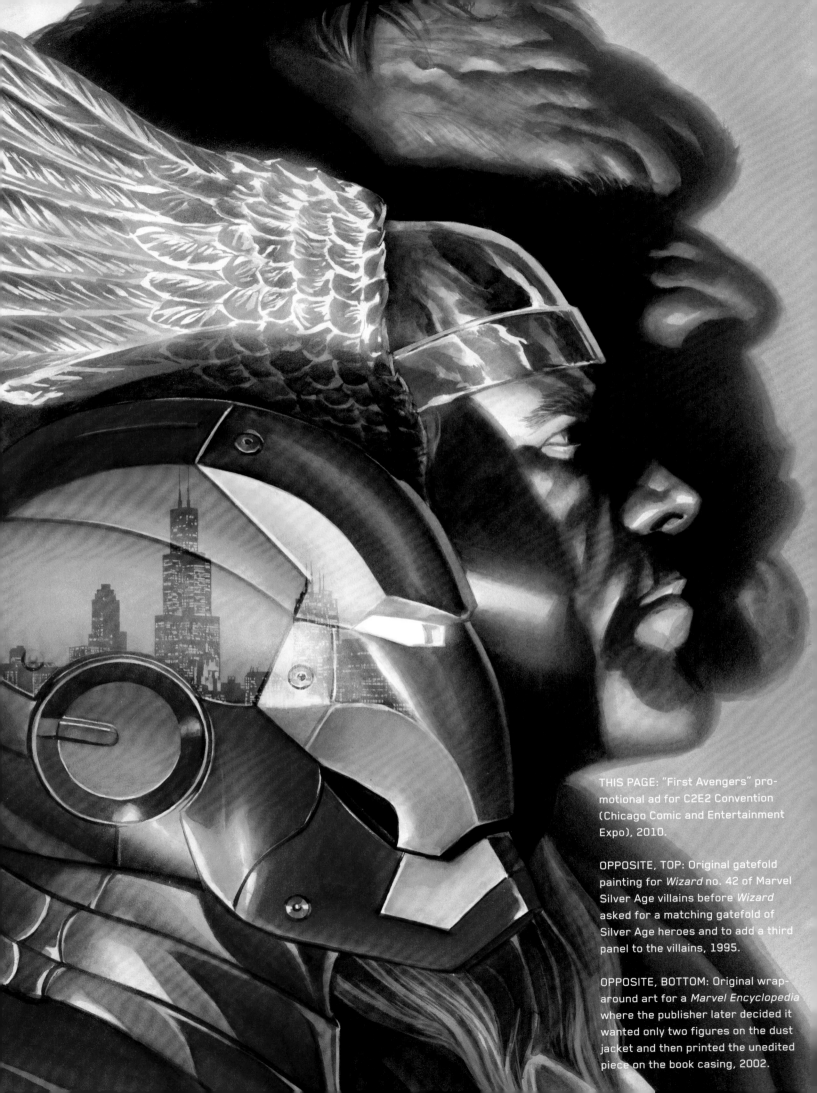

THIS PAGE: "First Avengers" promotional ad for C2E2 Convention (Chicago Comic and Entertainment Expo), 2010.

OPPOSITE, TOP: Original gatefold painting for *Wizard* no. 42 of Marvel Silver Age villains before *Wizard* asked for a matching gatefold of Silver Age heroes and to add a third panel to the villains, 1995.

OPPOSITE, BOTTOM: Original wraparound art for a *Marvel Encyclopedia* where the publisher later decided it wanted only two figures on the dust jacket and then printed the unedited piece on the book casing, 2002.

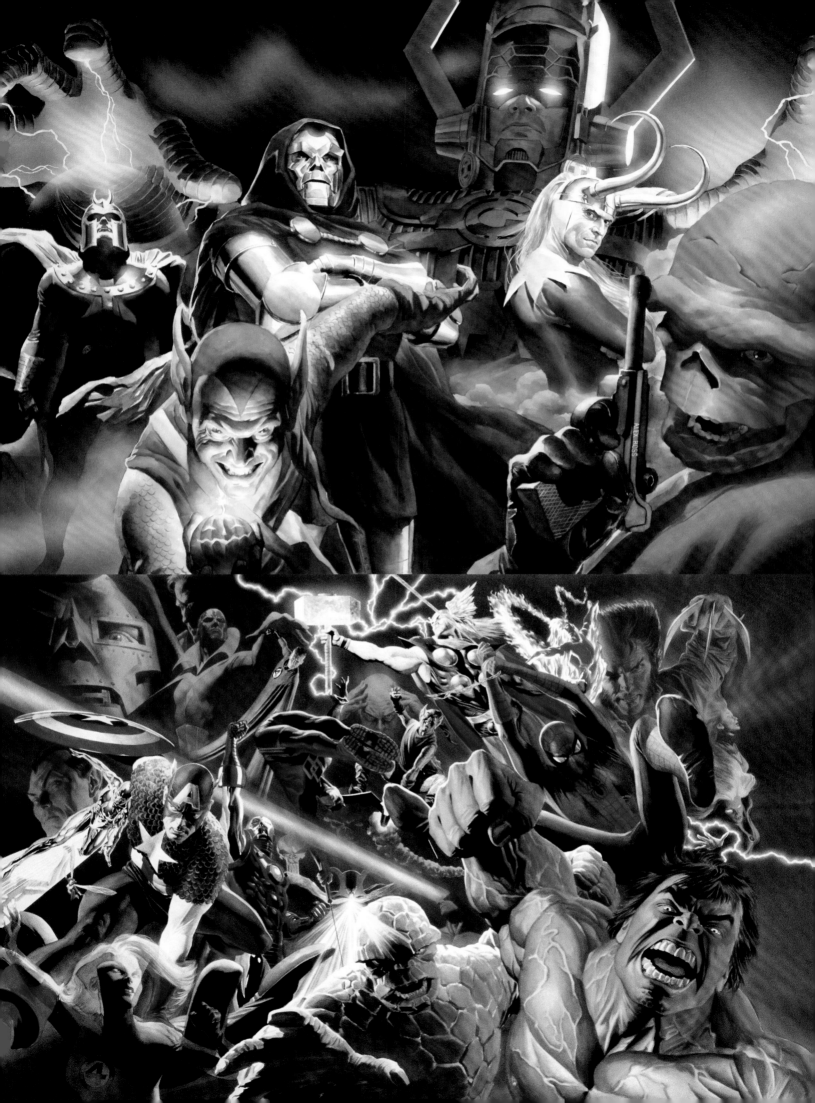

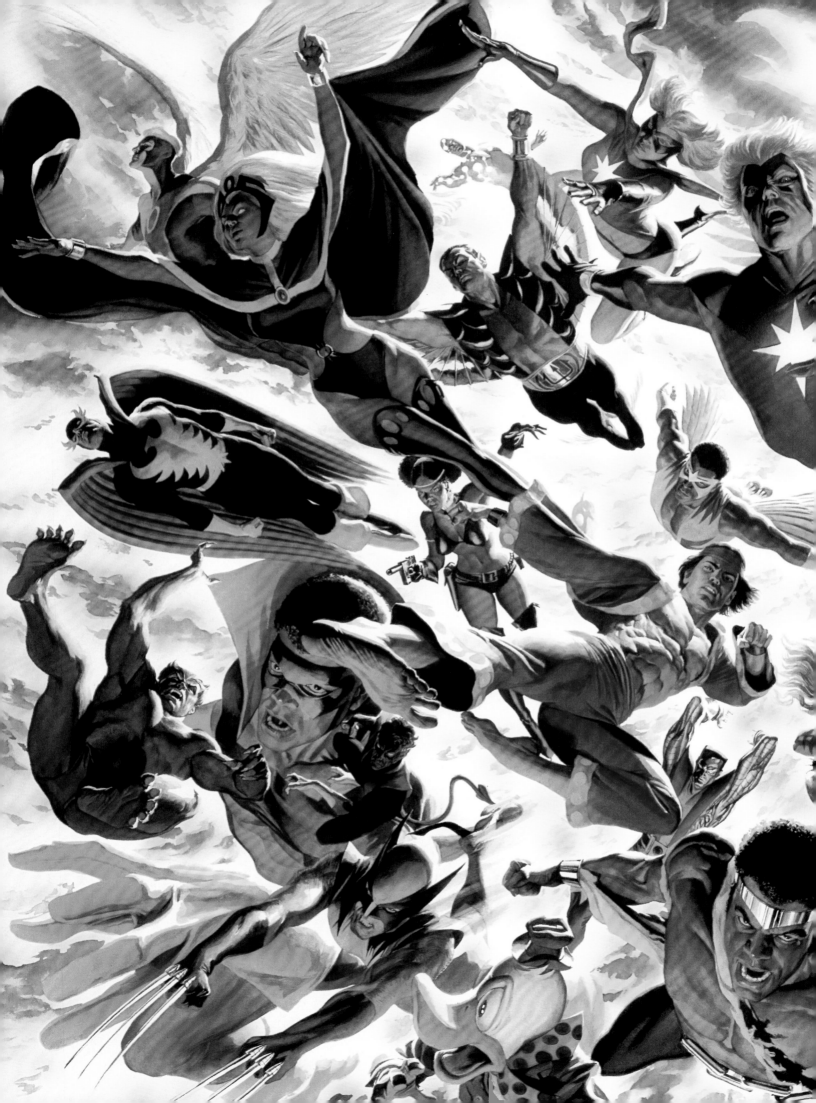

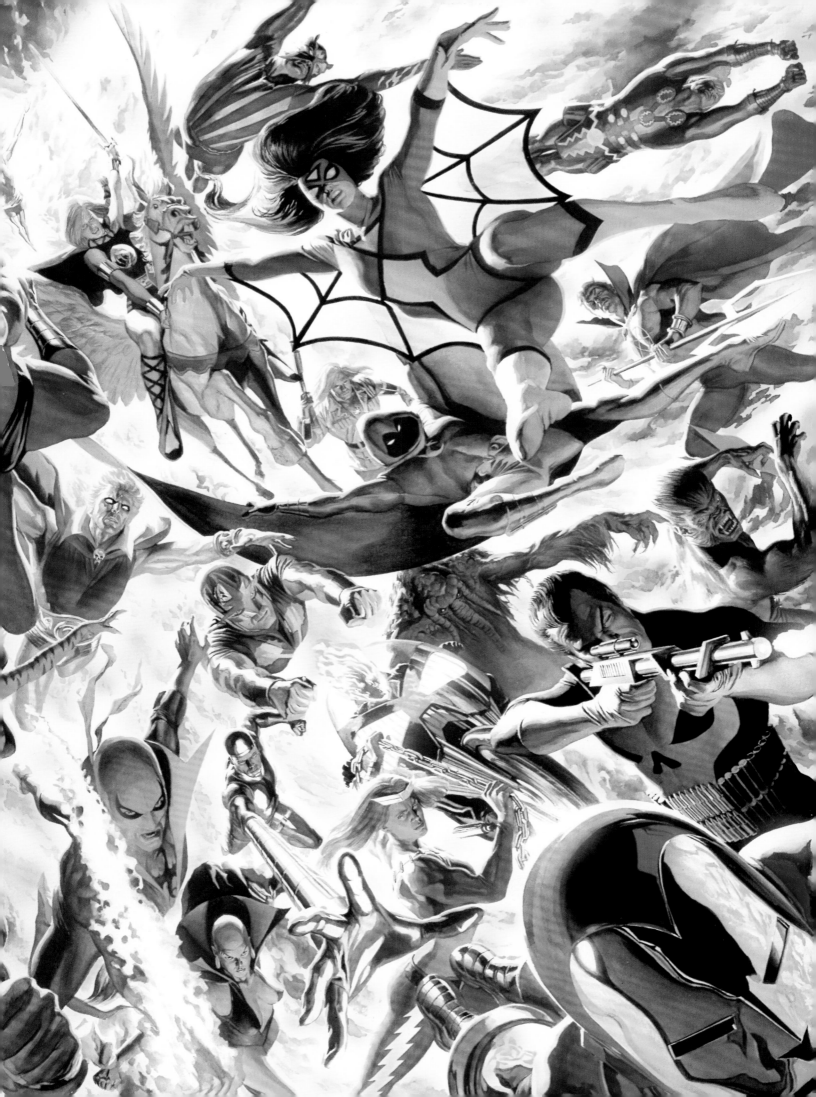

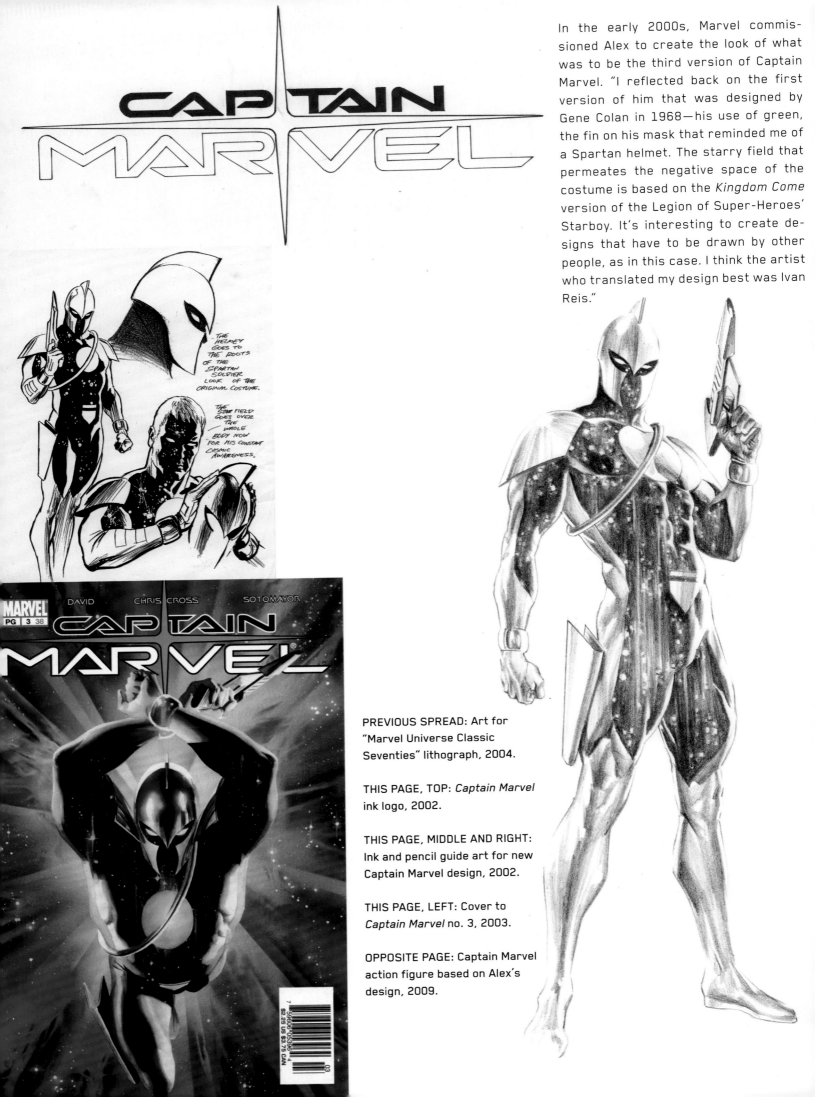

In the early 2000s, Marvel commissioned Alex to create the look of what was to be the third version of Captain Marvel. "I reflected back on the first version of him that was designed by Gene Colan in 1968—his use of green, the fin on his mask that reminded me of a Spartan helmet. The starry field that permeates the negative space of the costume is based on the *Kingdom Come* version of the Legion of Super-Heroes' Starboy. It's interesting to create designs that have to be drawn by other people, as in this case. I think the artist who translated my design best was Ivan Reis."

THE HELMET GOES TO THE ROOTS OF THE SPARTAN SOLDIER LOOK OF THE ORIGINAL COSTUME.

THE STAR FIELD GOES OVER THE WHOLE BODY NOW FOR HIS CONSTANT COSMIC AWARENESS.

PREVIOUS SPREAD: Art for "Marvel Universe Classic Seventies" lithograph, 2004.

THIS PAGE, TOP: *Captain Marvel* ink logo, 2002.

THIS PAGE, MIDDLE AND RIGHT: Ink and pencil guide art for new Captain Marvel design, 2002.

THIS PAGE, LEFT: Cover to *Captain Marvel* no. 3, 2003.

OPPOSITE PAGE: Captain Marvel action figure based on Alex's design, 2009.

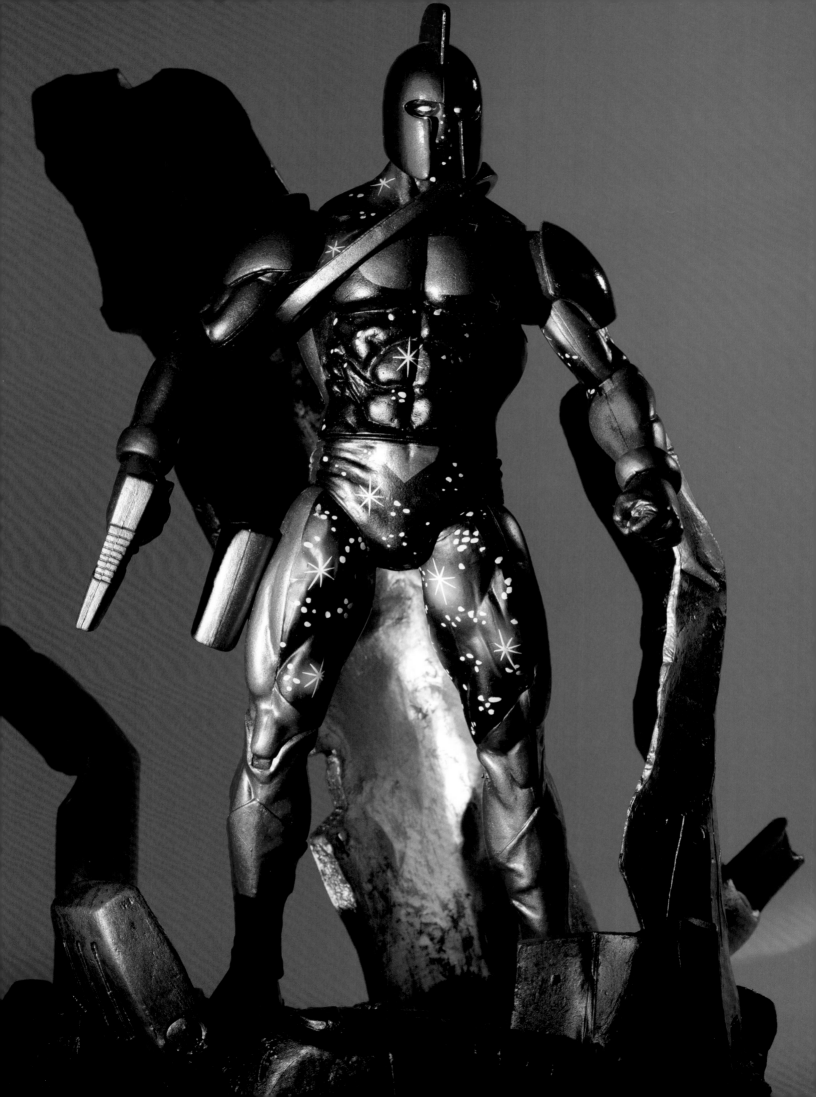

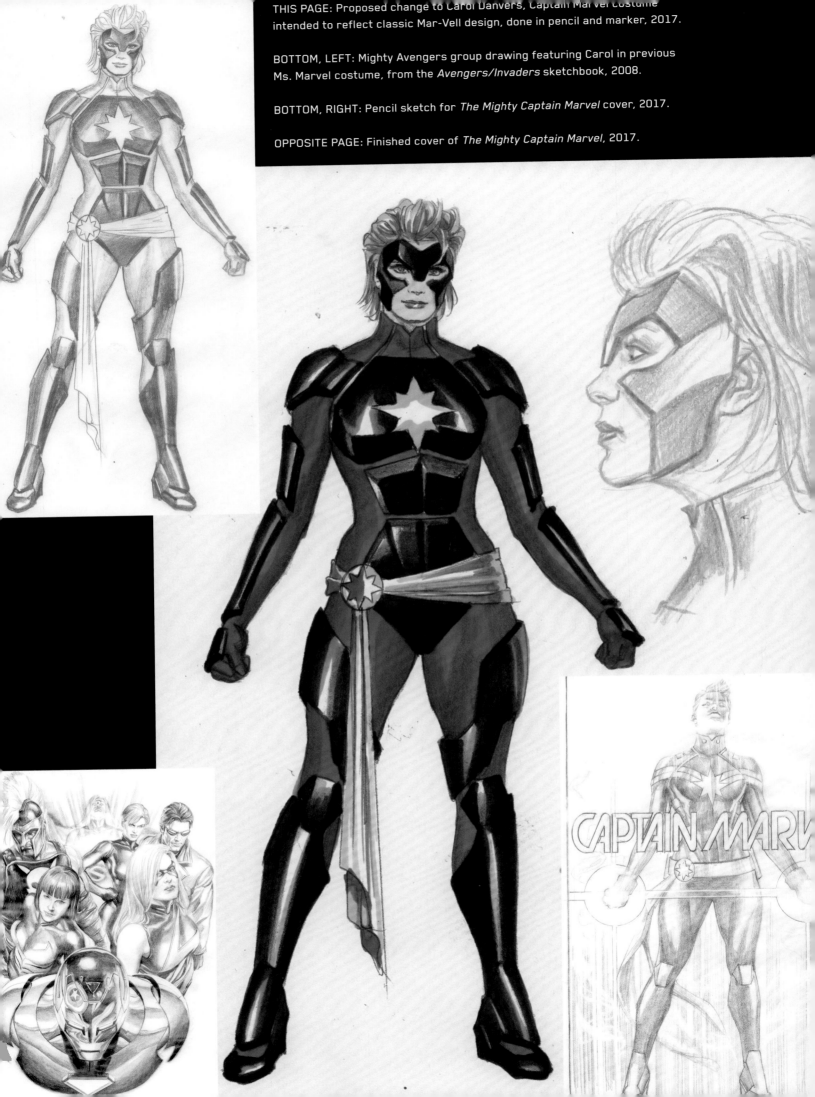

THIS PAGE: Proposed change to Carol Danvers, Captain Marvel costume intended to reflect classic Mar-Vell design, done in pencil and marker, 2017.

BOTTOM, LEFT: Mighty Avengers group drawing featuring Carol in previous Ms. Marvel costume, from the *Avengers/Invaders* sketchbook, 2008.

BOTTOM, RIGHT: Pencil sketch for *The Mighty Captain Marvel* cover, 2017.

OPPOSITE PAGE: Finished cover of *The Mighty Captain Marvel*, 2017.

CAPTAIN MARVEL

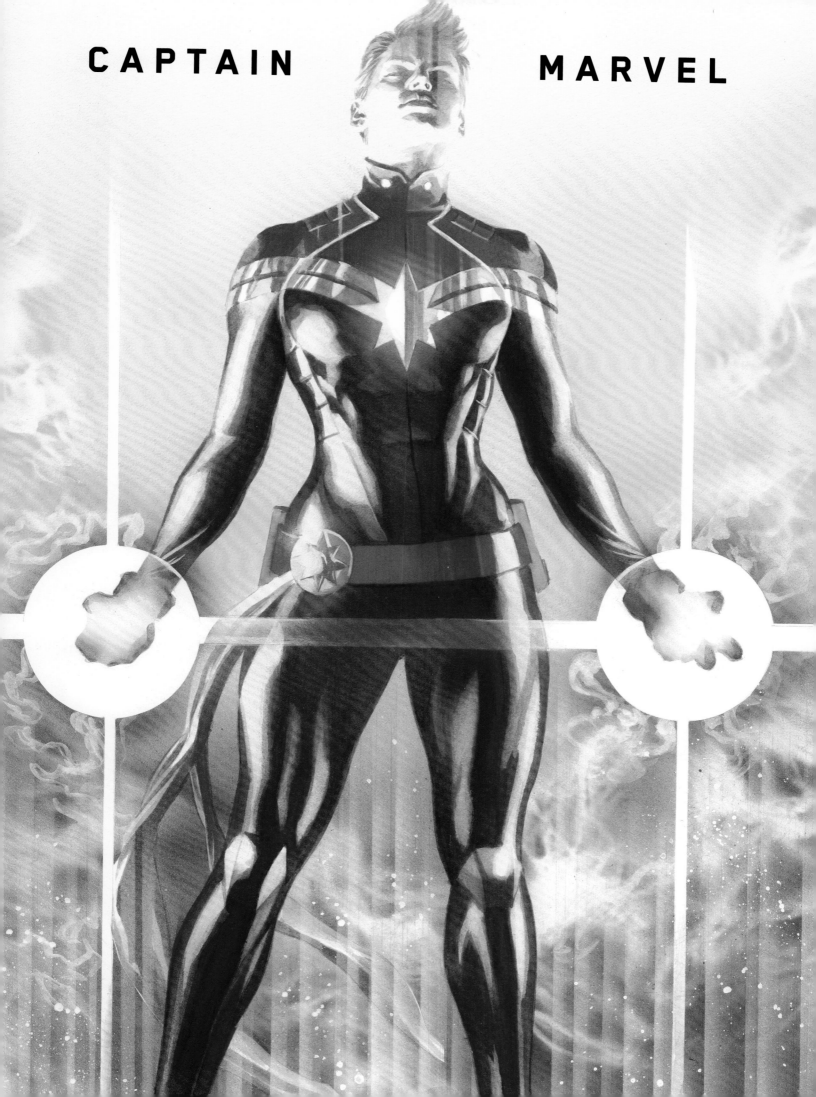

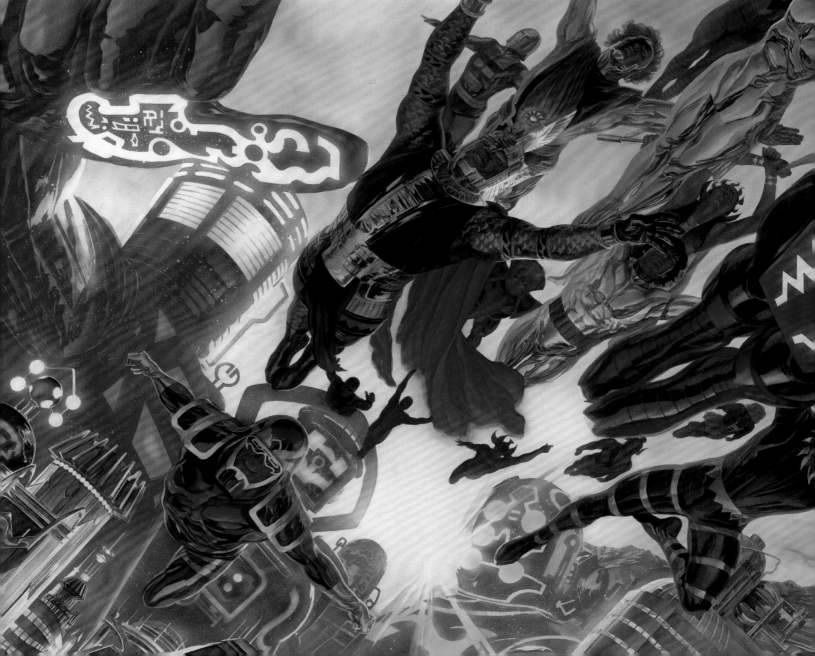

LEFT: Pencil sketch of Eternals piece, 2007.

BOTTOM: Eternals painting, never before published, featuring characters from Jack Kirby's last great group book in comics, including: the Celestials, Makkari, Ajak, Reject, Thena, Sprite, Ikaris, Zuras, and Sersi, 2007.

THE ETERNALS

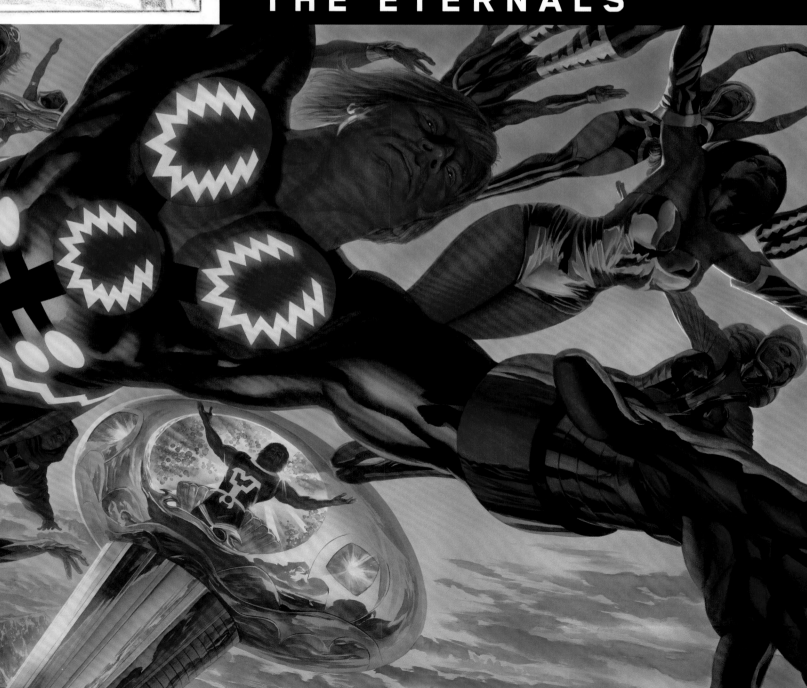

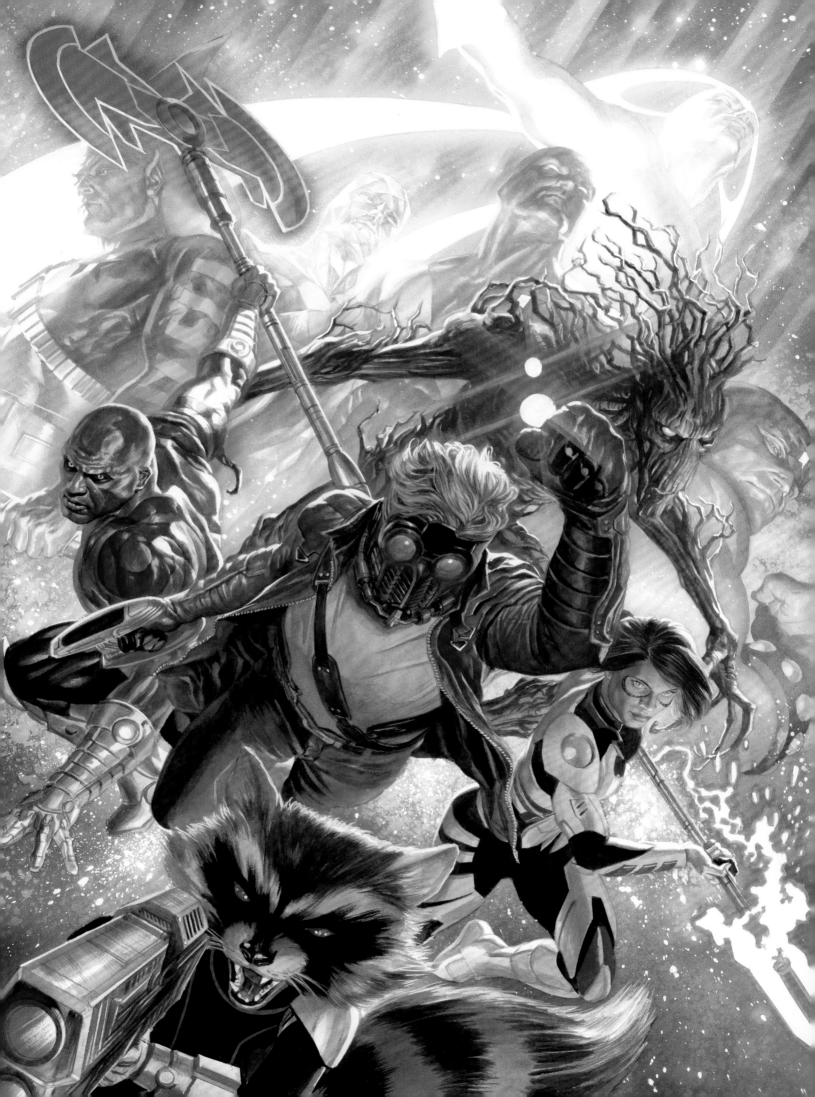

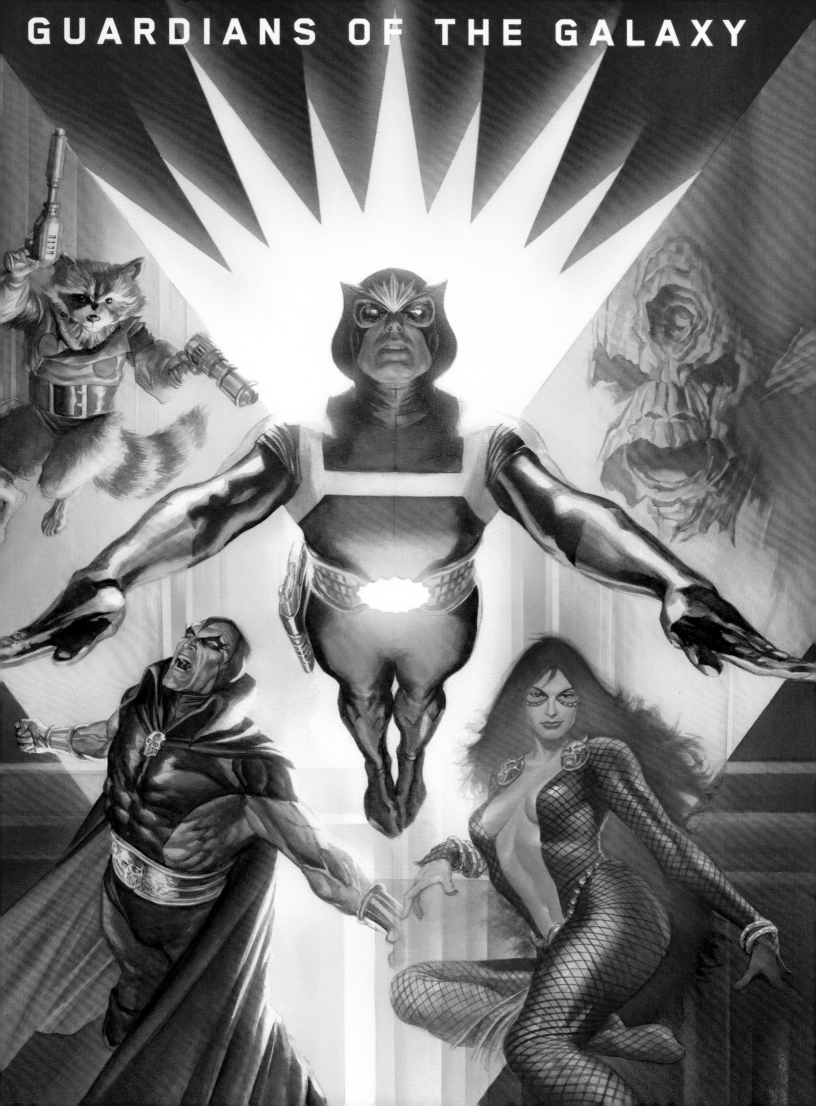

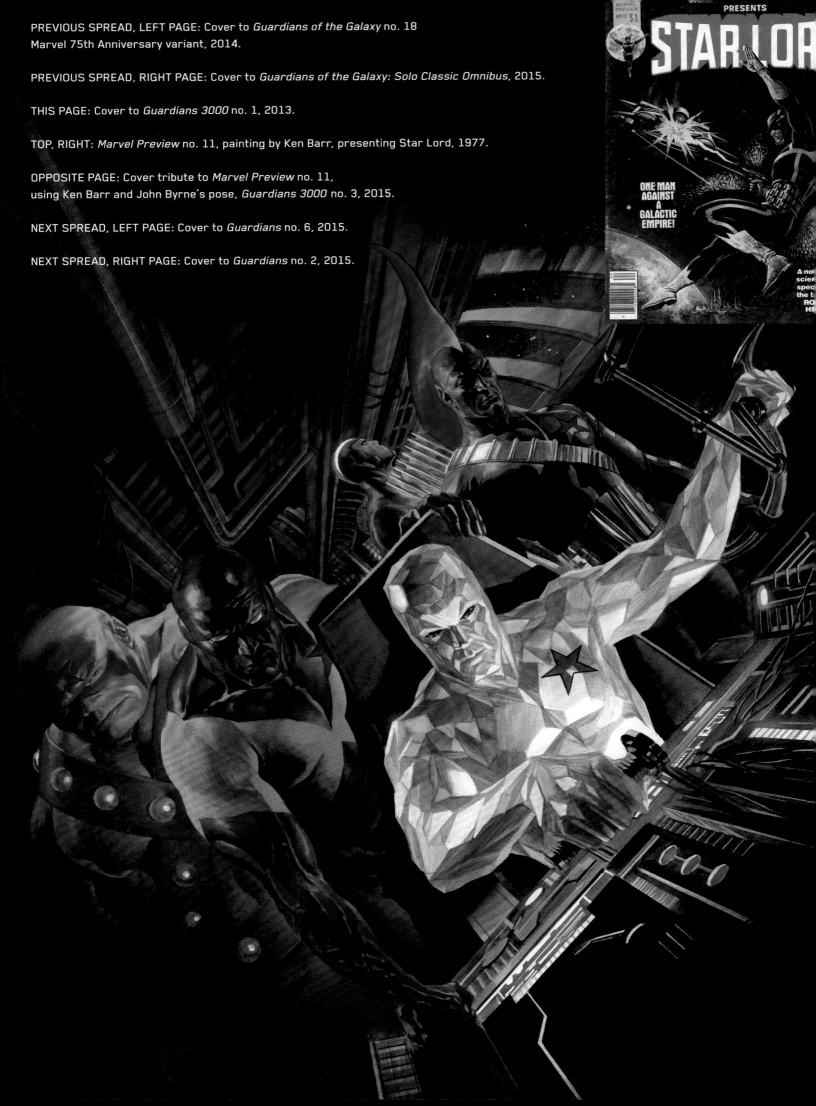

PREVIOUS SPREAD, LEFT PAGE: Cover to *Guardians of the Galaxy* no. 18
Marvel 75th Anniversary variant, 2014.

PREVIOUS SPREAD, RIGHT PAGE: Cover to *Guardians of the Galaxy: Solo Classic Omnibus*, 2015.

THIS PAGE: Cover to *Guardians 3000* no. 1, 2013.

TOP, RIGHT: *Marvel Preview* no. 11, painting by Ken Barr, presenting Star Lord, 1977.

OPPOSITE PAGE: Cover tribute to *Marvel Preview* no. 11,
using Ken Barr and John Byrne's pose, *Guardians 3000* no. 3, 2015.

NEXT SPREAD, LEFT PAGE: Cover to *Guardians* no. 6, 2015.

NEXT SPREAD, RIGHT PAGE: Cover to *Guardians* no. 2, 2015.

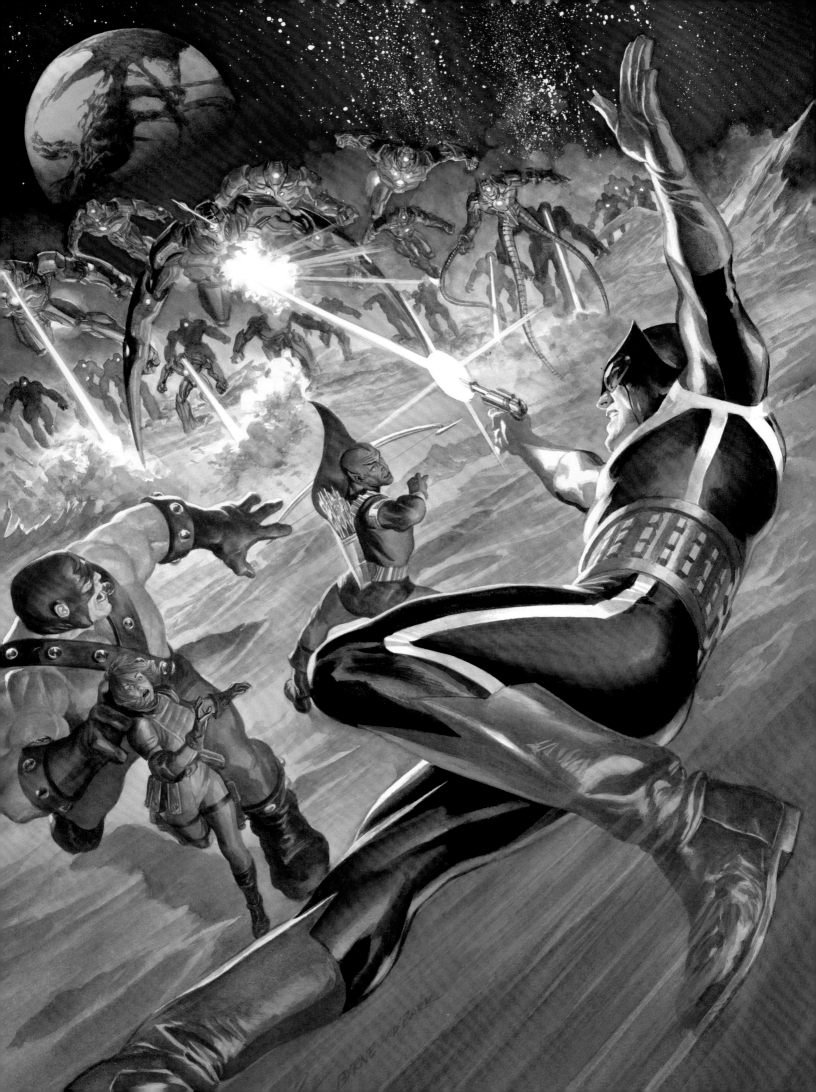

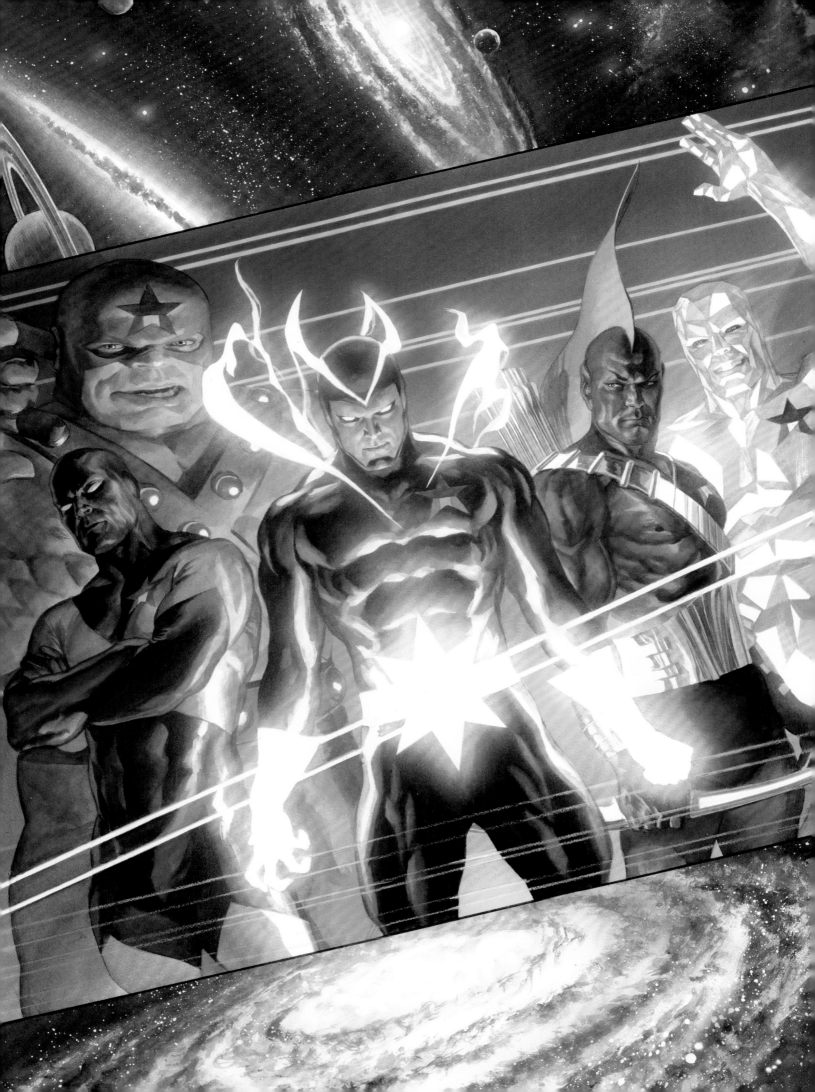

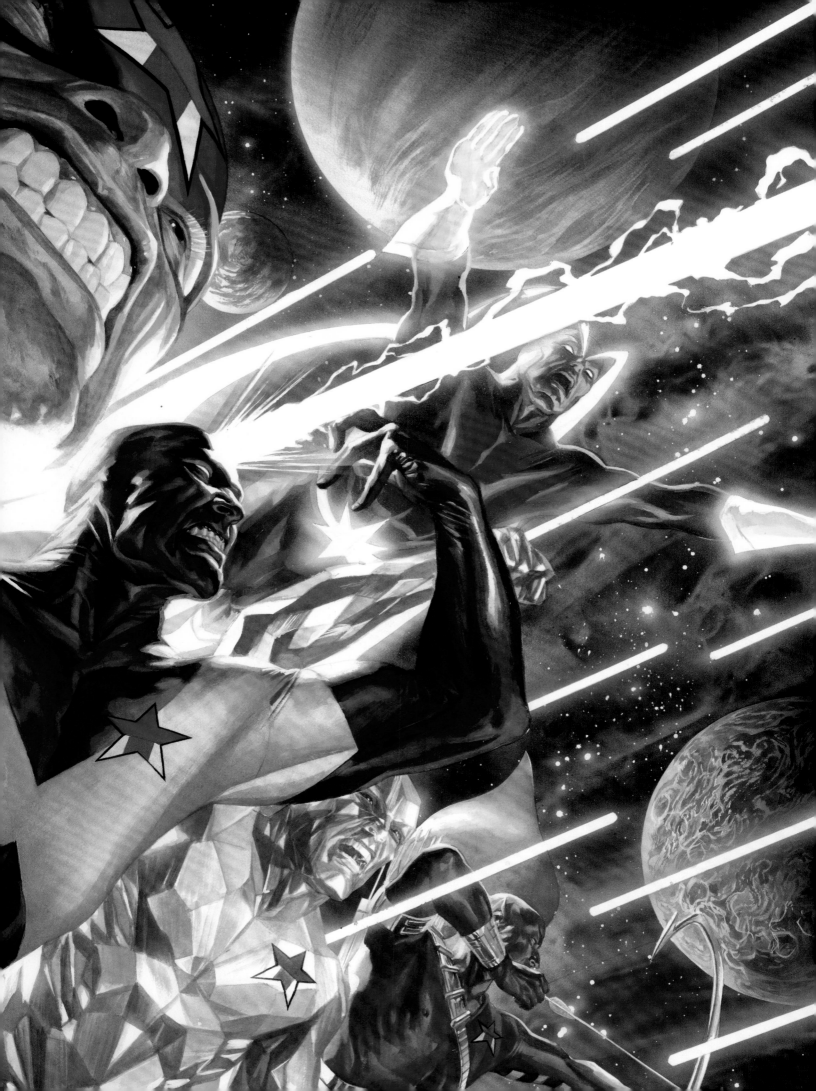

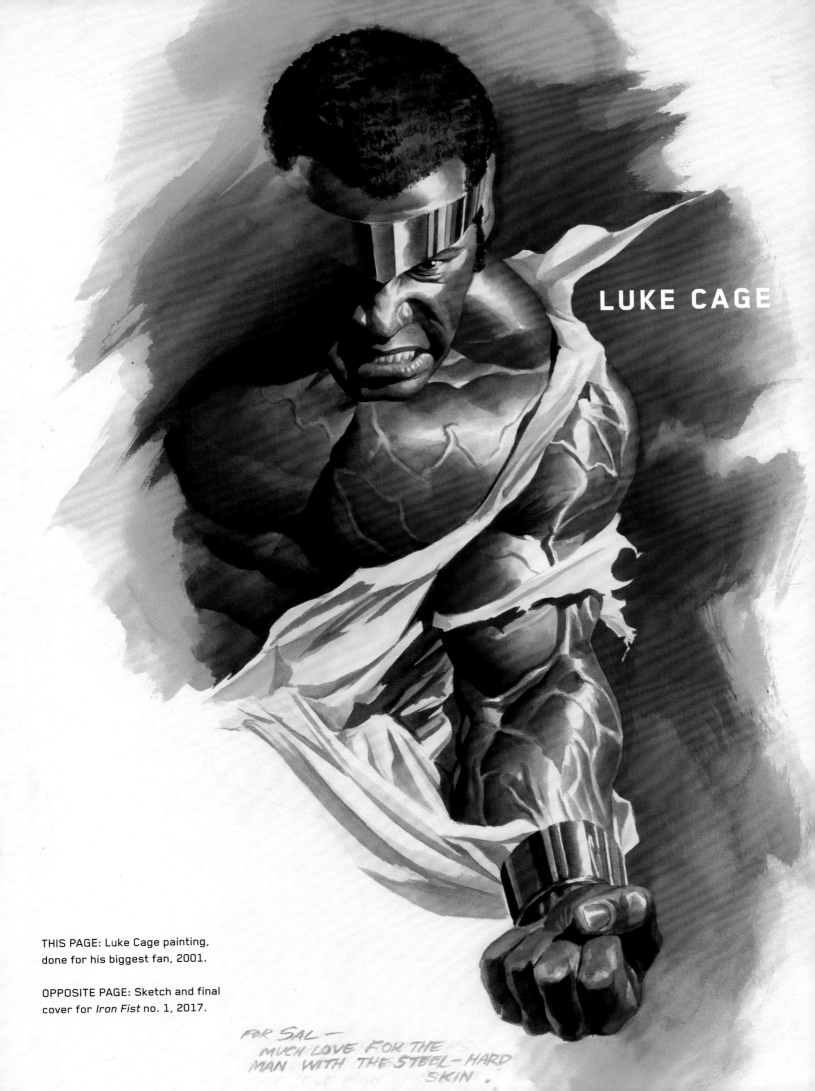

LUKE CAGE

THIS PAGE: Luke Cage painting, done for his biggest fan, 2001.

OPPOSITE PAGE: Sketch and final cover for *Iron Fist* no. 1, 2017.

FOR SAL—
MUCH LOVE FOR THE
MAN WITH THE STEEL-HARD
SKIN.

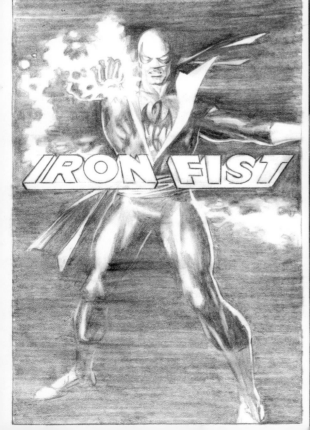

IRON FIST

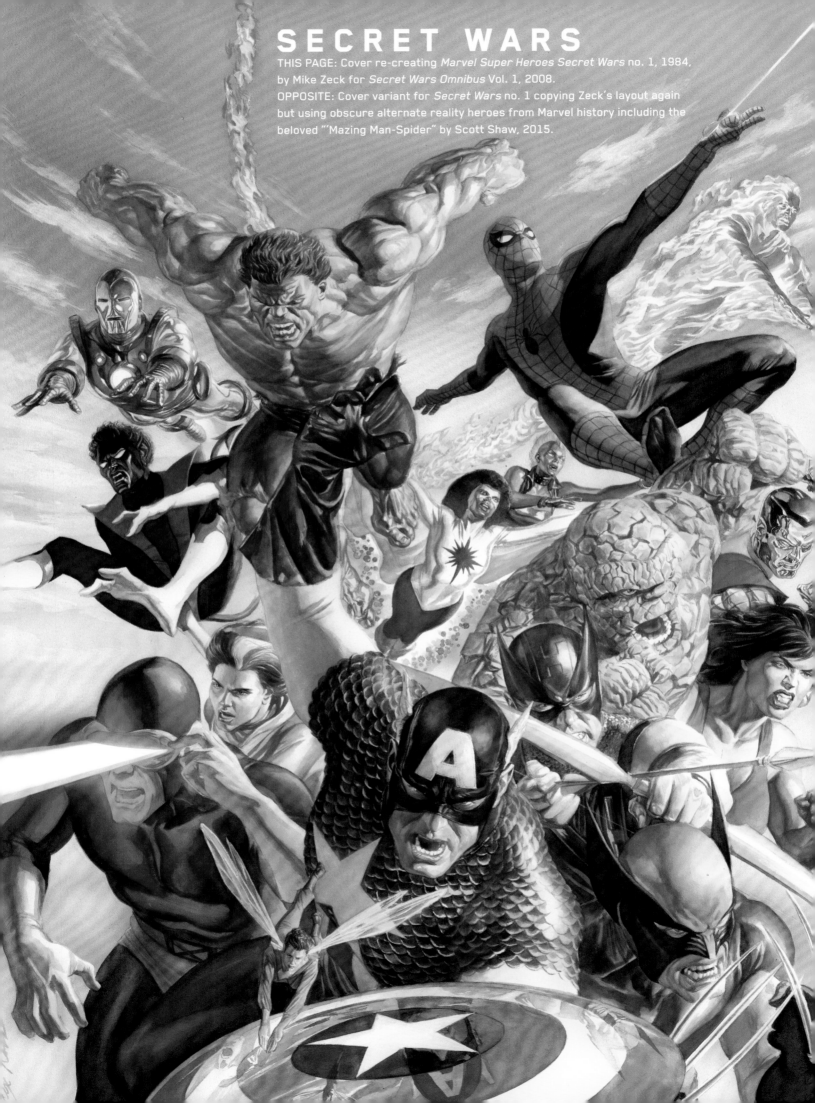

SECRET WARS

THIS PAGE: Cover re-creating *Marvel Super Heroes Secret Wars* no. 1, 1984, by Mike Zeck for *Secret Wars Omnibus* Vol. 1, 2008.
OPPOSITE: Cover variant for *Secret Wars* no. 1 copying Zeck's layout again but using obscure alternate reality heroes from Marvel history including the beloved "'Mazing Man-Spider" by Scott Shaw, 2015.

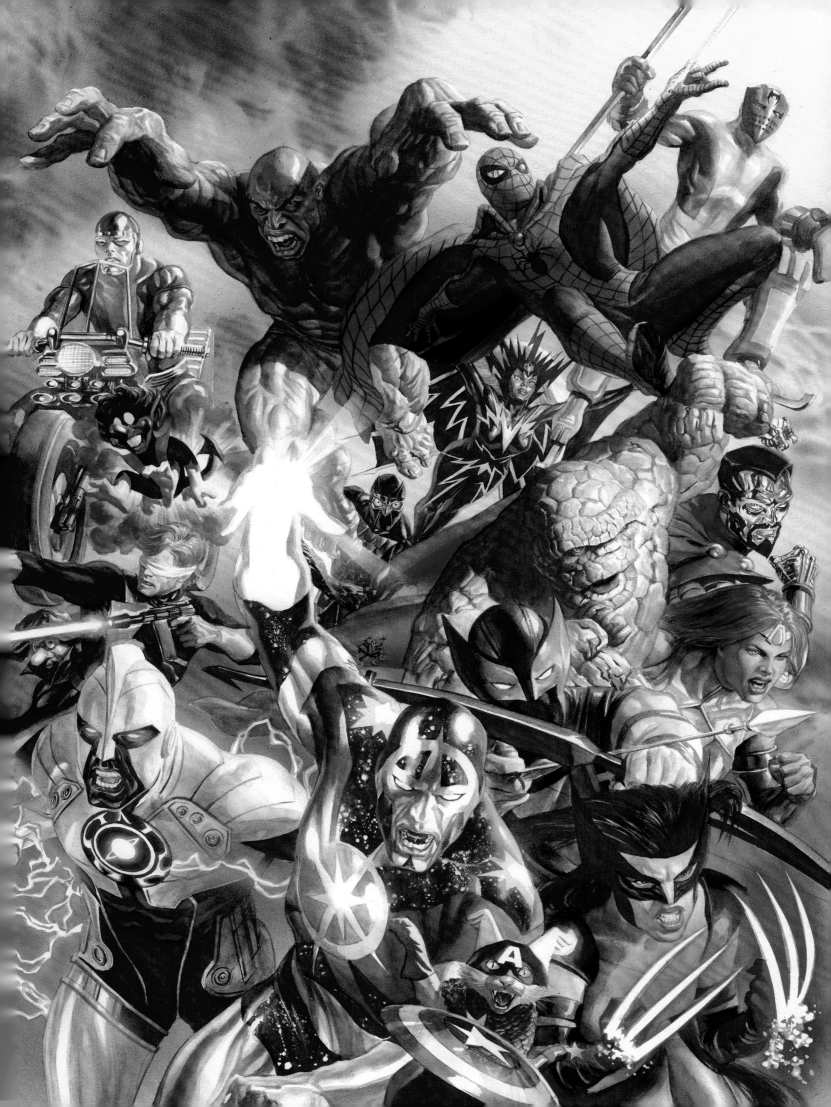

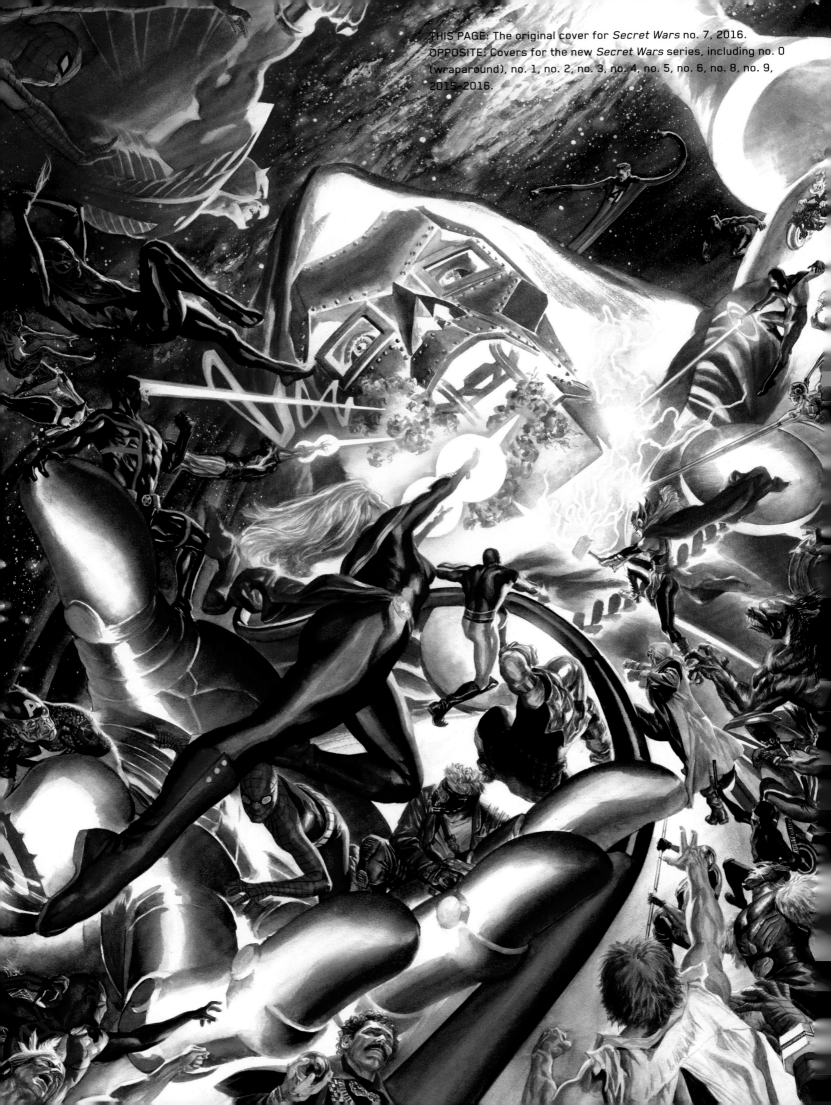

THIS PAGE: The original cover for *Secret Wars* no. 7, 2016.
OPPOSITE: Covers for the new *Secret Wars* series, including no. 0
(wraparound), no. 1, no. 2, no. 3, no. 4, no. 5, no. 6, no. 8, no. 9,
2015–2016.

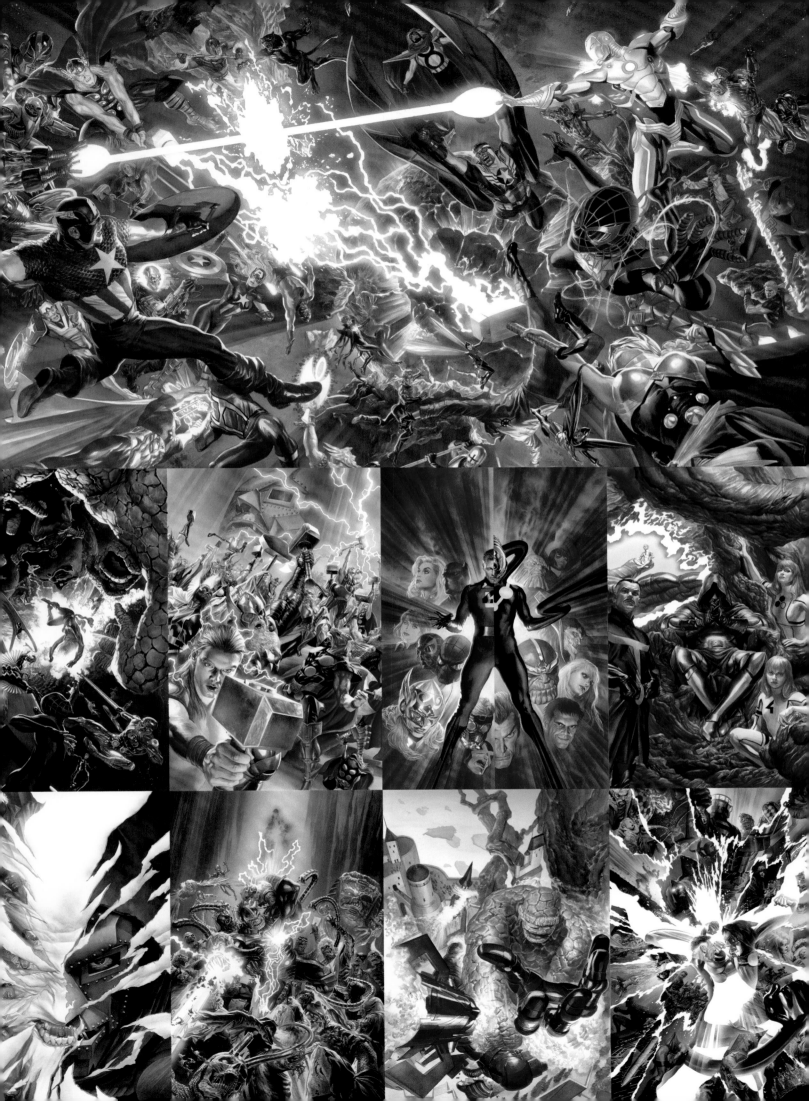

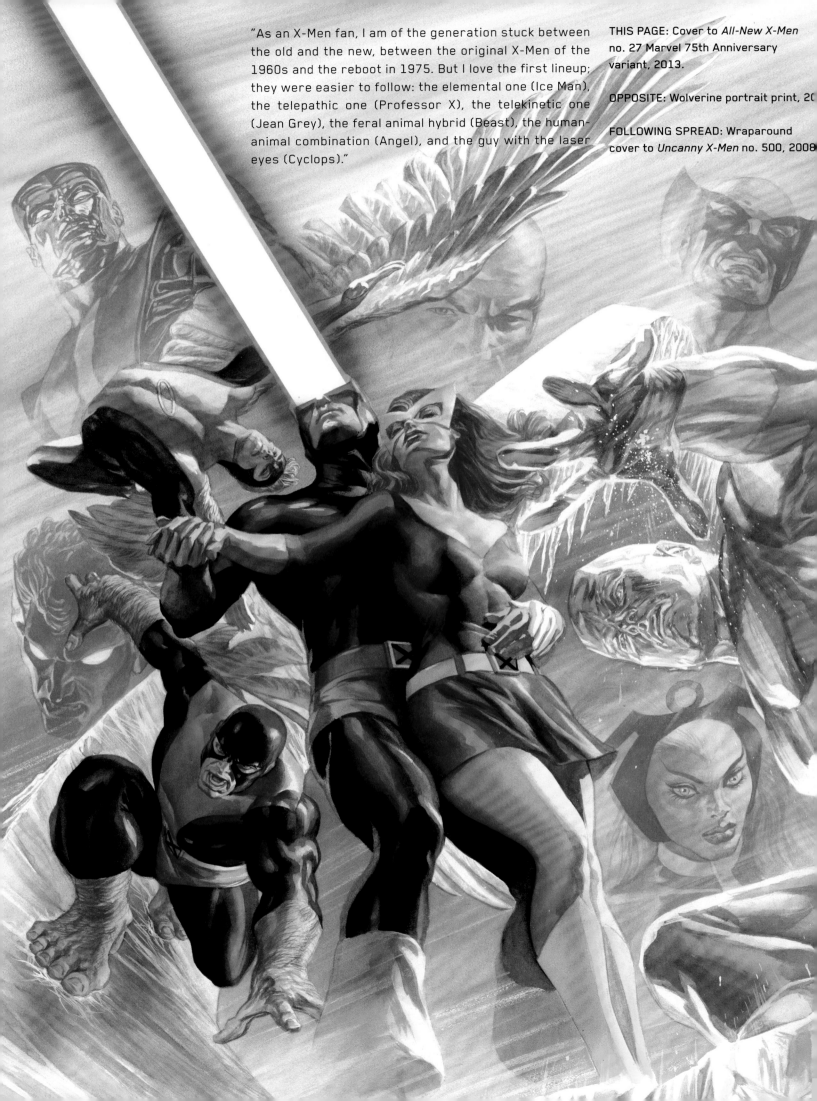

"As an X-Men fan, I am of the generation stuck between the old and the new, between the original X-Men of the 1960s and the reboot in 1975. But I love the first lineup; they were easier to follow: the elemental one (Ice Man), the telepathic one (Professor X), the telekinetic one (Jean Grey), the feral animal hybrid (Beast), the human-animal combination (Angel), and the guy with the laser eyes (Cyclops)."

THIS PAGE: Cover to *All-New X-Men* no. 27 Marvel 75th Anniversary variant, 2013.

OPPOSITE: Wolverine portrait print, 20

FOLLOWING SPREAD: Wraparound cover to *Uncanny X-Men* no. 500, 2008

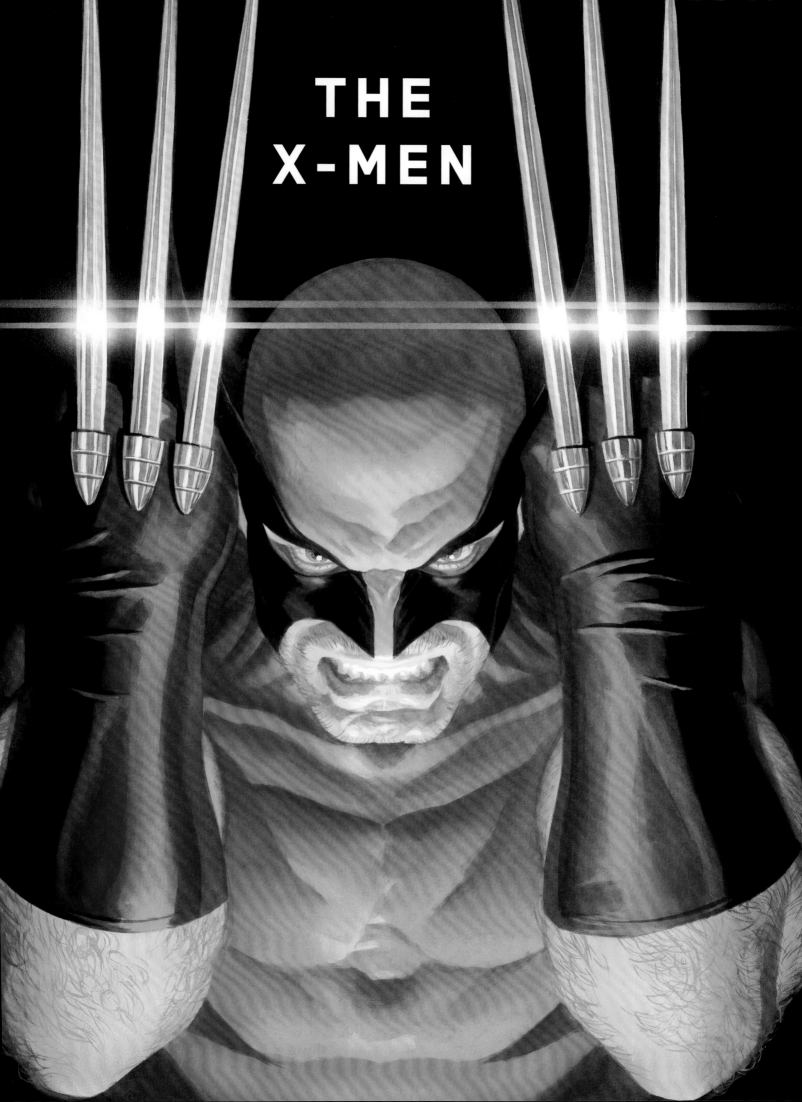

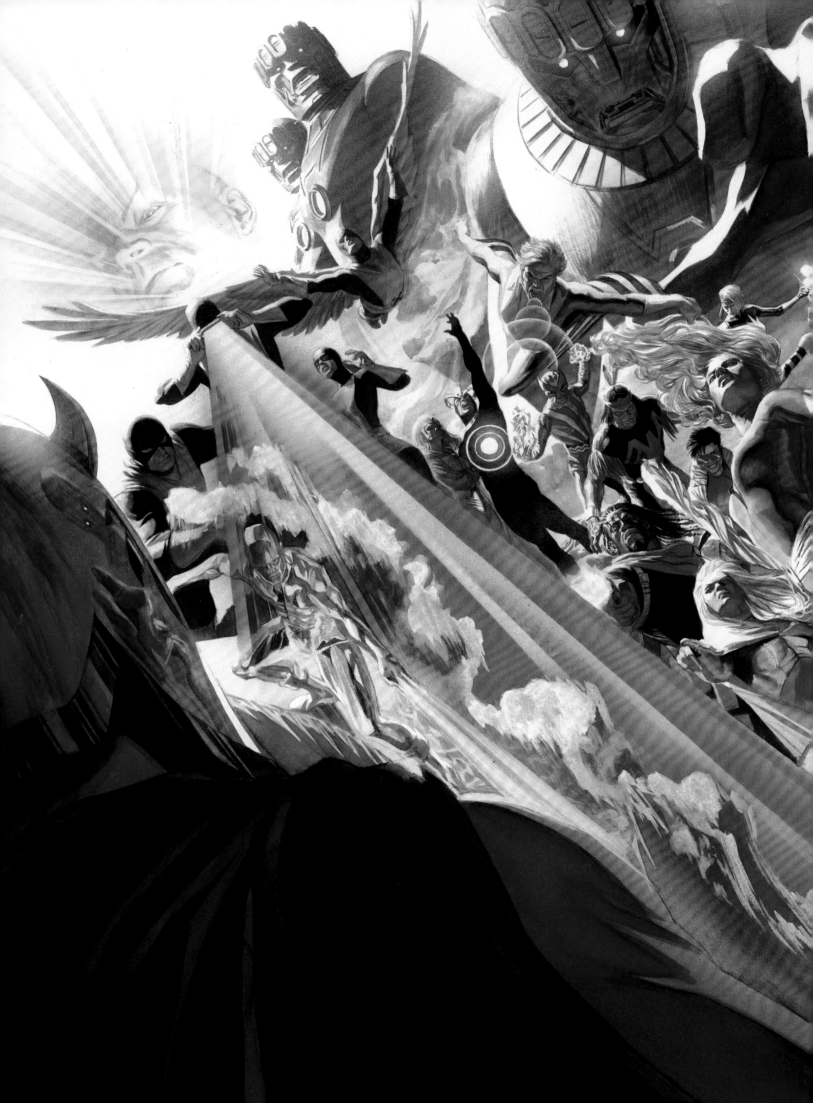

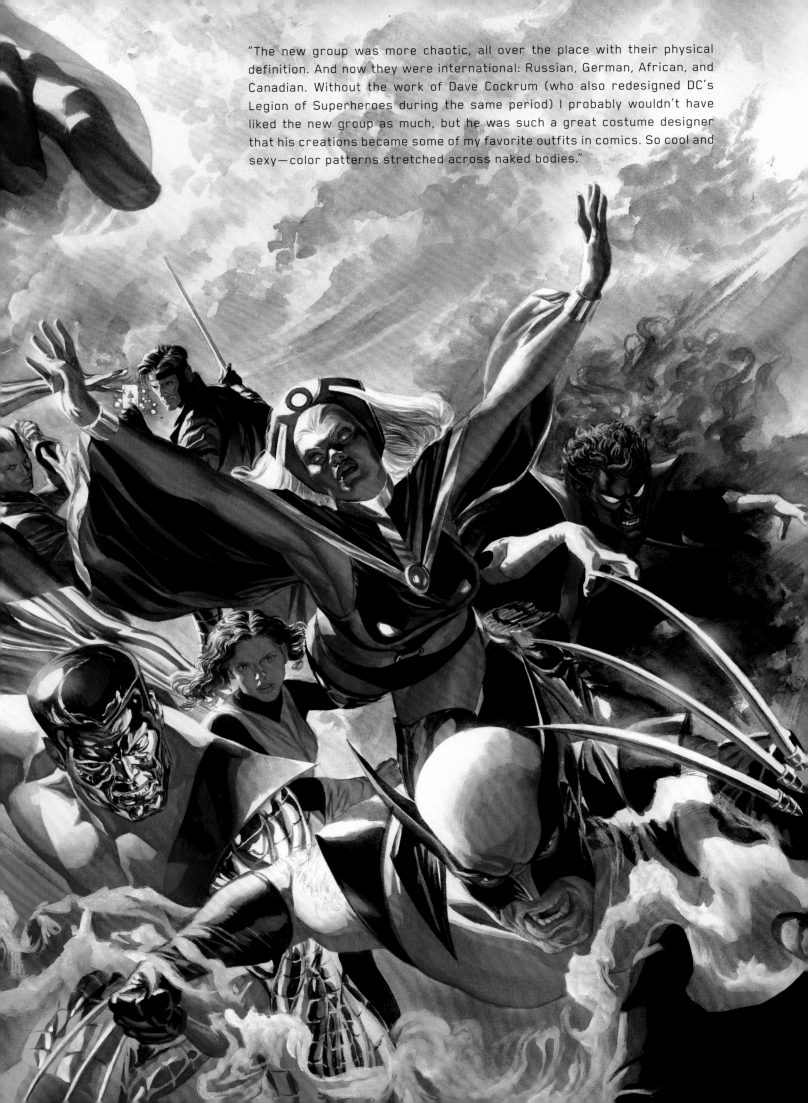

"The new group was more chaotic, all over the place with their physical definition. And now they were international: Russian, German, African, and Canadian. Without the work of Dave Cockrum (who also redesigned DC's Legion of Superheroes during the same period) I probably wouldn't have liked the new group as much, but he was such a great costume designer that his creations became some of my favorite outfits in comics. So cool and sexy—color patterns stretched across naked bodies."

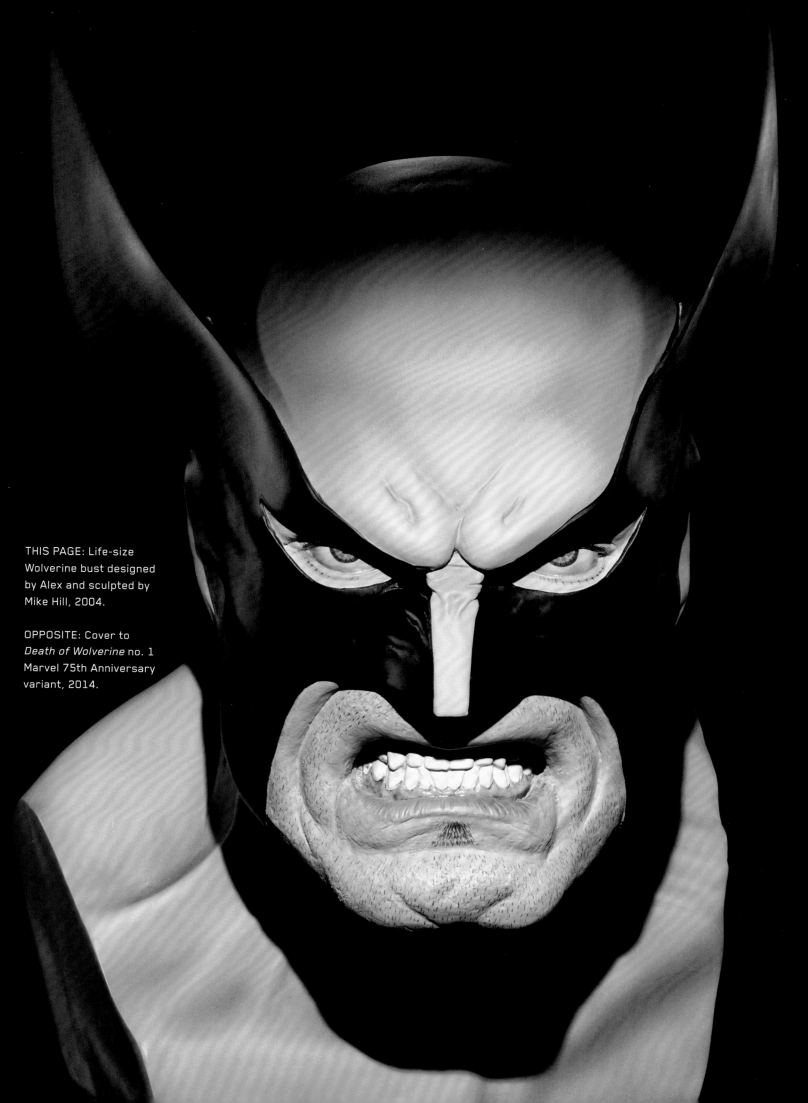

THIS PAGE: Life-size Wolverine bust designed by Alex and sculpted by Mike Hill, 2004.

OPPOSITE: Cover to *Death of Wolverine* no. 1 Marvel 75th Anniversary variant, 2014.

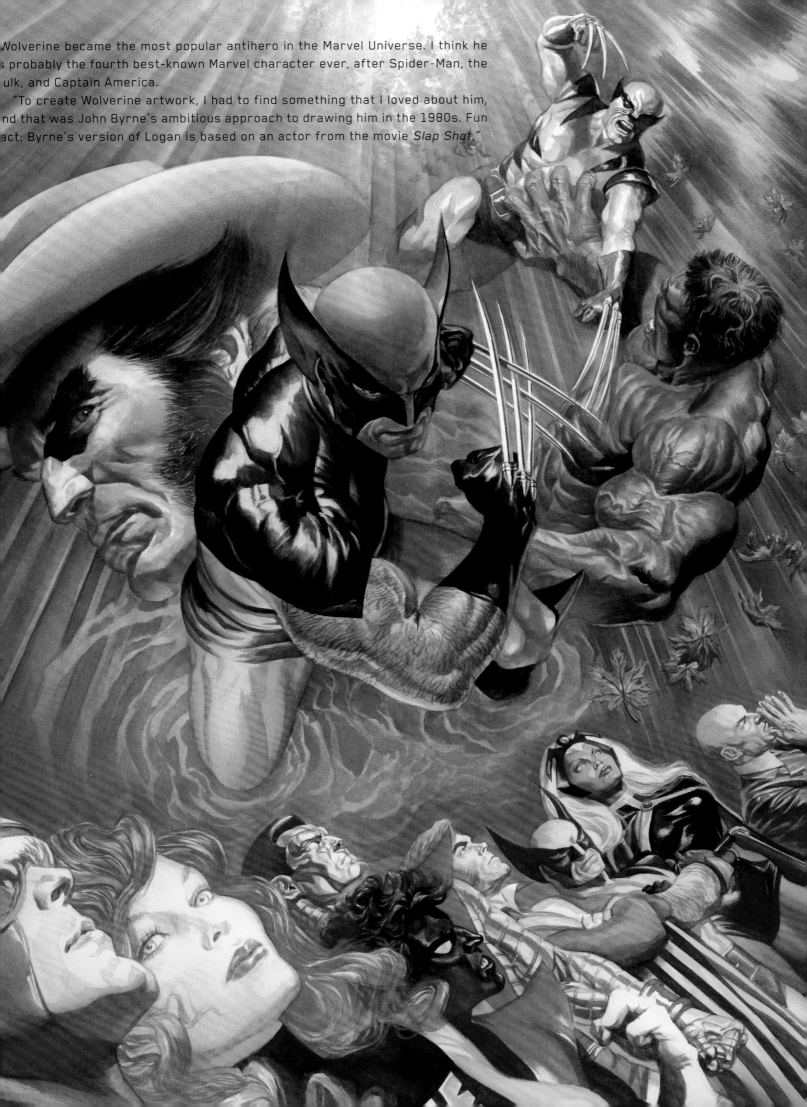

Wolverine became the most popular antihero in the Marvel Universe. I think he is probably the fourth best-known Marvel character ever, after Spider-Man, the Hulk, and Captain America.

"To create Wolverine artwork, I had to find something that I loved about him, and that was John Byrne's ambitious approach to drawing him in the 1980s. Fun fact: Byrne's version of Logan is based on an actor from the movie *Slap Shot*."

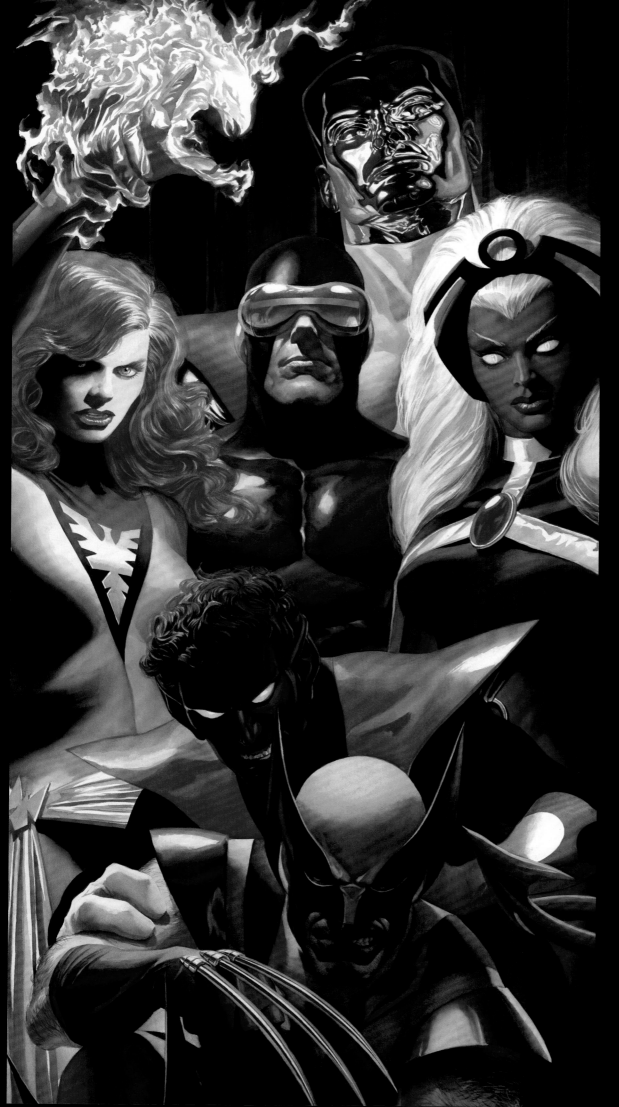

THIS PAGE: "Xtraordinary" print meant as Alex's counterpart to the Justice League's "Original Seven" print and the Avengers' "Assemble," featuring what he saw as the core six team members, 2014.

OPPOSITE: Life-size Nightcrawler bust designed by Alex and sculpted by Larry Malott, 2007.

FOLLOWING SPREAD, LEFT PAGE: Cover to *Uncanny X-Men* no. 29 Marvel 75th Anniversary variant, 2013.

FOLLOWING SPREAD, RIGHT PAGE: Cover to *Wizard* no. 95, 1999. Both covers based on Dave Cockrum's costume designs and layout style.

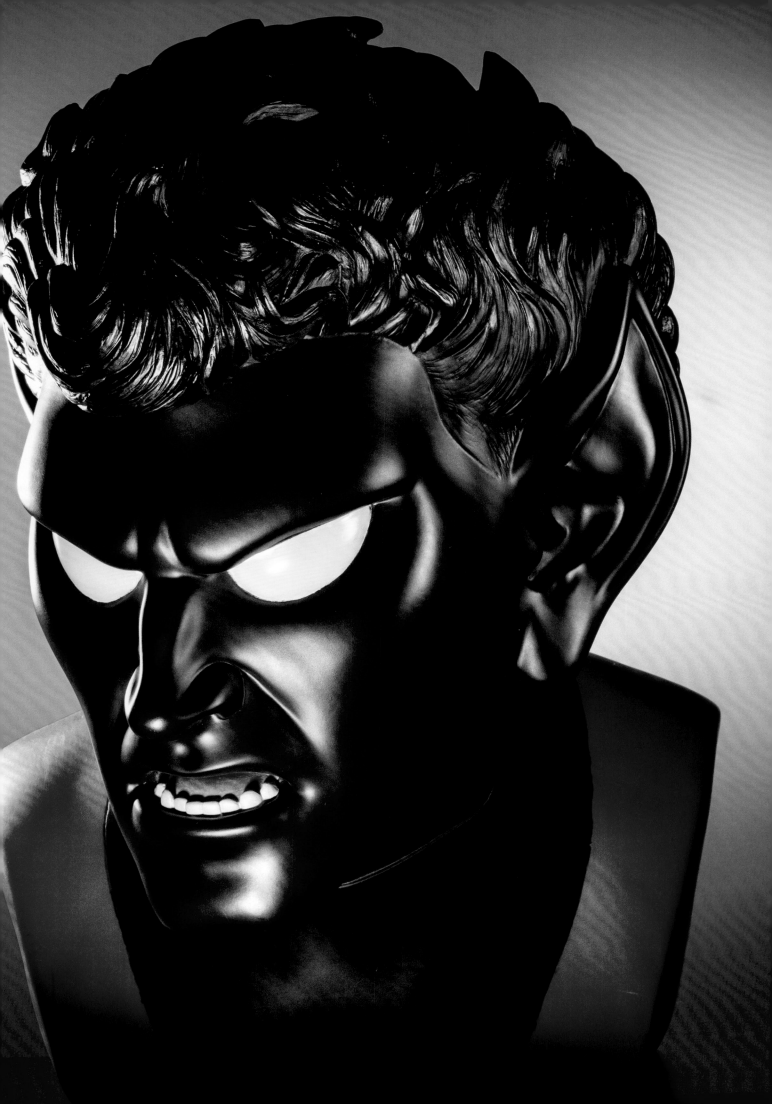

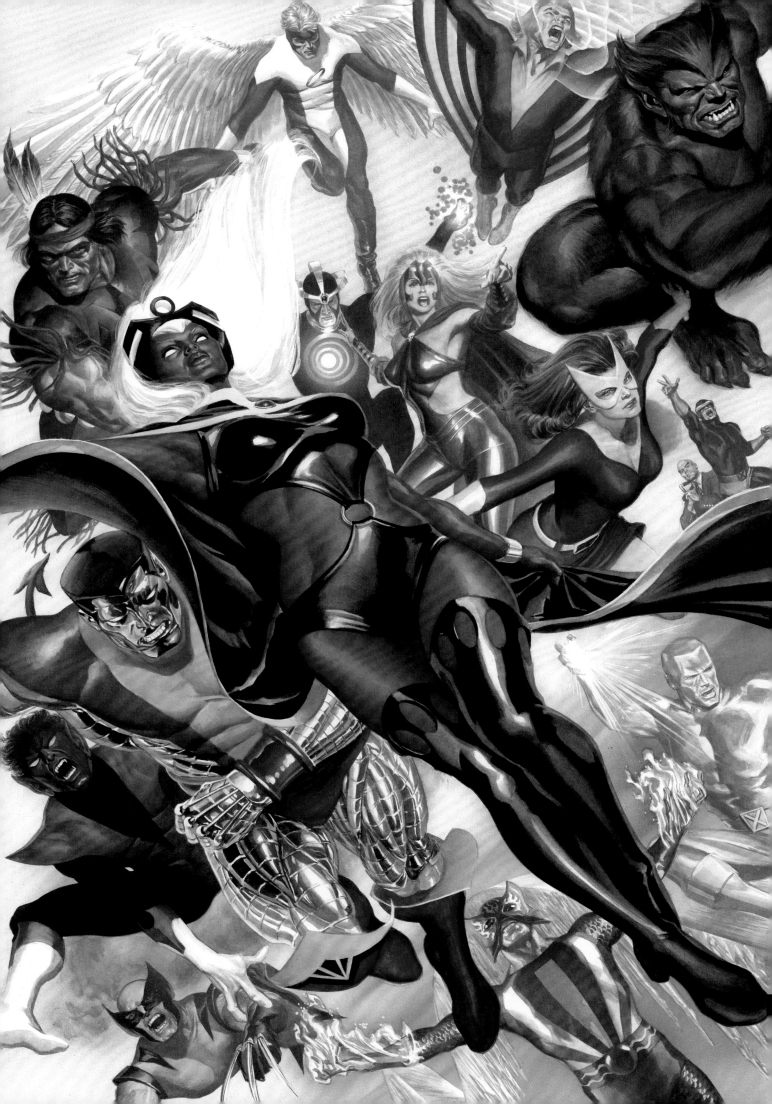

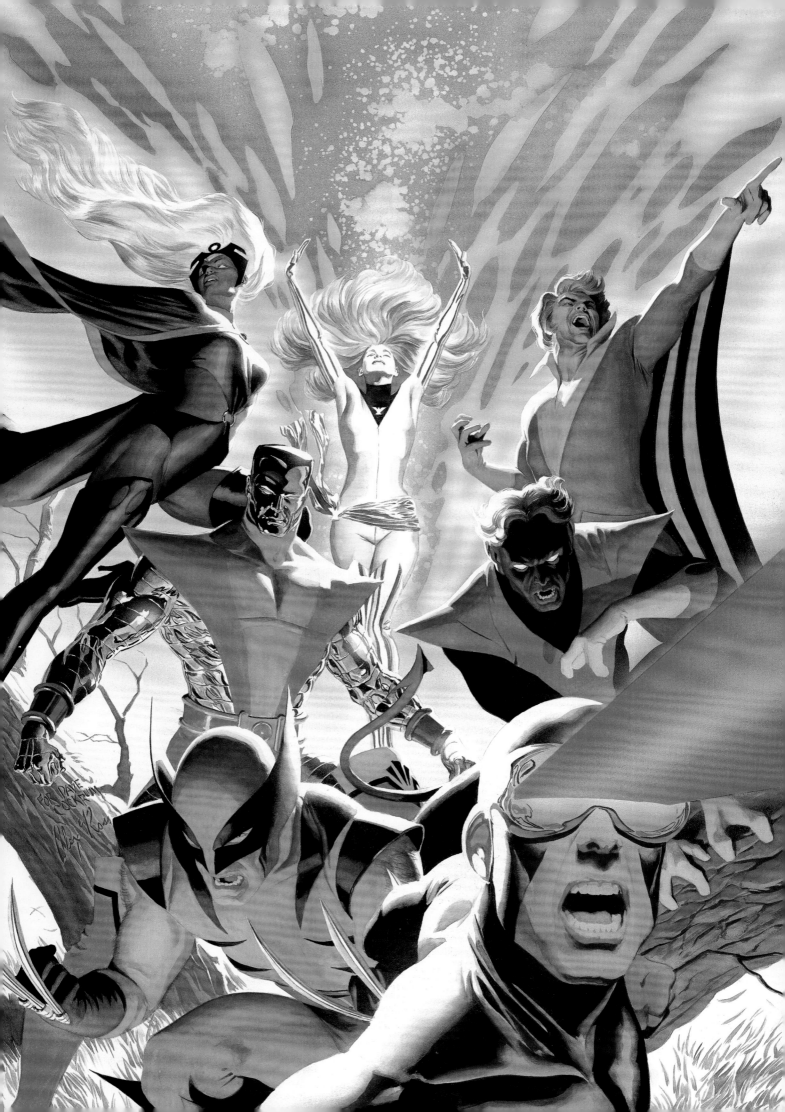

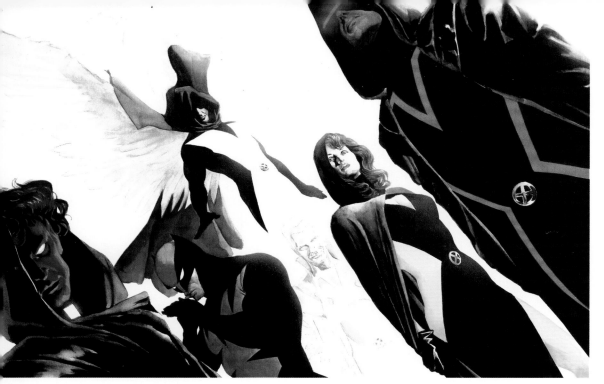

"In 2000, with the release of the *X-Men* movie, there was a call to redesign their costumes based on that look—black leather. But my inspiration was the solid black silhouette in the comics of the character called Havok, Scott Summers' brother. I wanted Cyclops to look the coolest, clearly in charge—the red X on him accents his visor. Each member has the solid black bodysuit accented by one color.

"They would have had these hooded black leather jackets, which would allow them to move among the populace—the black hints at a sense of stealth, but then the coats could come off and they could spring into action."

Alas, it was not meant to be.

X-MEN REDESIGN PROPOSAL

MY BIG, FAT X DESIGNS BY ALEX ROSS

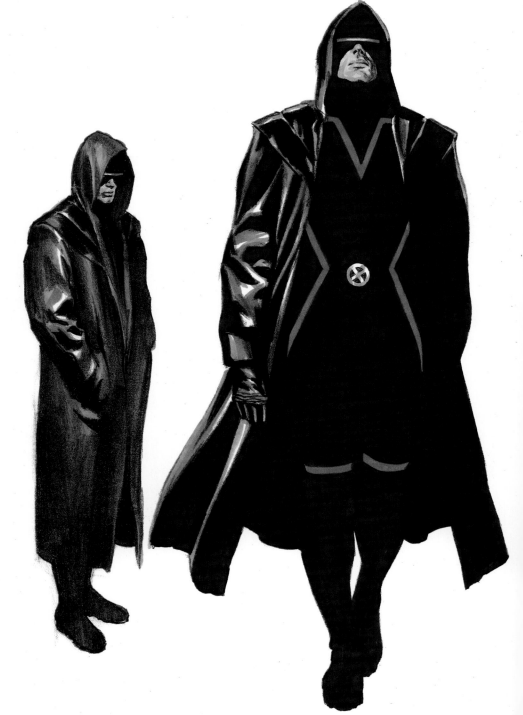

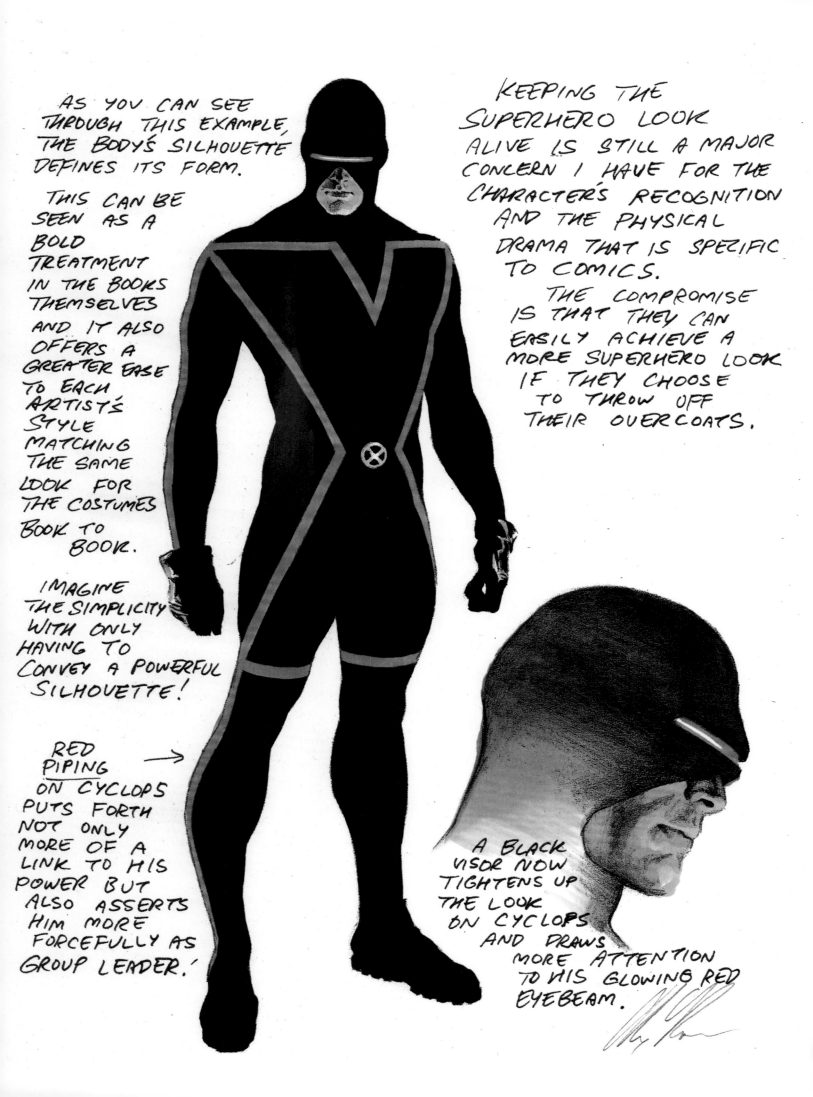

AS YOU CAN SEE THROUGH THIS EXAMPLE, THE BODY'S SILHOUETTE DEFINES ITS FORM.

THIS CAN BE SEEN AS A BOLD TREATMENT IN THE BOOKS THEMSELVES AND IT ALSO OFFERS A GREATER EASE TO EACH ARTIST'S STYLE MATCHING THE SAME LOOK FOR THE COSTUMES BOOK TO BOOK.

IMAGINE THE SIMPLICITY WITH ONLY HAVING TO CONVEY A POWERFUL SILHOUETTE!

RED PIPING → ON CYCLOPS PUTS FORTH NOT ONLY MORE OF A LINK TO HIS POWER BUT ALSO ASSERTS HIM MORE FORCEFULLY AS GROUP LEADER.'

KEEPING THE SUPERHERO LOOK ALIVE IS STILL A MAJOR CONCERN I HAVE FOR THE CHARACTER'S RECOGNITION AND THE PHYSICAL DRAMA THAT IS SPECIFIC TO COMICS.

THE COMPROMISE IS THAT THEY CAN EASILY ACHIEVE A MORE SUPERHERO LOOK IF THEY CHOOSE TO THROW OFF THEIR OVERCOATS.

A BLACK VISOR NOW TIGHTENS UP THE LOOK ON CYCLOPS AND DRAWS MORE ATTENTION TO HIS GLOWING RED EYEBEAM.

A LITTLE RED RIDING HOOD QUALITY ENHANCES JEAN WITHOUT GIVING HER A MASK OR ANOTHER POINTLESS HEADBAND. SHE COULD WEAR THE SAME OVERCOAT AS SCOTT BUT I FIGURE THAT THE SLIGHT SPANDEX TOUCHES ON HER WITH A LIGHT CLOAK AND SKIRT WOULD NOT MAKE HER STAND OUT RIDICULOUSLY.

KEEP IN MIND, WOMEN CAN ALWAYS GET AWAY WITH MORE FASHION RISKS THAN THE GUYS.

HER RED HAIR POURING THROUGH THE CORNERS OF HER HOOD COMMUNICATE A SENSE OF MYSTERY THAT FOCUSES ON HER HEAD, THE FOCAL POINT OF HER POWER!

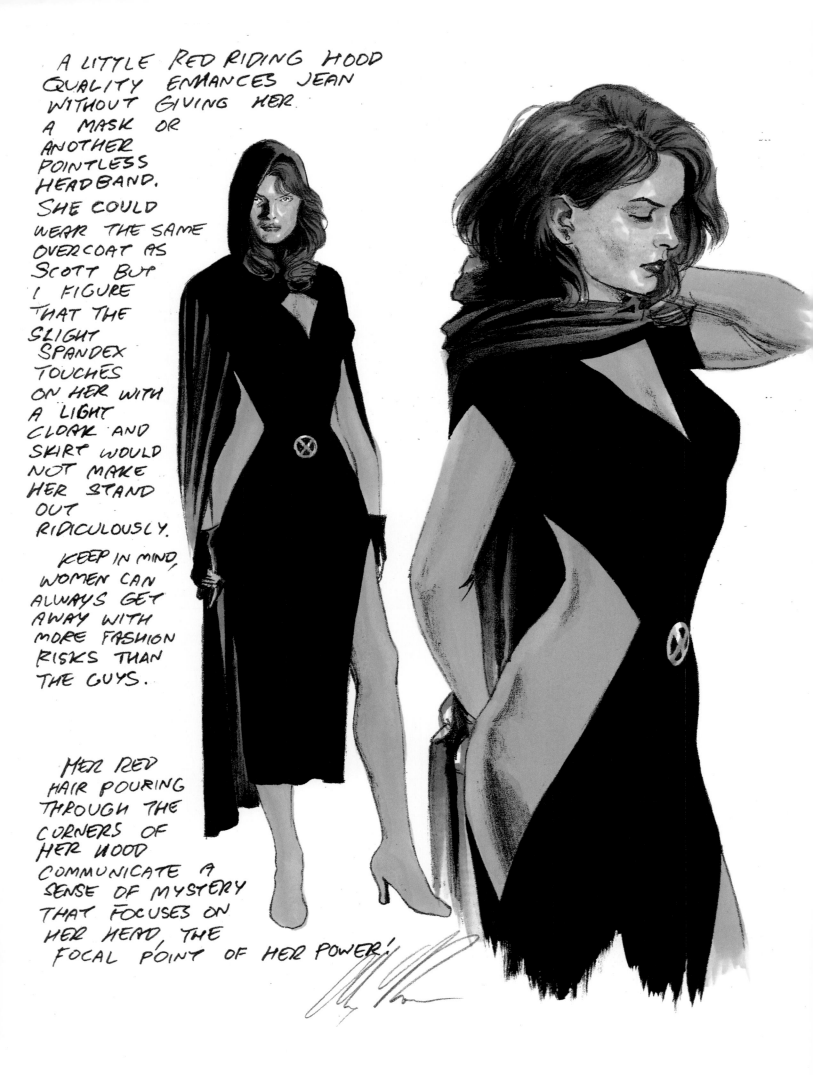

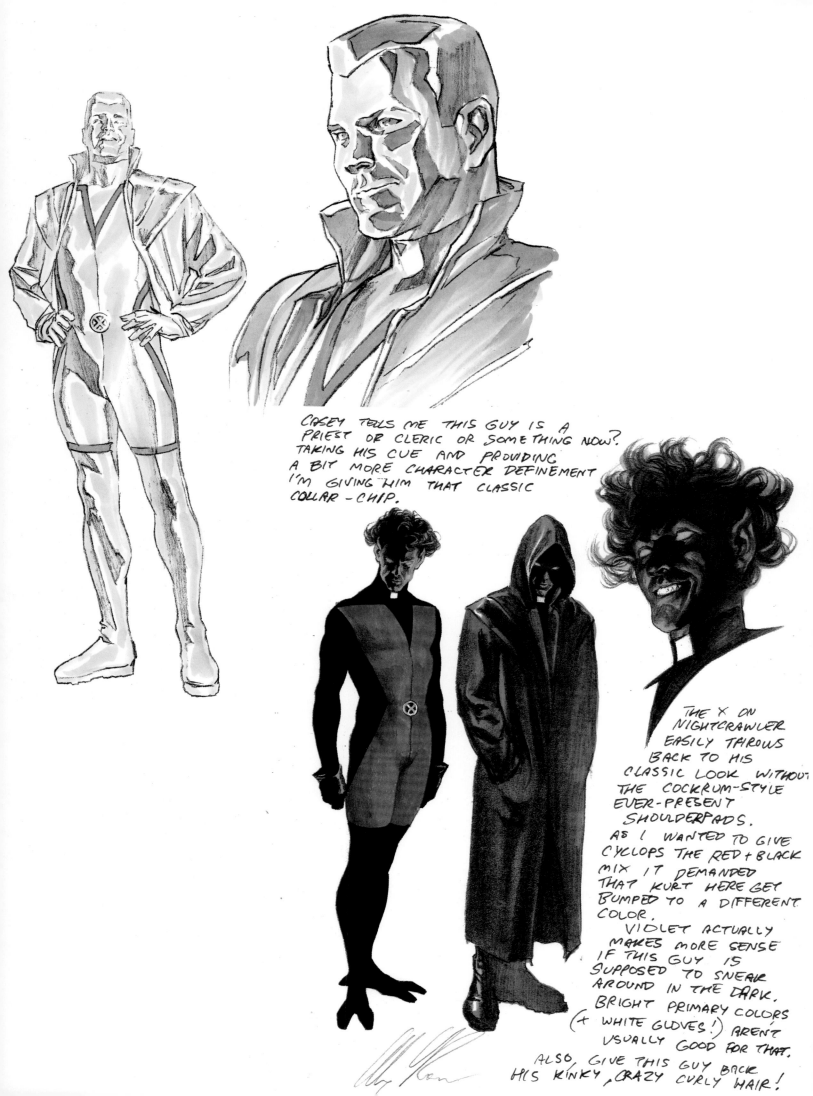

CASEY TELLS ME THIS GUY IS A PRIEST OR CLERIC OR SOMETHING NOW? TAKING HIS CUE AND PROVIDING A BIT MORE CHARACTER DEFINEMENT I'M GIVING HIM THAT CLASSIC COLLAR-CHIP.

THE X ON NIGHTCRAWLER EASILY THROWS BACK TO HIS CLASSIC LOOK WITHOUT THE COCKRUM-STYLE EVER-PRESENT SHOULDERPADS.
AS I WANTED TO GIVE CYCLOPS THE RED + BLACK MIX IT DEMANDED THAT KURT HERE GET BUMPED TO A DIFFERENT COLOR.
VIOLET ACTUALLY MAKES MORE SENSE IF THIS GUY IS SUPPOSED TO SNEAK AROUND IN THE DARK. BRIGHT PRIMARY COLORS (+ WHITE GLOVES!) AREN'T USUALLY GOOD FOR THAT.
ALSO, GIVE THIS GUY BACK HIS KINKY, CRAZY CURLY HAIR!

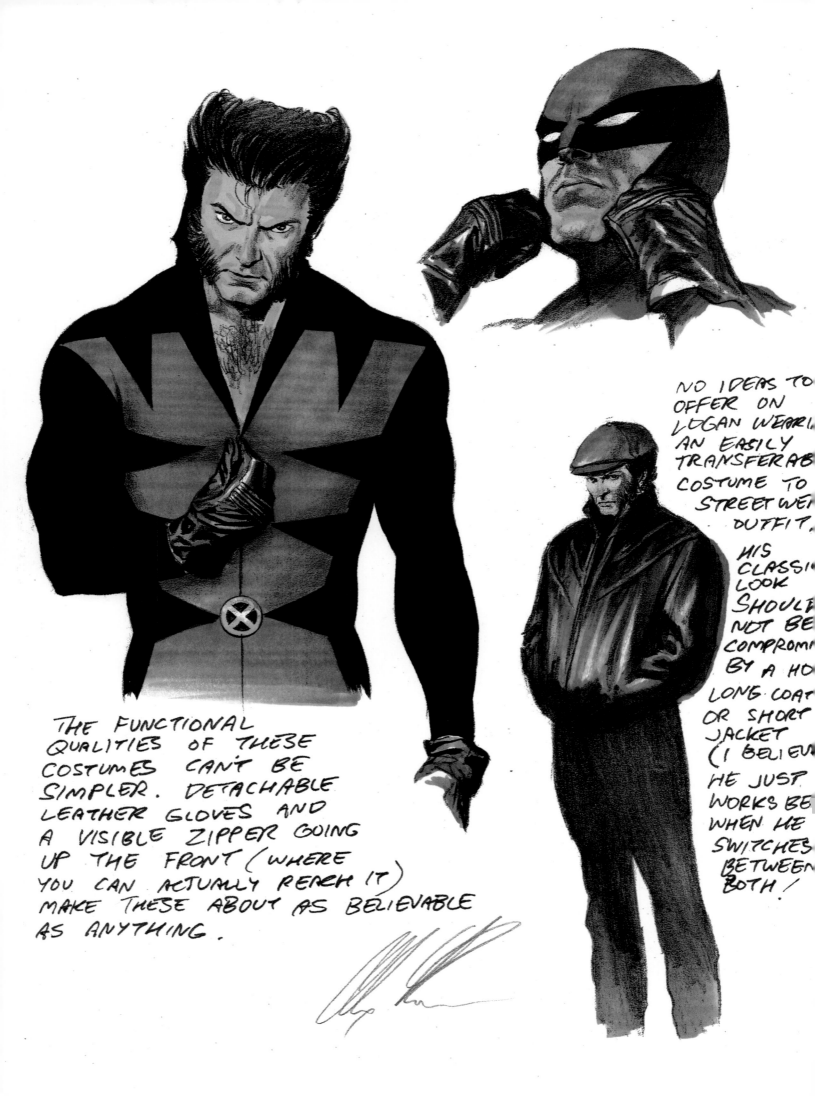

THE FUNCTIONAL QUALITIES OF THESE COSTUMES CAN'T BE SIMPLER. DETACHABLE LEATHER GLOVES AND A VISIBLE ZIPPER GOING UP THE FRONT (WHERE YOU CAN ACTUALLY REACH IT) MAKE THESE ABOUT AS BELIEVABLE AS ANYTHING.

NO IDEAS TO OFFER ON LOGAN WEARI AN EASILY TRANSFERAB COSTUME TO STREET WE OUTFIT.

HIS CLASSI LOOK SHOULD NOT BE COMPROMI BY A HO LONG COAT OR SHORT JACKET (I BELIEV HE JUST WORKS BE WHEN HE SWITCHES BETWEEN BOTH!

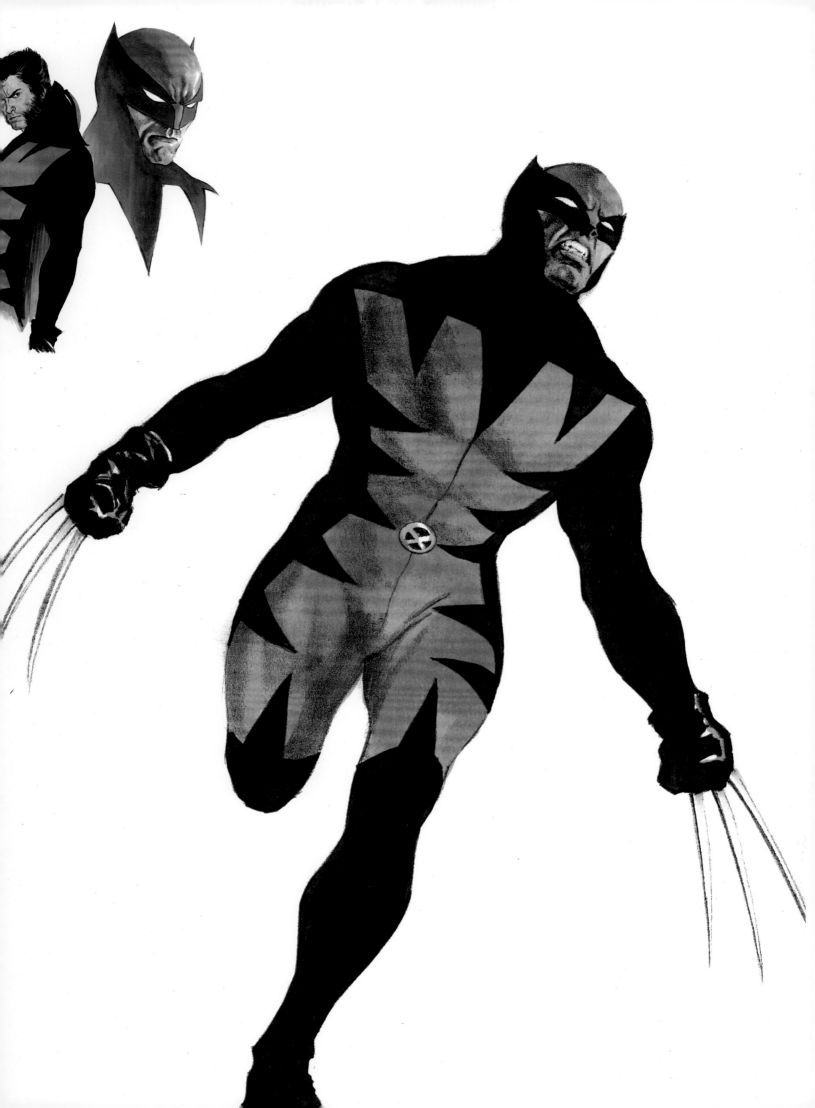

DR. STRANGE

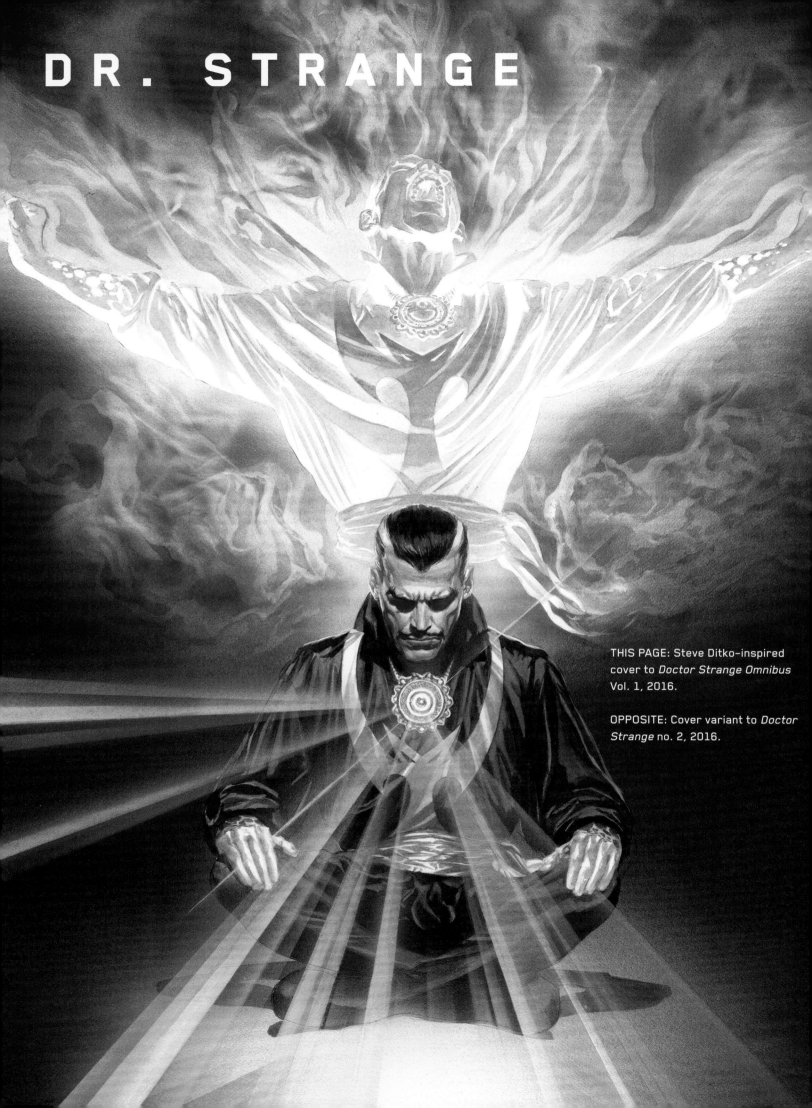

THIS PAGE: Steve Ditko-inspired cover to *Doctor Strange Omnibus* Vol. 1, 2016.

OPPOSITE: Cover variant to *Doctor Strange* no. 2, 2016.

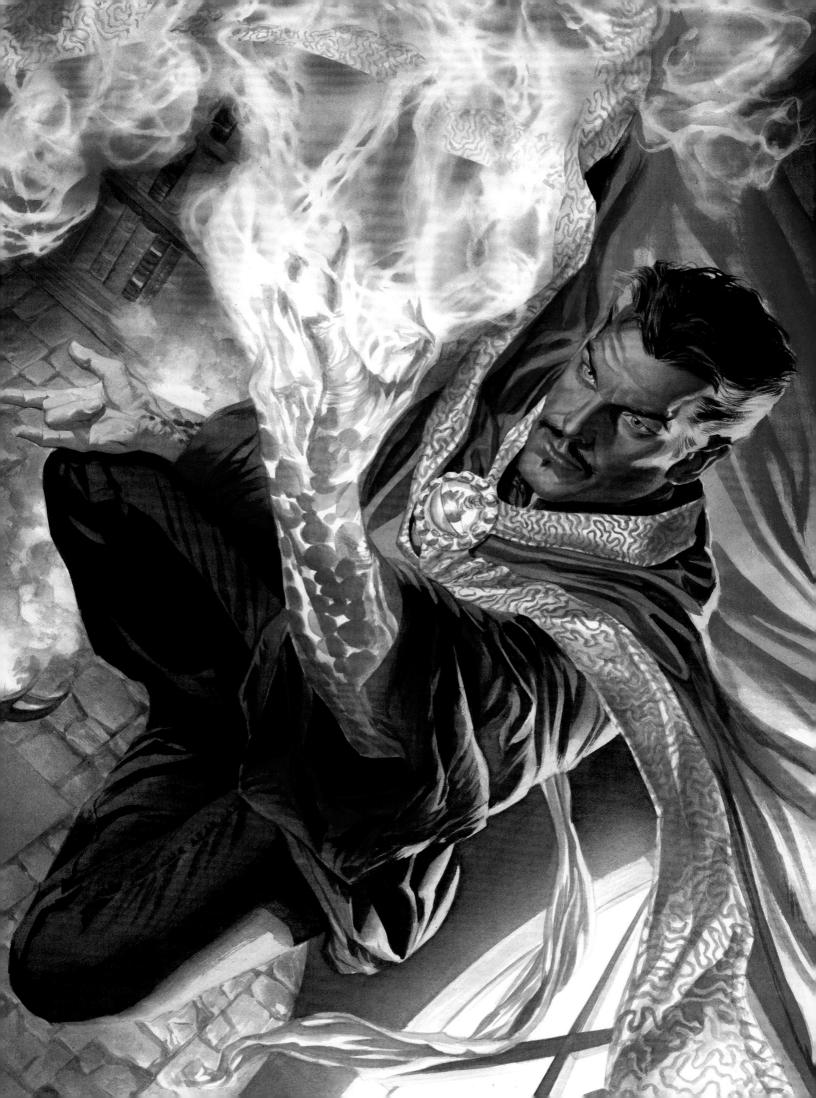

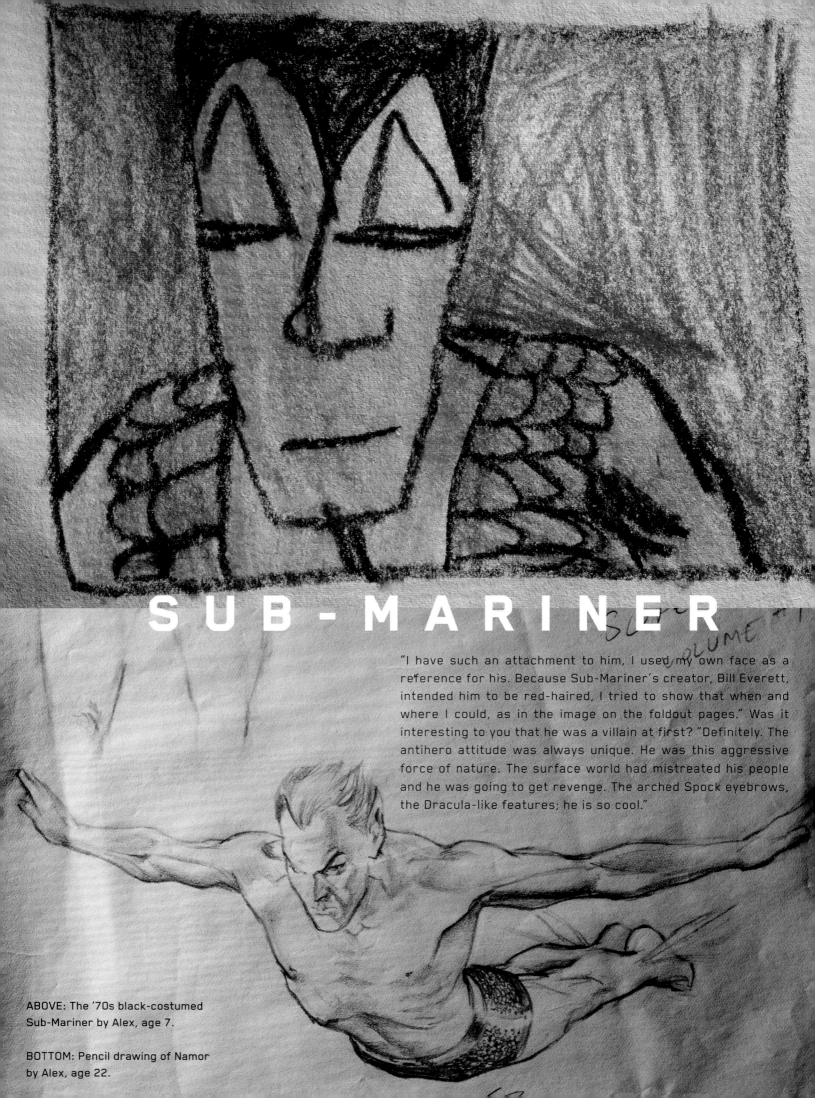

SUB-MARINER

"I have such an attachment to him, I used my own face as a reference for his. Because Sub-Mariner's creator, Bill Everett, intended him to be red-haired, I tried to show that when and where I could, as in the image on the foldout pages." Was it interesting to you that he was a villain at first? "Definitely. The antihero attitude was always unique. He was this aggressive force of nature. The surface world had mistreated his people and he was going to get revenge. The arched Spock eyebrows, the Dracula-like features; he is so cool."

ABOVE: The '70s black-costumed Sub-Mariner by Alex, age 7.

BOTTOM: Pencil drawing of Namor by Alex, age 22.

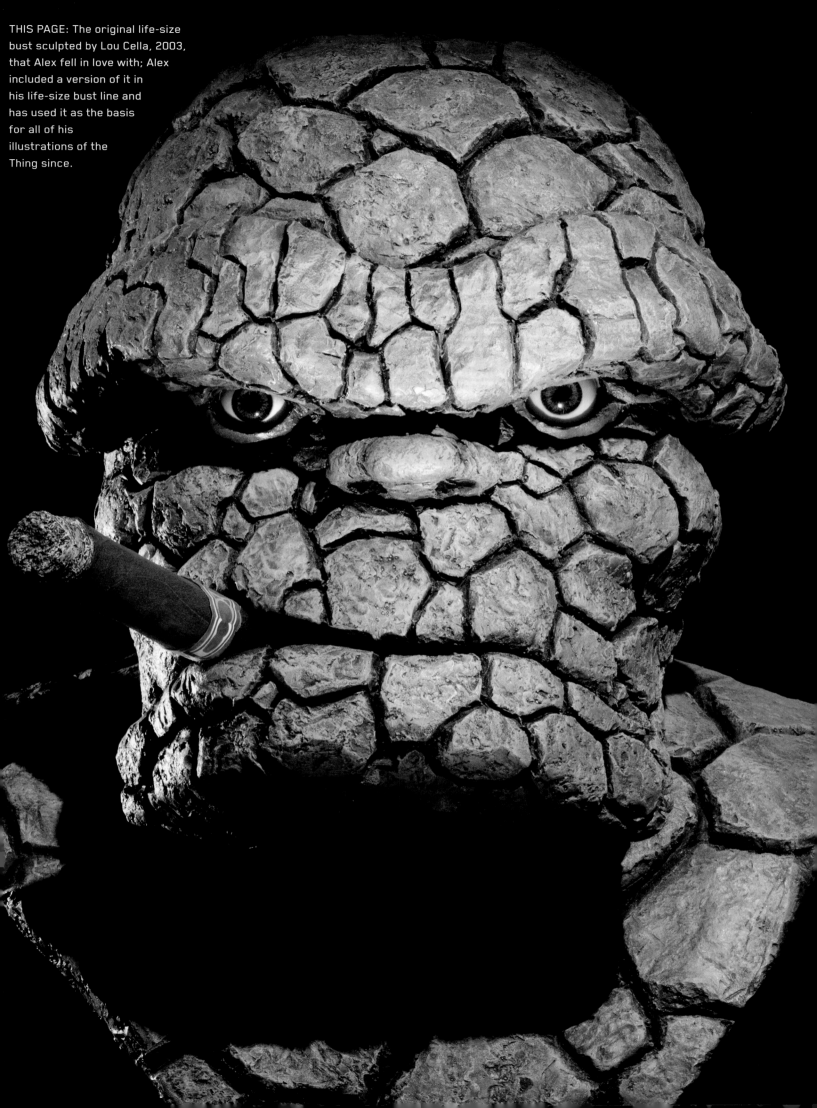

"*The Fantastic Four* was the greatest comic magazine. One of the earliest stories that I loved was Kirby's sequence of them reading their fan mail. That made them so endearing and real."

Many fans have theorized that the Thing (right, with the Johnny Storm incarnation of the Human Torch) is Kirby himself. Alex disagrees: "I think that Kirby was always Reed Richards, because he was the leader, the archetype of invention. He's the perfect metaphor for not just the great father figure, but the great artist. Richards represents Kirby the man: responsible, dependable, self-sufficient, faithful husband, provider. The Fantastic Four—Reed's family—are living in the Baxter Building, which he bought based on his own patents.

"And then he goes and saves the world, with his family . . .

"I find him infinitely more relatable than Spider-Man."

THIS PAGE: Thumbnail sketches for cover to *Marvel Two-in-One* no. 1 variant, 2017.

OPPOSITE: Finished cover to *Marvel Two-in-One* no. 1 variant, 2017.

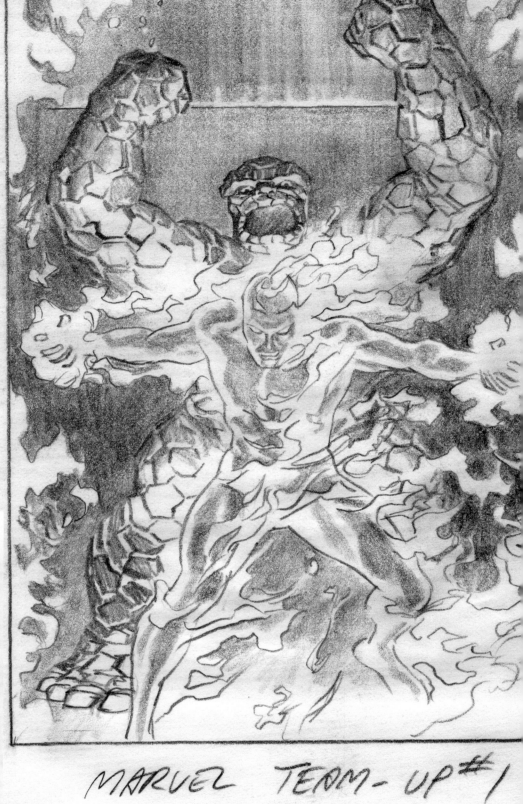

MARVEL TEAM-UP #1

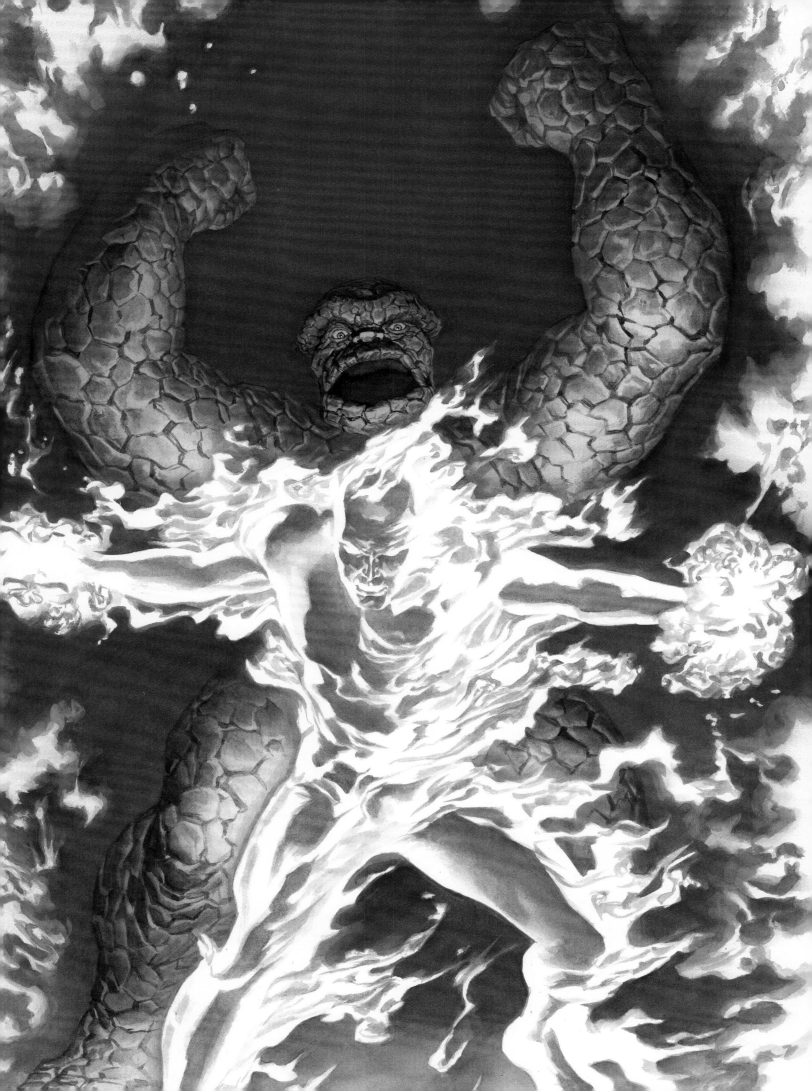

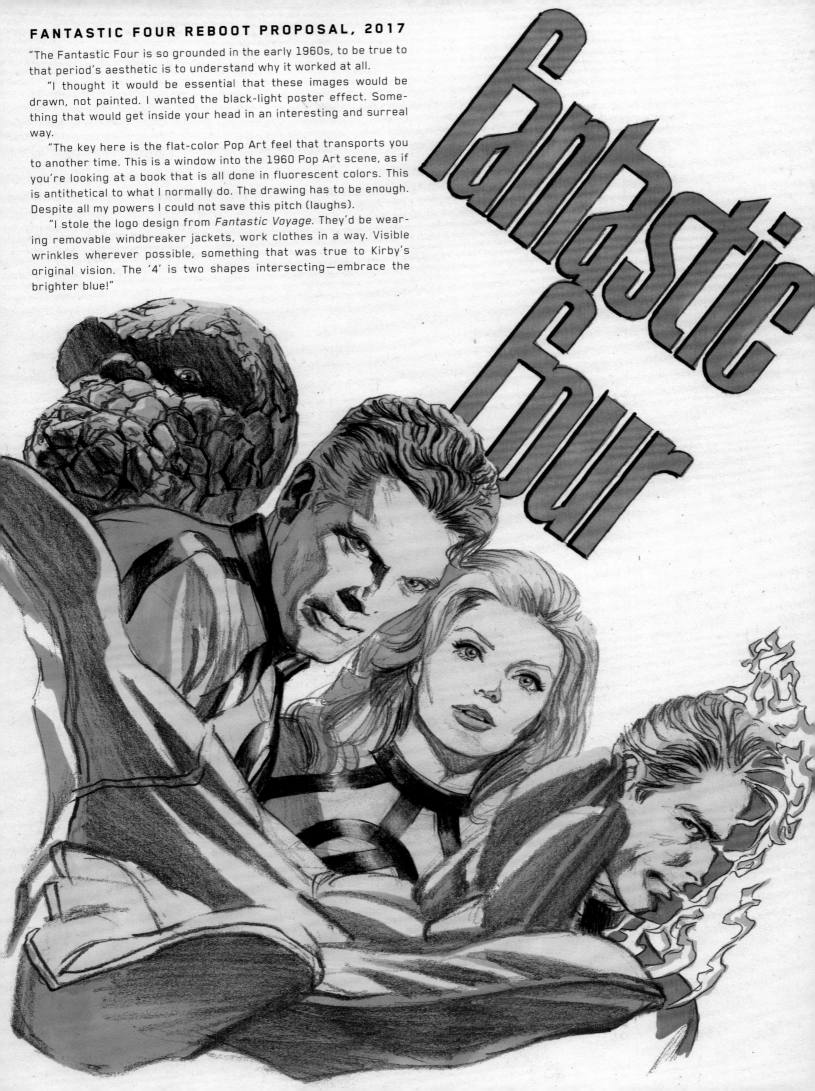

FANTASTIC FOUR REBOOT PROPOSAL, 2017

"The Fantastic Four is so grounded in the early 1960s, to be true to that period's aesthetic is to understand why it worked at all.

"I thought it would be essential that these images would be drawn, not painted. I wanted the black-light poster effect. Something that would get inside your head in an interesting and surreal way.

"The key here is the flat-color Pop Art feel that transports you to another time. This is a window into the 1960 Pop Art scene, as if you're looking at a book that is all done in fluorescent colors. This is antithetical to what I normally do. The drawing has to be enough. Despite all my powers I could not save this pitch (laughs).

"I stole the logo design from *Fantastic Voyage*. They'd be wearing removable windbreaker jackets, work clothes in a way. Visible wrinkles wherever possible, something that was true to Kirby's original vision. The '4' is two shapes intersecting—embrace the brighter blue!"

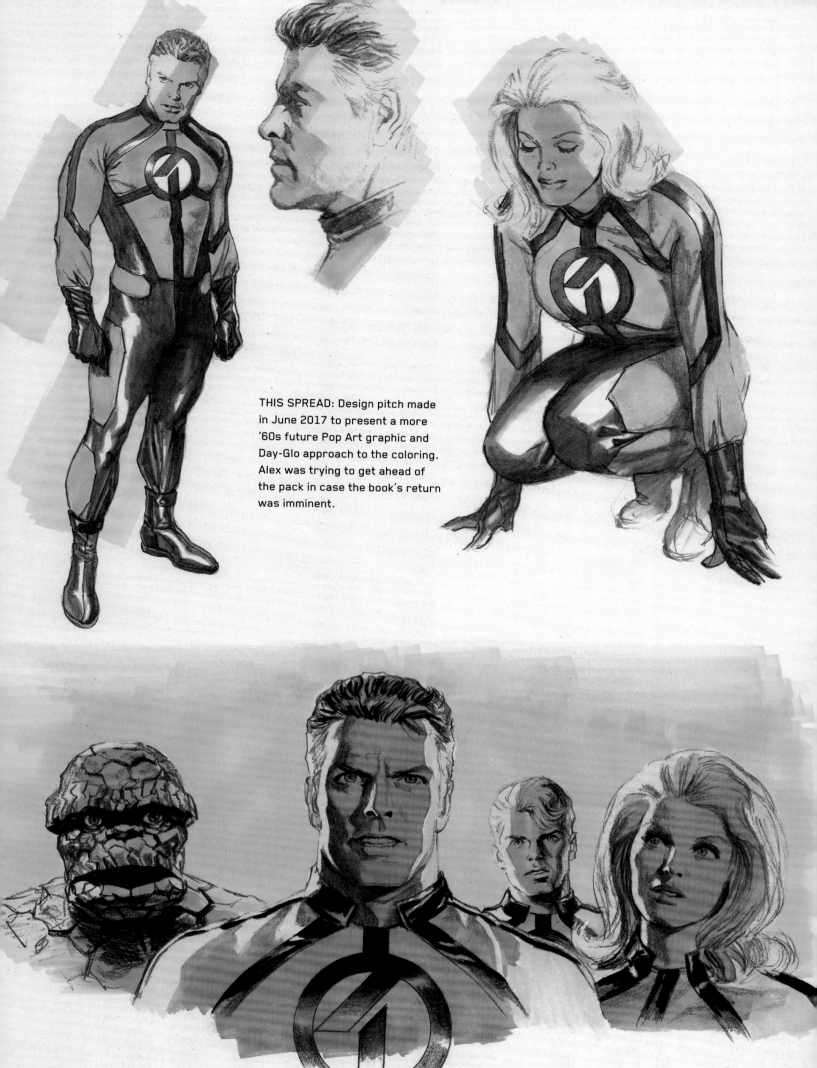

THIS SPREAD: Design pitch made in June 2017 to present a more '60s future Pop Art graphic and Day-Glo approach to the coloring. Alex was trying to get ahead of the pack in case the book's return was imminent.

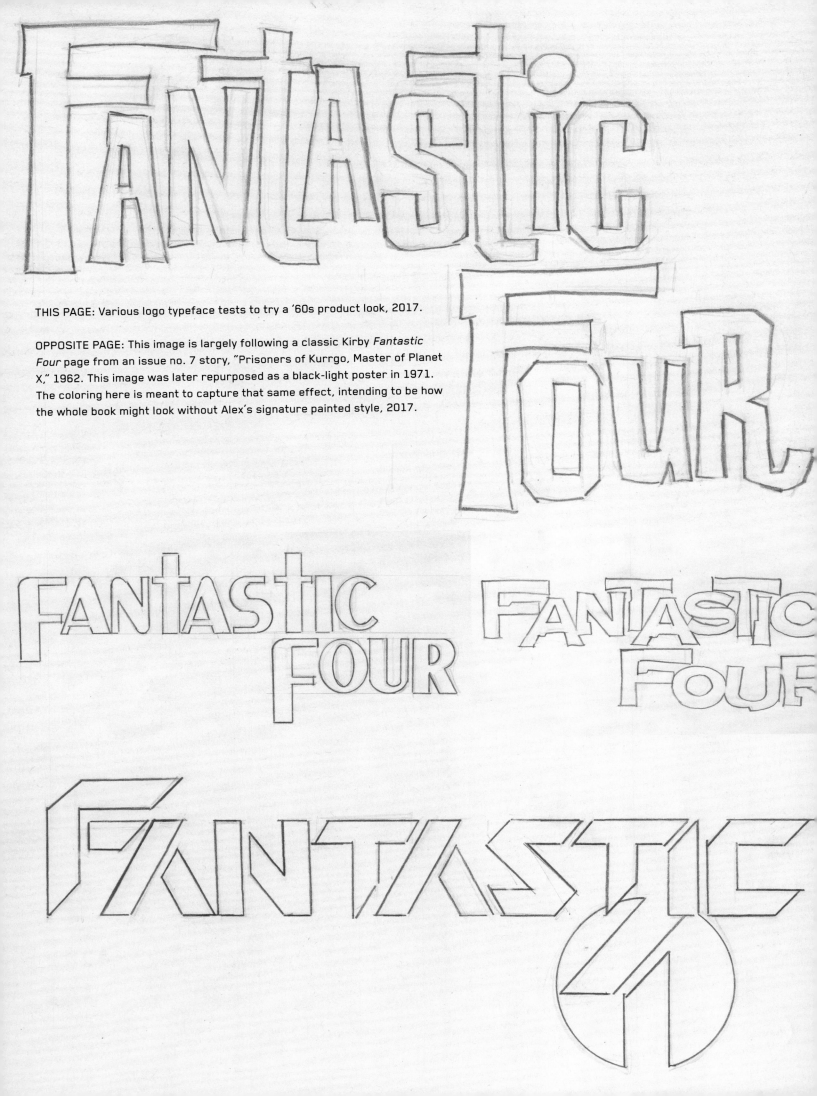

THIS PAGE: Various logo typeface tests to try a '60s product look, 2017.

OPPOSITE PAGE: This image is largely following a classic Kirby *Fantastic Four* page from an issue no. 7 story, "Prisoners of Kurrgo, Master of Planet X," 1962. This image was later repurposed as a black-light poster in 1971. The coloring here is meant to capture that same effect, intending to be how the whole book might look without Alex's signature painted style, 2017.

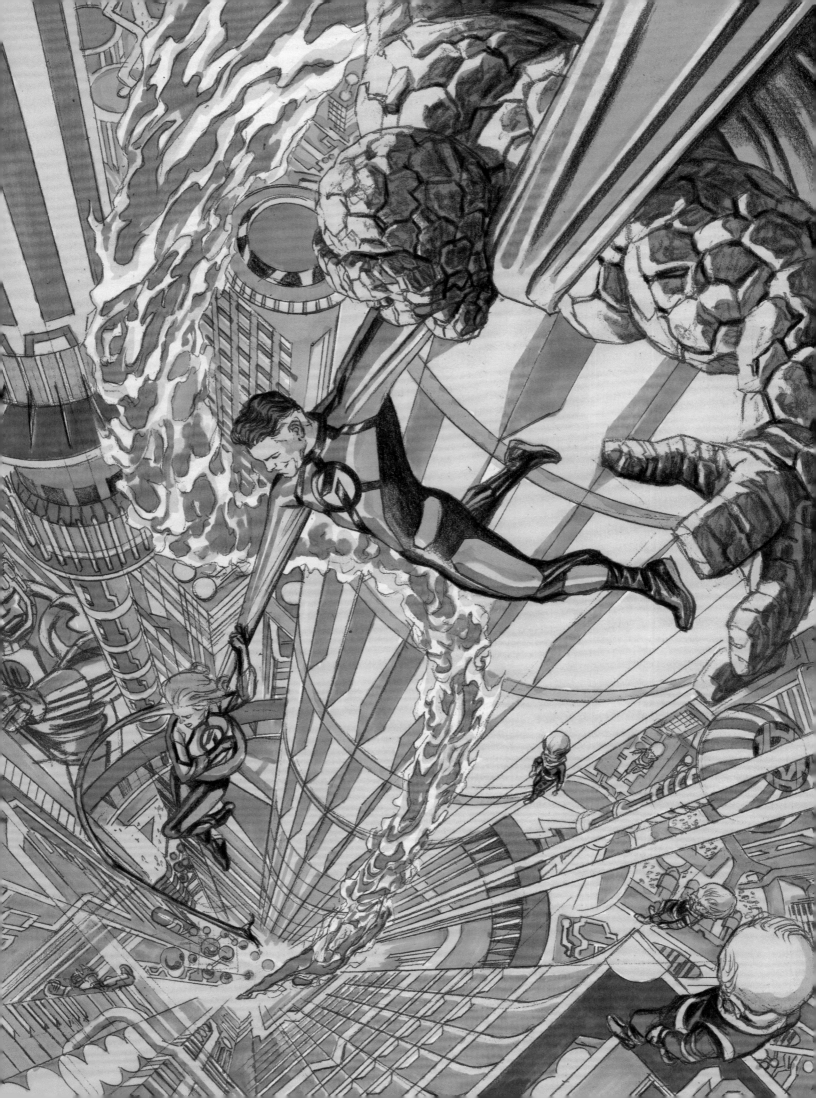

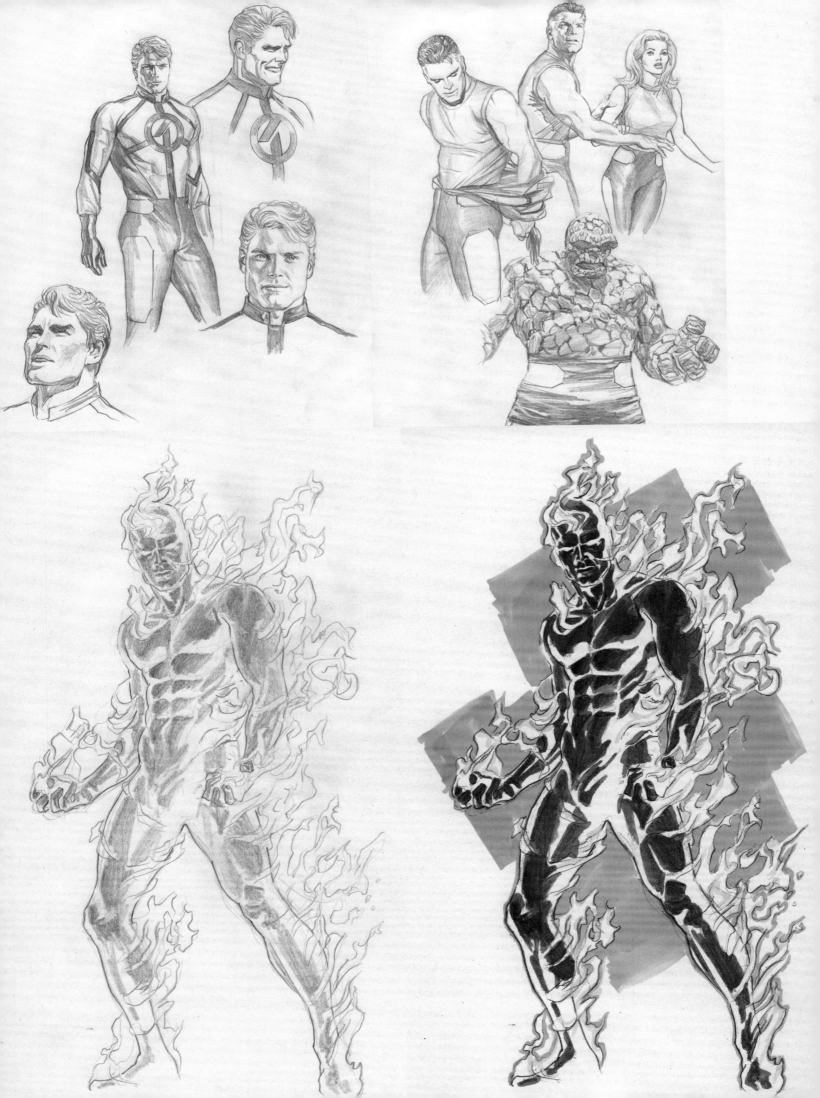

OPPOSITE, TOP: The costume studies were trying out a removable jacket style, with a sleeveless undershirt underneath to make it seem like the group's suits had a utilitarian function, 2017.

OPPOSITE, BELOW: Rendering figures with shading was still Alex's goal but with flat placement of color, letting the modeling from the initial drawings come through, 2017.

THIS PAGE: Crazy color placements for scenes was the intent, not actual red costumes, 2017.

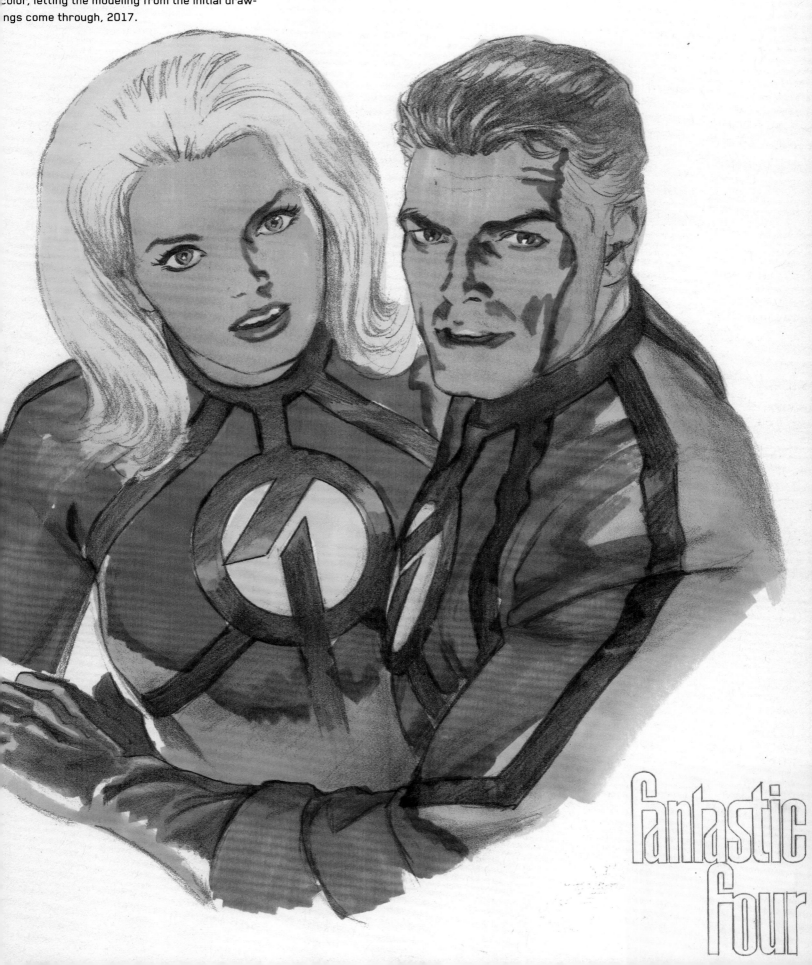

fantastic four

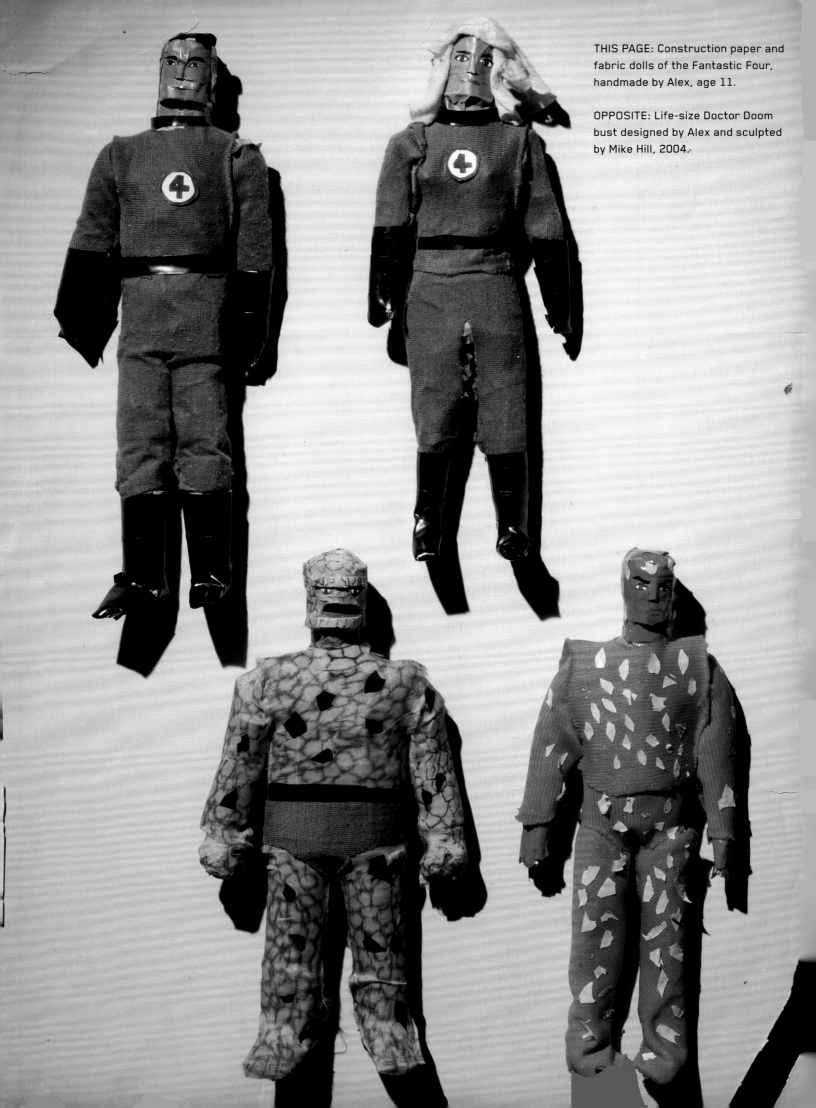

THIS PAGE: Construction paper and fabric dolls of the Fantastic Four, handmade by Alex, age 11.

OPPOSITE: Life-size Doctor Doom bust designed by Alex and sculpted by Mike Hill, 2004.

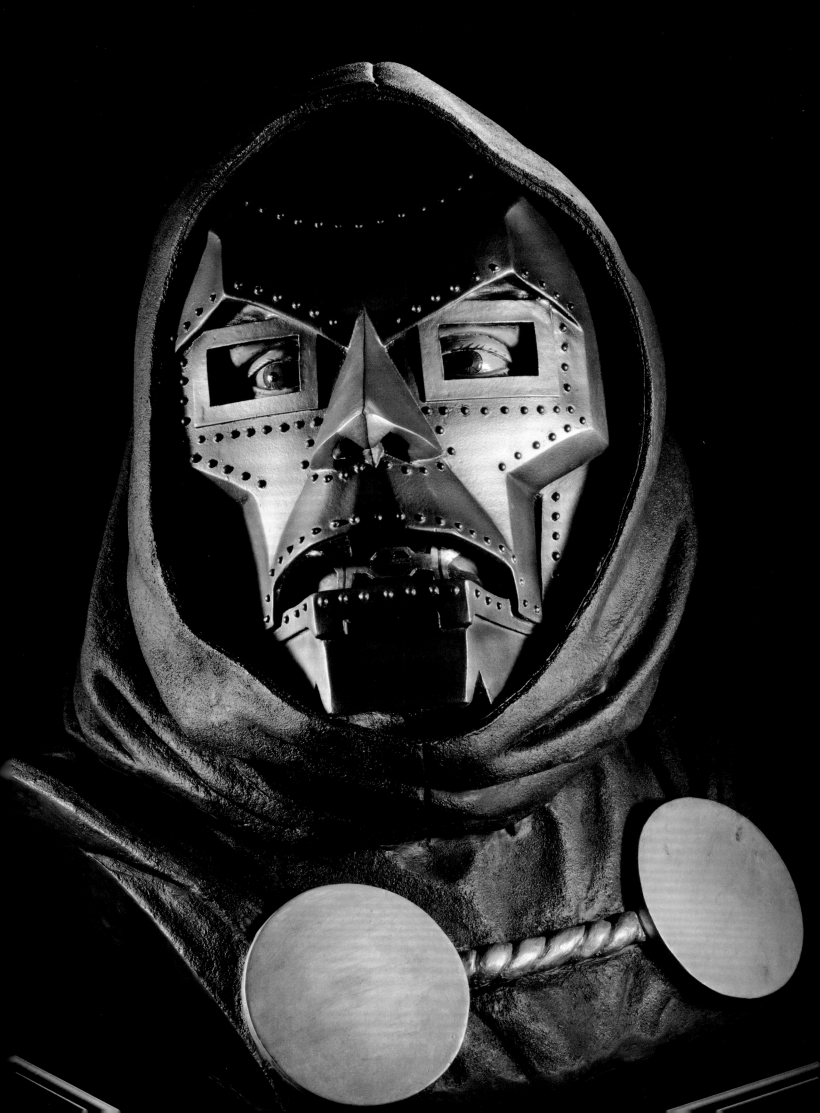

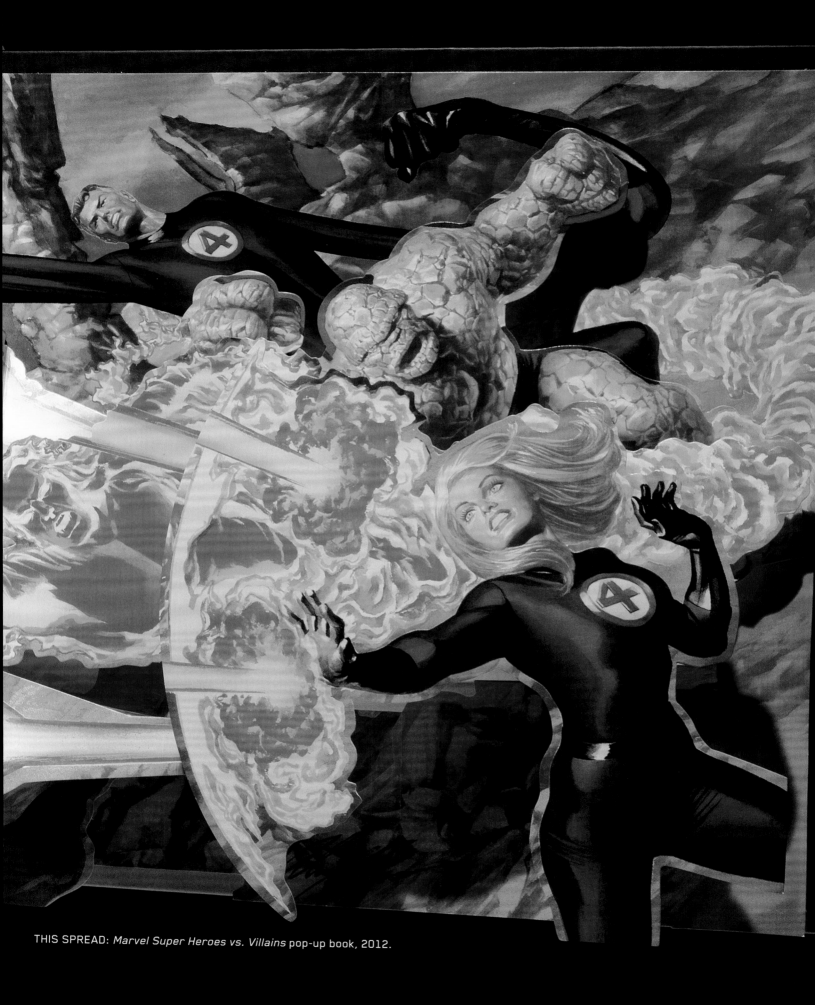

THIS SPREAD: *Marvel Super Heroes vs. Villains* pop-up book, 2012.

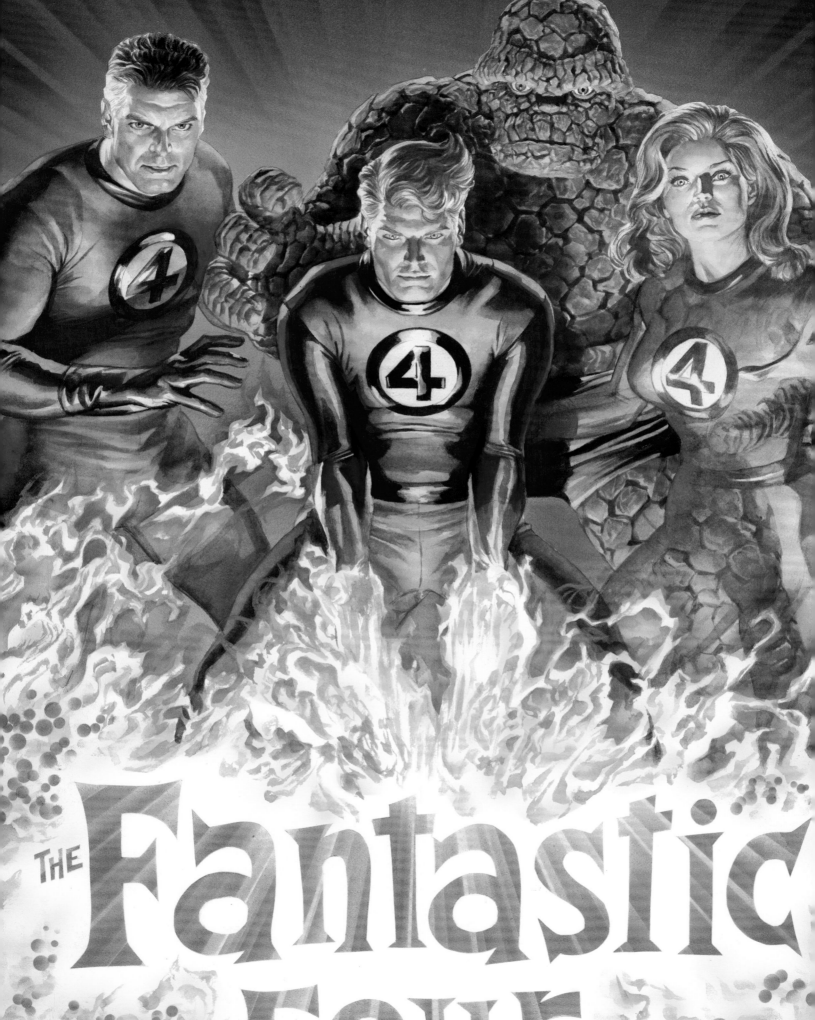

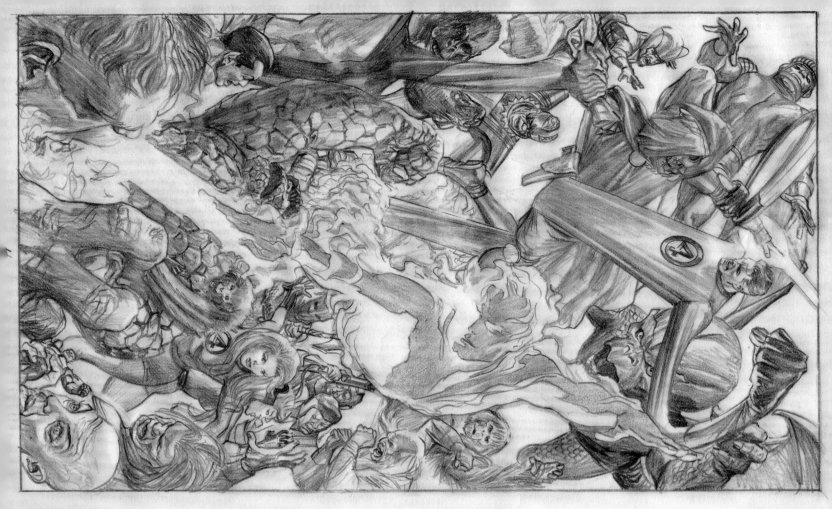

ABOVE: Pencils for a tribute print for *Fantastic Four* no. 100, 2018.

BELOW: Another image from the Fantastic Four Pop Art pitch, 2017.

OPPOSITE PAGE: Variant cover art for issue no. 1 of relaunched *Fantastic Four* comic, 2018.

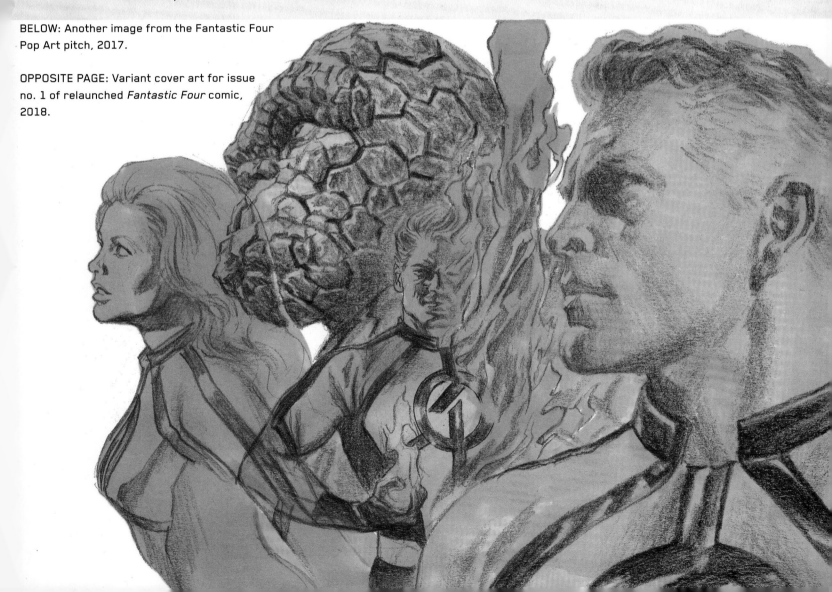

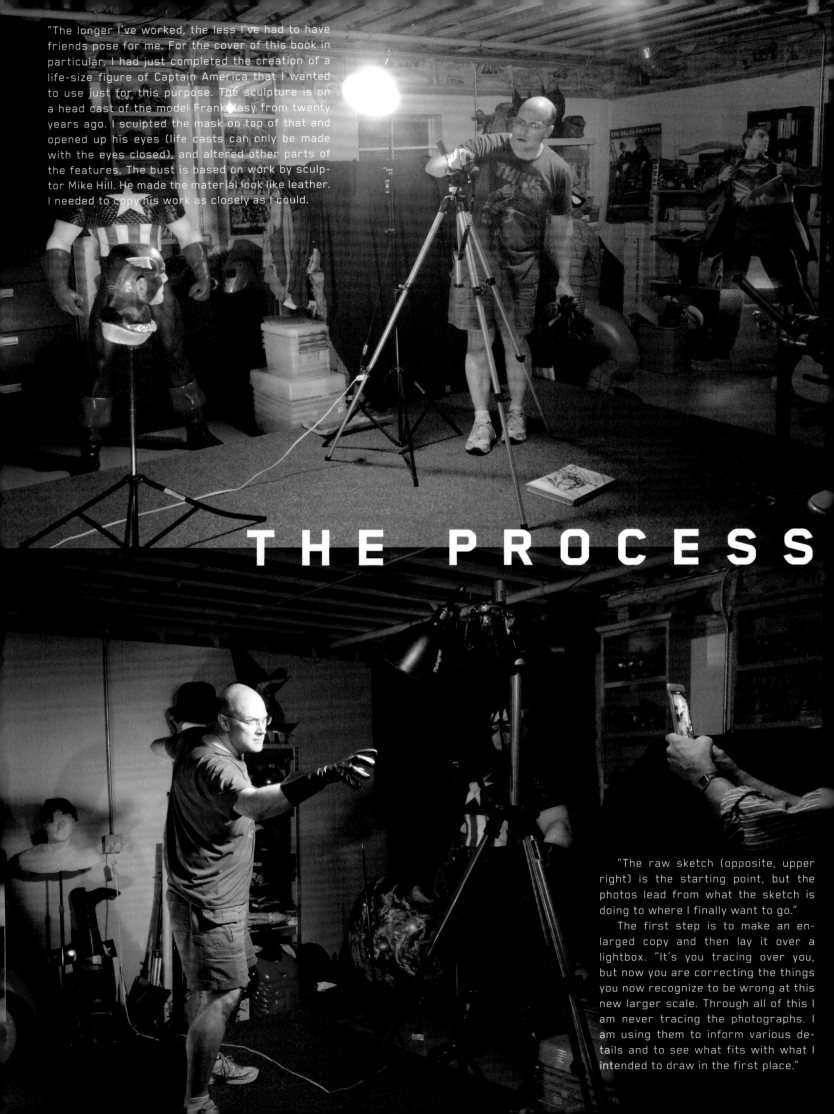

"The longer I've worked, the less I've had to have friends pose for me. For the cover of this book in particular, I had just completed the creation of a life-size figure of Captain America that I wanted to use just for this purpose. The sculpture is on a head cast of the model Frank Kasy from twenty years ago. I sculpted the mask on top of that and opened up his eyes (life casts can only be made with the eyes closed), and altered other parts of the features. The bust is based on work by sculptor Mike Hill. He made the material look like leather. I needed to copy his work as closely as I could.

THE PROCESS

"The raw sketch (opposite, upper right) is the starting point, but the photos lead from what the sketch is doing to where I finally want to go."

The first step is to make an enlarged copy and then lay it over a lightbox. "It's you tracing over you, but now you are correcting the things you now recognize to be wrong at this new larger scale. Through all of this I am never tracing the photographs. I am using them to inform various details and to see what fits with what I intended to draw in the first place."

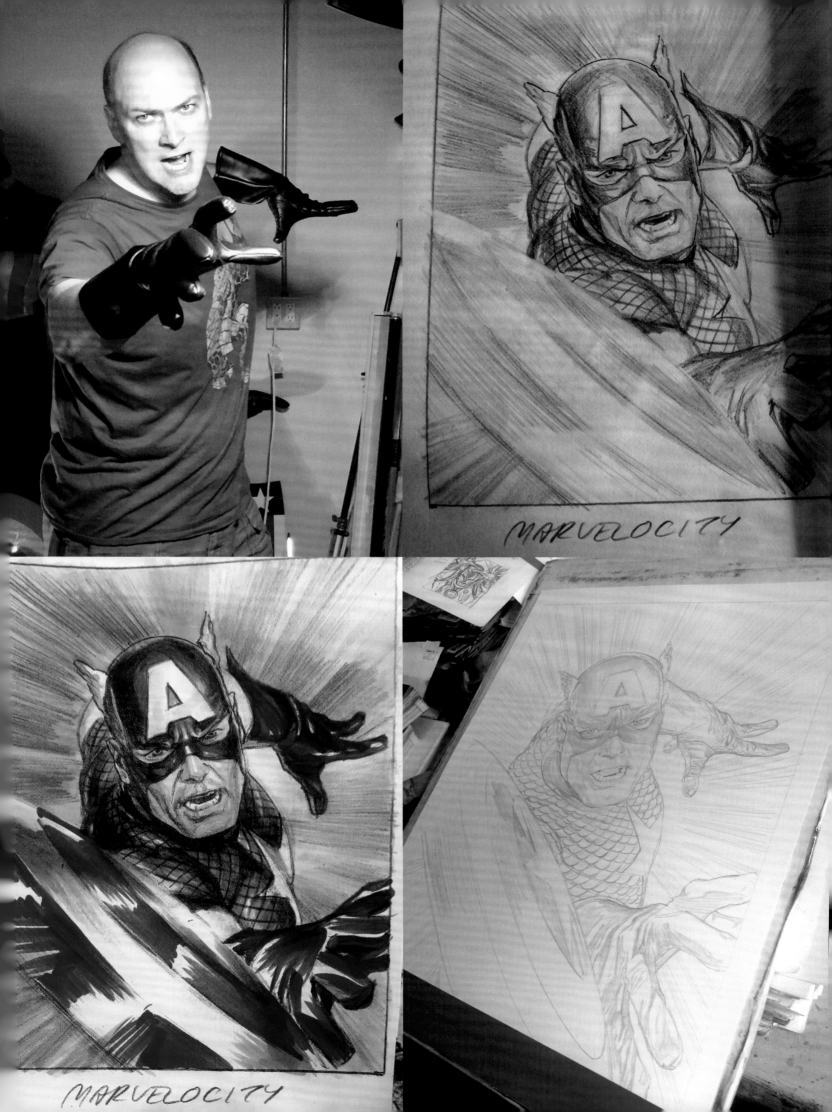

MARVELOCITY

MARVELOCITY

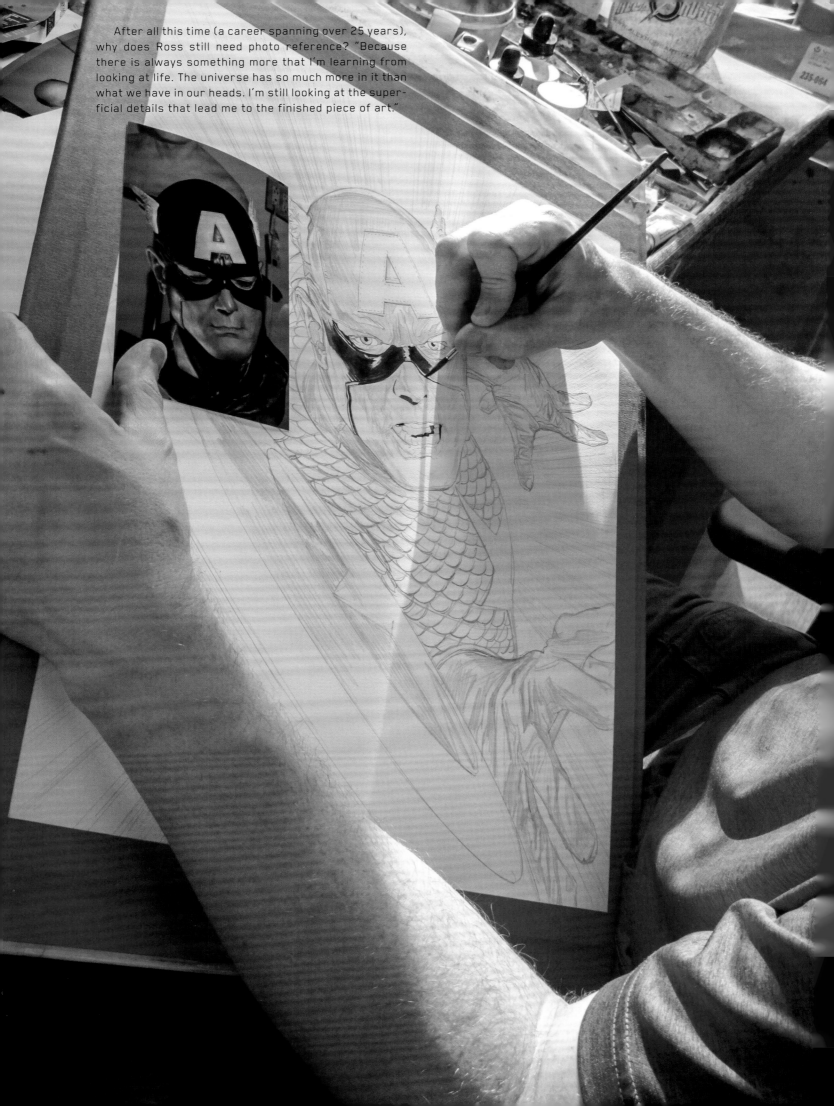

After all this time (a career spanning over 25 years), why does Ross still need photo reference? "Because there is always something more that I'm learning from looking at life. The universe has so much more in it than what we have in our heads. I'm still looking at the superficial details that lead me to the finished piece of art."

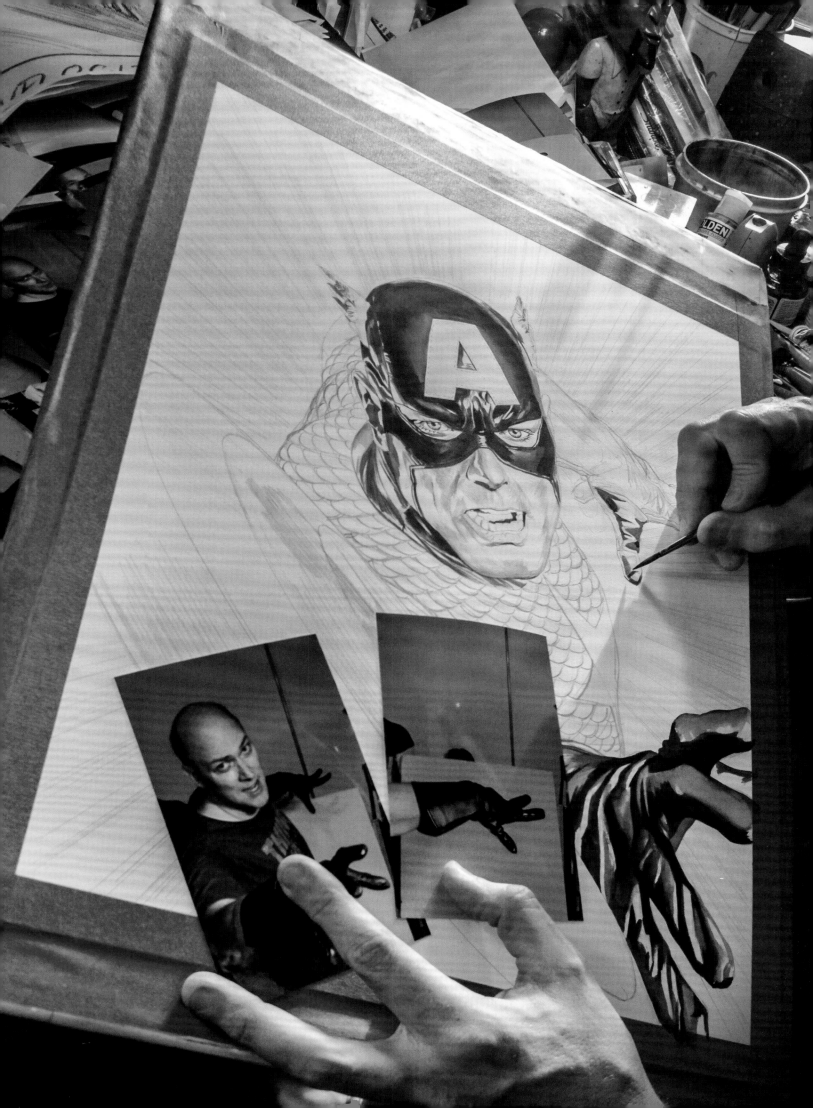

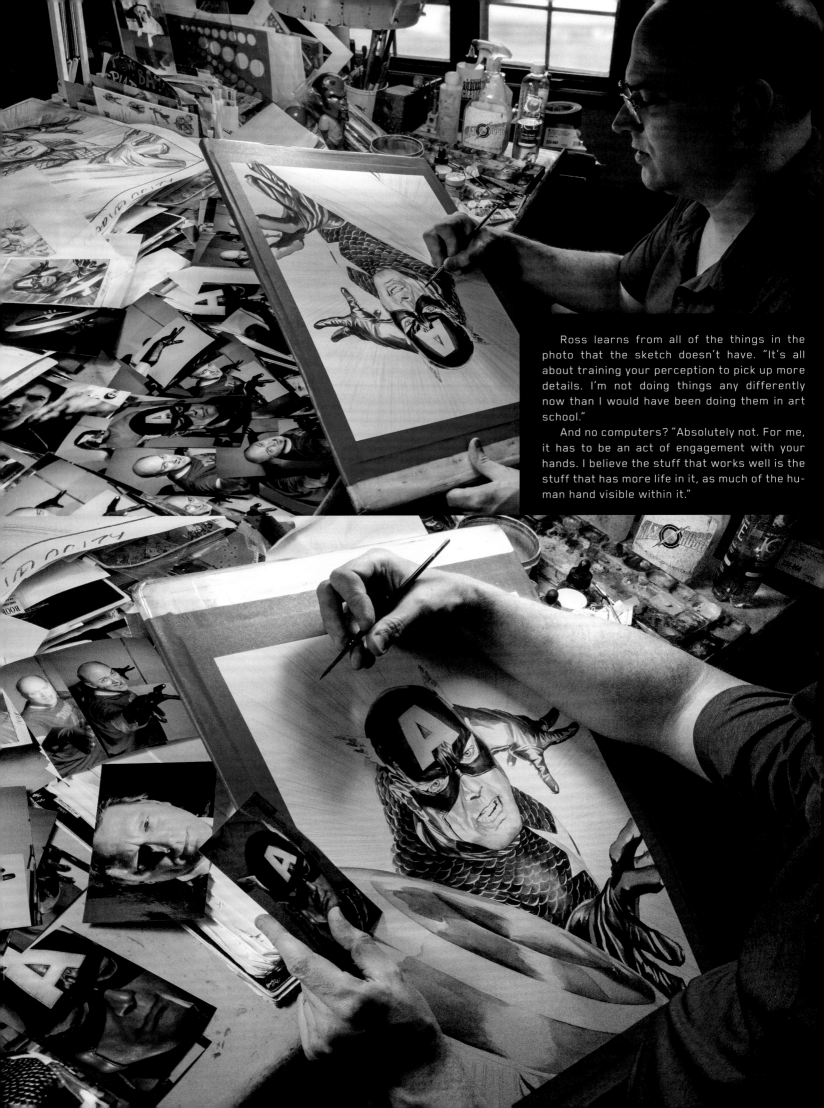

Ross learns from all of the things in the photo that the sketch doesn't have. "It's all about training your perception to pick up more details. I'm not doing things any differently now than I would have been doing them in art school."

And no computers? "Absolutely not. For me, it has to be an act of engagement with your hands. I believe the stuff that works well is the stuff that has more life in it, as much of the human hand visible within it."

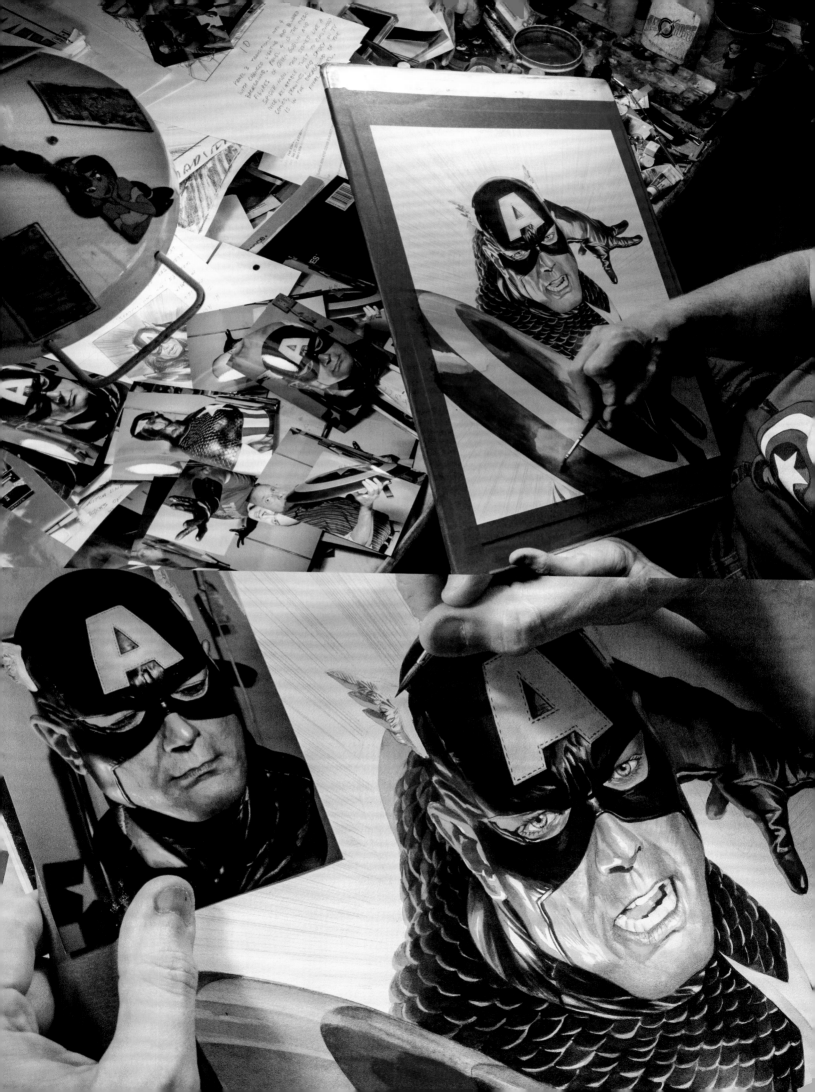

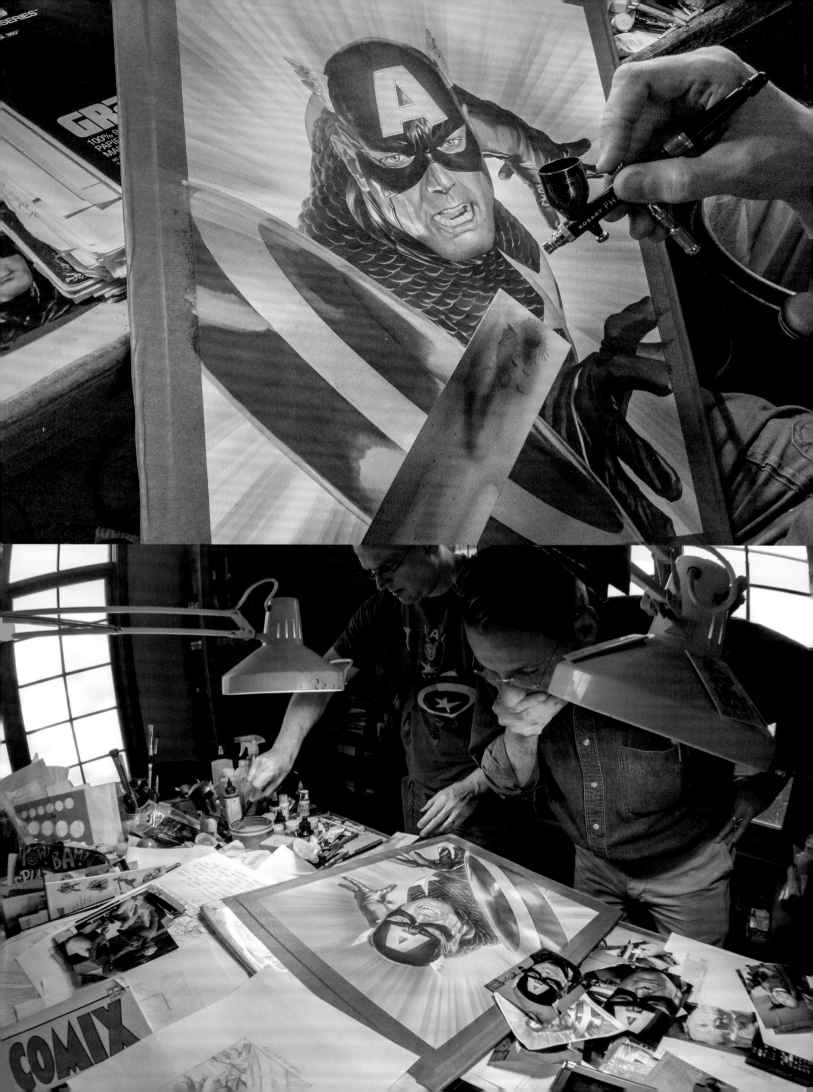

Alex doesn't normally do color roughs, but in this case he did. "I was adding a hot color highlight here to the right side of his face (Cap's right) and I needed to see what that might look like."

To sum up, the steps are: rough pencil sketch, which gets blown up and put on a lightbox, full-size pencils, earth-tone/sepia gouache over that, then full-color paint. Then airbrush. And throughout this, lots and lots of talent and hard effort. "There's so much transformation that goes on from the reference to the finish, the pictures are an imperfect match from what I want them to be. They need to be *interpreted* by the mind, not copied."

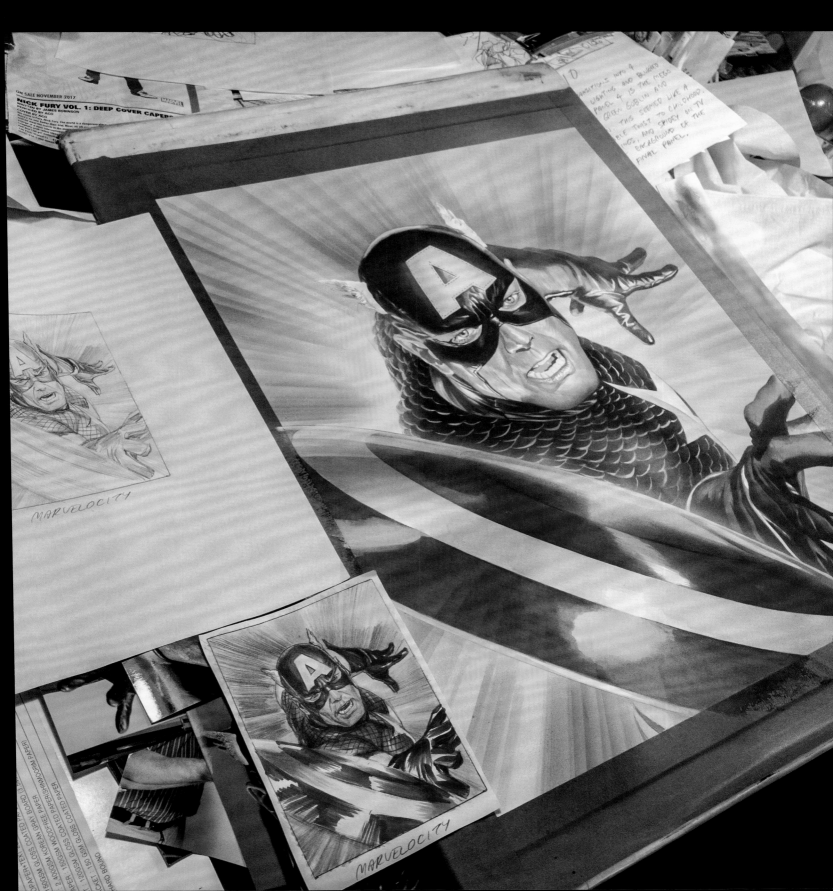

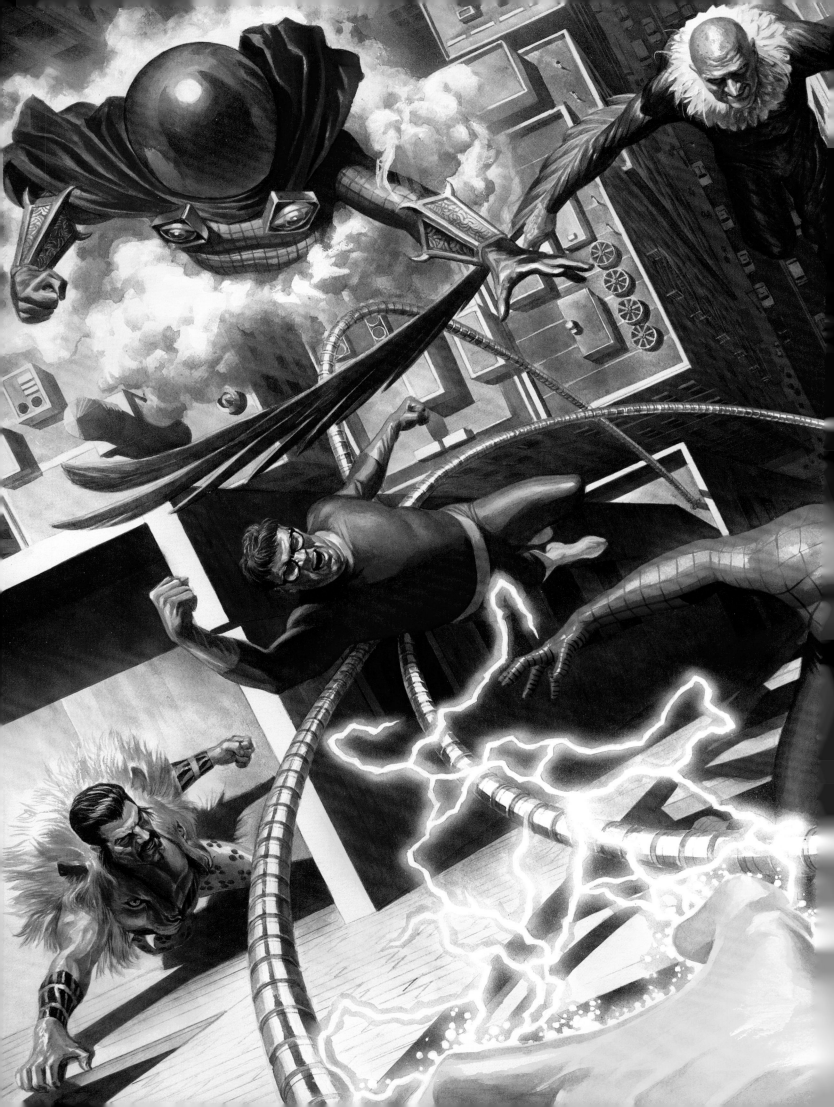

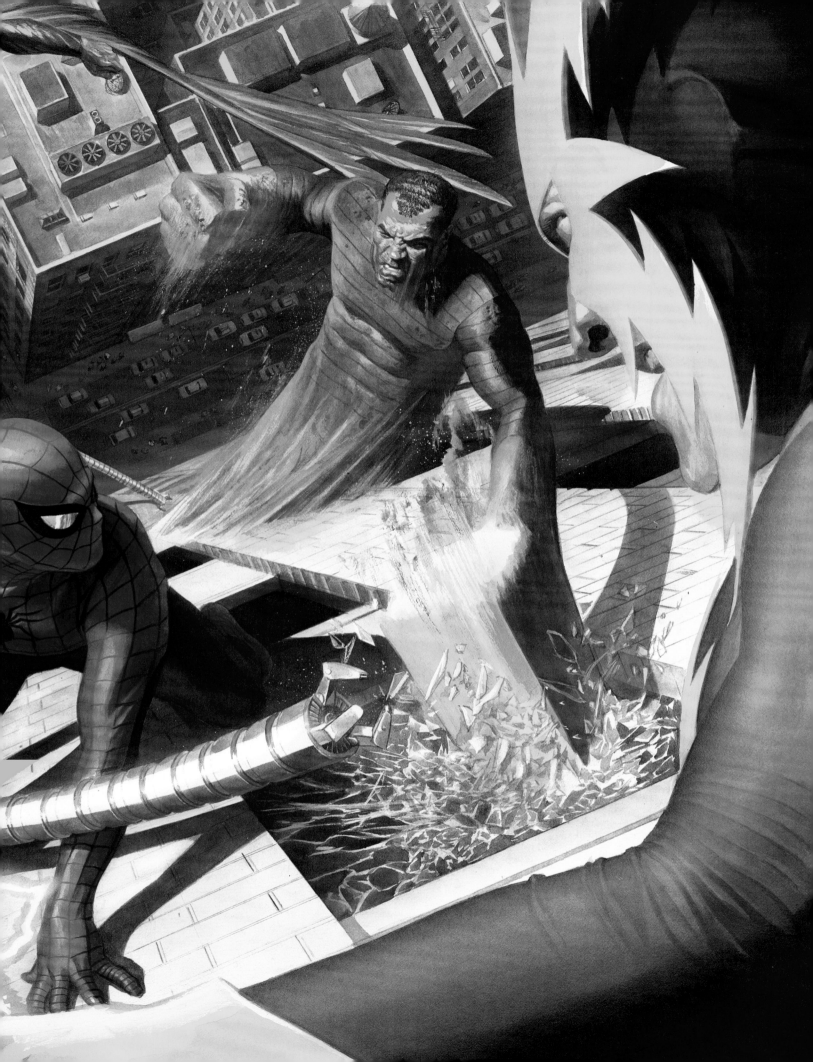

So, with this book, Alex had the opportunity to write and draw an original 10-page story using the Marvel characters of his choosing. I was of course eager to see what he had in mind, and the scenario he explained to me over the phone was, in his words, "an old idea looking for a home." It would be Spider-Man taking on the Sinister Six—a classic cadre of his enemies initiated in the 1960s. He would fight them all at once, outside of current Marvel Comics continuity, and inspired by iconic Steve Ditko drawings (see below).

I thought this sounded fine, because Alex so obviously had a clear vision of this in mind; he had been thinking about it for years; he needed to make it a comics reality, and thus he would knock it out of the park. However, my one caveat was that the ending needed to tie it all up in an unexpected and original way. To me, it was obvious what that should be—I pitched it, and Alex agreed. I won't give it away here, because you'll see it shortly in 10 pages. But I do think it captures the heart and soul of this book, and what Alex's inspiration for his work and dedication is all about.

As for the Sinister Six lineup here, ultimately we decided that the Vulture and Kraven the Hunter (below, top panel, third from right and far right, respectively) could go and that for this version of the Sinister Six, in addition to Mysterio, Doctor Octopus, Electro, and the Sandman, the substitution of the Lizard and the Green Goblin would be more fun.

Hope you agree. And away we go . . .

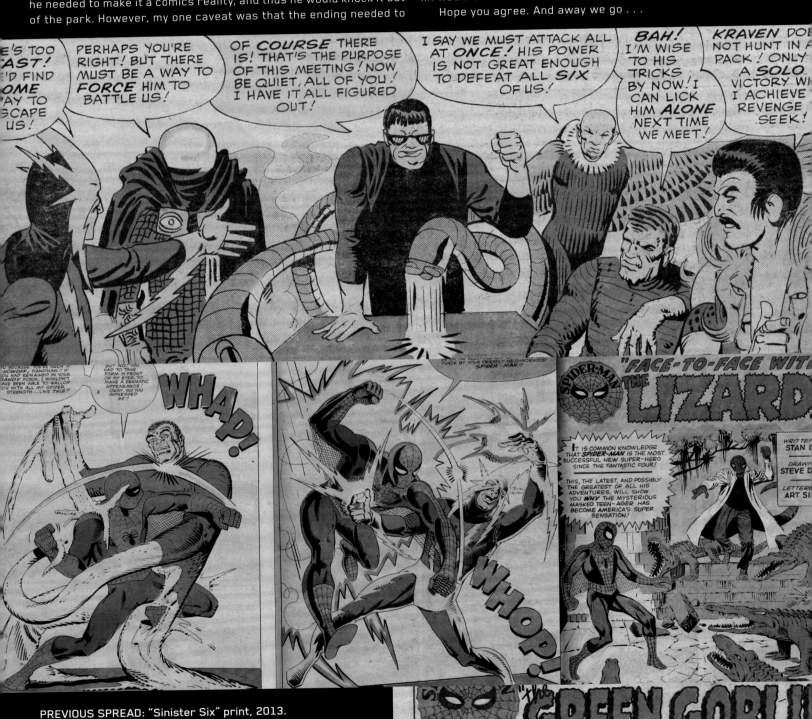

PREVIOUS SPREAD: "Sinister Six" print, 2013.
THIS PAGE, STARTING WITH TOP PANEL: A meeting of "The Sinister Six" and the next two panels of Spider-Man vs. Sandman and Spider-Man vs. Electro, all from *Amazing Spider-Man Annual* no. 1, 1964.
MIDDLE: Spider-Man with the Lizard from *Amazing Spider-Man* no. 6, November 1963.
BOTTOM, RIGHT PANEL: The Green Goblin from *Amazing Spider-Man* no. 14, July 1964.

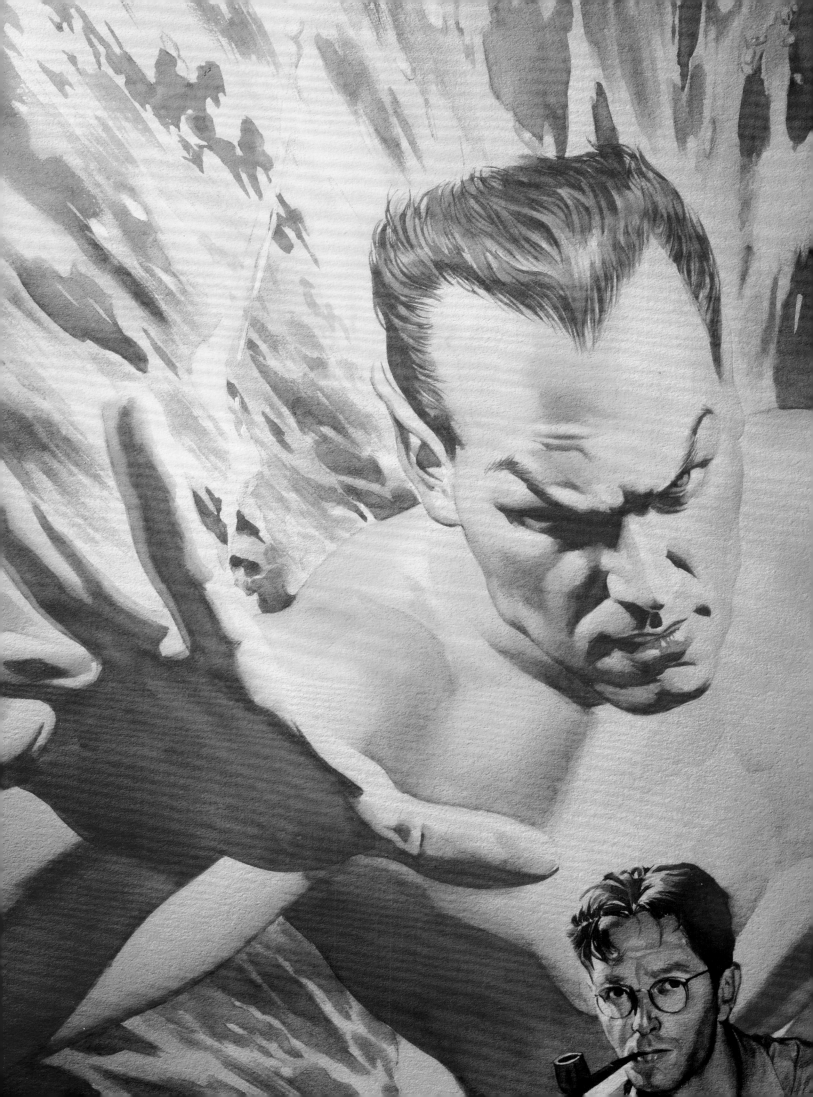

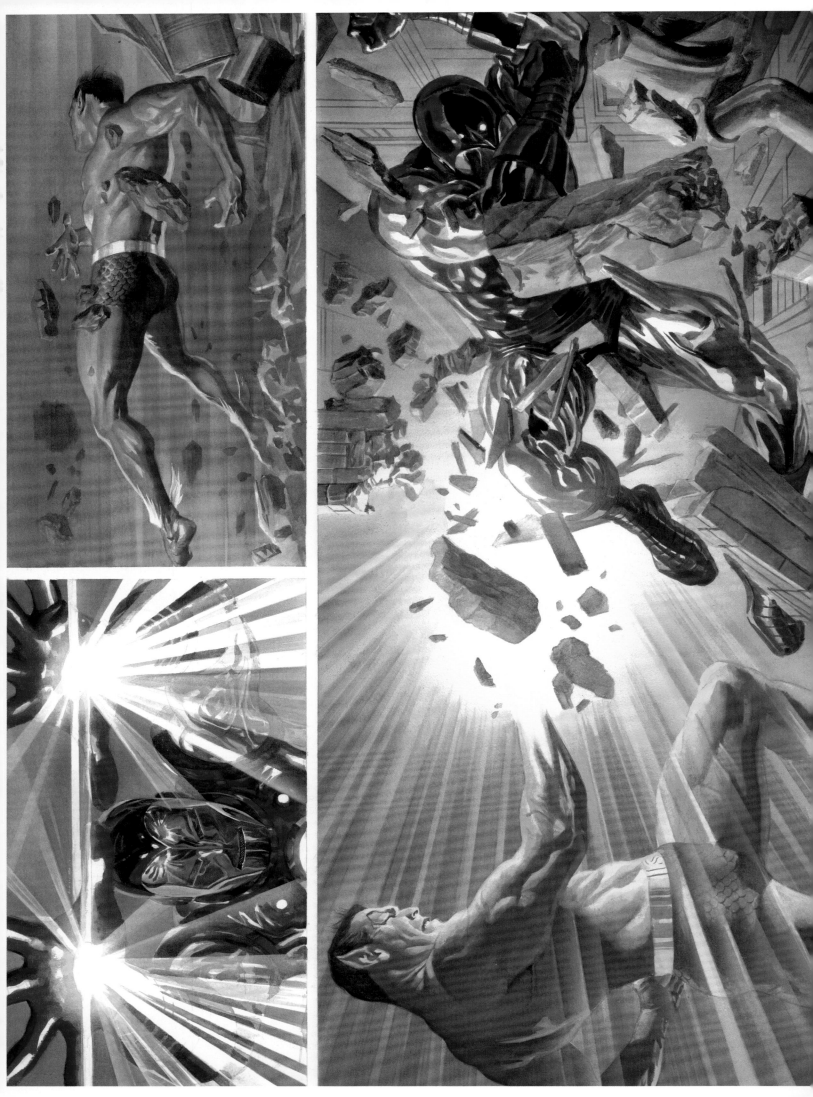

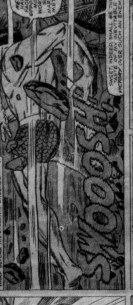
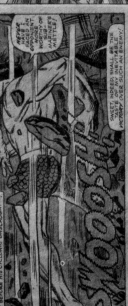

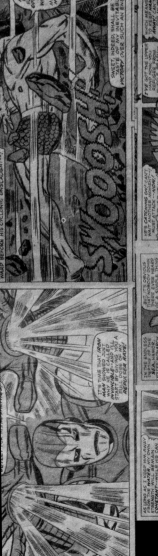

CONTINUED AFTER NEXT PAGE

RE-CREATING AN EPIC BATTLE

Okay, so why re-create this sequence of the Sub-Mariner taking on Iron Man from *Tales to Astonish* no. 82, 1966?

"I've always loved this story since it was first reprinted in *Marvel's Greatest Super Battles*, which I had gotten from the library (I got SO much from the library!).

"To me it wasn't about who was fighting whom; it was about Jack Kirby just doing an all-out fill-the-space-with-nothing-but-toxic battle, the most dynamic fight choreography I'd ever seen on the page. It made this moment in Marvel Universe history so memorable, and yet it didn't move the story at all. But the frames are so beautiful, it didn't matter.

"I thought that by re-creating this scene I would make the greatest connection to it, it inspired me so much. It's just so much *fun*."

PREVIOUS PAGE: Detail of cover to the *Comic Art Price Guide*, re-creating an unused cover to *Marvel Comics* no. 1, 1939, by Namor's creator, Bill Everett (with pipe), 2000.

FOLLOWING PAGE: Cover to *Fantastic Four* no. 1 Marvel 75th Anniversary variant, 2014.

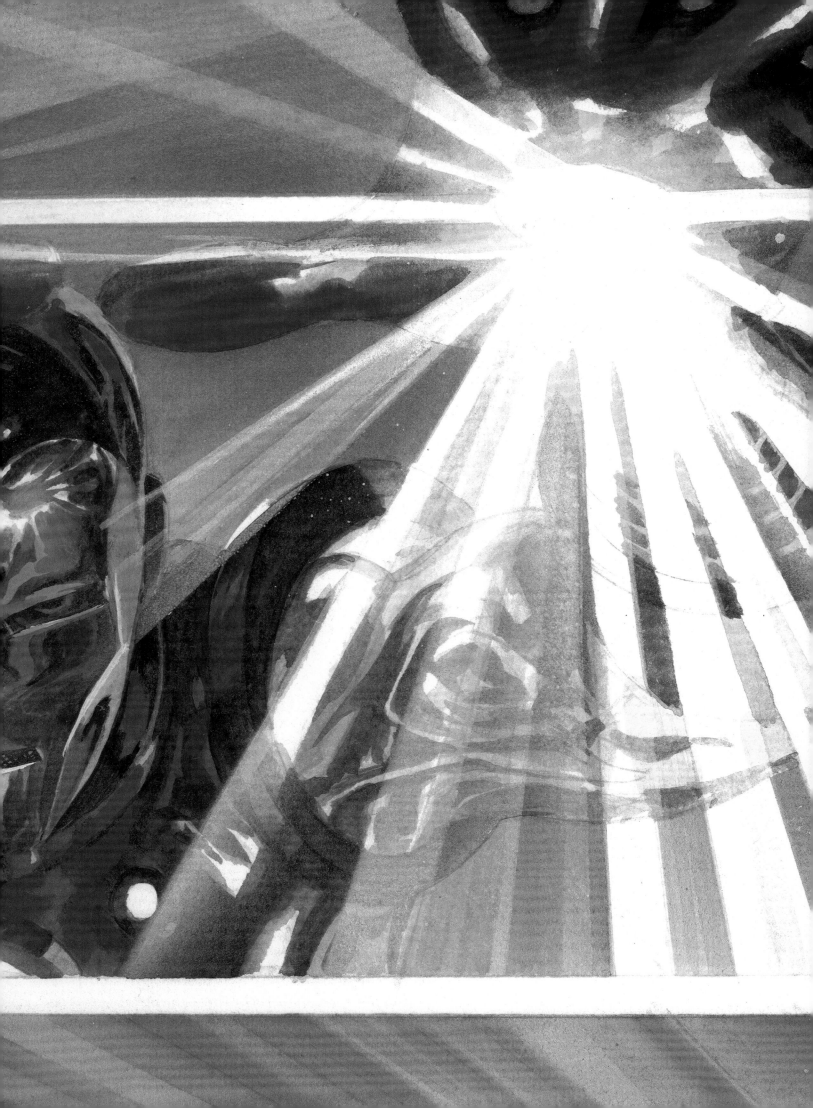

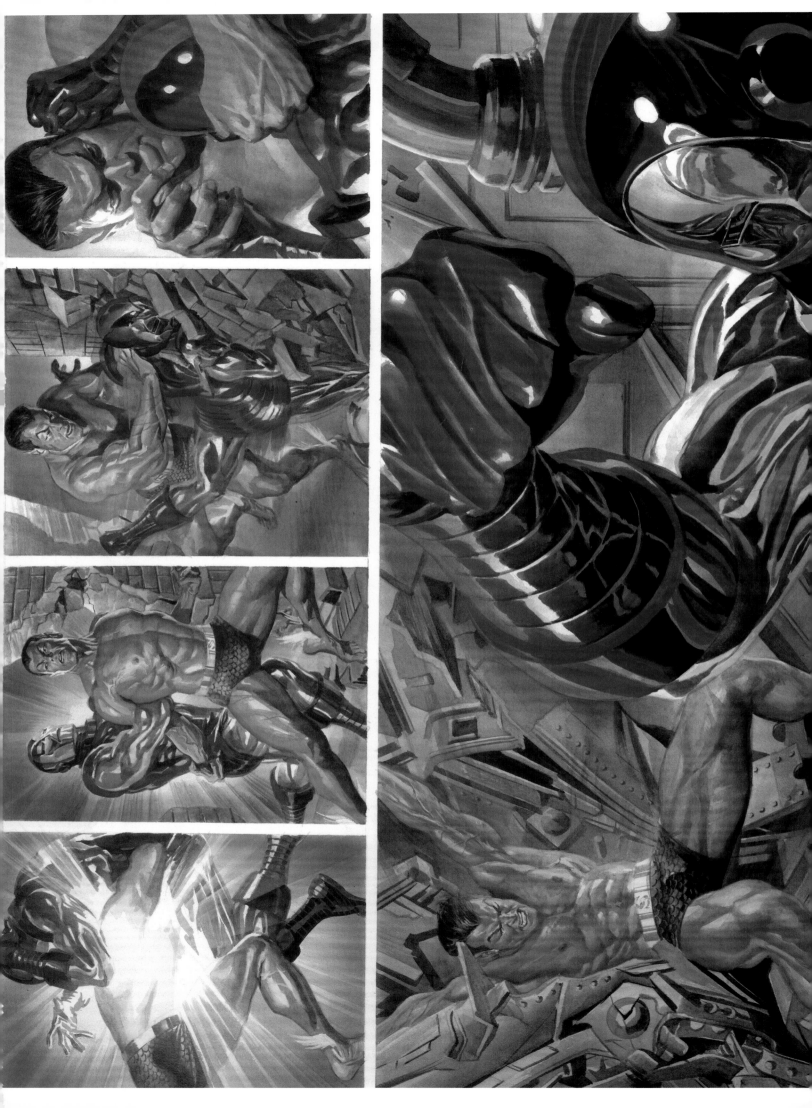

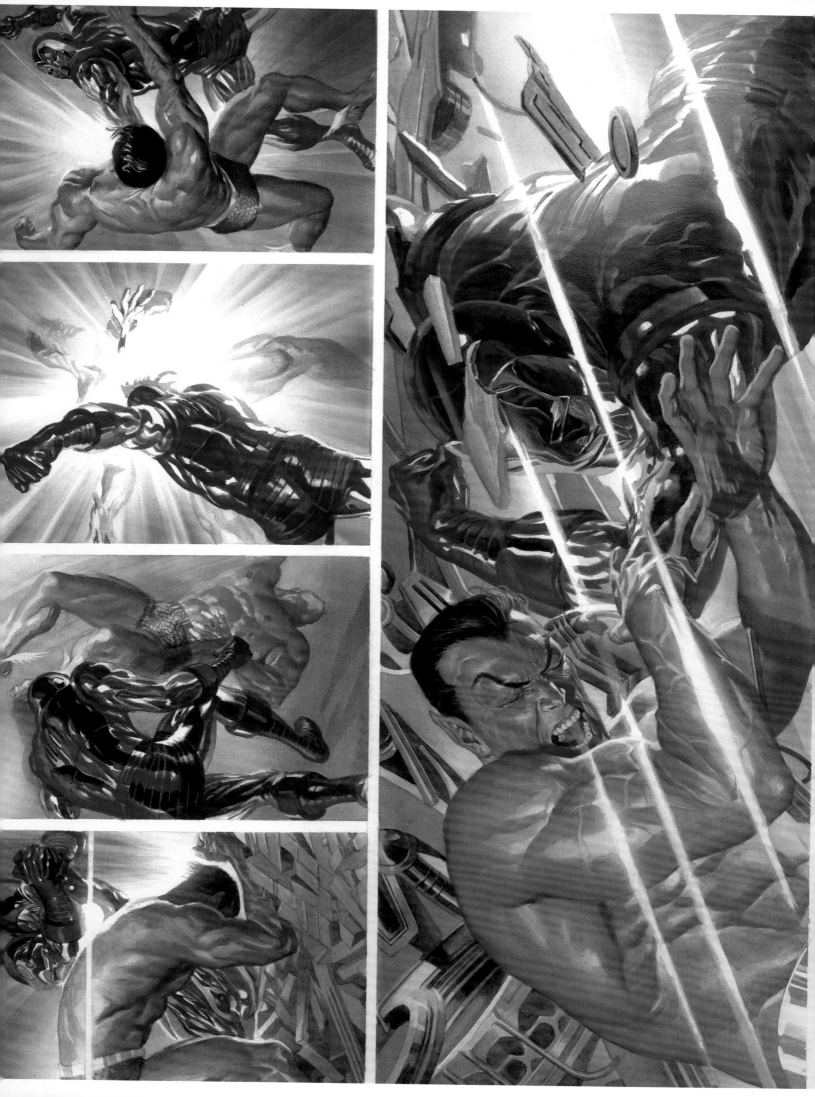

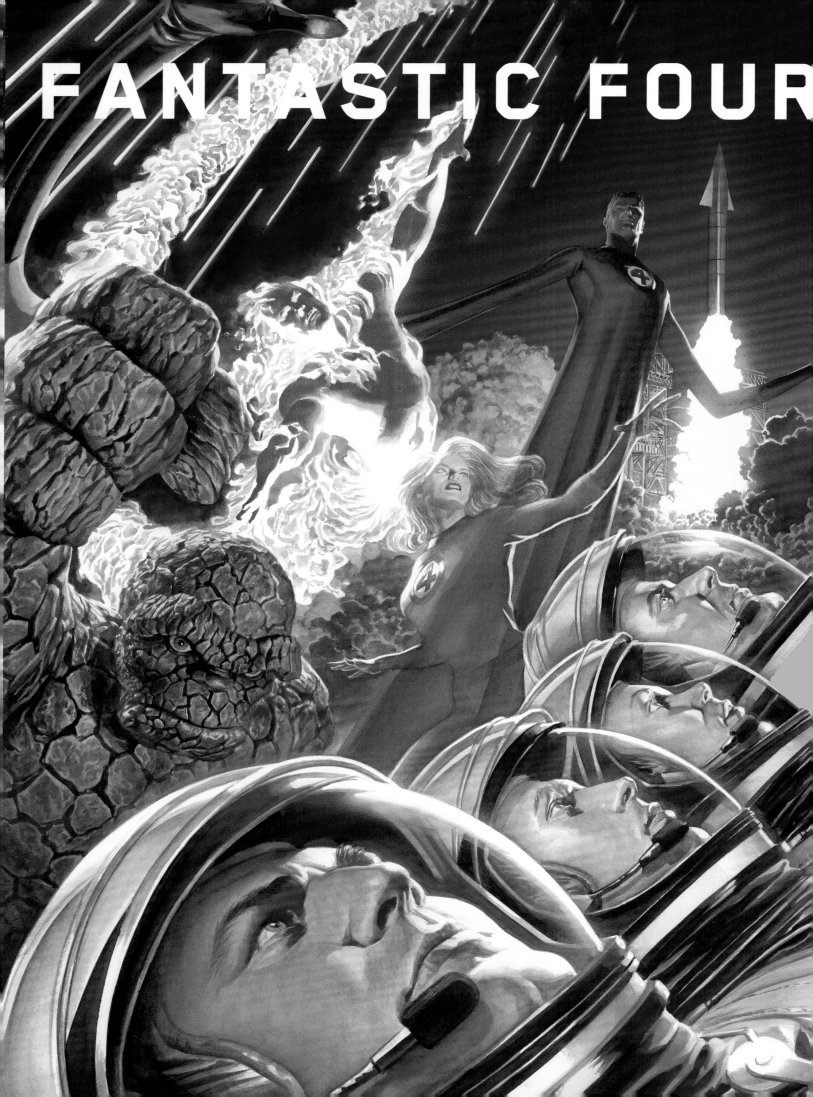

FANTASTIC FOUR

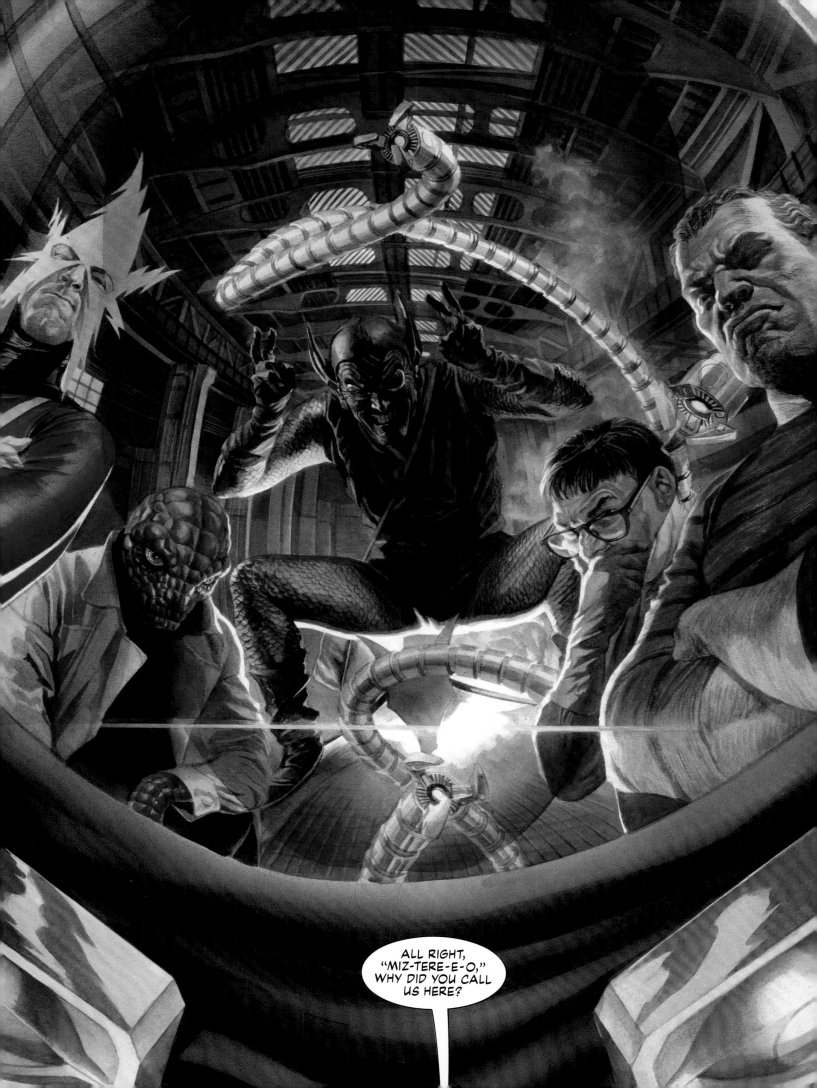

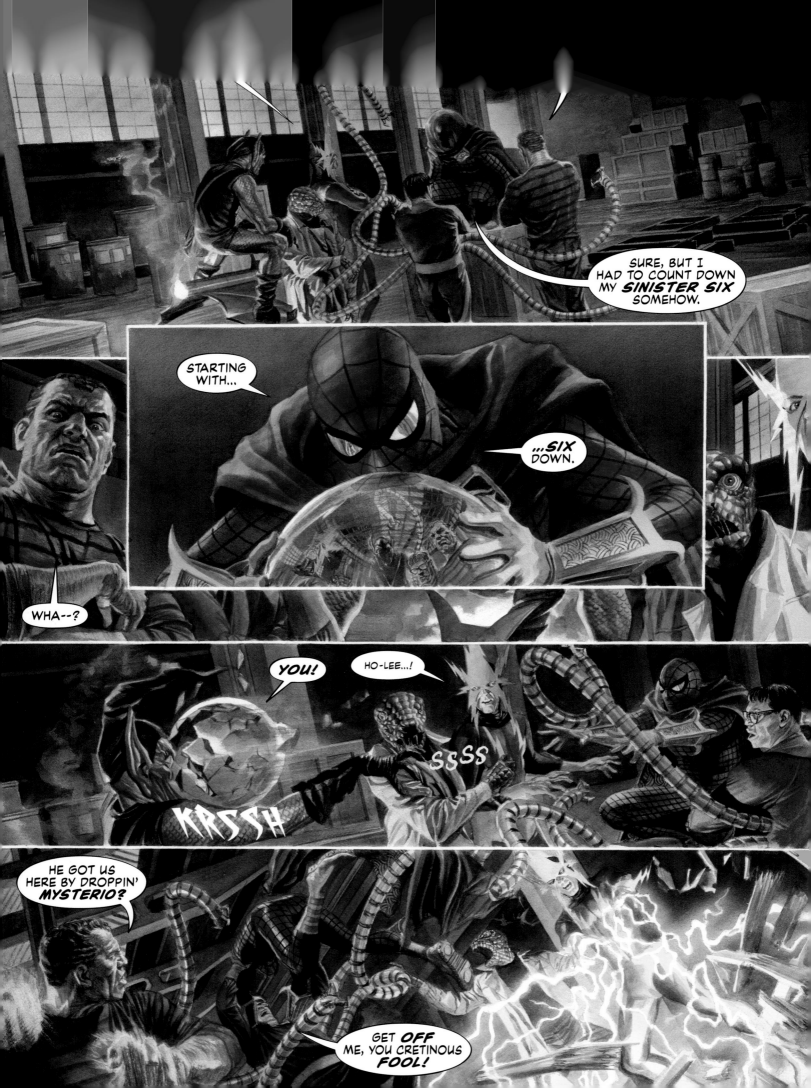

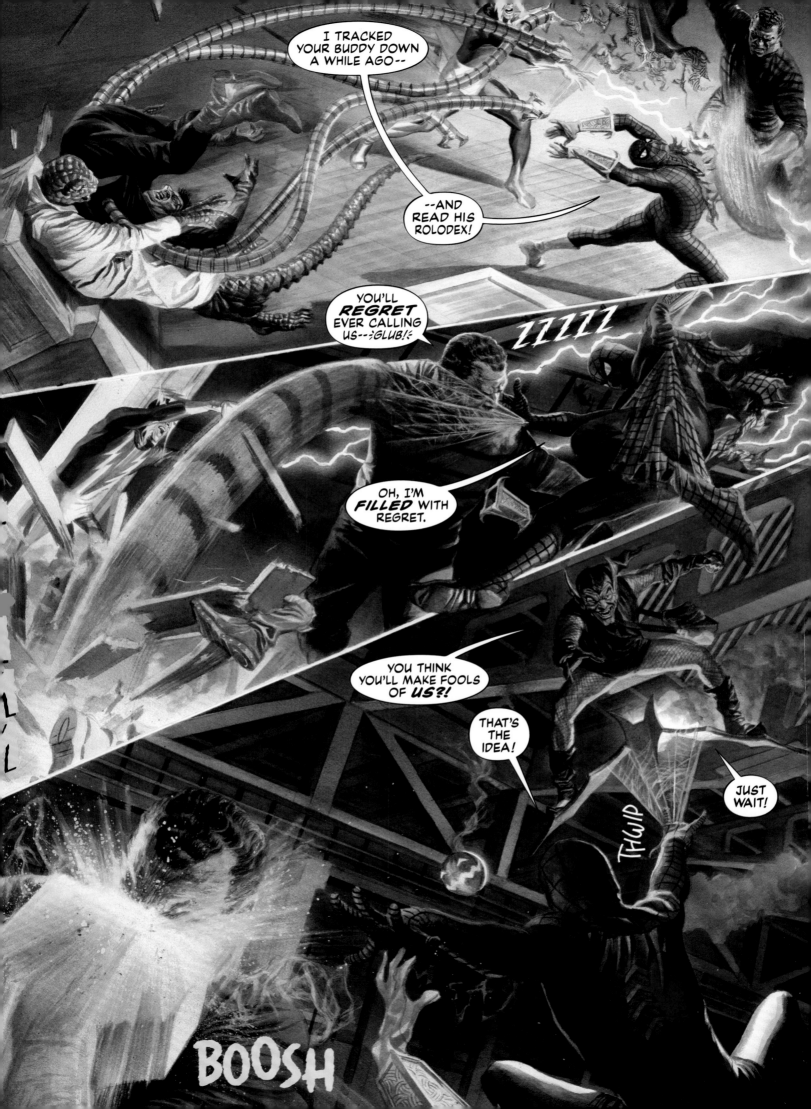

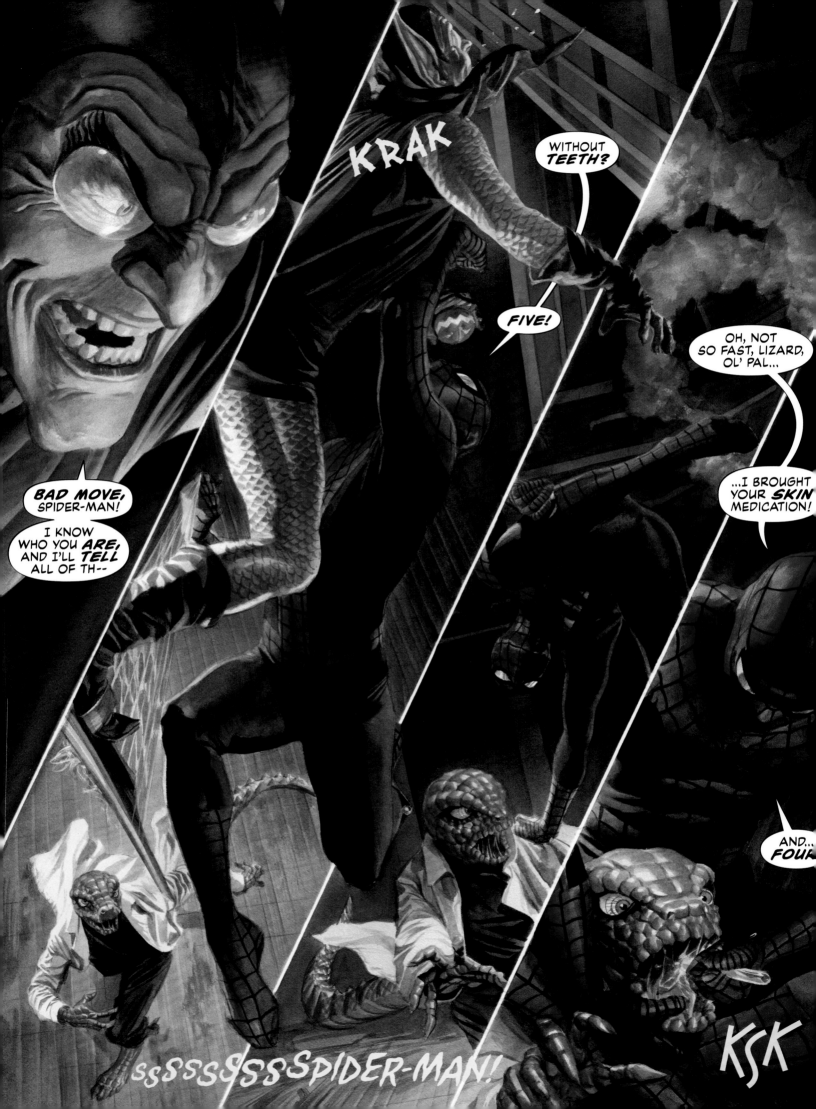

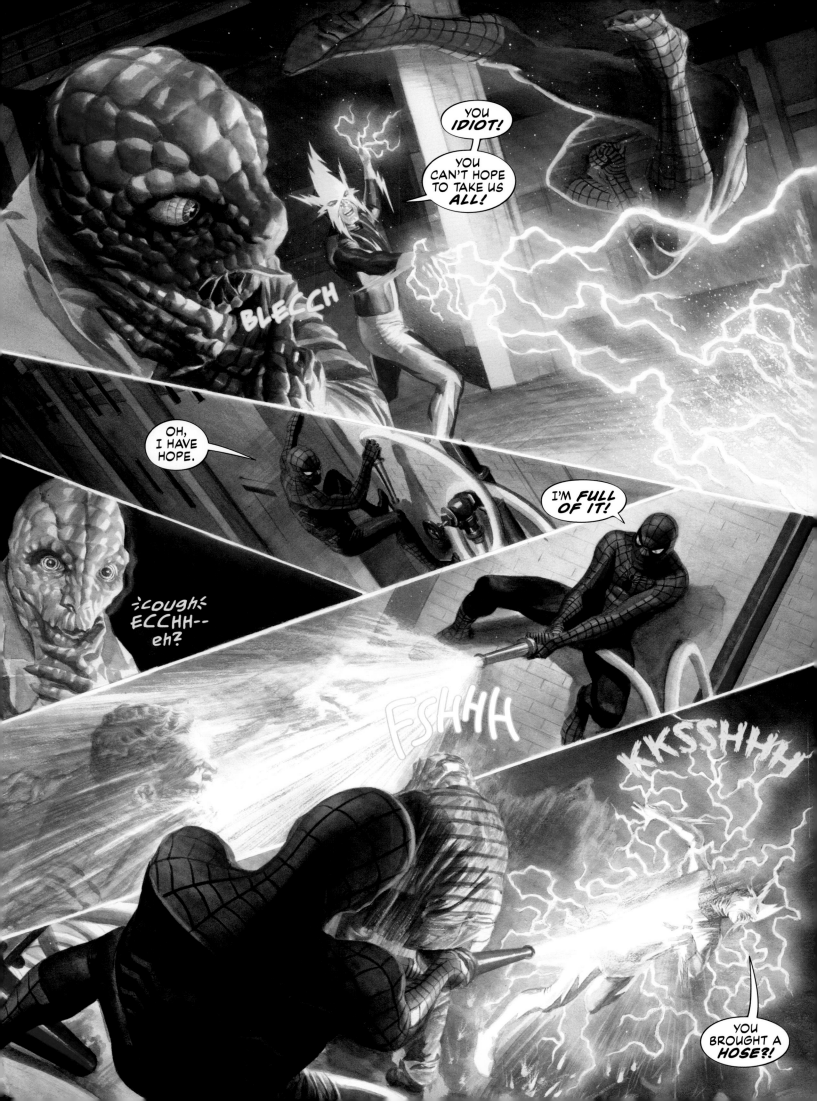

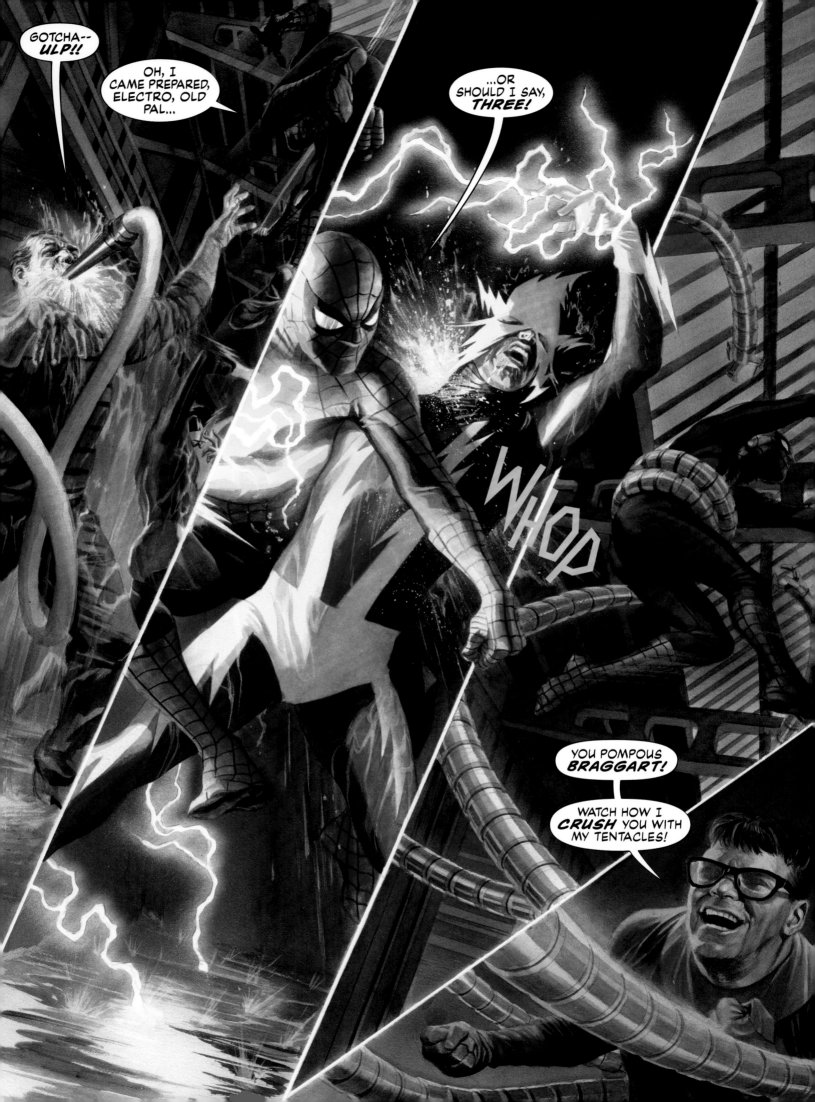

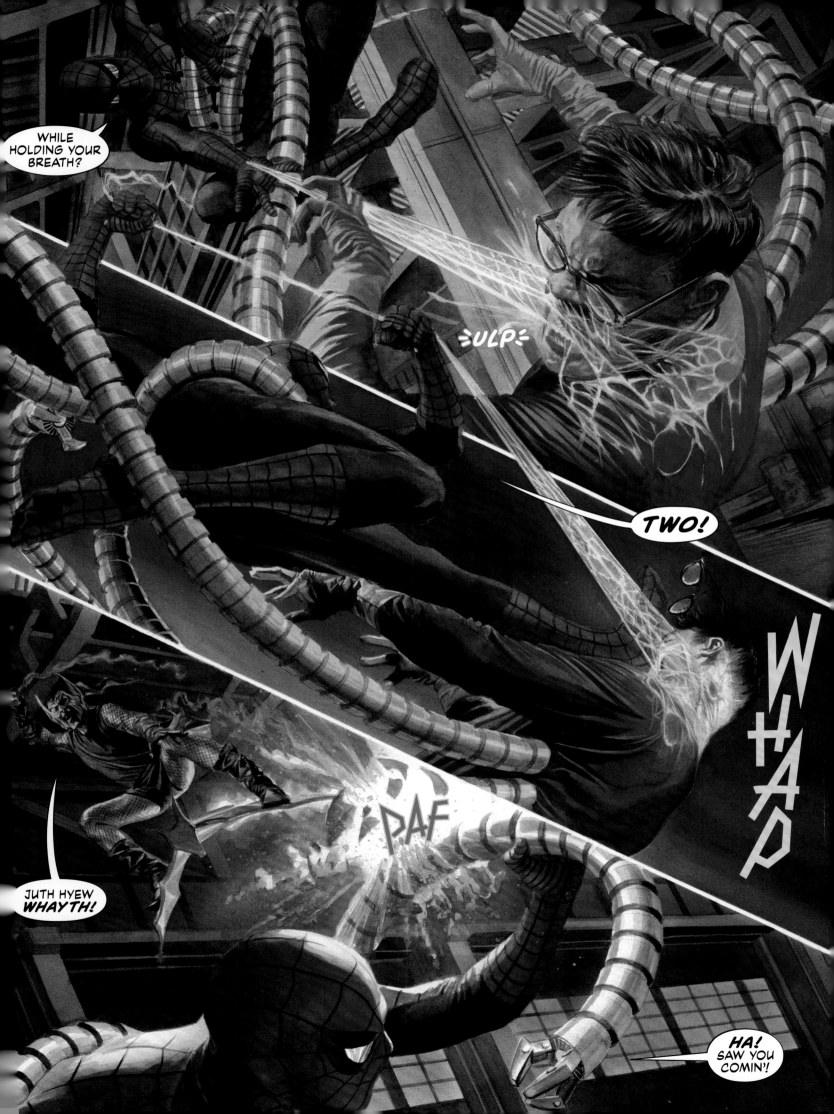

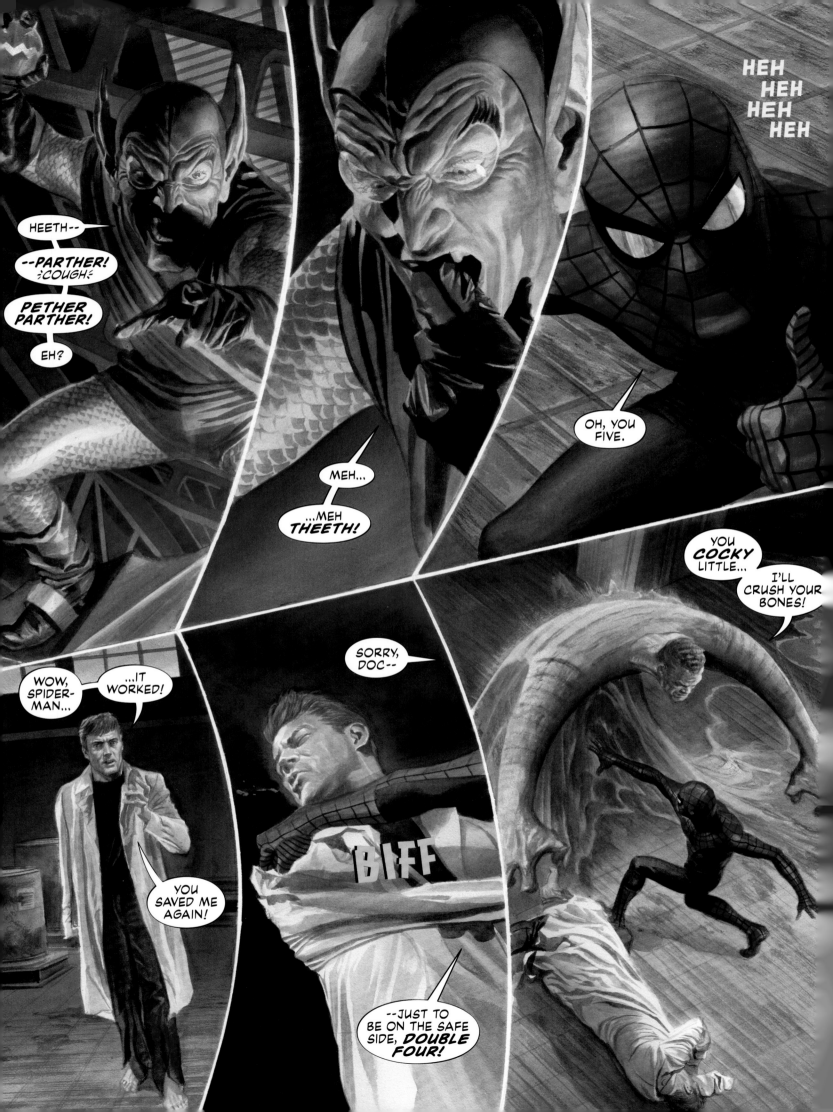

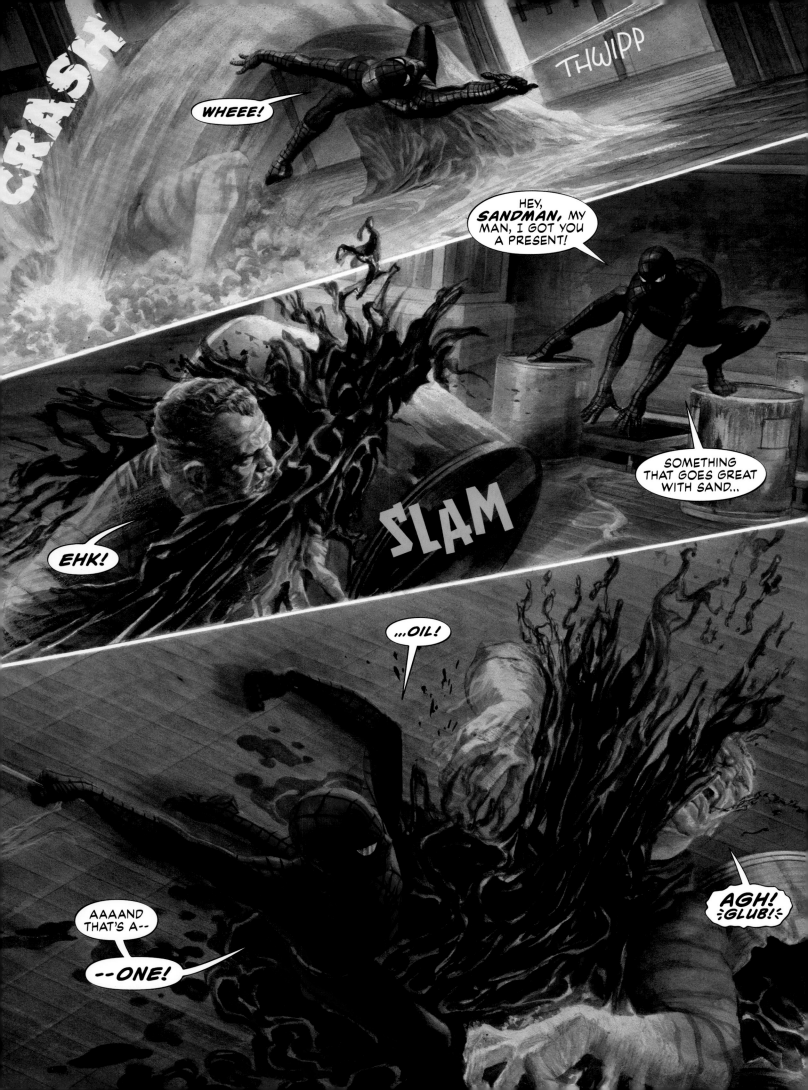

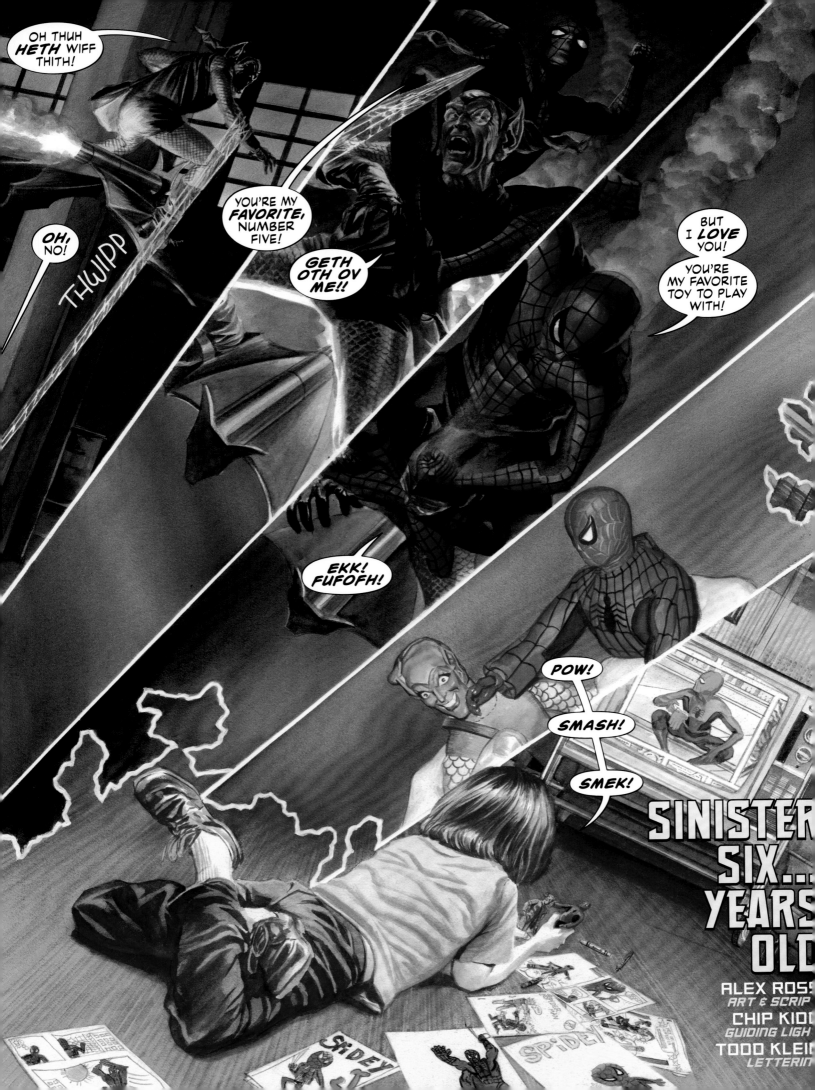

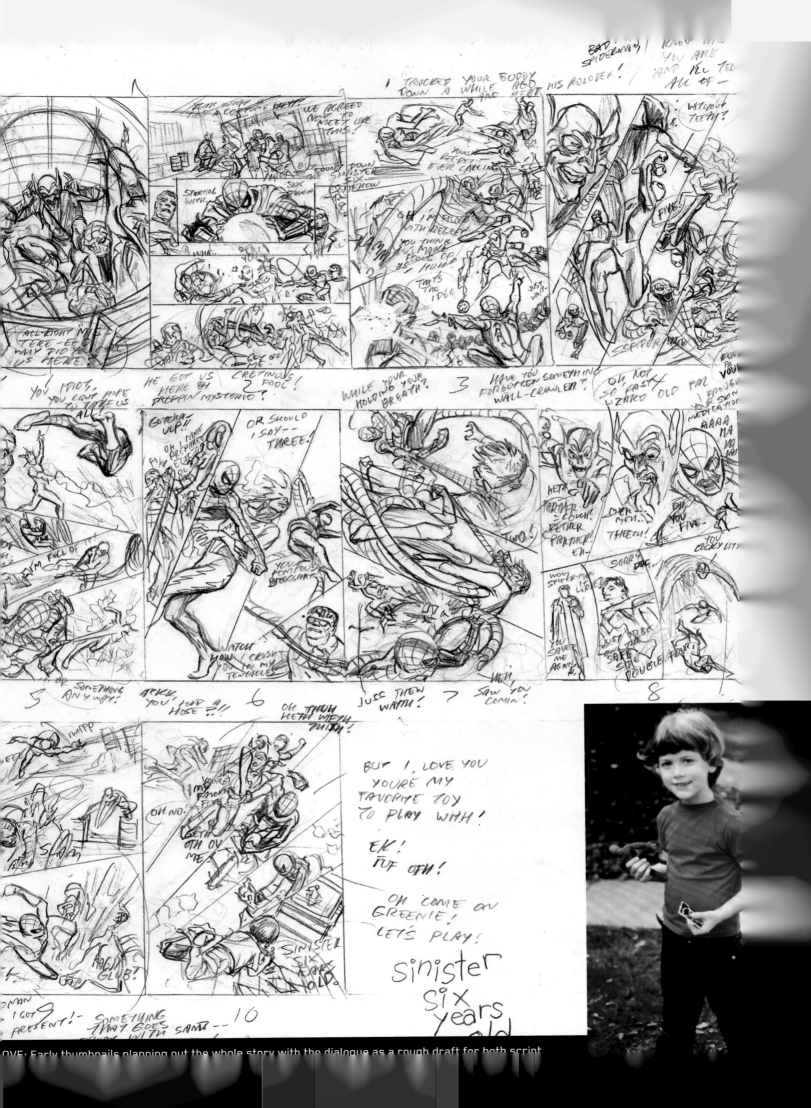

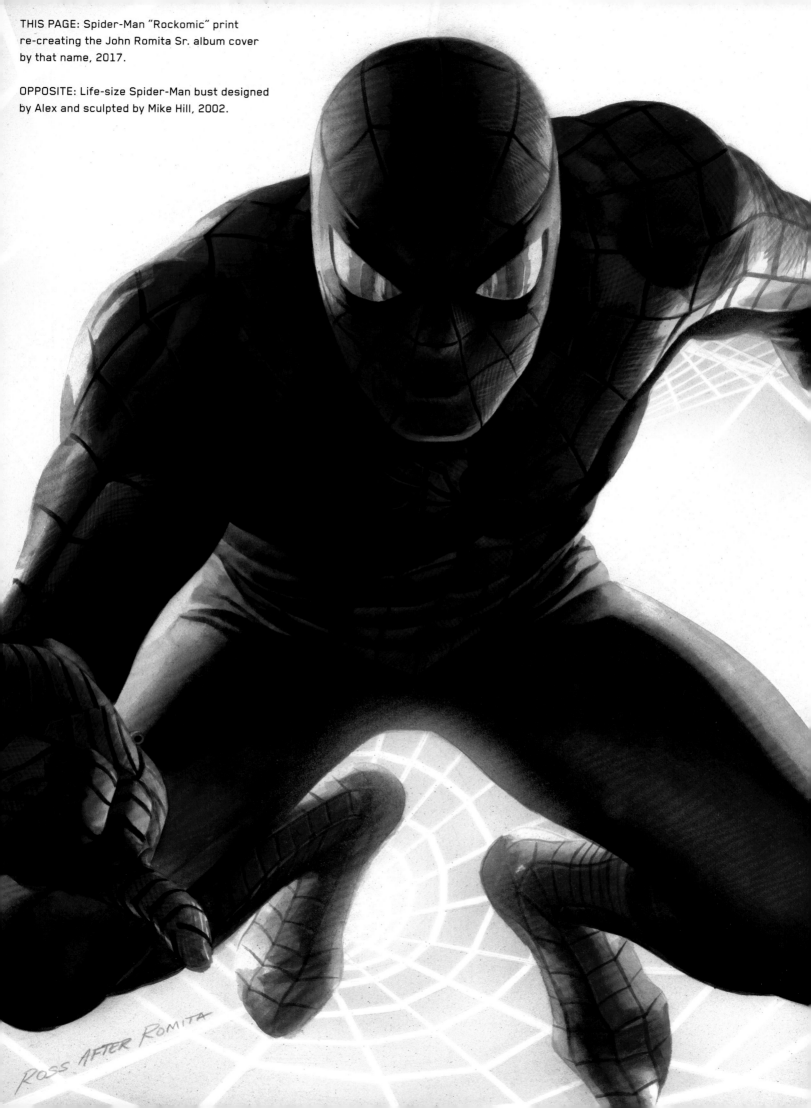

THIS PAGE: Spider-Man "Rockomic" print
re-creating the John Romita Sr. album cover
by that name, 2017.

OPPOSITE: Life-size Spider-Man bust designed
by Alex and sculpted by Mike Hill, 2002.

ROSS AFTER ROMITA

So here's a question: What do you call the ability to train yourself to draw beautiful pictures by hand, and then paint them, and then even figure out how to sculpt them into three dimensions? What exactly do you say it is to make hundreds and thousands of them for many years; to thrill and inspire a mass audience with something that you create from your eyes to your brain to your bare hands to the paper—is that a personal obsession or a public service? Or do we even have to make that distinction?

I think, to be able to produce so many fantastic images out of nothing, with such virtuosity of skill and emotion, honed over decades, in the case of Alex Ross it can only be called one thing: a superpower.　　　—C. K., 2018

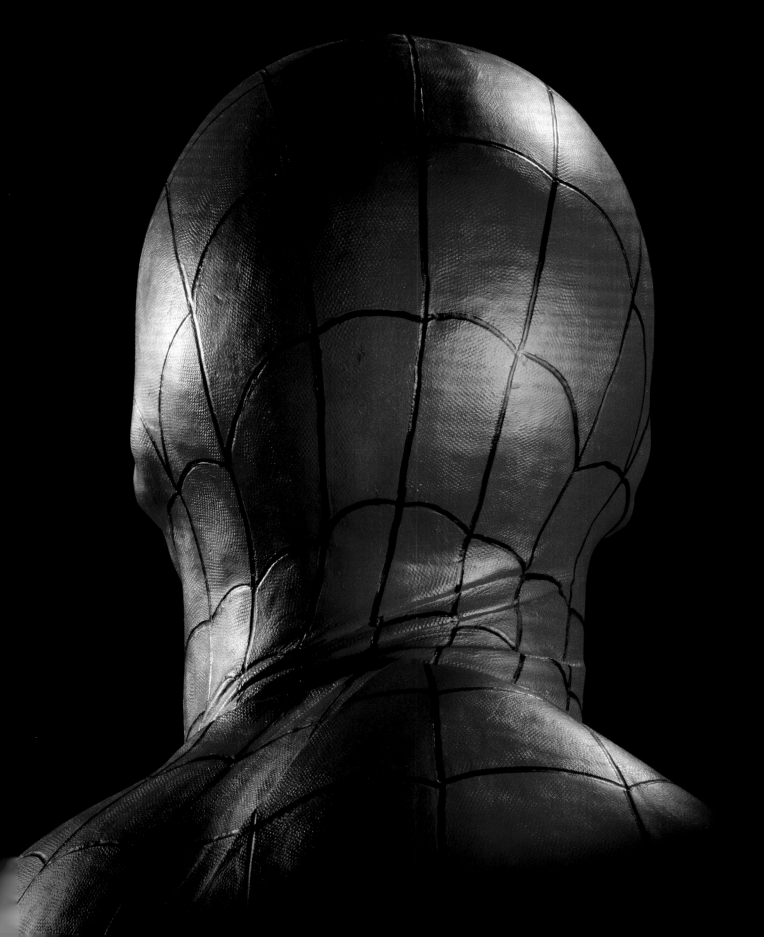

SELECTED BIBLIOGRAPHY

AUTHOR'S NOTE

Even though the list on these two pages (and the book you hold in your hands) might suggest a lifetime's worth of work, please keep in mind that this represents less than half of Alex's output in the last 29 years (and he's not even 50 yet!). He's created just as much art for DC Comics (see *Mythology*, hint hint) and other companies, comprising over one thousand pages of storytelling, and that doesn't even take into account all of the comic book covers. Also note that it doesn't tally the subsequent reprintings for other covers, collections, books, prints, posters, and pinups. We just didn't have the room.

And, no, even though I've seen it with my own eyes, I don't know how he does it. I'm just glad he does. —C. K.

Comic Books

Avengers/Invaders Sketchbook (September 2008) w/Jim Krueger
Earth X Sketchbook (expanded, February 1999) w/Jim Krueger
Earth X: Wizard Special Edition (December 1997) w/Jim Krueger
Marvels no. 0 (August 1994) w/Steve Darnall
Marvels no. 1 (November 1993) w/Kurt Busiek
Marvels no. 2 (December 1993) w/Kurt Busiek
Marvels no. 3 (February 1994) w/Kurt Busiek
Marvels no. 4 (March 1994) w/Kurt Busiek
Open Space no. 0 (*Wizard* exclusive, 1999) w/Lawrence
Watt-Evans
Paradise X: Wizard Special Edition (October 2001) w/Jim Krueger
Universe X Omnibus (June 2001) w/Jim Krueger
Universe X: Wizard Special Edition (July 2000) w/Jim Krueger

Collected Editions—includes content created by Alex Ross
Avengers/Invaders (hardcover, 2009) w/Jim Krueger
Avengers/Invaders (trade paperback, 2010) w/Jim Krueger
Earth X (Graphitti Designs Limited Hardcover Edition, 2001)
w/Jim Krueger
Earth X (hardcover, 2005) w/Jim Krueger
Earth X Trilogy Companion (trade paperback, 2008) w/Jim Krueger
Invaders Now! (trade paperback, 2011) w/Christos Gage
Marvels (Graphitti Designs Limited Hardcover Edition, 1994)
w/Kurt Busiek
Marvels (hardcover, 1994) w/Kurt Busiek
Marvels (hardcover, 2008) w/Kurt Busiek
Marvels (trade paperback, 1994) w/Kurt Busiek
Marvels (trade paperback, 2003) w/Kurt Busiek
Marvels 10th Anniversary Edition (hardcover, 2004) w/Kurt Busiek
Marvels: The Platinum Edition (hardcover, 2014) w/Kurt Busiek
Paradise X Vol. 1 (trade paperback, 2003) w/Jim Krueger
Paradise X Vol. 2 (trade paperback, 2004) w/Jim Krueger
The Torch (trade paperback, 2010) w/Mike Carey
Universe X Vol. 1 (trade paperback, 2002) w/Jim Krueger
Universe X Vol. 2 (trade paperback, 2002) w/Jim Krueger

Comic Book Stories
Captain America: Red, White, and Blue (hardcover,
September 2002)
Clive Barker's Hellraiser no. 17—"The Harrowing, Part One: Resur-
rection" (June 1992) w/Malcolm Smith, Anna Miller, Fred Vicarel
Earth X Epilogue (*Earth X* Graphitti Designs Limited Hardcover
Edition, 2001) w/John Paul Leon
Marvel Age no. 130–no. 133—Human Torch Origin (November
1993–February 1994) w/Steve Darnall
Miracleman: Apocrypha no. 3—"Wishing on a Star" (Eclipse
Comics, February 1992) w/Steve Moore

Comic Book Covers/Collections—first use of imagery only
All-New, All-Different Avengers no. 1 (3 covers)–no. 15
(January –December 2016)
All-New Captain America no. 1 (2 covers, January 2015)

All-New X-Men no. 27 Marvel 75th Anniversary variant (2 covers,
July 2014)
Amazing Spider-Man no. 1 (3 covers)–no. 32 (December 2015–
November 2017)
Amazing Spider-Man no. 1 Marvel 75th Anniversary variant
(2 covers, June 2014)
Amazing Spider-Man no. 568 (October 2008)
Amazing Spider-Man no. 600 (September 2009)
Amazing Spider-Man no. 789 (3 covers)–no. 800, Annual no. 42
(January 2018–June 2018)
Amazing Spider-Man Vol. 1.1: *Learning to Crawl* no. 1.1–no. 1.5
and variants (June–November 2014)
Avengers no. 1–no. 11 (January–November 2017)
Avengers no. 25 Marvel 75th Anniversary variant (2 covers,
March 2014)
Avengers no. 672–no. 674 (December 2017–February 2018)
Avengers/Invaders no. 1–no. 12 (2 covers each issue,
July 2008–February 2009) w/Jim Krueger
Black Panther no. 1 (June 2016)
Captain America no. 22 Marvel 75th Anniversary variant
(2 covers, September 2014)
Captain America no. 34 (March 2008)
Captain America no. 34 (Dynamic Forces variant, March 2008)
Captain America 75th Anniversary Magazine no. 1 (June 2016)
Captain America no. 600 (August 2009)
Captain America no. 695 (January 2018)
Captain America: Reborn no. 1 (September 2009)
Captain America: Sam Wilson no. 7 (2 covers, May 2016)
Captain Marvel no. 1, no. 3 (November 2002, January 2003)
Clive Barker's Hellraiser no. 17 (June 1992)
Daredevil no. 1 Marvel 75th Anniversary variant (2 covers,
May 2014)
Daredevil no. 500 (October 2009)
Darth Vader no. 1 (3 covers, April 2015)
Death of Wolverine no. 1 Marvel 75th Anniversary variant
(2 covers, November 2014)
Doctor Strange no. 2 and variant (January 2016)
Doctor Strange Omnibus Vol. 1 (hardcover, 2016)
Earth X no. 0–no. 12, no. X (March 1999–June 2000)
Earth X no. 0, no. 1, no. X (Dynamic Forces variants, March–
April 1999, June 2000) w/John Paul Leon
Earth X no. 1/2 (*Wizard* Exclusive, 1999)
Fantastic Four no. 1 Marvel 75th Anniversary variant (2 covers,
April 2014)
Free Comic Book Day 2015 (*Secret Wars* no. 0, June 2015)
Generations: Banner Hulk and the Totally Awesome Hulk no. 1
(October 2017)
Generations: Hawkeye and Hawkeye no. 1 (October 2017)
Generations: Phoenix and Jean Grey no. 1 (October 2017)
Guardians of the Galaxy no. 18 Marvel 75th Anniversary variant
(2 covers, October 2014)
Guardians of the Galaxy no. 150 (March 2018)
Guardians of the Galaxy: Solo Classic Omnibus (hardcover, 2015)

Guardians 3000 no. 1–no. 6 (December 2014–May 2015)
Hulk no. 5 (October 2014)
Incredible Hulk Omnibus Vol. 1 (hardcover, 2008)
Incredible Hulk no. 600 (September 2009)
Incredible Hulk: Nightmerica no. 1 (*Wizard* Limited Edition, 2003)
Invaders Now! no. 1–no. 5 (2 covers each, November 2010–
March 2011) w/Christos Gage
Iron Fist no. 1 and variant (May 2017)
Lando no. 1 and variant (September 2015)
Marvel Age no. 130 (November 1993)
Marvel Encyclopedia (2002)
Marvel Legacy no. 1 (November 2017)
Marvel Two-in-One no. 1 variant (December 2017)
Men of Wrath no. 5 (February 2015)
Midnight Sons Unlimited no. 9 (May 1995)
The Mighty Captain Marvel no. 1 and variant (March 2017)
Miracleman no. 5 (July 2014)
A Moment of Silence no. 1 (February 2002) w/Joe Quesada
New Mutants no. 1 (July 2009)
Paradise X no. 0–no. 12, no. X (April 2002–June 2003)
Paradise X: A (October 2003)
Paradise X: Devils (November 2003)
Paradise X Prelude: Heralds no. 1–no. 3 (December 2001–
February 2002)
Paradise X: Ragnarok no. 1 and no. 2 (March 2003–April 2003)
Paradise X: Xen (July 2002)
Princess Leia no. 1 (3 covers, May 2015)
The Savage Hulk no. 1 Marvel 75th Anniversary variant
(2 covers, August 2014)
Secret Empire no. 10 (October 2017)
Secret Wars no. 1–no. 9 and variant (July 2015–April 2016)
Secret Wars (hardcover and trade paperback, 2016)
Secret Wars (trade paperback, 2011)
Secret Wars Omnibus Vol. 1 (hardcover, 2008)
Spider-Man/Daredevil no. 1–no. 4 (January 2001–April 2001)
Spider-Man/Daredevil no. 1 (Dynamic Forces variant, January
2001) w/Phil Winslade
Spider-Woman no. 1 and variant (November 2009)
Squadron Supreme (trade paperback, 1997)
Squadron Supreme no. 1–no. 4 (December 2015–April 2016)
Star Wars no. 1 (3 covers, March 2015)
Star Wars no. 1–no. 4 (2 covers each, Dark Horse Comics,
February–April 2013)
The Superior Iron Man no. 1 Marvel 75th Anniversary variant
(2 covers, January 2015)
Superman/Fantastic Four (Marvel and DC Comics, March 1999)
w/Dan Jurgens
Thor no. 1 Marvel 75th Anniversary variant (2 covers,
December 2014)
The Torch no. 1 (3 covers)–no. 8 (November 2009–May 2010)
w/Mike Carey
Uncanny X-Men no. 29 Marvel 75th Anniversary variant
(2 covers, February 2015)

OPPOSITE AND BELOW: Initial ink design drawing and finished art for the Avengers box art for Vs. System, 2005.

FOLLOWING PAGE: Classic Marvel button from 1967 with heads illustrated by Jack Kirby, Gene Colan, Steve Ditko, Werner Roth, and Marie Severin, re-created for Alex Ross Art as a convention giveaway, 2017.

ENDPAPERS: Earth X Ben Grimm T-shirt, 2000.

Wraparound cover art to the Marvels trade paperback, 1994.

This book happened because of one main person who pushed for it, Sal Abbinanti. He pushed me, Chip, and Marvel together when all parties struggled with this happening. Sal had this vision, and I am very grateful to him for it. Chip Kidd, quite simply, honors me with his time in doing this. Our friend and supporter, Charlie Kochman, played a part helping us along again by contributing his eyes to the project. Josh Johnson, Chris Rupp, Eli Semer, and Alex Costa all helped with collecting art scans. Photographer Geoff Spear brought the cosmic touch I am thrilled to see with my Marvel work. Original artwork that made the book come alive was loaned by my friends Simon Powell, Mark Braun, John Vogel, and Carlos Pesina. Mike Hill, Lou Cella, and Larry Malott's inspirational sculptures, along with those of many other talented artists, make this whole experience more vivid. My creative collaborations with Kurt Busiek,

Jim Krueger, and Nick Barrucci are the pillars of my body of work with Marvel, for their work made everything in this book a reality. My thanks to my designers, Clark and Lynette Ross, whom I still try to impress. My models who lent their time and dignity to aid my artwork include Frank Kasy, Matt Paoletti, Tony Vitale, Terrence Hunter, Mark Braun, Ron Bogacki, Andrew Pepoy, Barry Crain, Holly Blessen, Valerie Studnik, Max Rocans, Kenn Kooi, Cory Smith, Scott Beaderstadt, Aidan Miller, Bob Miller, Julie Miller, Jon Oye, Brian Coberly, Jane Jensen, Chris Lawrence, Sung Koo, Steve Darnall, Meg Guttman, Mark Huckabone, John Romita Sr., and Geneva Ross Neberman.

And most of all I wish to thank my wife, T.J., for more than just the hard work she has contributed to this book, but for the life she has given me to enjoy, through which all creative expressions, like this book, are possible. —A. R.

MAKE MINE MARVEL

FOR PROMOTIONAL USE ONLY - NOT FOR RESALE.
© MARVEL ALEX ROSS COLLECTOR CLUB

First, thanks to Alex Ross for his passion, talent, hard work, and friendship. Alex, you are proof that magic exists. And Sal Abbinanti, you are proof that *magicians* exist (in the best possible way!). Geoff Spear, you did it again, even more brilliantly than before. A huge ration of my gratitude goes to the fantastic legal team at Penguin Random House, who never gave up, even when I sort of did: Patty Flynn, Amelia Zalcman, and Bill Shannon. At Pantheon: Shelley Wanger, Tony Chirico, Cameron Ackroyd, Dan Frank. This book looks as good as

it does thanks to the intrepid Pantheon production team: John Kuramoto, Andy Hughes, Peggy Samedi. Charlie Kochman and Mark Evanier provided invaluable guidance and vintage images. Bless you, "Team Prop Up Chip!": Marc Bailey, Joan Brennan, Bob Criso, Jessica Helfand, Rob Lane, Debbie Millman, Dede Pahl, and Azelis. Brian Overton at Marvel was incredibly helpful and made everything easy. J. J. Abrams, what can I say? You are the BEST. Sandy, now that you are gone, you are everywhere. Thank you, thank you. —C. K.

IN LOVING MEMORY OF J. D. McCLATCHY